A
S10

05

Women, Art and the Politics of Identity in Eighteenth-Century Europe

Women and Gender in the Early Modern World

Series Editors: Allyson Poska and Abby Zanger

In the past decade, the study of women and gender has offered some of the most vital and innovative challenges to scholarship on the early modern period. Ashgate's new series of interdisciplinary and comparative studies, 'Women and Gender in the Early Modern World', takes up this challenge, reaching beyond geographical limitations to explore the experiences of early modern women and the nature of gender in Europe, the Americas, Asia, and Africa.

Titles in the series include:

Women, Art and the Politics of Identity in Eighteenth-Century Europe

Edited by

MELISSA HYDE
University of Florida

JENNIFER MILAM
University of Sydney

ASHGATE

Published by
Ashgate Publishing Limited
Gower House
Croft Road
Aldershot
Hants GU11 3HR
England

Ashgate Publishing Company
Suite 420
101 Cherry Street
Burlington, VT Vermont, 05401-4405 USA

Ashgate website: http://www.ashgate.com

British Library Cataloguing in Publication Data
Women, Art and the Politics of Identity in Eighteenth-Century Europe
 (Women and Gender in the Early Modern World)
 1. Women in art. 2. Women artists—Europe—History—18th century. 3. Art, European—
 18th century. 4. Women—Europe—Social conditions—18th century.
 I. Hyde, Melissa. II. Milam, Jennifer
 704'.042

Library of Congress Cataloging in Publication Data
Women, Art and the Politics of Identity in Eighteenth-Century Europe / edited by Melissa
Hyde and Jennifer Milam.
 p. cm – (Women and Gender in the Early Modern World)
 1. Women painters—Europe—Biography—History and criticism. 2. Painting, European—
 18th century. 3. Women art patrons—Europe. 4. Women art collectors—Europe. 5.
 Women—Europe—History—18th century. I. Hyde, Melissa Lee. II. Milam, Jennifer Dawn,
 1968–. III. Series.
 ND456.W 2003
 759.94'082–dc21 2003043680

ISBN 0 7546 0710 0

Typeset by Manton Typesetters, Louth, Lincolnshire, UK.
Printed and bound in Great Britain by Biddles Ltd, Guildford and King's Lynn.

Contents

List of Figures

Contributors

Jill Casid is Assistant Professor of Visual Culture Studies in the Department of Art History, University of Wisconsin-Madison. Among her essays are an article on Marie-Antoinette's Hameau at Versailles in a forum on gay and lesbian studies in *Eighteenth-Century Studies* (1995), the essay 'Inhuming Empire: Islands as Colonial Nurseries and Graves' for the anthology *The Global Eighteenth Century* (The Johns Hopkins University Press, 2002), and 'His Master's Obi' for *The Visual Culture Reader* (Routledge Press, 2nd edition, 2002). Her book *Sowing Empire: Landscape and Colonization in the Eighteenth Century* is forthcoming with University of Minnesota Press. Other book manuscripts in progress include a study on the magic lantern and technologies of projection, and an anthology on 'Visual Transculture.'

Melissa Hyde is Assistant Professor of Art History at the University of Florida. She specializes in eighteenth-century French art; her research addresses the gendering of aesthetic culture and rococo painting. Hyde is currently completing a book, *François Boucher and his Critics: Making Up the Rococo* (to be published by the Getty Research Institute). She has published articles on Boucher in *Eighteenth-Century Studies* and *The Art Bulletin*. Hyde's most recent publication is an essay on women and the visual arts in the exhibition catalogue, *Anne Vallayer-Coster, Painter to the Court of Marie-Antoinette* (Yale University Press, 2002).

Christopher M.S. Johns is Norman and Roslea Goldberg Professor of Art History, Vanderbilt University. His books, *Papal Art and Cultural Politics in the Age of Clement XI* (Cambridge, 1993) and *Antonio Canova and the Politics of Patronage in Revolutionary and Napoleonic Europe* (University of California Press, 1998), established Johns as one of the leading authorities on the subject of patronage in eighteenth-century France and Italy. Johns has published widely on patronage (including that of Canova by Napoleon's mother) and many other topics in the *Gazette des Beaux-Arts*, *Master Drawings*, *Word and Image*, *Eighteenth-Century Studies*, *Zeitschrift für Kunstgeschichte*, *Storia dell'Arte* and *The Burlington Magazine*. He is author of a feature essay and numerous catalogue entries for *Art in Rome in the Eighteenth Century* (2000).

Jennifer Milam is Senior Lecturer in Art History and Theory at the University of Sydney, Australia. Her area of expertise is eighteenth-century French art, and she is completing a book-length manuscript on visual play in the paintings of Fragonard. She has published articles in *Art History*, *The Burlington Magazine* and *Eighteenth-Century Studies*, as well as an essay on Madame Adélaïde in *The Dictionary of Artists' Models*. Her work on child sexuality and response appeared in *Between Rousseau and Freud: Visual Representations of Children and the Construction of Childhood in the Nineteenth Century* (Ashgate, 2001).

Kathleen Nicholson is Professor of Art History at the University of Oregon. A specialist in the art of England and France during the eighteenth and nineteenth centuries, her first book was entitled *Turner's Classical Landscapes, Myth and Meaning* (Princeton, 1990). She has published museum catalogue essays on English landscape painting and the history of photography. Her work on women as artists and patrons in eighteenth-century France includes essays on Vigée-Lebrun and Labille-Guiard in the *Dictionary of Art* (Grove, 1996) and an essay 'The Ideology of Feminine "Virtue": The Vestal Virgin in French Eighteenth-Century Allegorical Portraiture,' in *Portraiture: Facing the Subject* (Manchester University Press, 1996). She is currently completing a book-length study entitled *'Beguiling Deception': Women and the Allegorical Portrait in Eighteenth-Century France*.

Paula Radisich is Professor at Whittier College, Los Angeles, where she teaches courses in art history, mainly in eighteenth- and nineteenth-century European art. Her book *Hubert Robert: Painted Spaces of the Enlightenment* was published by Cambridge University Press in 1998. She has published numerous articles in *Eighteenth-Century Studies*, *Studies on Voltaire and the Eighteenth-Century* and *Art Bulletin*. These publications include an article on Vigée-Lebrun's self-portraiture, and her recent book contains a chapter on Mme Geoffrin and Hubert Robert, one of the very few treatments of that important subject. Radisich is currently completing a book on Chardin entitled *Looking Sharp: Modern Life Subjects in the Art of Chardin*.

Angela Rosenthal is Assistant Professor at Dartmouth College where she teaches art history and gender theory, focusing on eighteenth- and nineteenth-century visual culture. She is the author of *Angelika Kauffmann: Bildnismalerei im 18. Jahrhundert* (Reimer, 1996), a book being reworked for publication in English. Her articles on contemporary feminist art and on eighteenth- and nineteenth-century culture have appeared in *Art History*, *Kritische Berichte*, as well as other journals and anthologies. Rosenthal is co-editor of the German feminist art journal *Frauen Kunst Wissenschaft* and of a

volume of essays entitled *The Other Hogarth: The Aesthetics of Difference* (Princeton, 2001).

Wendy Wassyng Roworth is Professor at the University of Rhode Island. As a distinguished scholar in the field of women artists, she has published widely on that subject, particularly on Angelica Kauffman, in *Femininity and Masculinity in Eighteenth-Century Culture* (Manchester University Press, 1994), the *Dictionary of Women Artists* (Fitzroy Dearborn Press, 1997), *Art Bulletin*, *The Burlington Magazine* and *Eighteenth-Century Studies*. Her book, *Angelica Kauffman: a Continental Artist in Georgian England* (Reaktion Books, 1992), was one of the first major studies of the artist since the nineteenth century.

Andrew Schulz is Associate Professor at Seattle University, where he teaches courses on eighteenth- and nineteenth-century European art. He specializes in Spanish art from 1750 to 1830, the history of graphic art, and Symbolism. His book, *Goya's 'Caprichos': Aesthetics, Perception, and the Body in Late Eighteenth-Century Madrid*, is forthcoming with Cambridge University Press. He has published articles on Goya in *Art Bulletin* (1998) and *Art History* (2000). His essay in this collection is part of a book-length study on the formation of Spanish cultural identity from the founding of the Royal Academy to the opening of the Prado (1750 to 1830).

Mary Sheriff is Daniel W. Patterson Distinguished Professor of Art at the University of North Carolina, Chapel Hill. She is author of *J. H. Fragonard: Art And Eroticism* (1990) and *The Exceptional Woman: Elisabeth Vigée-Lebrun and the Cultural Politics Of Art* (1996), both published by the University of Chicago Press. Her new book, *Moved by Love: Inspired Artists and Deviant Women in Eighteenth-Century French Art*, is forthcoming from the University of Chicago Press in fall, 2003.

Mary Vidal is Associate Professor in the Department of Visual Arts at the University of California, San Diego. She writes on the history of French art during the *ancien régime* and Revolution and has published a book entitled *Watteau's Painted Conversations: Art, Literature, and Talk in Seventeenth- and Eighteenth-Century France* (Yale University Press, 1992). Recent articles on David's portraits and mythological works have appeared in the *Journal of the History of Ideas*, *Art History* and *Art Bulletin*. She is currently completing a book entitled *Between 'Virtu' et 'Volupté': Jacques-Louis David's Images of Women and Love*, to be published by Yale.

Acknowledgements

This volume has been truly a collaborative work, and would not have been possible without the good will, good faith and good counsel of our friends and colleagues who contributed to this project. For us it has been the greatest of pleasures, and always illuminating, to read the various versions of their essays as the collection grew to completion. We are better scholars and thinkers for having had the opportunity to work with and to learn from these colleagues, who will always have our admiration and affection.

We are grateful to Pamela Edwardes of Ashgate Press for first prompting us to think of doing a book that would address the topic of women and art patronage. Our gratitude extends also to Abby Zanger, Allyson Poska, the editors for the Ashgate series, Women and Gender in the Early Modern World, to which this book belongs, for their continual enthusiasm for our project. Erika Gaffney and Kirsten Weissenberg have been exemplary editors and we count ourselves fortunate to have had the opportunity to work with them. To the anonymous reviewers of our book proposal and manuscript, we owe thanks for their incisive comments.

Melissa Hyde wishes to thank the University of Florida Office of Research and Graduate Programs, which provided funding for her contributions to this volume through the Fine Arts Scholarship Enhancement Award Fund. Postdoctoral fellowships from the American Association of University Women and from the Getty Research Institute provided her, too, with generous financial support. She also wishes to thank her wonderfully able research assistant, Christine Wegel. The University of Sydney supported Jennifer Milam's contributions to this volume with funding from SESQUI and Overseas Travel Grants. The Australian Research Council provided her with additional research support. She wishes to thank the Power Institute at the University of Sydney and the Art Gallery of New South Wales for sponsoring a master class on the subject of this volume in conjunction with Mary Sheriff's visit to Australia. We offer particular thanks as well, to Terry Smith, the former Director of the Power Institute, and to Donald McGlothlin, Dean of the College of Fine Arts at the University of Florida for their munificence in supporting this publication.

Our acknowledgments would not be complete without recognition of the debts of gratitude that we owe to each other; and perhaps, most of all, to our

families, whose unfailing good humor and confidence in our endeavors help us to push on and keep things in their proper perspective. It is to them we dedicate this book.

<div align="right">

Melissa Hyde
Jennifer Milam

</div>

Introduction: Art, Cultural Politics and the Woman Question

Melissa Hyde and Jennifer Milam

Woman in the eighteenth century is the principle that governs, the rea-
son that directs, the voice that commands. She is the universal and fatal
cause, the origin of events, the source of things ... Nothing escapes her,
she holds within her grasp the King, France, the will of the sovereign,
and the authority of opinion – everything. She gives orders at court, she
is mistress of the home. She holds the revolutions of alliances and
political systems, peace and war, the literature, the arts and the fashions
of the eighteenth century, as well as its destinies in the folds of her
gown.
　Jules and Edmond de Goncourt, *The Woman of the Eighteenth Century*,
1880

Being good Frenchmen, Jules and Edmond de Goncourt had their own coun-
try in mind when they wrote of the eighteenth century as 'the century of
woman and her caressing domination over manners and customs.'[1] Nonethe-
less, their inspired confabulations concerning 'the woman of the eighteenth
century' indelibly marked subsequent understandings of the subject with
respect to the rest of Europe. The success of the Goncourts' account must be
ascribed partly to the vividness, immediacy and rhetorical authority of their
poetic evocations, which are true in many particulars (the brothers were
meticulous researchers and cullers of archives); but it is due also to the ways
in which their interpretation of the period and the focus on its major female
players addressed, though with a different inflection, themes sounded in
debates about women, their nature and the relations between the sexes that
were central to the Enlightenment's investigation of human society. (These
debates fell under the rubric of the so-called 'woman question', to which we
shall return in due course.) Ultimately, however, the picture the Goncourts
painted of the 'century of Woman' belongs to the realm of fiction. Their

portrayal is at once highly selective, and highly embellished, most notably in its figuring of Woman as a generalized category rather than any specific individual, and in the ascendancy ascribed to her. The eighteenth century, the age of Enlightenment and revolution, was a deeply complex period of dramatic ruptures and epistemic shifts – that has long been acknowledged by historians, philosophers and political theorists. The place of women in this history, their relationship to its heroic narratives, to social, political and cultural institutions, the part they played in cultural production have more lately become the focus of study and lively debate.[2]

Much of the recent scholarship has been devoted to the critical analysis of eighteenth-century representations, textual and pictorial, of and by women. This line of inquiry has proved to be fruitful, for in recognizing representation as a form of cultural practice it has exposed the deep structural relationships between culture and the politics of gender during this period.[3] Careful consideration of women's participation in the Republic of Letters (and to a lesser extent, the art world) has established that their roles in shaping culture – whether through sponsorship or taking part in literary and philosophical salons,[4] writing, patronage, painting or some other means – were multifold, and sometimes as paradoxical as the individual women themselves.

Valuable though these initiatives have been, women's engagement with the visual arts is a topic about which a great deal remains to be said. Women's private lives, their participation in the project of Enlightenment and the formation of the public sphere have been the subjects of historical and literary studies in recent decades, but their involvement with the arts is as yet one of the richest and most under-explored areas for scholarly investigation. It is true that there is a vital and developing body of work on women artists of the period,[5] to which the chapters here on Rosalba Carriera and others contribute, but less attention has been paid to the specific conditions of female patronage and collecting. Though a venerable and abiding feature of art-historical study, patronage has been concerned chiefly with the enterprises of men. Moreover, current interests in the politics of collection and display have not usually been attuned to issues of gender, but instead continue to privilege a masculinist model of 'serious' patronage and taste based on antiquated notions about artistic progress and aesthetic disinterestedness. Since the later nineteenth century there have been a few instances in which students of the early modern period have strayed from the disciplinary protocols of art history to consider women as patrons, but these are apt to consist of vague generalizations and hyperbole (à la Goncourt), while more recent examinations of the subject, with a few notable exceptions, seem to want to foreclose on the notion that in the eighteenth century women had a hand in the visual arts at all.[6]

Looking back to her glory days as the chosen portraitist of Marie-Antoinette and one of the most fashionable painters in Paris, Élisabeth Louise Vigée-Lebrun asserted in her memoirs that 'women reigned then: the Revolution dethroned them.'[7] This lofty claim about women's *ancien régime* ascendancy, argued so seductively by the Goncourts, was wryly amended by Jean Starobinski in *The Invention of Liberty* (1964) when he wrote 'Woman reigned (she was made to believe she reigned).'[8] As recent historical scholarship attests, and the present volume confirms, the reality lay somewhere in between.[9] Women's influence over politics and culture, government and art, was rarely ever so complete or straightforward as writers of the past, for good or ill, would have us believe. Neither was it negligible, as others have more lately maintained.[10]

The woman/artist question and beyond

Before introducing some of the major themes and concerns of this book, a few words on our approach to the subject of women patrons and artists are called for. Convinced as we are that the history of women does not stand outside or even on the periphery of the Western tradition, but is integral to it, a central aim of this project is to advance the understanding of the significant role that women played in the visual culture of the Enlightenment. It is worth emphasizing, though, that the very subject of women and the arts is comparatively new to art history, and in taking it up, we are heir to the energetic spirit of critical re-examination and experimentation that characterizes this rapidly evolving field of inquiry.

The first sustained art-historical interest in women artists grew out of the feminist movement of the early 1970s. As these artists were rediscovered and returned to the historical record, one of the preoccupations of feminist art history from the 1970s and into the 1980s was to address the question, 'Why have there been no great women artists?' so provocatively posed by Linda Nochlin in her famous article of 1971.[11] Nochlin's question, which has become art history's own 'woman question' (or better, 'woman-artist question'[12]) generally inspired two varieties of response. There were those who sought out and made cases for lost female equivalents of canonical male artists – precisely the project Nochlin was cautioning against. Other scholars embraced the premise implied (if somewhat ironically) by Nochlin's question: that there have been no great female artists, and elaborated on her own response to it by further demonstrating that social, cultural, institutional structures made it impossible for women to be great artists, no matter how great their native genius. More recent feminist art history, while still concerned to varying degrees with the search for forgotten equivalents, has tended to set aside questions about women's genius

or lack thereof in favor of interrogating traditional categories themselves (say, of genius or greatness), along with their organizing assumptions.[13] And though critiquing the patriarchal structures that proscribed women artists' lives continues to be important for much feminist art history, this current work is complemented by an interest in reading for what Griselda Pollock has termed 'inscriptions in the feminine', by which she means 'being able to speak of the myths, figures and fantasies that might enable us to see what women artists have done … to provide, in our critical writings, representational support for feminine desires in a space which can also comprehend conflicting masculine desires …'[14] Another aim of the present volume is to broaden the interest in the signs of difference in art made by artists who were women to include how inscriptions in the feminine are legible in the 'works' of female patrons, collectors and sitters – for example, through their of use of allegory, and/or identification with figures of literature and myth (for example Penelope, Minerva, Dibutadis, Cornelia, the Turkish sultana) as paradigms of artistic production and self-representation.[15]

This kind of 'feminist intervention in art's histories' (to quote Pollock again), moves beyond the interpretative cul-de-sac of the woman-artist question in order to challenge the masculinist discourse that defines the discipline.[16] Each of the studies included here furthers the interventionist project of critiquing and reconsidering established lines of inquiry, categories and presuppositions that have informed art history. Mary Sheriff, Angela Rosenthal, Jill Casid and Jennifer Milam grapple in different ways with issues of art-historical methodology and propose fresh interpretative approaches, while the other contributors shed new light on their subjects by taking up more traditional modes of analysis and recasting the questions that are brought to bear on the art-historical objects under consideration. All of the authors attend to how constructions of gender conditioned either the making and interpretation of images or the self-fashioning through art of the painter, patron or collector.

Many women, perhaps unprecedented numbers of them, participated in the activities of art-making, commissioning and collecting during this period, and as a number of essays here point out, they did so in ways that often contested or laid claim to identities or categories that were (or are now) conventionally assigned to the masculine. Yet from Rosalba Carriera to the duchess of Osuna they usually did not transgress proprieties, or did not do so overtly. Indeed, as the chapters by Christopher Johns, Wendy Roworth, Paula Radisich and Andrew Schulz confirm, it was possible for women to embrace normative ideals of femininity (or appear to) and still function effectively in traditionally masculine domains such as the academy, history painting, art patronage or Enlightenment discourses about education. By contrast, Kate Nicholson, Melissa Hyde and Jennifer Milam offer instances in which promi-

nent, unmarried women of the French court were able to fabricate identities for themselves that did not fit so neatly into the prevailing conventions; identities that were not defined purely by their relationships to fathers, brothers or husbands, but insist on the individual selfhood and importance of the sitter; that convey a sense of her own agency, and in some cases defined her in relation not to men, but to other women.

Acknowledging that women's lives may indeed have been an 'obstacle race' in the eighteenth century,[17] most of our studies make a case for how deftly, productively and variously women negotiated (or helped men to negotiate, in the case of Mary Vidal's essay) the cultural institutions and restraints of the worlds in which they lived, whether as artists or as patrons. These essays point to a complexity if not pliancy in the norms that governed representations of femininity and some degree of latitude in maneuvering through the changing cultural structures of the period. Because of the long shadow cast over eighteenth-century gender studies by the philosophy of Jean-Jacques Rousseau and his influential vision of domesticized femininity within the emerging bourgeois social order, it has been all too easy to assume that there was one ideal of femininity in the eighteenth century, when it is clear that this was a period of competing or multiple femininities. (It worth recalling here that Rousseau's influential vision of womanhood was developed as a reaction against the ideal of equality between women and men that had been embraced by Enlightenment Salons.) Meanwhile Mary Sheriff's discussion of Vigée-Lebrun's *Marie-Antoinette and her Children* explores how volatile and unmanageable the meanings of representations of women could be, particularly when the subject portrayed was the queen and the artist a woman. Sheriff highlights the instability and equivocation in the discourses – both visual and political – that Vigée-Lebrun's portrait invoked. Her essay illustrates the high political stakes that were involved with the delicate balancing act performed by women in the public eye.

This volume, then, includes chapters that sally forth into the relatively uncharted terrain of women as patrons and collectors, as well as their critical reception, and brings these essays together with others that focus on female artists (who in some cases enjoyed the patronage of prominent women). Our consideration of female artists is broadly construed to include amateurs, usually an overlooked class of artists. In some cases patrons, too, fall into this category. As editors we have found striking resonances and thought-provoking contradictions in the accounts offered here, which we take to be an indication of the complex and vagarious nature of the specific histories that are being addressed, and a healthy effect of the variety of interpretative strategies that have been deployed to write them. However, before detailing further themes and concerns that have emerged in this project, some additional historical background to our period is warranted.

The woman question and the problem of visibility

In the eighteenth century itself the issue of women's influence (the nature of that influence, its degree and kind, its merits and failings), of women's role in society more generally, and the relations between the sexes were subjects as widely acknowledged as they were theorized and disputed. These controversies can be traced to earlier centuries in Europe, but the eighteenth century was a privileged time for debate on the 'woman question', as this cluster of concerns came to be known. In fact, deliberation on the woman question was a central feature of the Enlightenment exploration of human society.[18] The most famous and pitched of these debates took place in France, where progressive thinkers and social reformers identified with the Enlightenment (Rousseau, most famously) argued that the influence of women – namely of wealthy and aristocratic women at court, in their literary salons, and, as Casid argues, in their boudoirs – on the traditionally male domains of politics, literature and art, had degraded and effeminized French culture.[19] Woman's 'natural' place in the social order was, according to this view, the private world of the home and the family. Though many Enlightenment figures saw women's presence and influence in the arts, politics and intellectual life – which was in certain respects real and significant – as a salutary sign of civilization, the negative and exaggerated view of women's 'empire' was the one that would come to dominate in bourgeois and revolutionary ideology and in historical accounts of the *ancien régime* (at least until the Goncourts gave it a positive valence). Ancient, vexed questions about the nature of women themselves, about whether the differences between the sexes were innate or environmental in origin, whether men and women were fundamentally different at all, were at stake in these debates – waged in varying degrees throughout Europe – as were newer ones about what should be their proper role in an era that was drawing increasingly clear distinctions between private and public life, defining both as gendered domains. This was a period in which the concepts of the 'public sphere' and 'public opinion' were being articulated for the first time, as the power of the Church and monarchies diminished and the will of sovereigns faced ever greater challenges to their authority in the face of the will of the people (or those who claimed to represent them).[20]

The cultural anxieties about women's roles, social, political or otherwise, take on a deeper resonance when considered within the broader historical context of eighteenth-century Europe. Most women were unquestionably subject to the will of their fathers and husbands (legally and normatively), but over the course of the century a number of royal women and decidedly non-royal mistresses did act as major players in the arenas of domestic and international politics to a degree that was virtually unprecedented. In 1740

the fiercely independent archduchess Maria Theresa became the first woman ever to rule the Austro-Hungarian Empire; 1762 saw Catherine the Great ascend the throne as ruling empress of Russia. In the intervening years Princess Lovisa Ulrike, sister of the famously bellicose Frederick the Great of Prussia, was crowned queen of Sweden (how much power she actually wielded may be doubted, but she was clearly a force to be reckoned with, as Elisabeth Farnese had been as queen of Spain). Between 1745 and 1763 the marquise de Pompadour became the *de facto* prime minister (so she was called by her contemporaries) of Louis XV, as well as his titled mistress. Later in the century the long reach of Maria Theresa was felt by all as three of her daughters were married to Bourbon princes in Parma, Naples, and most famously in France, where Marie-Antoinette, like her sisters, was thought (rightly or wrongly) to be seeking to advance the interests of her mother in her own political maneuvering. Many more women of élite society (in a markedly non-Rousseauian way) promoted the interests of their families and protégés in the political intrigues and power struggles of the court and in the machinations of academic and religious institutions. The presence of such women at the highest echelons of European governments and in élite society must have given an urgent reality to the arguments of those concerned with defining and policing femininity and women's roles.

The contested matter of women's relationship to the public dominion and historically masculine realms of culture presented a complex situation for women artists and patrons.[21] If they were artists, their pursuit of the profession usually took them beyond private or domestic domains, and it did so in a conspicuous way if they showed their work in public exhibitions (as was the case with Vigée-Lebrun, Carriera, Kauffman, Labille-Guiard, and some of Jacques-Louis David's students, such as Marie-Guillemine Leroulx-Delaville). The kind of high visibility that came from being well known could alone make these artists morally suspect, like actresses, courtesans and what we might term other such 'spectacular' women. This suggestive visibility put them at odds with ideals of middle-class feminine propriety that were being widely promoted during the Enlightenment, as did the ambition it took to vie for recognition and patrons.[22] For women of the court and élite society, who already belonged to the quasi-public worlds of the court and salon, presenting images of themselves to the public eye at the Salon or some other 'spectacular' venue could be sometimes less problematic because justified by their social standing. As the case of Marie-Antoinette amply illustrates, however, even queens were not exempt from criticism if they appeared to transgress the proprieties and dictates of Salic Law.[23] (By the same token, mistresses like Pompadour were savaged if they appeared to have pretensions that extended beyond the bedroom or boudoir.) All women, but especially those in the public eye, had to be exceedingly careful and attentive to the image they

presented if they wished to function in society. All had to think carefully about how they defined themselves and who they wanted to (appear) to be. The range of choices they made when it came to pictorial representations of themselves is telling and illuminating about the individual women and the time in which they lived.

Institutions and critics: it's a man's world?

In France during the second half of the eighteenth century, Salon critics and administrative officials of the Académie royal de peinture et sculpture actively worked to ensure that artistic production and exhibition would remain the exclusive province of men.[24] One of the strategies for excluding women centered on the regulation of artistic practice: the number of women who could be admitted to the Académie was strictly limited to four, and though members, they could not teach or vote in the Académie.[25] The only women allowed within the walls of the Académie's classrooms were hand and face models in life drawing classes. As discussed by Mary Vidal, moves were even made to prevent the instruction and training of women in David's private Louvre studio. Another strategy of exclusion, this one discursive, is addressed by Jill Casid, who describes how women's patronage of painting became a particular target of critics who vociferously attacked the vogue for portraiture and small-scale paintings in the Flemish taste on the grounds that these genres were supported by women and were intended for the boudoir. The boudoir 'exhibition' and the Salon, Casid argues, were configured as oppositional, gendered spaces and were instrumental in defining the idealized (masculine) public sphere over and against the (feminine) and the private. But even as the critical opposition of Salon (privileged site for the generation of a new French nation) and *boudoir* (locus of dangerous feminine influence and display) contributed to the ideology of separate spheres, the boudoir also threatened to upset the spheres-in-formation of 'private' and 'public', contaminated as it was by financial capital and colonial commerce.

Undoubtedly these critical, disciplinary efforts were, at least in part, a reaction to the advancements made by women in their increased public recognition as successful artists, patrons of note, and women of power and influence, which did not square with the new ideologies. Yet, as Christopher Johns points out, official art institutions themselves had something to gain by admitting celebrated women artists. When the Roman Accademia de San Luca, with its 'thirst for fame', welcomed Rosalba Carriera to its ranks, it did not simply boost her career by giving her the imprimatur of the most distinguished art institution in the Italian states: her lauded reputation and exceptional status added to the Accademia's own cultural capital. That the female artist

was not the only one to benefit from male patronage (institutional or otherwise) is further illustrated by Vidal's study of the workings of David's 'other atelier', which consisted of a number of women. She suggests that David's support and tutelage of female students stemmed from a mix of motives – generosity, empathy, but also self-interest, and explains how such patronage sometimes worked to his professional advantage by allowing him to foster future patronesses for himself. Vidal's study indicates that patronage can be a fluid, reciprocal relation rather than a unilateral one, while Johns complicates the usual assumption that women were admitted into academic institutions because they were the daughters or wives of established male artists. If celebrity rather than patrimony was indeed the motivation for admittance, then the highly visible academic female artist, a woman who was recognized on her own merit, might have functioned as a disturbing sign of female autonomy. In other words, being 'an ornament of Italy and the Premier Female Painter of Europe' was a double-edged sword. It might mean being a credit to an prestigious cultural institution, or a threat to the *status quo*. Carriera was keenly aware of this, as Johns' analysis of the artist's canny choices in producing her acceptance piece suggests.

From here to maternity: women and the art of self-fashioning

Here we have arrived at a theme that runs through a number of these essays: namely, the clear cognizance of women artists about how their choices and treatments of subject could either reflect on them badly and be held against them if they undertook immodest or 'improper' subjects or be used productively to fashion an identity for themselves that would project the desired (sometimes feminist, to use an anachronistic term, sometimes compensatory) image of their own womanhood. Wendy Roworth demonstrates how Angelica Kauffman selected unusual historical subjects focusing on virtuous, exemplary Roman matrons to distinguish herself as a painter of the highest status without overtly challenging gender norms. Angela Rosenthal, for her part, explores the pictorial strategies that Kauffman used to mobilize alternative narrative modes. These modes bespeak what Rosenthal, following Julia Kristeva, calls 'women's time' as the site for the production of historical narrative and subtly call into question the notion, deeply embedded in eighteenth-century theories of art, that storytelling (e.g. history painting) was solely the concern of men.

Let us note parenthetically that where Rosenthal argues that Kauffman's history paintings propose an alternative model of narrative, Kate Nicholson holds that Nattier's portraits of Mademoiselle de Clermont posit the space inhabited by the princess as feminine/feminized alternatives to manly realms

(of the hunt, politicized displays of turquerie). Is it possible that *claiming*, rather than being relegated to, a separate realm (a room of one's own, a narrative of one's own, as it were) could be read as a controversial gesture? Perhaps the provocativeness of such a claim is one of the things that made the woman's boudoir seem so threatening.

To return to the matter of mindful self-representation: the examples presented here bear witness to the fact that many women adopted the new ideals of femininity, womanhood and the ideology of separate spheres that were emerging as key features of Enlightenment thought. Themes of domesticity and maternity were subject choices frequently favored by women in their representations during this period. While claiming motherhood as central to one's identity was assuredly not new, the vision that was being embraced of affective, nurturing motherhood as a sign of womanly virtue certainly *was* (prior to the eighteenth century motherhood was more circumscribed in meaning, indicating that a woman had performed her familial duty in producing an heir).[26] What is more, it is clear that these new notions held great appeal for most women. Among other things, they valorized motherhood as never before and accorded mothers a social role of signal importance: as the earliest, crucially formative teachers of their children.[27] Several of our contributors examine how 'spectacular' women also chose to identify themselves with the new image of motherhood to offset behavior and activities in other areas of their lives that could have been seen as transgressive.

Andrew Schulz's investigation into the world of the duchess of Osuna, for example, shows her to have been a woman who was able to circulate easily within the masculinist culture of the Spanish Enlightenment. Osuna's relatively high rank provided her with this freedom. Nevertheless the tangible outcome of this involvement is located in her achievements as a mother – her progressive aims to educate her children. Her role as educator and center of the family is foregrounded by Goya in several of his portraits of the duchess and her children and husband; in others, her taste for French fashion, though largely identified as a feminine preoccupation in late eighteenth-century Spain, is a vehicle for expressing her allegiance to French Enlightenment ideals.

This adherence to gender norms defined by Enlightenment thought (that is, the notion that the proper role for women is within the private sphere, with responsibility for the children and their upbringing) similarly informs the identity constructed by Lovisa Ulrike as female *philosophe* in her patronage of Chardin. As Radisich contends, the princess aimed to exercise power within socially approved norms of eighteenth-century womanhood (she shunned any identification with her infamous predecessor Queen Christina, for example), but she did so in a way that also allowed her to engage with the most advanced intellectual ideas of her time. Her patronage of Chardin, her

contribution to the representations of Enlightened forms of education that Chardin produced for her, were acts of self-fashioning that cast the princess as a patron of good taste, but also as one possessed of powers of discernment, reason and good judgment, above all in matters of education, and as one who has undertaken seriously the role of pedagogue in the education of her own son (an ambitious gesture, given that Gustav, her son, was heir to the Swedish throne). What is more, although Lovisa Ulrike's self-fashioning and educational activities were located in an ostensibly private rather than the public sphere, it is within the realm of the private that she developed her public identity as seeker of a virtuous life lived *en philosophe*.

The insights of Schulz and Radisich make evident that these women did not regard themselves as passive or marginalized, but that they took on a social role in rearing their children as actively as they did in defining themselves. Nor did the ways in which they defined themselves exclude the possibility of understanding their maternal enterprises as 'feminist'. Similarly, maternity and its virtues were paramount to Vigée-Lebrun's portrait of Marie-Antoinette. But, as Sheriff ably shows, identifying the Austrian-born queen as the mother of the children of France carried with it a mixed bag of compliments, transgressions and threats. Sheriff's analysis of the scope of meanings generated by this controversial work again points to the conflicted status of women in a period of wide-ranging social and political transformations, much of which centered on the changing expectations of women and definitions of their roles.

Motherhood is a subject that also appears in the self-representations of women artists. Radisich has elsewhere argued that Vigée-Lebrun's numerous portraits of herself and her daughter compared the achievements of motherhood with the creative impulses of artistic production.[28] Not a mother herself, Kauffman's forays into maternal themes are altogether different, but there is in her work, too, a provocative similarity in the parallels between the condition of motherhood and the situation of the female artist, as Roworth contends. While it is tempting to interpret these choices as proto-feminist statements on the part of Vigée-Lebrun and Kauffman through which they defined themselves as artists and women, separate and different from their male counterparts but equally capable of genius, it is likely that in their choice of maternal subjects they found a way to defuse their daring incursions into the sacrosanct male artistic field by depicting subjects that they could 'naturally' and safely claim as their own. Then again, perhaps these should be considered feminist gestures, for not all feminisms are confrontational.

While they enjoyed greater freedom and independence in certain respects, for unmarried women the project of self-definition and self-representation could be more problematic and presented different challenges in terms of visual representation – all the more so if the woman in question was a

spinster. Being neither wife nor mother, and having no aspirations to those states, the unmarried woman beyond her twenties had to define herself in other terms. Madame Adélaïde, the eldest surviving daughter of Louis XV (and the subject of the essays by Hyde and Milam), in her maturity eschewed the conventional feminine niceties of beauty and sexual desirability in the portraits she commissioned of herself. Hyde looks at how the princess opted instead for a personal iconography that identified her with the qualities and strengths of vestal virgins and the wise authority and attributes of Minerva, patron goddess of the arts, while Milam makes a case for the centrality of loyal sisterhood as a defining element of Adélaïde's persona throughout her life (and for the way in which that sisterhood was defined and changed over time). Nicholson's contribution on Nattier's two portraits of Adélaïde's distant cousin, the Bourbon princess Mademoiselle de Clermont, focuses on the very different ways in which this princess had herself imaged (and in a sense imaged herself) some fifty years earlier in the century, as a sister and a woman of purpose, authority and grace. Nicholson offers an account of how in the one likeness of Mademoiselle de Clermont, an allegorical portrait type was adapted by and for her to clarify and underscore her social persona. The second portrait of this princess is, Nicholson argues, 'a demonstration piece of identity formation and control, contributing to the eighteenth century's creation of the very notion of the individual.' By contrast, Adélaïde's portraits have less to do with notions of individuality than with asserting her high status within hierarchies of her family; and as Milam reveals, these portraits often functioned and signified intertextually in relation to pendant images of Madame's sisters. While in the most famous portrait of Adélaïde by Labille-Guiard she projects the chilly, haughty authoritarianism of a dowager aunt, Mademoiselle de Clermont audaciously appears in Nattier's portraits as a woman who is confident of her sensuality and sexuality. The choice is striking in view of the imperative of virtuous modesty that seems to have governed the portraits of other women. It might suggest that the range of possible personas was broader in the 1730s than in the 1780s, or perhaps the imperatives were never so hegemonic as they have sometimes been made to seem.

Who exercises the brush? Questions of agency

The emphasis on portraiture in the essays that follow points to the fact that this was the kind of painting with which women were most closely associated as artists and patrons, and the one that commonly functioned as the vehicle for re-presenting the self – though Kauffman's history paintings and Lovisa Ulrike's didactic genre paintings indicate that other subject categories could operate in this way as well. Now, referring to 'Kauffman's history paintings'

and 'Lovisa Ulrike's genre paintings' in the same breath, as we have just done, is to introduce deliberate ambiguities concerning ownership, authorship and artistic agency, and opens onto another set of important issues for this book. Thanks to the modern, originally Romantic, formulations of art as a subjective expression of its maker's thoughts and desires, it is easy to think of 'Kauffman's paintings' as images purely of her own device, reflecting her own subjectivity and intentions. But the matter is never so simple as that, for paintings are produced by artists who are as much constructed by society as they construct themselves within it. When a painter makes a work for a patron, as Chardin did for Lovisa Ulrike, as Nattier did for Mademoiselle Clermont, the finished work belongs to, and takes on meanings for and about, the patron.

In that sense we can speak of the queen of Sweden's genre paintings; but we can also speak of her paintings in a more complicated and nuanced way. Although the princess did not literally wield the brush, conceptually she had a 'hand' in the making of the pictures she commissioned from Chardin. Radisich demonstrates how, as a source of the ideas about education expressed by these works, Lovisa Ulrike could lay claim (at least partially) to their authorship. Nicholson highlights the similarly active agency of Mademoiselle Clermont in the ideation and realization of the Nattier portraits. As collaborators in the conception of the work (and as the person whose approval the final work must meet), these female patrons were not only agents of their own self-representations, but were 'artists' themselves. That is, they were participating in the intellectual processes behind the making of art – the very processes that since the Renaissance had been used to define painting as a liberal art, rather than a mechanical one, and a masculine rather than a feminine enterprise.[29] Nicholson and Radisich, then, call attention to a kind of agency on the part of the patron that is rarely acknowledged – especially when the artist is a famous man.[30] Also in this vein, Casid presents evidence that the artistic claims of female patrons were recognized and seen as a threat by Salon critics later in the century. For such critics these women were no collaborators, but were figured like rival artists usurping male privilege and tyrannically diverting painting from its properly edifying public function towards the trivial task of self-adornment.[31]

Female patrons, then, were sometimes viewed as artists (for better or worse), a slippage that had long been expressed in representations of the goddess Minerva as patron of the arts and artist herself. Against the iconographic background of Minerva imagery in France, Hyde's essay explores how Labille-Guiard's *Portrait of Madame Adélaïde* portrayed the princess as a Minerva-like patron/artist in a way that functions allegorically, both picturing Adélaïde as maker of her own image and referring to Labille-Guiard's own artistic practice. Hyde elaborates on the notion of portrait painting as a

collaborative, collective enterprise (as 'an intersubjective exchange') in which both artist and sitter exercise the brush.[32] In her account, both women are represented through this process: the portrait of Madame Adélaïde is, in an important sense, also a portrait of Labille-Guiard.

Milam considers this *Portrait of Madame Adélaïde* within the more topical context of the pendant portraits that Adélaïde and her sister Victoire subsequently commissioned from Labille-Guiard, their Première peintre. With the focus on how Adélaïde defined sisterhood through portraiture and was defined by it, Milam also examines the Labille-Guiard image in relation to earlier portraits of Mesdames, as Adélaïde and her sisters were known. Milam approaches this body of images not as the product of individual agency, or of a collaborative, intersubjective exchange between artist and sitter, but rather in terms of the broader collective concerns of what she terms 'matronage'.[33] Through her analysis of these portraits as originating from a network of women who were related to each other, rather than as representations of an individual for an individual, Milam offers a means of setting aside traditional patronage questions of who commissioned and paid for a given work, and presents another interpretative *entrée* into the matter of how a woman like Adélaïde not only used works she commissioned for the ends of self-fashioning, but how she managed perceptions of her persona, of her political clout, status at court and in the royal family through her collecting of family portraits and grouping them meaningfully in relation to one another.

Milam's suggestive notion of 'matronage' might be productively applied as well to interpretations of the meanings that were generated collectively at the Salon and other exhibitions, by paintings that were 'related' to one another (whether formally or in terms of subject-matter) and displayed together – an issue Milam and Hyde both begin to touch on in connection with the Salon of 1787, where women of the court and their favorite female artists made such a significant showing.

Conclusion: becoming visible and the rules of engagement

Much like the paintings at the Salon of 1787, the chapters in this collection can be read as discrete entities that offer a particular take on the topic under consideration. But like pictures in the Salon, when these essays are read collectively and relationally, other interpretative possibilities become visible. What we offer here is no comprehensive survey, but a collection of case studies whose subjects run from the famous to the hitherto unknown. Taken together, these essays, with their various lines of argument, methodological inclinations and topics that range across the entire century and much of Europe, present not a seamless narrative, but richly textured pictures of

specific (sometimes overlapping) episodes in the eighteenth century that convey an idea of some its rules, exceptions and contradictions.

To sum up briefly: this volume explores the different means by which gender identity was negotiated and defined through various kinds of individual involvements with the arts in eighteenth-century Europe. It is rooted in the notion that the acts of commissioning, collecting and making art, as well as the patronage of individual artists, can be (and were in the eighteenth century), understood both as forms – if mediated ones – of self-representation and as signs of cultural influence. Special emphasis is given to exploring the nature of women's interventions in visual culture, and to understanding the rules of their engagement with the public sphere, which was increasingly being partitioned off as a masculinist space. Traditional studies of patronage do not take into account the sitter's role in the making of her own image, or the reciprocal relations between artist and patron – some of the omissions of that tradition begin to be remedied here. This book addresses how the sitter/ subject of an art work could claim authority and ownership without being the principal agent responsible for its creation and/or payment. It looks at the critical reception of art produced by and/or for women, the ways in which they could or could not shape that reception, and how gender politics intersected with cultural politics when women exercised the brush. In short, this book is about how gender matters in matters of art.

The philosopher Montesquieu described French court and society as ruled by a 'republic of women' in his famous *Lettres Persannes*. He claimed that 'any man who is at Court, in Paris, in the Provinces, and sees ministers, magistrates, prelates in action without knowing the women who govern them, is like a man who perceives very well a machine that works, but has no idea what makes it run.'[34] Perhaps, like most fictions, there is an element of truth in Montesquieu's assertions. While the 'machine' of the art world was surely not powered solely by women, the essays in this volume make visible some of its intricate and internal workings, and the important roles women played in it. Our intention has been to extend current debates about how women made, acquired and used the visual arts and what was at stake when they did so. We hope to broaden perspectives on the relationships between gender, art and the politics of identity. It is our hope, too, that the critical methods adopted in the individual case studies will augment the current work on the history of women (who are still becoming visible[35]), as well as in the history of art, by contributing to the efforts now being made to 'difference the canon',[36] and the efforts to think more critically about our own rules of engagement with the past.

Notes

The authors wish to thank Sheryl Kroen for her reading of this introduction, and for her indispensable thoughts on it.

1. Jules and Edmond de Goncourt, *La Revolution dans les moeurs: La Famille, le monde, la vielle femme, les jeunes gens, le mariage, les demoiselles à marier, les gens riches, les lettres et les arts, la pudeur sociale, le catholicisme* (Paris, 1854) n.p.

2. For example, many feminist accounts of the pre-revolutionary era regard it as an age of relative freedom and sexual equality for women, and argue that the Revolution silenced women, relegated them to the domestic sphere and foreclosed their participation in public life. This 'antirepubican' perspective has been called into question most recently by Carla Hesse in *The Other Enlightenment. How French Women Became Modern* (Princeton: Princeton University Press, 2001).

3. The literature on culture and the politics of gender in this period is vast. Some of the most important texts include: Joan Landes, *Women and the Public Sphere in the Age of the French Revolution* (Ithaca and London: Cornell University Press, 1988), a book which inspired much of the subsequent and ongoing debate about women and the gender politics of the Enlightenment; Dena Goodman, *The Republic of Letters: A Cultural History of the French Enlightenment* (Ithaca: Cornell University Press,1994); Hesse (2001); Dorinda Outram, *The Body and the French Revolution. Sex, Class and Political Culture* (New Haven: Yale University Press, 1989); Madelyn Gutwirth, *The Twilight of the Goddesses: Women and Representation in the French Revolutionary Era* (New Brunswick, NJ: Rutgers University Press, 1992). Lynn Hunt's work on representations of Marie-Antoinette in *The Family Romance of the French Revolution* (Berkeley: University of California Press, 1992) has been a crucial contribution to recent understandings of queenship; as is her essay, 'The Many Bodies of Marie-Antoinette,' and that of Sarah Maza, 'The Diamond Necklace Affair Revisited,' in *Eroticism and the Body Politic*, ed. Lynn Hunt (Baltimore: Johns Hopkins University Press, 1991).For discussion of representation as a cultural practice see Griselda Pollock, 'Feminist Interventions in Art's Histories,' *Kritische Berichte* (1988), 1: 8.

4. See especially the work of Goodman (1994).

5. Recent examples include: Laura Auricchio, 'Portraits of Impropriety: Adélaïde Labille-Guiard and the Careers of Professional Women Artists in Late Eighteenth-Century Paris,' Ph.D. dissertation, Columbia University, 2000; Vivian Cameron, 'Woman as Image and Image-Maker in Paris During the French Revolution,' Ph.D. dissertation, Yale University, 1984; Angela Rosenthal, *Angelika Kauffmann: Bildnismalerei im 18. Jahrhundert* (Berlin: Reimer, 1996); Wendy Wassyng Roworth, ed., *Angelica Kauffman: A Continental Artist in Georgian England* (London: Reaktion Books and Brighton Art Gallery and Museum, 1992); Shearer West, ed., *Italian Culture in Northern Europe in the Eighteenth Century* (Cambridge: Cambridge University Press, 1999); and Mary Sheriff, *The Exceptional Woman: Elisabeth Vigée-Lebrun and the Cultural Politics of Art* (Chicago and London: University of Chicago Press, 1996).

6. Cynthia Lawrence, ed., *Women and Art in Early Modern Europe* (University Park, PA: Pennsylvania State University Press, 1997) comes to mind as one of the only sustained studies of the subject that considers our period.

7. Élisabeth Louise Vigée-Lebrun, *Souvenirs* (1891), ed. Claudine Hermann (Paris: Editions des Femmes, 1984), 1: 122.

8. Jean Starobinski, *L'Invention de la liberté 1700–1789* (Geneva: Skira, rpt 1987), 55.

9. For recent debates concerning the cultural influence of women in the *ancien régime* and their relationship to the Enlightenment see Landes (1988), Goodman (1994) and Hesse (2001).

10. This line of argument was first proposed by Donald Posner in his 1990 article on Madame de Pompadour's art patronage, and recently has been pursued with great vigor by Xavier Salmon and Alden Rand Gordon. See Posner's 'Madame de Pompadour as a Patron of the Visual Arts,' *Art Bulletin* 72 (1990), 75–108; Xavier Salmon et al., *Madame de Pompadour et les arts*, exh. cat. (Paris: Réunion des musées nationaux, 2002), and Alden Rand Gordon and Teri Hensick, 'The Picture within the picture: Boucher's 1750 Portrait of Pompadour identified,' *Apollo* CLV, no. 2 (February, 2002), 21–31.

11. 'Why Have There Been No Great Women Artists?' (1971) in *Art & Sexual Politics*, eds Thomas B. Hess and Elizabeth C. Baker (New York and London: Macmillan, 1973); reprinted in *Women, Art and Power: and Other Essays* (New York: Harper & Row, 1988).

12. Art history's 'woman-artist question' has been concerned to answer whether or not there ever has been or could be any woman artist of genius.

13. The trends in feminist art history of 1970s and 1980s are discussed at length by Thalia Gouma-Peterson and Patricia Mathews, 'The Feminist Critique of Art History,' *Art Bulletin* 69, no. 3 (September 1987), 326–57.

14. Griselda Pollock, *Differencing the Canon. Feminist Desire and the Writing of Art's History of Art's Histories* (London and New York: Routledge, 1999), xv.

15. For treatment of these themes see essays by Johns, Rosenthal, Milam, Hyde, Roworth and Nicholson (Chapters 2, 10, 6, 7, 9 and 4 in this volume).

16. Pollock's 'Feminist Interventions' aimed to move discussion beyond a 'local concern with the Woman Question' in order to challenge the masculinist discourse of art history in general. See also *Differencing the Canon* (1999).

17. We refer here to Germaine Greer's 1979 study of women artists entitled *The Obstacle Race: The Fortunes of Women Painters and their Work* (New York: Farrar, Strauss, Giroux, 1979). Her book was essentially an elaboration on the persecution complex thesis she explored earlier in *The Female Eunuch* (a thesis much critiqued at the time and after): women were so profoundly oppressed and persecuted under patriarchy as to be capable of very little.

18. A cogent and indispensable account of the Woman Question in the eighteenth century is to be found in Dena Goodman's essay 'Women and the Enlightenment,' in *Becoming Visible: Women in European History*, eds R. Bridenthal, S. Mosher Stuard and M. Wiesner (Boston: Houghton Mifflin Company, 1998), 3rd edn, 233–62. See also Karen Offen, *European Feminisms 1700–1950. A Political History* (Palo Alto: Stanford University Press, 2000), chapter 2, 'Reclaiming the Enlightenment for Feminism,' 31–49. Whitney Chadwick briefly discusses the Woman Question in the nineteenth century as it related to art in *Women, Art and Society* (London: Thames & Hudson, 1992), 166.

19. An exemplary articulation of Rousseau's views about women and their influence on society is to be found in *Politics and the Arts. Letter to M. d'Alembert on the Theater*, trans. Allan Bloom (Ithaca: Cornell University Press, 1989). See also Goodman (1998), as in note 18.

20. The classic text on the formation of the public sphere is Jürgen Habermas, *The Structural Transformation of the Public Sphere: An Inquiry into a Category of Bourgeois Society* (Cambridge, MA: Cambridge University Press,1989). See also Landes (1988) and Goodman (1994); and Thomas Crow, *Painters and Public Life in Eighteenth-Century Paris* (New Haven: Yale University Press, 1985).
21. For a discussion of women artists and issues of visibility see Sheriff (1996), chapter 4.
22. For a study of female ambition in the eighteenth century, with particular attention to the marquise du Châtelet, a mathematician and Voltaire's mistress, see Elisabeth Badinter, *Émilie, Émilie ou l'ambition féminine au XVIIIe siècle* (Paris, 1983). In her excellent dissertation Laura Auricchio makes a convincing argument about the ways in which impropriety was used to advantage by women artists. See note 4 above.
23. On the Salic Law, see Sheriff (1996), 149–51.
24. The Royal Academy in Great Britain was in certain respects less exclusionary. For more details, see Wendy Roworth, 'Anatomy is Destiny: Regarding the Body in the Work of Angelica Kauffman,' in Gill Perry and Michael Rossington, eds, *Femininity and Masculinity in Eighteenth-Century Art and Culture* (Manchester: Manchester University Press, 1994); Chadwick (1996); and Gill Perry, ed., *Gender and art* (New Haven and London: Yale University Press, 1999). On the artistic activities of women beyond the Academy see Melissa Hyde, 'Women and the Visual Arts in the Age of Marie-Antoinette,' in Eik Kahng et al., *Anne Vallayer-Coster: Painter to the Court of Marie-Antoinette* (New Haven: Yale University Press, 2002).
25. See Sheriff (1996), chapter 4 for discussion of the Académie's policies concerning women; and Gill Perry, ed., *Academies, museums and canons of art* (New Haven and London: Yale University Press,1999).
26. The classic essay on this subject is Carol Duncan's 'Happy Mothers and Other New Ideas,' in Norma Broude and Mary Garrard, eds, *Feminism and Art History: Questioning the Litany* (New York: Harper & Row, 1982).
27. For women's attitudes towards Rousseau, see Mary Seidman Trouille, *Sexual Politics in the Enlightenment. Women Writers Read Rousseau* (Albany, NY: SUNY Press, 1997); Margaret Darrow, 'French Noblewomen and the New Domesticity 1750–1850,' *Feminist Studies* 5 (Spring 1979), 41–65.
28. For superb analyses of these paintings involving issues of maternity, creativity and self-definition as an artist see Paula Radisich, 'Que peut définir les femmes?,' *Eighteenth-Century Studies* 25 (1992), 441–68 and Sheriff (1996), 180–220.
29. A similar claim might be made about Labille-Guiard's *Portrait of Madame Adélaïde*, which presents the princess as an artist and emphasizes her connection both to drawing and to design (*dessein*) through the architectural plans on the stool in the foreground and the drawing implement in her hand. See Hyde's essay, 'Under the sign of Minerva,' Chapter 7 in this volume.
30. Sheriff's essay in the present volume (Chapter 8) complicates questions of agency: if the examples of Mademoiselle Clermont, Madame Adélaïde, the duchess of Osuna and others offer instances of identity formation and control through visual representation, the portrait of Marie-Antoinette again stands as the counter-example that shows that meaning can only be managed up to a point.
31. Angela Rosenthal, 'Angelica Kauffman ma(s)king claims,' *Art History* 15:1

(March 1992), 38–59 discusses Kauffman's treatment of the theme of usurpation of the brush as it relates to artists and models.

32. This phraseology was used by Diderot in his 'L'influence du luxe sur les beaux-arts (*Salon de 1767*)' in Jean Seznec and Jean Adhémar, eds, *Diderot: Salons* (Oxford: Clarendon Press, 1957–67), 3: 54. See Casid's essay in this volume (Chapter 5).

33. Deborah Cherry discusses matronage in the context of nineteenth-century English painting in *Painting Women. Victorian Women Artists* (London: Routledge, 1993). See especially chapter 6.

34. Charles de Secondat, baron de Montesquieu, *Lettres Persanes* (Paris: Baudel, 1964), Letter 107.

35. For an excellent general study of this topic see *Becoming Visible: Women in European History*, eds Renate Bridenthal et al. (Boston: Houghton Mifflin Company, 1998).

36. We are borrowing this turn of phrase from the title of Pollock's *Differencing the Canon*, which concerns the future direction of feminist art history. She is specifically concerned with how the visual text can be interrogated as a dynamic process through which determinations of the feminine have been produced. Her aim is to discern how the difference of woman has been historically constructed and is constantly in the making, not just through the practices of making art, but also through the act of interpretation.

'An Ornament of Italy and the Premier Female Painter of Europe': Rosalba Carriera and the Roman Academy

Christopher M. S. Johns

An important milestone in the history of art was reached by the Roman Accademia di San Luca at its general meeting of 25 September 1705. On that day the celebrated Venetian painter Rosalba Carriera (Figure 2.1) was unanimously elected to membership in the venerable artists' academy despite institutional restrictions against female members. Admitted as an *accademica di merito*, a rank that acknowledged professional status, Carriera was immediately distinguished from those few previous women who had been received only as honorary members in a category designed to include learned amateurs, collectors, patrons and connoisseurs, but not professional artists (*accademico d'onore*). The fact that Carriera lived exclusively in Venice and worked in media (miniature and pastel) often considered 'lesser', 'decorative' or 'feminine' (quite possibly because of her association with them), was doubtless of significance to the Roman academicians, but I shall argue that her unprecedented degree of international fame and the professional ambition of the Academy itself worked in her favor. Cultural celebrity was a commodity in which eighteenth-century academies increasingly wished to invest; indeed, they could not afford to ignore it. Carriera's meteoric rise in popularity and reputation made her an attractive candidate for membership in the Accademia di San Luca and the officers of the institution, including the principe (president) Carlo Maratti, the professor of painting Benedetto Luti, and the life secretary Giuseppe Ghezzi, were not slow to welcome her into their ranks. The academic thirst for fame

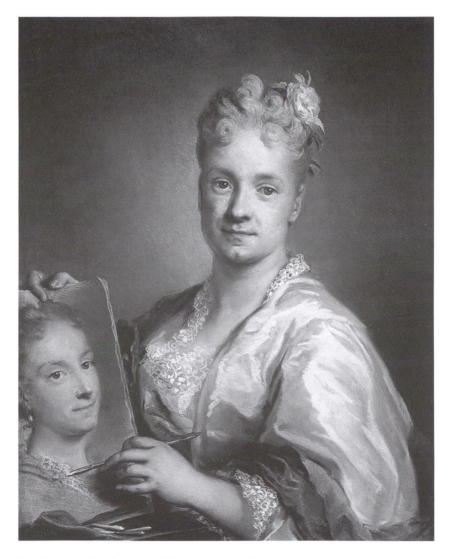

Fig. 2.1: Rosalba Carriera, *Self-Portrait*, 41 × 32 cm, pastel on paper, c. 1708–09, Florence, Galleria degli Uffizi (Scala/Art Resource, NY)

triumphed over long-standing prejudice against women artists and media usually associated with women.

Rosalba Carriera attained a remarkable degree of celebrity in a very short period of time. Her earliest datable works are from the mid-1690s and, less than a decade later, she became a full member of Europe's most prestigious

artistic academy. There are many reasons for her rapid professional ascent, including the increased popularity of the Grand Tour that brought the wealthy to Venice and thus into contact with her work, and the waxing of an international aesthetic that valued preciosity of scale, pastel colors and decorative effects. Moreover, the ivory medium used in Carriera's early miniatures was increasingly prized for its rarity, portability and luminosity, characteristics of the material deftly exploited by the artist. It was her astute recognition of ivory's promising possibilities as a medium for miniature painting that initially brought her widespread recognition, although it is as a pastel painter that she is best known today. Indeed, Carriera originated the idea of painting miniatures in tempera on ivory, removing them from the realm of snuff-box decoration and placing the practice solidly in the realm of 'fine' art.[1] It should be remembered that her admission to the Accademia di San Luca was based primarily on her activities as a miniature artist. In 1705 she had only just begun to paint pastel portraits, the popularity of which brought her accolades from Paris and, in 1720, membership in the Académie Royale.

For so celebrated and innovative an artist, surprisingly little is known about Carriera's artistic training. The numerous early biographies contradict one another concerning her teachers in miniature and pastel, and even the year of her birth is disputed, although most scholars accept 1675 as the best guess.[2] This dearth of reliable information is partly due to her origins as a designer for lace patterns and other decorative objects, 'obscure' activities little esteemed and often forgotten when writing about famous artists, and the fact that she had little direct input into what was written about her during her lifetime. In fact, a voluminous correspondence, which she curated with some care, has no item that dates before 1700, by which time she had already attained remarkable professional success.[3] Like many of her male counterparts, Carriera was deeply interested in her contemporary and posthumous reputation, concerns manifested in the letters related to her admission to the Accademia di San Luca that will be considered in due course.

Despite conflicting evidence, there are some aspects of the painter's training that can be described with confidence. Accepting the claims of Pierre-Jean Mariette, a life-long friend of Carriera, it may be assumed that she learned the rudiments of miniature painting from a French artist working in Venice, Jean Stève, about whom little else is known. As a painter of snuff boxes, he often worked in ivory, and it is likely that Carriera learned how to paint such objects under his supervision. Beyond Stève, she has been associated with a wide range of possible teachers, including the painters Giuseppe Diamantini, Gianantonio Lazzari, Gregorio Lazzarini and Pietro Liberi, but there is little or no documentation to substantiate these claims. Moreover, she was a friend of several leading Venetian artists who may have had a general influence on the development of her style, including Sebastiano and Marco Ricci; Antonio

Balestra; Gianantonio Pellegrini, who married her sister Angela; and Sebastiano Bombelli, who executed her portrait for the diploma gallery of the Accademia di San Luca in Rome.[4] There can be little doubt that Carriera's male artist friends helped to promote her career, both from affection and admiration for her work. As a miniature painter, the crucial fact is that it was the artist herself who decided to paint portraits on ivory removed from the functional traditions of the decorative snuff box. Her mother's instruction in lace-making design and Stève's example as a snuff-box painter form a sufficient pedagogical foundation for the development of an accomplished miniaturist.

The uncertainties regarding Carriera's training as a miniature painter are also a problem for understanding her mastery of pastel portraiture. The earliest dated pastel is from 1703, but she probably began working in the medium around the turn of the century.[5] Although she was strongly encouraged to work in pastel by her friend Christian Cole, the secretary of the British diplomatic legation in Venice, it is unlikely that he trained her.[6] Generally speaking, Carriera would have been familiar with pastel paintings by Federico Barocci, Baldassare Franceschini and Benedetto Luti, among other Italian artists. She also would have known works by Robert Nanteuil, the leading French pastel artist of the late seventeenth century who specialized in portraits.[7] By 1705, when she became a member of the Roman Academy, Carriera was beginning a professional shift towards pastel portraits in addition to her activities as a miniaturist. The move to pastel, which allowed the artist to work with greater rapidity and on a larger scale, had obvious economic advantages, but I would like to emphasize the artistic ambition at work in her decision to paint pastels. While still considered a 'feminine' medium, pastel had no lingering association with the snuff box and elevated Carriera in the eighteenth-century cultural hierarchy that privileged oil on canvas and fresco painting above all other media. Despite the recognition accorded her miniatures by the Accademia di San Luca, it was primarily as a pastel artist that Carriera became 'an ornament of Italy and the premier female painter in Europe'.[8]

An artist who arguably had a profound impact on Carriera's professional development was the miniature painter Felice Ramelli, who is often listed among her teachers but whose influence has, in my view, been seriously underestimated. Born in Piedmont, Ramelli was an Augustinian monk and a canon of San Giovanni in Laterano in addition to being a painter. He spent most of his life in Rome. As a miniaturist, Ramelli executed numerous copies of Old Master paintings on ivory, a traditional medium for such small-scale works. He was extensively patronized by King Carlo Emmanuele of Piedmont and was the best-known miniature painter in Italy after Carriera. His small oil on copper portrait by the Venetian painter Francesco Trevisani (Figure 2.2) includes a miniature copy on ivory of a work by Carlo Maratti.[9]

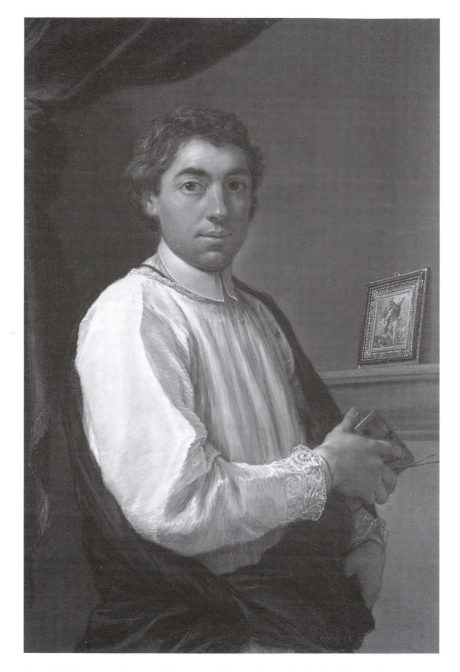

Fig. 2.2: Francesco Trevisani, *Portrait of Felice Ramelli*, 29.8 × 20 cm, oil on copper, c. 1715–20, London, Derek Johns Fine Arts

It is quite possible that Ramelli adopted Carriera's innovation of painting miniatures on ivory, a practice she introduced shortly before Ramelli's visit to Venice in 1700, and it is also possible that he helped to develop her miniature technique. In any event, he became a close friend, as subsequent letters more than amply demonstrate. Indeed, as an Augustinian cleric he seems to have been both a friend and a spiritual advisor. Ramelli's stay in Venice coincided with Carriera's first flush of success as a miniaturist, and it seems likely that he, who was at least ten years her senior, had something to do with this, although the extent of his influence is open to debate. I think it is also clear that both artists benefited from their association.

In addition to her training as a miniaturist and pastel painter, Carriera also received an exceptional classical education. While neither an intellectual *virtuosa* nor a *femme savante*, she nonetheless was deeply informed about the classics, music, contemporary poetry and modern languages, being conversant in both French and English, in addition to various dialects of Italian. Her sisters Giovanna and Angela, both of whom were practicing artists, were equally well educated. The high degree of intellectual attainment of the Carriera sisters stands in marked contrast to the majority of Venetian settecento artists who, with few exceptions, had little formal education.[10] The intellectual contrast between Angela Carriera and her husband Gianantonio Pellegrini is a remarkable case in point. I believe that Carriera's status as an educated artist helped to fuel her professional ambition, a possibility that is overlooked by most scholars, who take pains to undermine her élite status as a highly educated woman by belittling an accomplishment they would trumpet had it been possessed by a male artist.[11]

The widespread appreciation of small-scale works of art so typical of the Rococo was a major factor in Rosalba Carriera's professional success in early eighteenth-century Venice. While miniature painting has a long-standing association with the art of jewelry design and an overt relationship with courtly rituals of the exchange of amorous tokens adorned with images of the beloved, it was Carriera who first popularized them as an independent form of portraiture. Moreover, she was the first eighteenth-century painter to explore allegorical themes in the medium in a sustained way. The majority of Carriera's portrait miniatures are painted either in tempera or gouache on an ivory ground. In addition to increasing the monetary value of the object without embellishing and encumbering the image with jewels, gems and precious metals (ivory was quite expensive), it also enhanced their delicacy and luminosity, since ivory mellows with age and does not absorb pigment. This allowed the artist to exploit the transparency of the colors while simultaneously employing impasto to augment textural richness. A heightened sense of delicacy was also achieved by Carriera's almost exclusive use of such pastel colors as pale blue and gray, rose pink and various subtle shades of white.[12] In

sum, intimate scale, pastel colors, financial value and visual immediacy all combine in Carriera's miniatures to create objects that were avidly collected by the European élite.

The creation of miniature portrait painting on ivory divorced from the decorative-arts functionality of snuff-box lids was one of Carriera's major artistic innovations, a fact that is further underscored when one considers the lack of precision in contemporary descriptions of the objects *as* objects. Letters written by the painter and her myriad correspondents indicate that a critical language to classify the new art form and to describe its technique was still in the process of formation. The painter often used the term *fondello* to describe her miniatures, although this archaic word comes from the term traditionally applied to the lid component of a snuff box. An even older word that one encounters in the documents is *ritrattino* (diminutive portrait), which is more accurate than *fondello* in terms of specificity of scale but has the disadvantage of being applicable to any visual medium. Carriera's letters use *fondello* and *ritrattino* interchangeably, but she also crucially introduces the word *miniatura*, which is much more precise and has a modern resonance that the other nouns lack.[13] Although Carriera did not invent the word *miniatura*, she was the first artist to apply it to her paintings in so consistent a fashion. Soon her particular type of miniature painting came to be identified as the standard, in terms of format, medium and style, and this association greatly increased her reputation as an artist. I believe that it was an essential step in the legitimization of miniature painting as a category that could be officially recognized by the Accademia di San Luca, although such recognition was less dogmatic than might be imagined.

By 1705, the phenomenal popularity of Carriera's miniatures had made her one of the most famous artists in Europe. She was not only admired by the patrons who competed for her portraits, but was also lavishly praised by many notable artists. A letter to Carriera from her Bolognese friend Ferdinando Maria Nicoli of 26 June 1703 describing Giuseppe Maria Crespi's positive reaction to one of her miniatures is a case in point. As the doyen of the early settecento Bolognese school of painters, Crespi's favor could be both flattering and professionally advantageous. Nicoli paraphrases Crespi's verbal exchange with an unknown gentleman as follows:

> While Signore Giuseppe Cresta [Crespi] … was admiring your [Carriera's] beautiful work a few days ago, especially praising the truth of the drawing and the appositeness of the coloring, there was someone whom I do not know who said: ' … a painter who had so virtuous and talented an artist as a wife would be fortunate indeed', to which he [Crespi] responded that it would be necessary, in order to have her equally mated, to have Guido Reni brought back from the dead.[14]

This letter is a vivid testimony to the great fame she enjoyed shortly before her election as an *accademica di merito* of the Roman Academy. And even if

the letter is only a piece of gallantry on Nicoli's part, it still must tell a simple truth: that Crespi (or Nicoli) admired Carriera's work. If there were not some degree of admiration, why would the gallantry have been deployed in the first place? The letter is also an interesting document for what it reveals about contemporary expectations surrounding women artists in early modern Europe. Since almost all female practitioners of note before Carriera were related either by blood or marriage to professional male artists, it seemed difficult to imagine that an artist who was independent of such connections would not marry another artist. Moreover, such a union was seen as an advantage primarily for the husband, since he would benefit from his wife's highly skillful assistance. The assumption that her career would be subordinated to his is obvious. Perhaps that is one of the reasons why Rosalba Carriera decided to remain single.

An additional advantage a prospective husband of Carriera might enjoy was financial. By 1705 she charged fifty *zecchini* (a considerable sum) for a miniature on ivory and a few years later her pastel paintings usually fetched between twenty and thirty *zecchini*, depending on whether the hands were shown and if such accessories as bouquets, straw hats and birds were present. As Francis Haskell has pointed out, large-scale historical compositions in *fresco* and oil on canvas religious and mythological paintings were, relatively speaking, far less expensive than Carriera's works in terms of price per square inch. Similarly, Antonio Canaletto sometimes charged as much as 120 *zecchini* for a *veduta* painting, an exorbitant price that reflects the high demand for his work.[15] Appealing to a cosmopolitan clientèle and working in the 'lesser' genres so prized by contemporaries, the economic prowess of both Carriera and Canaletto could be viewed as helping to undermine existing academic hierarchies that privileged textually based, narrative subjects. Thus both Italian artists have more in common with such French painters as Antoine Watteau, Jean-Baptiste-Simeon Chardin and Jean-Baptiste Oudry, among many others who prospered financially working in less academically respected genres, than might initially be supposed.

Popular acclaim and financial success stirred Carriera's professional ambition, and the extended visit of her intimate friend Christian Cole to Rome in 1704 paved the way for her first real professional triumph – admission to the Accademia di San Luca. In a letter of 1 November, Cole informs Carriera that he has shown her portrait of him to many artists and collectors in Rome 'con grandissima admiratione'. He adds that he has seen miniatures executed by Roman artists, none of which can compare to hers in quality. Significantly, later in the letter Cole heaps lavish praise on Carlo Maratti, Europe's most famous painter and the principe of the Academy, understanding that his support would be necessary for her admission.[16] As part of his promotion, Cole persuaded another Englishman, David Roberts, to commission a mytho-

logical theme from Carriera, doubtless to show her to advantage in a superior genre of painting. In a letter of 22 November 1704 Cole gives Carriera very careful instructions about the painting, dictates that reveal a perceptive appreciation of the academic audience in Rome:

> If you now have the time, I beg you to buy for me one of the largest pieces of ivory that you may be able to find and to paint on it a Venus sleeping in a garden, surrounded by flowers, etc., but they [the audience in Rome] would want Venus [to be] as nude as your conscience would permit her [to be]: at least the breast, the hands and the legs [to be] nude ... [17]

In addition to the mythological subject, Cole was eager to ensure that the work be as large as possible, intimating that a large miniature, however oxymoronic that notion may be, would be more highly valued than a small one. He also considered nudity to be essential to real artistic distinction and wished to showcase Carriera's ability to paint such figures despite her lack of academic instruction in life drawing. In reality, it was to be a reception piece before the fact.

While Cole's partisanship of Carriera was important to her ultimate attainment of membership in the Academy, she was hardly unknown in Rome before 1704. Both Antonio Balestra and Sebastiano Ricci, friends of Carriera, had been in the papal capital in the early years of the century, and it seems likely that they discussed her work with Roman artists such as Benedetto Luti and Carlo Maratti.[18] The delicate grace of her miniatures responded to a contemporary enthusiasm for Correggio and Barocci, a passion that Luti especially shared. It is possible that the Venetian painters actually showed works by Carriera to interested people in Rome, anticipating Cole's activities in 1704–05. Miniatures were highly portable and many people traveled with them.

Felice Ramelli, who was in Rome in the early years of the century, also helped promote Carriera among Roman artists. In a letter dated 28 June 1703, he wrote to Venice to say that he was going to visit Luti to recommend her, although he does not say whether this was specifically related to possible membership in the Academy. I must confess, however, that it seems very likely. Luti, an artist who also worked extensively in the pastel medium, was an influential figure in the Accademia di San Luca and one who was known to be favorable to foreign artists.[19] In the postscript of his letter Ramelli states that in future he will address correspondence to her under the name 'Mr. Jean Carriera' in order not to provoke gossip or the suspicion that might arise from a celibate monk writing frequently to an unmarried female artist.[20] While this precaution would have been advisable in Ramelli's circumstances, it also may have been motivated by a desire to protect her reputation in Rome, where the highly moralizing tone of clerical society had recently been reinvigorated by

Pope Clement XI Albani, to whom Ramelli was thoroughly devoted.[21] In a letter written a few weeks later, he also informed Carriera that he had discussed her work with the rising sculptor Angelo de' Rossi and that Balestra was also praising her to both de' Rossi and to Luti.[22] It is hard to avoid the conclusion that this was a part of a premeditated campaign to obtain membership in the Academy for Carriera and that she must have at least tacitly approved the designs of her friends.

The campaign for Carriera orchestrated by Balestra, Ricci, Ramelli and Cole bore fruit in 1705, when her official acceptance into the Accademia di San Luca was finalized, although the bureaucratic procedures took several months. On 31 January, Cole wrote that he had spoken with Life Secretary Ghezzi about Carriera's candidacy. He said that Maratti would have the final word, adding that Ghezzi would not advise risking either Cole's or Carriera's reputation by too direct an approach, perhaps indicating that there would be some opposition to the innovation of admitting a female artist as an *accademica di merito*.[23] The secretary went on to describe the requirements for members, including a reception piece and the presentation of a portrait of the new academician.

Carriera agreed to the Academy's requirements and began her reception piece in the spring, several months before the formal admission on 27 September. It is clear that she believed she would be approved as a member and went so far as to ask Bombelli to paint her portrait for the Academy's gallery. Responding to a letter of Cole's dated 9 May that described enthusiastically the Academy's prize-giving ceremonies that took place on the Capitoline Hill, she mentioned an illness that had delayed the completion of her miniature diploma piece.[24] In subsequent letters, she expressed trepidation about the reception of her work by the members of the Academy, a perfectly natural reaction for a female artist working in a professionally undervalued medium.

When Christian Cole received Carriera's reception piece, *Allegory of Innocence* (Figure 2.3), he took it to Giuseppe Chairi's studio where he also found Carlo Maratti. He described the principe of the Academy's reaction to the painting in a letter to Carriera dated 19 September 1705:

> I showed them your work, which was admired equally by both of them. [Maratti] held it in his hand for than half an hour and said that you have tackled a difficult subject, white on top of white, and that you have done it with great artistry, that Guido Reni would not have been able to do better.[25]

The letter continues to record Maratti's compliments and subsequently those of Ghezzi, informing the artist that her work would be shown to the pope. Cole adds that he will be unable to attend the Accademia's awards ceremony on the Campidoglio the following week, when Carriera was to be inscribed on the roster of academicians[26] (see Appendix 1).

Fig. 2.3: Rosalba Carriera, *Allegory of Innocence*, 15 × 10 cm, tempera on ivory, 1705, Rome, Accademia Nazionale di San Luca

Carlo Maratti's enthusiastic support of Carriera is worth considering, especially in the context of her admission to the Accademia di San Luca. Usually characterized as a conservative painter who was the last important exponent

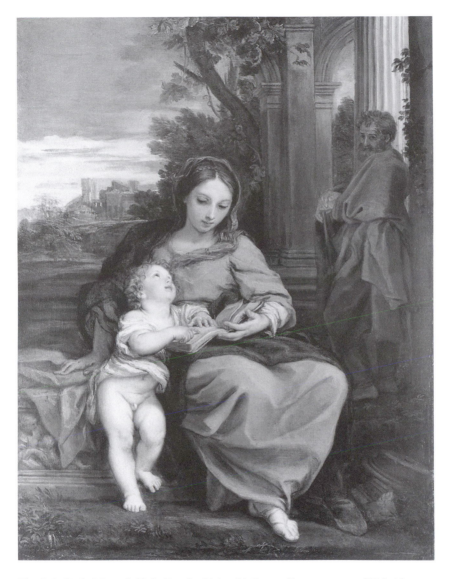

Fig. 2.4: Carlo Maratti, *Holy Family*, 71.1 × 53.5 cm, oil on canvas, c. 1700–05, Toledo, Ohio, Toledo Museum of Art

of the traditions of Carracci classicism, in fact Maratti was a highly progressive artist who encouraged Arcadian tendencies and the nascent Roman Rococo. If one looks carefully at his late paintings, such as the suave, intimate *Holy Family* (Figure 2.4), a work doubtless intended for a rich

connoisseur's picture cabinet rather than an ecclesiastical setting, his admiration for the Venetian miniature painter is unsurprising (see Appendix 2). Moreover, Maratti's only child, Faustina Maratti Zappi, was also a painter of considerable ability who executed miniatures, and one wonders if the father's ambitions for his daughter might have predisposed him to support Carriera as an *accademica di merito*. While lack of documentation makes such an assertion highly speculative, it would explain Maratti's deep interest in Carriera at a time when he was less and less involved in the activities of the Accademia di San Luca. His praise of Carriera in the fortuitous meeting with Cole at Chiari's studio may not have been entirely disinterested.

It might be useful at this point to speculate on the nature of the relationship between Cole and Carriera. They met in Venice during his posting to the British embassy, where he was first secretary to the ambassador, Lord Manchester. He continued in this position after the latter's return to England in 1708 but appears to have enjoyed little distinction as a diplomat.[27] In the scholarly literature on Carriera he is usually credited with encouraging her to work in pastel; some even say he was an amateur *pastelliste* who became her teacher.[28] What no one seems inclined to acknowledge is the strong possibility that he was in love with her. Indeed, Bernardina Sani scrupulously avoids any speculation about Carriera's amorous interests in her otherwise attentive readings of the painter's letters. After Cole's successful efforts in favor of Carriera's admission to the Academy, he went to considerable pains to obtain pastel chalks for her use, often performing similar friendly services. Such facts would be inconclusive but for a passage in a letter of 1 September 1707, after the diplomat's return from Rome to Venice. Responding to a lost letter of Carriera that indicates a considerable lacuna in their correspondence, he tells her: 'You do not know how to understand how much I interest myself in all that concerns you, and I see that you do not want to believe it when I profess to you the friendship, in order not to say another thing, that I have for you.'[29] Taking into account the hyperbolic language of eighteenth-century letters, especially those from men to women, the phrase 'in order not to say another thing' still seems unequivocal – he had passionate feelings for her that she did not return. It may be possible that her professional ambitions precluded amorous attachment, although this observation must remain in the realm of speculation. I think it is no accident that this is the last known letter he wrote to her despite the fact that he remained in Venice for several more years.

Christian Cole personally presented his friend's reception piece to Carlo Maratti on Carriera's behalf (Figure 2.3). The subject of the diploma painting has been identified in different ways despite the fact that it represents a pre-adolescent girl holding a dove, a seemingly uncomplicated subject. Such confusion and misreading are a result of the ambiguity of Carriera's position

as a celebrated female artist in a public, intellectual and patriarchal institution. The iconography has been interpreted by some scholars as either Chastity or Innocence, while others avoid the issue altogether by simply describing it as a pastoral genre painting – *Little Girl holding a Dove*.[30] While each of these identifications is partly accurate, the early guidebooks describe the picture as *Allegory of Innocence*, and I think this is the most accurate identification.[31] Identified simply as *donzella* in the academic minutes (see Appendix 1), such shorthand is characteristic of descriptions of diploma paintings and by no means indicates a belief that this was all there was to it. The youth of the girl, who appears to be barely adolescent; the soft, rounded facial features that stand in sharp contrast to the coy, angular lines of most of the pastoral shepherdesses and elemental allegories that were also among Carriera's most popular forms; the frank unsophistication of the gaze; the demure white garment, with its high neckline and lack of reference to a bosom; and the fact that 'chastity' hardly seems an obvious referent in a work so devoid of erotic possibility; all militate against any title other than *Allegory of Innocence*.

In this context, it is innocence of the soul rather than the body that is intended, the dove being a vague referent to the Holy Spirit rather than to the goddess Venus. Such a choice, I believe, indicates self-awareness of her status as an unmarried woman and self-consciousness of the male audience for the painting who, after all, belonged to a pontifical cultural institution and would not have expected an eroticized image from a female artist, however subtly desire may have been encoded. Perhaps this is why she possibly declined the *Venus Sleeping in a Garden* for David Roberts, despite the potential advantages that representing a nude could have given her in some academic circles. She may well have understood that she had more to lose by violating contemporary notions of gender decorum than by demonstrating mastery of the nude female form. The widespread cultural tendency in eighteenth-century Europe to elide the work of art and its female creator perhaps encouraged Carriera to select an 'innocent' subject as the theme of her Accademia di San Luca diploma piece.

Allegory of Innocence also reveals Carriera's appreciation of the intellectual foundation on which the Academy rested. By presenting an allegorical subject rather than a straightforward portrait or a genre painting, she helped to transcend the decorative, 'feminine' medium in which she worked and positioned herself in a more prominent way.[32] Traditionally, allegory was grouped with biblical and mythological scenes and historical subjects in the highest genre in the academic hierarchy – history painting. While no one, least of all Carriera, would have argued that she was a history painter, her decision to present an allegorical reception piece demonstrates a desire for official recognition at a higher level than she could obtain in normal circumstances. The fact that the subject is the first of its type in her oeuvre and is almost unique in her art is

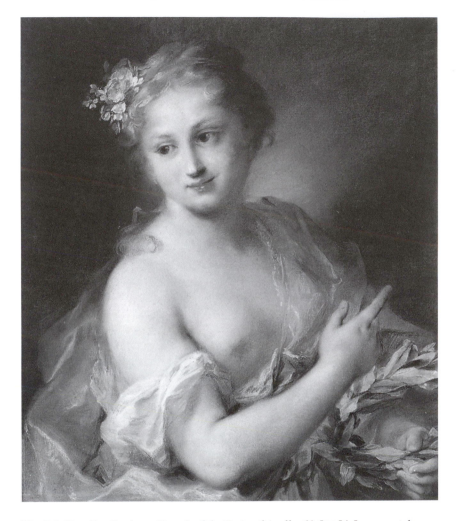

Fig. 2.5: Rosalba Carriera, *Nymph of the Train of Apollo*, 61.5 × 54.5 cm, pastel on paper, 1721, Paris, Musée du Louvre (Réunion des Musées Nationaux/Art Resource, NY)

additional proof that she carefully calculated both its subject and effect on the academicians in Rome.[33] Moreover, Carriera continued to 'elevate' her art by producing portraits that have historical overtones, a category designated *ritratto istoriato* or *portrait historié*, in addition to her numerous elemental allegories and rare sacred and mythological subjects. Indeed, it was her historiated portraits that were most popular in France and that helped her become a member of the Académie Royale. She was formally received (*reçu*) on 26 October 1721,

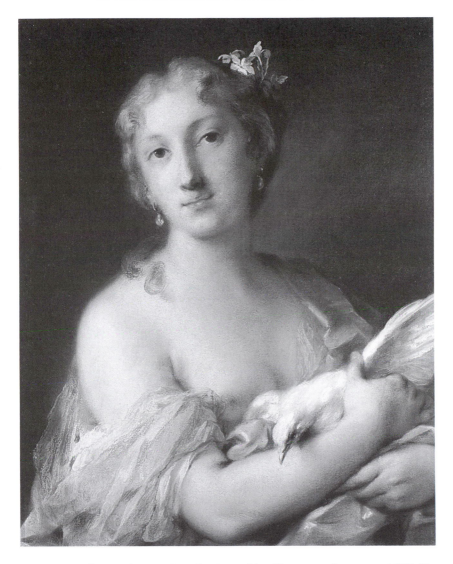

Fig. 2.6: Rosalba Carriera, *Lady with a Dove*, 54 × 43 cm, pastel on paper, 1727–28, Dijon, Musée des Beaux-Arts (Erich Lessing/Art Resource, NY)

significantly presenting as her *morceau de réception* a mythological subject, *Nymph of the Train of Apollo* [34] (Figure 2.5).

The Arcadian naïveté and sweet guilelessness of *Allegory of Innocence* (Figure 2.3) are underscored by comparison to another work by Carriera of ostensible similarity, *Lady with a Dove*, now in Dijon (Figure 2.6). Commis-

sioned by Charles-Jean-Baptiste de Fleuriau, comte de Morville, the pastel
painting was completed in 1728, seven years after the artist's triumphant
sojourn in Paris. Morville paid fifty *zecchini* for the work and offered a
generous pension if she would relocate her studio to Paris, an offer she
declined.[35] Curiously identified by the title *Little Girl in the Act of Clutching
a Dove to her Breast*, the subject is clearly a beautiful woman well past
adolescence.[36] Compared to the *Allegory of Innocence*, the Dijon lady seems
graceful, sophisticated, alluring and, above all, immediate. This immediacy is
achieved by the direct, nonchalant gaze and an utter disregard for the
décolletage that reveals her right arm and shoulder along with most of her
right breast. She is carefully coifed, with a tuft of hair sensuously caressing
her neck and shoulder, and she wears makeup and earrings. Even the dove is
larger and more mature than in the Accademia di San Luca miniature, with an
elongated beak that suggests physical far more than divine love. We are only
one step short of such overtly erotic historiated portraits as Nattier's *Madame
de Caumartin as Hebe* (Figure 2.7), where the eagle aggressively engages his
object of desire. In spite of the superficial similarities, a greater contrast to
the little girl of Carriera's *Allegory of Innocence* can hardly be imagined.

While images of females with doves are relatively rare in Carriera's *œuvre*,
representations of women with birds are not uncommon. *Allegory of Innocence*
should also be considered in this iconographical context. Given the fact that
most of Carriera's paintings are half-length single figures, the extensive use of
objectified attributes (literally from dogs to doughnuts) to expand their mean-
ing is unsurprising. Sani's definitive *catalogue raisonné* lists nine paintings of
female figures with birds, not counting the dove pictures discussed above.
There are also numerous replicas and variants of these paintings. Three pastels
depict unidentifiable birds and are to be read as signifiers of air in elemental
allegories. A rooster appears in two allegorical portraits, symbolizing vigilance,
while four pastels and at least one untraced miniature show ladies holding
parrots.[37] The best known and finest of the latter group is *Lady with a Parrot* in
the Art Institute of Chicago (Figure 2.8). Juxtaposition of this painting to
Allegory of Innocence is instructive and provides a good indication of the broad
range of interpretative possibilities present in such seemingly 'simple' images.

Lady with a Parrot, painted about 1720, depicts a voluptuous lady half-
length, richly dressed in a powdery blue dressing gown trimmed in lace. The
décolletage is exaggerated, revealing most of her right breast and even part of
her stomach. Partly turned in profile, the body has an energetic, sensual air
enhanced by the copious auburn curls that cascade down her back. Wearing a
bouquet and a bow in her hair and conspicuously accessorized by a gaudy
string of pearls that encircles her throat and right breast, she seems oblivious
to the blue parrot whose plumage matches her gown. Perched on her left
index finger, the bird has seized the lace tuck above her left breast and is in

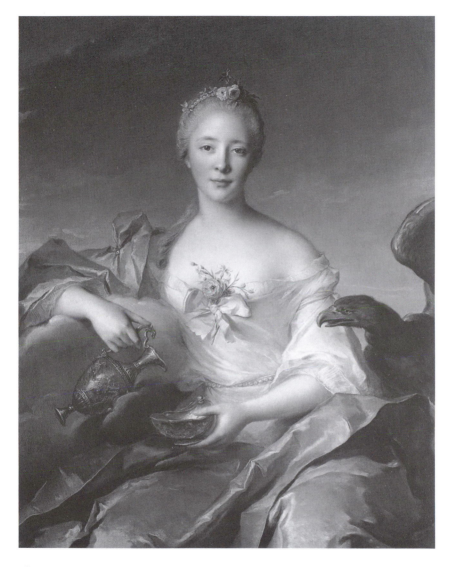

Fig. 2.7: Jean-Marc Nattier, *Madame de Caumartin as Hebe*, 1.025 m × 815 cm, oil on canvas, 1753, Washington D.C., National Gallery of Art (Samuel H. Kress Collection, 1946.7.13, National Gallery of Art, Washington, D.C.)

the process of pulling it back to reveal even more than we already see. It is an overtly erotic image of sexual desire and challenge.

Like the dove in the Accademia di San Luca miniature, the parrot in the Chicago pastel also gives the image meaning, but of a very different kind.

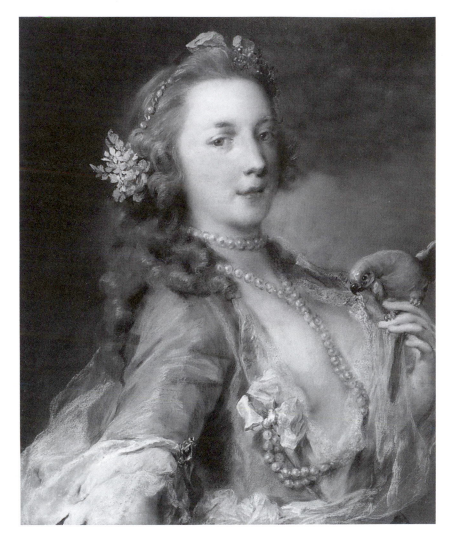

Fig. 2.8: Rosalba Carriera, *A Young Lady with a Parrot*, 60 × 50 cm, pastel on blue laid paper, mounted to laminated paper board, c. 1730, Chicago, Art Institute of Chicago (Photograph © 2002, Regenstein Collection, 1985.40, The Art Institute of Chicago. All Rights Reserved)

Cesare Ripa, the primary source book of symbolic attributes in the early eighteenth century, says that parrots represent quiescence, since they only mimic sounds created by others. It is obvious that the woman is anything but placid and tractable, so Ripa may be discounted here. More interesting is Bernardina Sani's association of the parrot with the sparrow, specifically in

the context of the famous passage in Catullus where a sparrow, symbol of lust, is held to Lesbia's breast. Such a signifier of promiscuity, or at least sexual availability, seems highly plausible. Carriera's superior education and friendship with the Paduan humanist Antonio Volpi, who published an edition of Catullus, support this interpretation.[38] Given the shared classical culture of Carriera and the majority of her patrons, an allusion to Catullus's Lesbia would have been understood and appreciated.

Another phenomenon relating to *Lady with a Parrot* that should be considered is the popularity of series portraits of acknowledged 'beauties'. Enjoying great vogue at the court of Charles II and William and Mary in England (one thinks especially of the portraits by Sir Peter Lely and Sir Godfrey Kneller), 'beauties' were also in demand on the continent, above all in the German states. Carriera executed at least two such series, one for King Frederick IV of Denmark and another for the duke of Mecklenburg. Tapping into Venetian Renaissance traditions of portraits of women celebrated for their physical charms by Giorgione, Titian and Palma Vecchio, among others, Carriera updated the practice in a number of painted 'beauties'. I believe that the Chicago painting is one of these. Could this lady be a courtesan portrait in the venerable Venetian mode? If she is, the specificity of her features indicates that she may be an individual rather than simply a type. As Shearer West has pointed out, Carriera's 'beauties' often are portraits of identifiable women noted for their unconventional lifestyles.[39] Her portraits *Lucrezia Mocenigo* and *Caterina Sagredo Barbarigo*, among others, are cases in point. In similar representations she camouflaged the courtesan/beauty with Arcadian attributes such as garden hats, fruit baskets, and so on, recognizing the necessity of appealing to male patrons while simultaneously distancing herself from the subjects of her paintings.

While such ambiguous (in all senses) portraits were wildly popular, I believe they would have been indecorous as academic reception pieces, especially in papal Rome. The aesthetic, social and academic distance between *Allegory of Innocence* and *Lady with a Parrot* was barely bridgeable and is compelling testimony to the obstacles an ambitious female artist had to negotiate in the early eighteenth century. Crucially, the works that made her rich, that made her 'an ornament of Italy and the premier female painter of Europe', were the same ones that potentially could have destroyed her reputation, had she not fabricated in other, different pictures a powerful counterbalancing persona as the domesticated virgin and dutiful daughter and sister. Far more than her male counterparts, Rosalba Carriera had to concoct a number of disguises to conceal her professional ambition while not seriously violating the gender expectations of the era. In this regard she was viewed by contemporaries who never saw her as both the virginal girl in *Allegory of Innocence* and the object of desire in *Lady with a Parrot*. In reality, she was neither.

Appendix 1

The following document is the unpublished text of the minutes of the meeting of 27 September 1705, when Rosalba Carriera was elected an *accademica di merito* of the Accademia di San Luca.

Signora Rosalba Carriera, miniature painter from Venice, having requested to be admitted as an *accademica di merito* and to this purpose having exhibited a half-figure portrait of a young girl painted by her on a slab of oval ivory a little less than half a *palmo* [about 15 inches], covered with glass and placed in an oval-shaped tin box, in order to leave it as her reception piece in our Academy, where it was immediately received, seen and approved with jubilation and applause and [she was judged] by general consensus to be an *accademica*, and without any dissension was declared by us to be *accademica di merita* notwithstanding the fact that [such an action] runs counter to our statutes that have been disobeyed in order to [accommodate] this foreign spinster, who is applauded everywhere and is truly a *virtuosa* by fame and ability, with orders to me the Secretary [Giuseppe Ghezzi] to inscribe her [name] among the others in the usual manner in the Catalogue, and that he [the Secretary] send the letters patent in the most ample form.

The following members of the General Congregation of the Academy participated:

Signore Cavaliere Carlo Maratti, Principe
Signore Lorenzo Ottoni, Camerlengo (Chamberlain)
Signore Pietro Papaleo
Signore Francesco Monnaville
Signore Lorenzo Nelli
Signore Carlo Buratti
Signore Carlo Francesco Bizzaccheri
Signore Domenico Ruberti
Signore Filippo Luti
Signore Pier Francesco Garolli
Signore Benedetto Luti
Signore Giuseppe Ghezzi, Secretary

The original text reads:

Avendo fatto istanza la S. Rosalba Carriera Pittrice e miniatrice Venetiana, d'esser ammessa per nostra Accademica di Merito ed a tale effetto havendo esibito un ritratto d'una mezza figura di Donzella fatta di sua mano in una

lastra d'avolio ovata poco meno di mezzo palmo col cristallo avanti e serrata in una scatola parimente ovata di latta per lasciarlo in sua memoria nella nostra Accademia onde fù subito con giubilo, et applauso ricevuto veduto et approvato et essere meritevole di esser Accademica onde di commun consenso e senza alcuna discrepanza fù dichiarata per nostra Accademica di merito [*sic*] non ostante non sia corsa la Bussola in conformità del decreto è ciò si è preterito per esser questa Zitella forastiera, applaudita da per tutto è veramente virtuosa per fama et virtù con ordine à me segretario di descriverla fra le altre nel solito Catalogo, e che gli se nè spedisse le lettere patenti nella più ampla forma.

Source: Rome, Archivio storico dell'Accademia Nazionale di San Luca, *Libri delle Congregazioni*, 46A, ff. 46–7.

Appendix 2

The inscription on the reverse of Carriera's reception piece, believed to be in Carlo Maratti's hand:

> The present miniature has been made by the celebrated miniature painter Rosalba Carriera from Venice on a piece of perfect ivory, the coloring of which is enhanced by the half tint [of the ivory] with astounding artifice. The author having been received as an *accademica di merito* in the year 1705 made of the present [painting] a free gift.

The original text, transcribed in Sani, *Carriera*, 277:

> La presente miniatura è stata fatta dalla insigne miniatrice Rosalba Carriera Veneziana sopra lastra di perfetto avolio, il colore del quale è servito di mezzatinta con stupore dell'arte. L'autrice essendo stata ricevuta per accademica di merito l'anno 1705 fece del presente gratuito dono.

Notes

I would like to thank Mary D. Sheriff, Melissa Hyde, Wendy Wassyng Roworth, Edgar Peters Bowron and Tommaso Manfredi for their help with this essay. All translations are my own. I have used *sic* sparingly, when there may be a question of meaning; otherwise, I have left the original texts to speak for themselves.

1. Carriera's invention of independent miniature painting on ivory is generally accepted in the literature on the history of the medium, but it is unclear if she ever painted snuff-box lids. In any event, such decorative objects were popular in late seventeenth-century Venice. See Carlo Jeannerat, 'Le origini del ritratto a miniatura su avorio,' *Dedalo* 11 (1931), 768–70; and Torben Holck Colding, *Aspects of Miniature Painting: Its Origins and Development* (Copenhagen: E. Munksgaard, 1953), 133–5. Before the late seicento, ivory as a medium was

used exclusively for copies of paintings on a small scale or for painted objects for jewelry.

2. For example, Pietro Orlando, *Abecedario pittorico, contenente le notizie de' professori di pittura, scoltura, ed architettura*, s.v. 'Carriera, Rosalba' (Venice, 1753), 448–49, published shortly before the artist's death, gives 1678 as the year of her birth. Based on a baptismal record that very probably refers to Rosalba, 1675 is the generally accepted year. See Bernardina Sani, s.v. 'Carriera, Rosalba,' in *Dictionary of Art*, ed. Jane Turner, 5: 877–8, with additional bibliography.

3. Carriera's letters are the primary source for our knowledge of the artist and have been edited in the magisterial study by Bernardina Sani, *Rosalba Carriera: Lettere, diari, frammenti*, 2 vols (Florence: Leo S. Olschki, 1985). The best general discussion of the artist's life and career is found in 1: 1–41.

4. For the diploma portrait, which was damaged in transit to Rome and has been heavily restored, see Francesco Cessi, 'Il ritratto di Rosalba Carriera dipinto da Sebastiano Bombelli per l'Accademia di San Luca,' *Arte Veneta* 19 (1965), 174, with an illustration. In the portrait Carriera holds a nosegay, a frequently encountered signifier of unmarried status for women.

5. Gabriella Gatto, s.v. 'Carriera, Rosalba,' in *Dizionario biografico degli Italiani* (Rome, 1977), 745–9.

6. Girolamo Ravagnan, s.v. 'Carriera, Rosalba', in *Biografia degli Italiani illustri nelle scienze, lettere, ed arti del secolo XVIII e de' contemporanei compilata da letterati Italiani di ogni provincia e pubblicata a cura del professore Emilio de Tipaldo* (Venice, 1836), 3: 361–65.

7. Alessandro Bettagno, 'Rococo Artists,' in *The Glory of Venice: Art in the Eighteenth Century*, exh. cat., ed. Jane Martineau and Andrew Robison (New Haven and London, 1995), 118–19.

8. Quoted from a letter of Christian Cole in Rome to Carriera in Venice dated 2 May 1705: 'un ornamento d'Italia et prima pittrice de l'Europa.' Sani, *Lettere*, I: 89.

9. See Edgar Peters Bowron in *Art in Rome in the Eighteenth Century*, exh. cat., eds Joseph J. Rishel and Edgar Peters Bowron (Philadelphia and London, 2000), 446–7.

10. Bernardina Sani, 'La "furia francese" de Rosalba Carriera: Ses rapports avec Watteau et les artistes français,' in *Antoine Watteau (1689–1721), le peintre, son temps et sa légende*, exh. cat., eds François Moreau and Margaret Morgan Grasselli (Paris and Geneva, 1987), 73.

11. Such sexist language is lamentably quite recent. Michael Levey, 'Introduction to 18th-Century Venetian Art,' in *Glory of Venice*, eds Martineau and Robison, 31. Levey's statement that Carriera was 'unusually literate for a Venetian artist of the period, cultured and intelligent without any claim to be erudite' is essentially accurate, but the intellectual basis of her professional ambition is unfortunately explained in rather different terms: 'Like a benevolent, hyper-industrious spider, she spun a web of contacts ... ' Carriera, easily the most renowned artist in Venice since Veronese and Tintoretto and arguably the most famous painter of the settecento Venetian school during her lifetime, is given appallingly short shrift in this catalogue. See Christopher Johns, 'Venetian Eighteenth-Century Art and the Status Quo,' *Eighteenth-Century Studies* 28 (1995), 427–8. Until quite recently, almost all authors have called the artist Rosalba instead of Carriera, a traditional patronizing practice when discussing women artists.

12. Per Bjurström and Görel Cavalli-Björkman, 'A Newly Acquired Portrait of Anton Maria Zanetti by Rosalba Carriera,' *Nationalmuseum Bulletin* 1 (1977), 45–7.

13. For an excellent discussion of the development of a taxonomic system for Carriera's miniatures see Bernardina Sani, 'La terminologia della pittura a pastello e in miniatura nel carteggio di Rosalba Carriera,' *Convegno nazionale sui lessici technici del Sei- e Settecento* (Pisa, 1980), 387–417, with additional bibliography.

14. The letter is quoted in Sani, *Lettere*, I: 67–8. The original text reads:

 > Mentre il Sig. Giuseppe Cresta ... ammirava giorni fa la vostra bell'opera, lodandone singolarmente la fedeltà del disegno e la diligenza del colorito, vi fu un non so che chi che disse: che fortuna d'un pittore che havesse una sì virtuosa emola dell'arte per consorte; a cui egli ripigliò che bisognava, per ben accoppiarla, far risuscitare il Sig.r Guido Reni.

15. Francis Haskell, *Patrons and Painters: A Study in the Relations between Italian Art and Society in the Age of the Baroque*, 2nd edn (New York: Harper & Row, 1971), 262.

16. Sani, *Lettere*, I: 82. 'Molti qui hanno con grandissima admiratione, veduto il mio ritratto, fatto dalla sua arteficiossima mano. Ho veduto qui alcuni pittori chi fanno in miniatura, ma nissun chi può comparato con Ella.'

17. Ibid., I: 84. 'Se Ella ha tempo, adesso, Vi prego di comprar per me una delle più grande pezze d'ivoro che poterà trovare et d'y depingere una Venere che dorme in un giardino, ornato di fiori, etc., ma vorrebbero la Venere tanto nuda che la sua consciensa la può permeter: all meno il seno, le mani et le gambe nude ... ' Cole's use of the verb *vorrebbero* proves that he understood the audience for the work to be plural (*they would want*, or *they would expect*) and not just something to please the patron. See Vittorio Malamani, *Rosalba Carriera,* 2nd edn (Bergamo, 1910), 20–22. It is not known whether or not Carriera actually executed the work and no such miniature has come to light. I suspect she declined the commission, for reasons that I shall discuss in due course. David Roberts was an English Grand Tourist resident in Rome during the early years of the eighteenth century.

18. Bernardina Sani, *Rosalba Carriera* (Turin, 1988), 12–13. For her interest in Correggio see idem., 'Lo studio del Correggio in alcuni pastelli di Rosalba Carriera,' *Annali della Scuola Normale di Pisa* 8 (1978), 203–12.

19. For Luti, see especially Edgar Peters Bowron, 'The Paintings of Benedetto Luti (1666–1724)', PhD diss., New York University, 1979; and idem., 'Benedetto Luti's Pastels and Coloured Chalk Drawings', *Apollo* 111 (1980), 440–47.

20. Sani, *Lettere*, I: 69. He frequently wrote to her in French. 'pour ne pas doner prise aux curieux des affaires autruy, dont il y en a a beaucoup icy, il vaut mieu que je fasse le dessus de vos lettres: à Mr. [sic] Jean Carriera ... '

21. For the strict moral tone Clement XI attempted to impose in early settecento Rome, see Christopher Johns, *Papal Art and Cultural Politics: Rome in the Age of Clement XI* (Cambridge and New York: Cambridge University Press, 1993), especially chapter 3.

22. Sani, *Lettere*, I: 73.

23. Ibid., I: 87. 'Luj [Ghezzi] ho detto che non verrebbe risquar la riputazione de la Signora Rosalba, né la mia.'

24. Ibid., I: 90–91.

25. Ibid., I: 94–5.

> Hieri andiede dal Sig.r Josepho Chiari pittore et là trovò il Sig.r Cavalier Carlo Maratti, Principe del Accademia, li ho mostrato suo lavoro, chi fu admirato equalmente da tutti duoi. Il Sig.r Cavalliero [Maratti] la teneva più de meza hora in mano et diceva che V. Signora haveva chiesto un sugetto dificile, bianco sopera [sic] bianco, che havete fatto da maestra grande, che Guide Rheni no poteva fare più.

Chiari was Maratti's favorite pupil and a leading member of the Academy. He later served as principe shortly before his death in 1727. See also Malamani, *Rosalba Carriera*, 25–6.

26. Ibid., 'La feranno [sic] vedere al Papa ... '

27. In 1733, Cole published *Memoirs of Affairs of State* (London: H. Woodfall Publishers, 1733), but never rose above the rank of first secretary. He is not listed in the *Dictionary of National Biography*.

28. For example, Emilie von Hoerschelmann, *Rosalba Carriera: Die Meisterin der Pastellmalerei* (Leipzig, 1908), 54–6.

29. Sani, *Lettere*, 1: 118. 'Vous ne sçauriez comprendre combien je m'intéresse dans tous ce que vous regarde, et je vois que vous ne voulez pas croire quand je vous explique l'amitié, par ne pas dire autre chose, que j'ay pour vous.' Carriera turned down at least one proposal of marriage but, to judge by the tone of her letter of refusal, the suitor could not have been Cole. See Sani, *Lettere*, 2: 753.

30. Colding, *Aspects of Miniature Painting*, 30, identifies the painting as Chastity, while Sani opts for the safer genre identification (Sani, *Carriera*, 277, item 15).

31. Aristide Sartorio, *Galleria di S. Luca*, vol. 9–10, *Musei e Gallerie d'Italia* (Rome, 1910), xxiii. The author curiously suggests that since the painting in question is a miniature painted on ivory, it is probably by Giovanna Carriera, Rosalba's sister, who is known to have painted miniatures. This idea is a good indication of how Carriera's eminence as a pastel painter swamped her initial reputation as a miniaturist.

32. A better-known instance of such a tactic by a high-profile female artist in the context of the Académie Royale is Élisabeth-Marie Vigée-Lebrun's *Peace Bringing Back Abundance*. See Mary D. Sheriff, *The Exceptional Woman: Elisabeth Vigée-Lebrun and the Cultural Politics of Art* (Chicago, 1996), 73–104, with additional bibliography.

33. There is a reduced version, probably autograph, in the Bayerisches National-museum in Munich. See Sani, *Carriera*, 277. This may have been executed as a *ricordo* to be kept in the artist's studio. Replicas in the Royal Museum of Fine Arts in Copenhagen and at Windsor Castle are, in my opinion, by another hand. See Colding, *Aspects of Miniature Painting*, 130–34.

34. Sani, 'La terminologia', 402–3. Lacombe's popular dictionary defined the *portrait historié* as 'a portrait figure accompanied by other figures or by allegorical attributes'. As a means of giving themselves greater professional, intellectual and social status, portraitists as diverse as Joshua Reynolds and Jean-Marc Nattier 'historiated' their likenesses when circumstances permitted.

35. Sani, *Carriera*, 303–4, item 206. The painting was copied by Charles Coypel and was widely acclaimed for its Correggesque grace and *sfumato*. See idem, 'Studio del Correggio,' 211.

36. This title is given in Malamani, *Rosalba Carriera*, 68–69.

37. Sani, *Carriera*, item numbers 82, 356, 360 (unspecified birds); item numbers 176 and 177 (roosters); item numbers 39, 92, 232 and 272 (parrots). The

Chicago painting is discussed on page 287. See also idem, 'Rosalba Carriera's *Young Lady with a Parrot,' Museum Studies: The Art Institute of Chicago* 17 (1991), 74–87, 95.

38. Sani, 'Young Lady with a Parrot', 82–5, with additional bibliography.
39. Shearer West, 'Gender and Internationalism: The Case of Rosalba Carriera,' in *Italian Culture in Northern Europe in the Eighteenth Century*, ed. Shearer West (Cambridge, Cambridge University Press: 1999), 57. West's excellent study is primarily concerned with Carriera's strategies of self-presentation in an international context, and I have greatly benefited from her ideas.

Lovisa Ulrike of Sweden, Chardin and Enlightened Despotism

Paula Rea Radisich

Do you know the *Bureau Typographique*? It is a new invention, originating in France, to teach children to read by jesting with them. I have one, and I dare assure you, my dear mother, that before my son is four, he will know how to read. It is rare enough that at three they can spell. Since all is a game, he has no aversion to it.[1]

Lovisa Ulrike to her mother, 1749

Although the writer of these lines sounds like an ambitious but ordinary woman of the present era who has decided to home-school her child, she actually lived two and a half centuries ago, and she could hardly be described as ordinary. The protagonist of my story is a Hohenzollern, Lovisa Ulrike, sister of Frederick the Great. In 1744, this Prussian princess was married to the elected heir to the Swedish throne, another German prince, Adolf Fredrik of Holstein-Gottorp. Through this marriage, she became crown princess of Sweden and eventually, in 1751, queen of Sweden. The son to whom she refers in the passages would inherit the Swedish throne.

Lovisa Ulrike caught my attention as an art historian because of her interest in the great eighteenth-century French painter, Jean-Siméon Chardin. In 1745, she commissioned Chardin to paint a pair of pictures for her representing 'the harsh education' and 'the soft, insinuating education', a subject of her own devising.

This act of patronage is intriguing for several reasons. First, the patron is a woman. Second, the subject is rather unusual.[2] Third, at the time of the commission, Lovisa Ulrike is pregnant, carrying her first child, the crown prince whom she later will attempt to teach to read by playing with him at the French 'invention', the *Bureau Typographique*. Did the odd theme of contrasting pedagogical methods point to her impending maternity in some way?

Was this act of patronage a complex act of self-fashioning in which the princess (through an embodiment of the theme by Chardin) represented herself as an educator? If so, where was the power quotient in such a representation? Tangentially, which of the two 'educations' did she consider the *good* one? And what exactly is an insinuating education?

Lovisa Ulrike, *philosophe*

Described by historian Michael Roberts as a woman 'of masterful temper, an unflagging interest in politics, and abilities greatly superior'[3] to those of her husband, Lovisa Ulrike, nevertheless, would not be described as a feminist by today's standards. Like the governesses represented in Chardin's pictures, the princess aimed to exercise power within socially approved norms of eighteenth-century womanhood. Those parameters had shifted markedly since the seventeenth century. Lovisa Ulrike flatly rejected any identification with the baroque queen, Christina of Sweden, for example, despite the latter's precocious intellectuality. When Voltaire, seeking to flatter, called Lovisa Ulrike a 'new Christina', she politely but emphatically resisted the moniker. 'There is no way to convince her,' wrote one of her courtiers, 'that there is any glory in resembling Queen Christina.'[4]

Her refusal to be fashioned a 'new Christina' is telling. It is impossible to know exactly what aspects of Christina's history Lovisa Ulrike found objectionable; so much of that remarkable woman's life might have offended the princess. Was it the donning of masculine attire and Christina's self-identification with Alexander the Great?[5] These acts were interpreted as unambiguous rejections of womanhood in Lovisa Ulrike's day. Christina's adoption of the masculine was seen as a discount of the feminine: 'In affecting the virtues of our sex,' wrote Monsieur de Billemond in the *Encyclopédie*, 'she [Christina] willingly renounced the graces of her own.'[6] Was it the disdain Christina expressed for marriage?[7] Her rejection of heterosexual love? Although her own marriage was a dynastic arrangement, Lovisa Ulrike seems to have fallen in love almost instantaneously with her designated consort, Adolf Fredrik. 'Here is the portrait of the person that I love and adore the most in the world,' she effused to her sister, Amalie, in 1747, speaking of Adolf Fredrik.[8] Or was the crux of the matter the political power that Christina abjured by abdicating the throne of Sweden and converting to Catholicism? A monarch who willingly gave up her prerogatives of power would be deemed a fool in Lovisa Ulrike's eyes.[9]

In contrast to Queen Christina, who selected an ancient hero like Alexander the Great to signify aspects of her identity, both Lovisa Ulrike and her brother, Frederick II of Prussia, pass over specific historical or mythological

associations, preferring instead the generic *'philosophe'* as their sign and attribute. This is most evident in the case of Frederick, who signed himself the *'roi philosophe'*.[10] However, Lovisa Ulrike also used the word rather consistently to describe herself. 'I am *philosophe* or at least I am trying to become it,' she wrote at one point to her brother Wilhelm. Or, to her mother, she declared: 'I live here *en philosophe*, far from noisy pleasures, having none but those that reading procures for me.'[11]

Turning to the entry *'esprit philosophique'* in the *Encyclopédie*, we find the philosophical spirit defined as the gift to judge all things sensibly (*sainement*). Since it is a gift, I note it is not unlike 'genius'. Though only certain individuals are endowed with this mysterious aptitude, they can perfect it by study (*travail*), by skill (*art*), and by habit, exactly like genius. Louis de Jaucourt, who composed the entry, credits the *esprit philosophique* with a marvelous intelligence, a forceful reasoning, and a sure and contemplative taste regarding what is good and bad in the world.[12]

For a person to describe herself as living *en philosophe*, then, means that she read to hone her reason and her ability to make judgments. An example of this is the pleasure she derived from reading the six-volume *Traité de l'opinion: ou, Memoires pour servir à l'histoire de l'esprit humain* by Gilbert Charles Le Gendre, a work informed, as Le Gendre proudly declares in his opening sentence, by 'the science of doubting'. Lovisa Ulrike read this work twice because she liked it. Such a strongly expressed preference deserves our attention, for the preferences of women usually have to be inferred.[13] Le Gendre states that his objective in writing the work – which covers a staggering amount of information about ancient and modern *belles lettres*, history, philosophy, metaphysics, mathematics, natural science, politics, and ethics – was to strip the obscurity from abstract subjects so as to render them intelligible to those who had not learned about them. That constituency, of course, is one that lacked the ancient languages and thus included most women. Lovisa Ulrike's enthusiastic response to the *Traité de l'opinion* leaves a historical trace of the fugitive point of contact between an author and a reader, demonstrating how the Cartesian spirit emboldened women of the eighteenth century to exercise their reason, encouraged them to reach independent judgments, and stimulated self-education.

'Forceful reasoning' is also central to Hohenzollern concepts of enlightened despotism. In his *The Refutation of Machiavelli's Prince or Anti-Machiavel*, written 1739–40, Frederick defines the enlightened ruler as one who aims for public utility by undertaking actions directed by reason and virtue. 'Virtue should be the only motive for our actions, for virtue and reason are and always will be inseparable if one wants to act consistently,' wrote Frederick.[14] 'It is thus not power, force, or wealth which win the hearts of men, but personal qualities, goodness, and virtue … it is not a question of dazzling the

public and absconding, so to speak, with their esteem. It is a question of meriting it.'[15]

Frederick breaks decisively with Baroque formulas of representation in these passages. Magnificence, so central to the social positioning of Renaissance and Baroque princes, is reviled by him as a dissolute form of 'dazzling' others through visible signs of material wealth. It is clear from this statement that the patronage or the collecting of art works will not play the same role for Frederick as it did for Louis XIV or Queen Christina, for that matter. Christina possessed around 750 paintings, three quarters of them looted from Prague after the successful siege of the city by Swedish troops in 1648.[16] Like most aristocrats in the seventeenth century, Christina was motivated by a desire to demonstrate power through princely magnificence.

Both Lovisa Ulrike and Frederick, however, viewed the residences housing their art collections as refuges from public life.[17] Their palaces are ostensibly sites in the private rather than the public sphere. But it is there that they develop their public identities as seekers of a life lived *en philosophe*. The Frederician model of enlightened absolutism in the *Anti-Machiavel* depends upon an interiority made public – an interiority signified by the representation *philosophe*. Lovisa Ulrike acknowledges the representation perfectly when she imagines Frederick alone in his garden lost in thought: 'Occupied only by the good of your subjects, the hours you employ at leisure would be counted by others as moments of work.'[18]

While both Lovisa Ulrike and her brother sought to demonstrate the vigor of a philosophical spirit absorbed in refining judgment through study, skill and habit (*pace* Jaucourt) within the sanctuary of the private sphere, educational activities provided Lovisa Ulrike with a particular means of bringing this representation into sharper focus. Whether her efforts to educate her son Gustav bore salutary results or not does not interest me here; rather, it is her appropriation of the role of pedagogue that I find significant.[19] Education was a subject that offered royal women an opportunity to engage in rhetoric about judgment and right rule, since ruling a household and ruling a nation evoked certain parallels in the eighteenth-century mind. In one of the conflicted musings[20] about women in the *Esprit des Lois* (1748: Book VII, Chap. 17), Montesquieu, for example, argued that it was contrary to reason and nature that women should reign in families, but not that they should govern empires. He suggested that soft and insinuating ways could make for a fitter administration (*un bon gouvernement*) than roughness and severity (*les vertus dures & féroces*).[21]

Montesquieu's syntax alerts us to the nuances of gender underlying the language of the subject Lovisa Ulrike commissioned Chardin to paint for her. Women are linked to softness and insinuation, men to roughness and severity. Montesquieu is not alone in designating softness and insinuation as 'natu-

rally' descriptive of women. Lovisa Ulrike would have encountered similar usage in Charles Rollin's *De la Manière d'enseigner et d'étudier les belles-lettres par rapport à l'esprit & au coeur* (1726).[22] Rollin, rector of the University of Paris, was a favorite author of both Frederick II and Lovisa Ulrike.[23] He employs the locution *'douce et insinuante'* in the context of a discussion about the role of mothers in the education of their children. The care of young children, writes Rollin, 'is chiefly theirs; and constitutes part of that little domestic empire, which providence has immediately assigned them'. To fulfill this duty successfully, however, women need to combine 'a gentle, but steady authority to their natural sweetness of temper, and their soft, insinuating ways'.[24]

Though Rollin did not specifically advise mothers to teach their children to read, it is here we find the direct link to the *Bureau Typographique*. Rollin turns out to be the *Bureau's* most influential supporter among French educators. (Several of his colleagues at the University of Paris vehemently contested the efficacy of its inventor's methods.) In *De la Manière d'enseigner*, Rollin actually singles out the *Bureau Typographique* by name, recommending it to readers who wish to press a reading method into service.[25]

L'éducation douce et insinuante

Nicolas Guérard's print, *De Tout Côté Peine* (1694 or 1699)[26] furnishes a graphic definition of what was meant in the *ancien régime* by 'the severe education'. From the instructor's desk a scroll unfurls (Figure 3.1), bearing the inscription 'Good correction makes good education.' Guérard's tearful pupil is shown getting his fingertips rapped, his ear boxed, and his backside switched – all simultaneously – a comical reference to the picture's title, *Pain from all Sides*. In the background, two boys beating their tops emblematize the saying inscribed beneath them: 'The more one beats them the better they go.' The harassed allegorical figure depicted by Guérard sustains it all stoically, barricaded into the center of a maze with narrow radiating channels labeled the church, the robe, the sword, the arts and sciences, the crafts, the navy and trade. Guérard apparently equates the necessity of a severe education to success in all the different paths of a man's life.

Nevertheless, forcing children to learn by threatening them with beatings – the most extreme 'severe' method of instruction – had a surprisingly long and illustrious line of detractors in European pedagogical theory. Critics of the rod ranging from Quintilian to Fénelon believed that making children suffer to learn achieved only negative results. Some of these educators extended the list of abuses caused by the severe method to include the tedious and onerous exercises of recitation and memorization routinely imposed on children in the

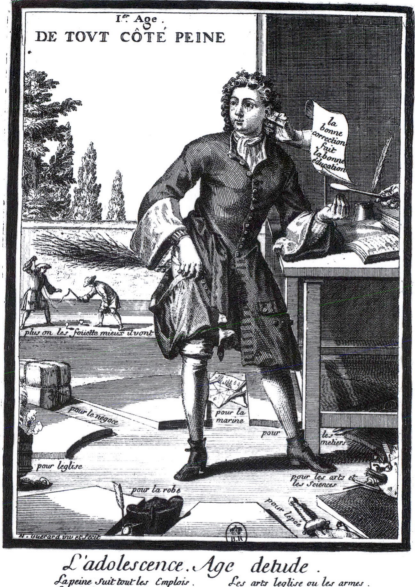

Fig. 3.1: Nicolas Guérard, *De Tout Côté Peine*, 1694–1699, Paris, Bibliothèque Nationale (Bibliothèque Nationale)

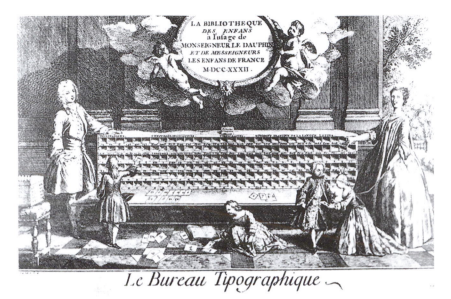

Fig. 3.2: Illustration for the *Bureau Typographique* from Marie-Christine Skuncke, *Gustav III, det offentliga barnet: en prins retoriska och politiska fostran* (Stockholm: Atlantis, 1993)

ancien régime. Instead, they proposed to mix instruction with play, cater to the child's intellectual and emotional level, and to transform learning into a pleasure. Fénelon, for example, coined the phrase 'Indirect Instruction' for this approach. He developed his ideas at length in Chapter 5 of *De l'éducation des filles* (1687), a chapter bearing the imperious subtitle 'Instructions Indirectes: Il ne faut pas presser les enfants' ('Indirect Instruction: You must not force children').

Louis Dumas, inventor of the *Bureau Typographique*, retooled the old idea of 'indirect instruction' by grounding it in the fashionable theories of the English philosopher, John Locke. Dumas's *Bureau* was a low desk surmounted by several shelves of cubbyholes containing cards labeled with different signs. Children would combine these cards, imprinted with letters, words and other symbols, into an order proposed by the instructor and thereby learn to read, write and count. As the illustration promoting Dumas's book intimates (Figure 3.2), children utilizing the *Bureau Typographique* learned through sensation, seeing and observing, moving around and using their bodies. As a sympathizer writing in the *Mercure* put it (1741): 'the method of the *Bureau* … puts into play, the ears, the eyes, the hands, the feet, and the entire body, by a useful, pleasurable and instructive movement.'[27] The ruler and the switch,

symbols of the old-fashioned 'severe' education, 'become absolutely useless with this method', concluded one schoolmaster.[28]

Judging from the articles and letters published in the *Mercure de France*, controversy about Dumas's methods reached a fevered pitch in the 1730s and 1740s. Feelings about the *Bureau Typographique* ran high, pitting advocates identified with the *'esprit philosophique'* against those deemed anti-*philosophiques*.[29] Partisans of the *Bureau*, wrote Louis Dumas, 'are ordinarily ... *gens d'esprit philosophique* loving the public good, and, in contrast, those who declare themselves against the *Bureau Typographique* are only simple Latinists, very indifferent to the good and the best, most of whom are incapable of analyzing ideas and following ... the least reasoning'.[30] Echoes of these formulations mark Lovisa Ulrike's rhetoric: 'I do not know if the method I am using will be able to succeed,' she writes, 'but his [Gustav's] learning about history, geography and theology depends on reasoning. Nothing encumbers his memory, because learning too much by heart creates a mechanical study with no judgment ... '[31] In these remarks, the princess characteristically attributes paramount significance to judgment, the distinguishing mark of the philosophical spirit.

Of course, the *gens d'esprit philosophique* denoted by Dumas as champions of his system were partially attracted to it because they identified its philosophy as Lockean. However, for true believers of the 'science of doubting', the use of the *Bureau Typographique* held the potential to destabilize a number of *ancien régime* power relations. A letter sent to the *Mercure* (January 1731) by one of Dumas's detractors, a preceptor from Provence, highlights one of them for us. 'What!' wrote the furious *maître*, 'We [who] have passed so many years tormenting ourselves to learn things that we feel cannot even be learned in an advanced age, and children of five or six years, governesses, servants will learn by play what cost us so much pain, tears and toil?'[32]

According to Dumas, children as young as five or six, or even three or four, could learn to read, not just French, but Latin, using the *Bureau* with a properly trained adult. The emphasis he placed on childhood education was one of the most novel aspects of the *Bureau Typographique*. Finding a *maître* willing to take on a role that required him to come down to the child's level was the problem. As Dumas observed in an update published in the *Mercure* (November 1738): 'Maîtres following the ordinary method have a bit of trouble adapting [to the *Bureau*]; they feel that to teach the *Typographie* they must study it and become a student themselves; they find it humiliating to renounce the quality of master for awhile; this is why it is as difficult to find maîtres for the *Typographie* as it is easy to find them for the ordinary method.'[33] Targeting as it did the education of such very young children, Dumas's system put pressure on the power relations of class and gender separating the *maître* from the governess. The *maître* traditionally enjoyed a respected, even

exalted, male-to-male relation with youthful charges at least six or seven years old, whereas the governess often resembled a nanny in the *ancien régime*, indistinguishable from an ordinary house servant. Her task was to look after the material needs of children rather than their intellectual ones. No wonder the *maîtres* described by Dumas feel humiliated. They believed the *Bureau Typographique* relegated them to the inferior domain of the female house servant and charged them with woman's work, that is, supervising the activities of toddlers with undeveloped reasoning.

From this angle Lovisa Ulrike's conflation of the maternal role with a pedagogical one can be categorized as subversive and even feminist.[34] Despite the risk of becoming identified with their servants when they experimented with becoming the 'educators' of their children, bold women like Lovisa Ulrike who employed the *Bureau Typographique* could do more than merely supervise the instruction their children received from others. At least in theory, they could sidestep many of the patriarchal structures controlling élite education in the *ancien régime*. With the *Bureau Typographique*, anyone could become a *maître*. (The political effects of this transgression are abundantly dramatized in the story of Lovisa Ulrike, for the Swedish Diet or parliament ultimately would bar her from engaging in the education of her son, fearful of her power over their future king. She would declare ruefully to her mother in 1756: 'I have had a great deal of chagrin with regard to education.'[35])

Self-fashioning and patronage

We now see that the *Bureau* epitomized *'l'éducation douce et insinuante'* in the 1740s. Its partisans were vulgar Lockeans inclined to accept empiricist notions about knowledge and its acquisition.[36] And from that central postulate, a number of other ideological assumptions could flow, more or less modernist, and more or less hostile to the authority of the past. Given this, we must reconsider Lovisa Ulrike's aims as a patron and her particular interest in Chardin.

One objection to this line of inquiry will be that it was the Swedish statesman, Carl-Gustav Tessin, not Lovisa Ulrike, who stood behind the Chardin commission.[37] It is true that Tessin brokered the contract, using the relation he had forged with Chardin in years past to negotiate a good price for the pictures and to exert gentle pressure for timely completion.[38] But in this he acted as an intermediary. When Chardin inquires about the possibility of fulfilling the commission by substituting studio copies of old pictures instead of creating new ones, Tessin defers to Lovisa Ulrike. (Her answer is no.) In addition, she *says* she gave the artist the subject herself. She first mentions it in a letter to her mother written on 31 May 1746:

I am also building two galleries that will be decorated with paintings I have ordered from Paris. Boucher and Chardin are the leaders (*maîtres*) there. I have given as a subject to the former 'The Four Parts of Day' and to the other The Harsh Education and The Soft, Insinuating Education. The paintings are due to arrive at any moment. My very dear Mama has many prints copied from original paintings by these two painters.[39]

Although today we think of Chardin primarily as a still-life painter, it is clear from these passages that Lovisa Ulrike thought of him as one of Paris's two leading figure painters (Boucher being the other). At the first regular Salon organized by the Academy in 1737, and then in subsequent Salons through the 1740s, Chardin had exhibited chiefly figure paintings representing modern life subjects – subjects, moreover, critically acclaimed by the reviewers of the widely read *Mercure de France*. In some years, for instance 1740 and 1741, Chardin appeared to dominate the Salon because Lépicié's engravings after the artist's *La gouvernante*, *La petite maîtresse d'école* and *La Mère Laborieuse* were exhibited there too. Prints such as these caused Chardin's work to be well known all over Europe. As the letter cited above indicates, Lovisa Ulrike's mother possessed some of them.[40] Besides providing a 'canon' of images on which aspiring collectors might ground their judgments, print collections served a rather different but equally important purpose. They furnished a domain of publicity for collectors and patrons. It was through prints and their 'tags' – dedications and other texts – that the representation of an individual as a discerning patron or collector circulated throughout the territory of the Republic of Letters. Lovisa Ulrike had every reason to expect that one yield of her commission to Chardin would be engraved reproductions of '*l'éducation sévère*' and '*l'éducation douce et insinuante*' bearing the inscription 'in the collection at Drottningholm' and perhaps accompanied by a dedication to her from the artist.

Chardin's painted response to Lovisa Ulrike warrants its own separate study; it is too complicated to narrate in detail here. Although he accepted the commission, he was reluctant to be commandeered into a debate about educational methods, and this is where the story takes a startling turn. Chardin seems to have used at least one half-completed picture he had begun to paint for another patron or for another purpose to satisfy the commission from Lovisa Ulrike. In the end, he expanded the commission into two pairs of paintings for her: *Amusemens de la vie privée* and *L'économe*; *L'élève studieux* and *La bonne education*.[41] Lovisa Ulrike nonetheless judged the four paintings the greatest works in her art collection. But more curious is how she described them. Bragging to her sister in 1748 about the masterpieces she had assembled, she alludes to them as follows: 'primo, four little Chardins whose subject I gave myself ... ' ('primo, quatre petits Chardin, dont j'ai donné les sujets moi-même ... ').[42]

This surprising claim of authorship – that she devised all *four* subjects herself – bears the stamp of a self-fashioner. Lovisa Ulrike evidently saw herself as a partner in the production of these paintings. Recalling how Jaucourt's definition of the philosophical spirit calls to mind reigning notions of 'genius', Lovisa Ulrike's concept of partnered cultural production through patronage is not, perhaps, so remarkable. However, on this point the patronage practices of brother and sister exhibit a striking divergence. Unlike Frederick, Lovisa Ulrike refused to merely purchase works from Chardin, insisting, rather, to commission them instead.[43] In her commission, moreover, she demanded originals.[44] By doing so, she forced – a power relation – the artist to produce a novelty. (Frederick, in contrast, was happy to acquire studio copies of Chardin's *La pourvoyeuse* and *La ratisseuse*.) Because she furnished the artist with subjects to represent, she claimed credit for the paintings' invention (even if their thematic trajectory changed).[45]

This is different from Frederick, but consonant with what I have called Frederician interiority. Gender is responsible for the differences in how that interiority was performed. Lovisa Ulrike claims power through the instrumentality of art ostensibly within the private sphere (but when the images are translated into prints they become public). Through her commission of subjects representing Lockean ideas about education, she shows herself an enlightened and judicious ruler of her family, and by extension, a progressive heir to the Swedish throne. Thus the commission of 1745 doubles as a soft and insinuating improvisation on the theme of Reason and Virtue trumpeted by Frederick the Great as the basis of *his* claim to rule in the *Anti-Machiavel*.

Notes

The author wishes to thank the editors for their excellent suggestions about improving the clarity and the organization of this essay.

1. *Luise Ulrike, die schwedische Schwester Friedrichs des Grosen: Ungedruckte Briefe an Mitglieder des preussichen Königshauses*, ed. Fritz Arnheim (Gotha: Friedrich Andreas Perthes, 1909), II: 167; letter dated 13 March 1749. See also II: 170, letter of 25 March 1749, which refers to her mother's response:

 Je ne suis point surprise de ce que ma très chère Maman soit étonnée que je m'amuse à apprendre à lire à Gustave. Il est vrai qu'il faut de la patience; mais, comme tout ce qu'il apprend est en badinant, cela ne donne pas beaucoup de peine. D'ailleurs il comprend fort facilement et a beaucoup de mémoire. Il sait les histoires des métamorphoses d'Ovide presque toutes, ce qu'il a appris en regardant les estampes. Il y prend tant de plaisir que c'est une punition quand il n'ose point les raconter ni en apprendre de nouvelles. Le mois d'octobre prochain je compte de le mettre entre les mains du comte Tessin [appointed to serve as his Governor], et je crois qu'il ne peut être mieux, ayant beaucoup de talents.

1. Although two similar subjects were engraved by Desplaces after Charles Coypel, *L'Éducation douce et insinuante donnée par une Sainte* (a representation of the Virgin and St Anne) and *L'Éducation sèche et rebutante donnée par une prude*. Even if she hadn't seen these particular prints, and she never mentions seeing them, she may have read the titles in the advertisement appearing in the January 1738 issue of the *Mercure de France*.

3. Michael Roberts, *The Age of Liberty, Sweden 1719–1772* (Cambridge, London, New York, New Rochelle, Melbourne, Sydney: Cambridge University Press, 1986), 178.

4. Scheffer, letter from Paris, 20 May 1746. He sent a copy to Sweden of Voltaire's speech to the Academy in which Voltaire called Lovisa Ulrike 'une nouvelle Christine, égale à la première en esprit, supérieure dans le reste … '. The reaction of Lovisa Ulrike was reported by Tessin (a reaction that also tells us she was not avid at being pregnant):

 > J'ai lû a Madame la Princesse le discours de Mr de Voltaire, elle en a été enchantée; L'autheur la reconnoitra quand je dirois que ce qui l'a le moins touchée a eté de voir la maniere dont Elle y est louée, outre qu'elle n'est pas avide d'encens, il n'y a pas moyen de la faire convenir qu'il y a de la gloire à resembler a la Reine Christine …

 See Carl Fredrik Scheffer, *Lettres particulières à Carl Gustaf Tessin, 1744–1752*, ed. Jan Heidner (Stockholm: Kungl. Samfundet för utgivande av handskrifter rörande Skandinaviens historia, 1982), fn 2, 124. The moniker evidently endured, though. The phrase is used again by Hénault in a response to Scheffer penned in January 1753 in which Hénault refers to Lovisa Ulrike as 'la moderne Christine', concluding 'Christine en effet n'étoit qu'une personne fameuse et Ulrique sera illustre.' See Gunnar von Proschwitz, 'Lettres inédites de madame Du Deffand, du président Hénault, et du comte de Bulkeley au baron Carl Fredrik Scheffer, 1751–56', *Studies on Voltaire and the Eighteenth Century* 10 (1959), 307–8. Voltaire and his *confrères* remembered Christina as a young queen who rose at 5 every morning to converse about questions of metaphysics with Descartes, a philosopher (they invariably point out) ignored in France and persecuted in Holland, but received with due honors in Sweden. Thus the male perspective from the French Republic of Letters adopted a far more sympathetic view of Christina's life than did Lovisa Ulrike.

5. See Eva Haettner Aurelius, 'The Great Performance: Roles in Queen Christina's Autobiography,' in *Politics and Culture in the Age of Christina,* ed. Marie-Louise Rodén (Stockholm: Suecoromana IV, 1997), 55–66. The identification with Alexander is a theme emerging from Christina's writing about herself. The thematic parallels between the two, which Christina drew from Plutarch, were a birth accompanied by miracles, a passionate but controlled character, an excellent education, a thirst for knowledge, and an ascetic nature. Aurelius speculates that Christina's heroic deed was the abdication, which could be seen as bold, noble and unselfish. In the visual realm, Christina seems to have encouraged an identification of her body with the mythological figures of Diana and Minerva; on this, see Rose Marie San Juan, 'The Queen's Body and its Slipping Mask: contesting Portraits of Queen Christina of Sweden', in *ReImagining Women: Representations of Women in Culture*, eds Shirley Neuman and Glennis Stephenson (Toronto, Buffalo, London: University of Toronto Press, 1993), 19–44. San Juan discusses how challenging the issue of finding form for a woman

ruler could be in the seventeenth century, since conventions ruling portraiture in this patriarchal society were based on the cultural assumption that women were subjugated.

6. *Encyclopédie, ou Dictionnaire raisonné des sciences, des arts et des métiers*, s.v. 'Christine (Histoire de Suède)', t. VII, 852.

7. Susanna Akerman, *Queen Christina of Sweden And Her Circle The Transformation of a Seventeenth-Century Philosophical Libertine* (Leiden, New York, Kobenhavn, Köln: E. J. Brill, 1991), 302.

8. Letter of 9 June 1747, *Ungedruckte Briefe*, II: 43. Also letter of 14 July 1752 to her mother, *Ungedruckte Briefe*, II: 306:

> Peut-être que mes suffrages pourront paraître suspects à votre majesté, mais je ne puis nier que je ne puis assez remercier Dieu de mon bonheur, et que je ne troquerais pas mon sort pour tout l'empire du monde, tous les autres chagrins et désagréments n'étant point à mettre en comparaison aux agréments que je trouve dans la vie domestique.

9. Lovisa Ulrike was a Calvinist who converted to the Lutheran faith as part of her marriage contract.

10. See Theodor Schieder, *Frederick the Great*, ed. and trans. Sabina Berkeley and H. M. Scott (London and New York: Longman, 2000), 248. Also *Enlightened Absolutism: Reform and Reformers in Later Eighteenth-Century Europe*, ed. H. M. Scott (Ann Arbor: University of Michigan Press, 1990), especially the Introduction by Scott, 'Introduction: The Problem of Enlightened Absolutism', 1–35, and T. C. W. Blanning, 'Frederick the Great and Enlightened Absolutism', 265–88.

11. 'Je suis philosophe ou du moins je tache à le devenir,' wrote Lovisa Ulrike, in a letter to Wilhelm, her brother, dating from 1751. See *Ungedruckte Briefe*, II: 247. Ibid., I: 300, to Amalie, August 1746: 'Je vis philosophiquement, et mes amusements sont la lecture, l'ouvrage et mes bâtiments.' For another example, see I: 327, 25 Novembre 1746, to her mother:

> Je vis ici en philosophe, loin des plaisirs bruyants, n'en ayant d'autres que ceux que la lecture me procure. J'ai taché de me faire une raison (et j'ose dire que j'y ai assez bien réussi) que, quand les temps et les circonstances ne nous permetttent point de certains agréments, de savoir s'en passer et d'en chercher d'autres.

Ibid., II: 108, 21 May 1748, to her sister Amalie: 'Je suis dans mon chez-moi à Drottningholm comme un philosophe.'

12. 'Philosophique,' in *Encyclopédie, ou dictionnaire raisonné* (Neufchastel: Chez Samuel Fautche & Co., 1765), t. 12, 515.

13. Letter 25 November 1746, *Ungedruckte Briefe*, I: 327:

> Ensuite succèdent l'ouvrage et la lecture, qui est le Traité de l'Opinion. J'avais eu l'honneur de le lire en présence de ma chère Maman à Wusterhausen, et les idées qui m'en étaient restées m'inspirèrent l'envie de le lire de nouveau. Il est écrit avec tout l'esprit imaginable et tout propre à donner une idée superficielle des sciences, ce qui est tout ce qu'une femme doit savoir …

The full reference for the work in question is Gilbert Charles Le Gendre, marquis de Saint-Aubin-sur-Loire, *Traité de l'opinion, ou, Memoires pour servir à l'histoire de l'esprit humain*, 6 vols (Paris: Chez Briasson, 1733).

14. Frederick of Prussia, *The Refutation of Machiavelli's Prince or Anti-Machiavel*, introduction, trans. and notes by Paul Sonnino (Athens: Ohio University Press, 1981), 73.

15. Ibid., 106. These ideas owe a large debt to the cameralists. See Isabel V. Hull, *Sexuality, State, and Civil Society in Germany, 1700–1815* (Ithaca and London: Cornell University Press, 1996), chapter 4, 'The Cameralist Theory of Civil Society.'

16. Theodore K. Rabb, 'Politics and the Arts in the Age of Christina,' in *Politics and Culture in the Age of Christina*, ed. Marie-Louise Rodén (Stockholm: Svenska instituteti Rom, 1997), 10–11.

17. Lovisa Ulrike articulates this very distinctly, when she muses about the appeal her paintings hold for her: 'Il me semble que, quand on est seule, c'est une compagnie [referring to her paintings] qui amuse toujours ...', in a letter of 12 December 1747, to her mother, *Ungedruckte Briefe*, II: 88. Or again on 7 January 1749: 'On a bien de la peine a se refuser le plaisir d'avoir des tableaux. C'est un amusement quand on est en solitude. On y retrouve toujours de nouvelles beautés ...'. See *Ungedruckte Briefe*, II: 151. See also the important article by Merit Laine on this subject, 'An Eighteenth-Century Minerva: Lovisa Ulrika and her Collections at Drottningholm Palace 1744–1777,' *Eighteenth-Century Studies* 31, 4 (Summer 1998), 493–503. Laine takes a long view of Drottningholm, whereas my focus is very narrow here, that is, the mid-1740s.

18. Letter to Frederick, 5 December 1747, *Ungedruckte Briefe*, II: 85. Frederick's public representation, we do well to remember, was a Janus face: the side of the *philosophe* balanced by the fiercely combative commander in chief of the Prussian army. When he was not living *en philosophe*, he was invading Silesia or engaging in other military exploits. On representation in the private domain, see Vogtherr's interesting article exploring the topic of homosexuality and Frederick as a collector and patron: Christoph Martin Vogtherr, 'Absent Love in Pleasure Houses. Frederick II of Prussia as art collector and patron,' *Art History* (2001), 231–46.

19. Marie-Christine Skuncke, for instance, assesses Lovisa Ulrike's involvement in her son's education negatively. See her essay in *Le Soleil et l'Étoile du Nord; La France et la Suède au XVIIIe siècle*, exh. cat., Galeries Nationales du Grand Palais, 15 mars–13 juin 1994 (Paris: Réunion des Musées Nationaux, 1994), 277–82; also see Marie-Christine Skuncke, *Gustaf III, det offentliga barnet: en prins retoriska och politiska fostran* (Stockholm: Atlantis, *c*. 1993), abstract in French, 327–31.

20. 'Conflicted musings' is a phrase borrowed from Jean DeJean's perceptive analysis of Montesquieu's thought in *Ancients Against Moderns: Culture Wars and the Making of a Fin de Siècle* (Chicago and London: University of Chicago Press, 1997), 76.

21. It is noteworthy that Lovisa Ulrike did not limit her pedagogical projects to the domestic sphere. Emulating Madame de Maintenon, she took up a venture at this time modeled on Saint-Cyr, Madame de Maintenon's school for the daughters of impoverished nobles. By December 1747, 63 poor but well-born girls were enrolled at Lovisa Ulrike's institute at Wadstena, where they received food, lodging and education at state expense. Lovisa Ulrike to her mother, letter dated 16 May 1747, *Ungedruckte Briefe*, II: 35 and Lovisa Ulrike to Frederick, letter dated 26 December 1747, *Ungedruckte Briefe*, II: 90.

22. Although her article does not mention Lovisa Ulrike, Snoep-Reitsma identified

Rollin with the words *'douce et insinuante'* in her important iconographical study of Chardin's imagery. See Ella Snoep-Reitsma, 'Chardin and the Bourgeois Ideals of his Time,' *Nederlands Kunsthistorish Jaarboek*, XXIV (1973), 185.

23. Rollin was so admired by Frederick, in fact, that he invited him to come to Berlin. See Charles Rollin, *Opuscules de feu M. Rollin* (Paris: Frères Estienne, 1771), I: 83. In 1740, Rollin sent him a copy of his *Traité des Études*. During those years, Lovisa Ulrike was still at the Prussian court. After her marriage, she writes to her sister: 'Ayez la grâce, chère Lili, de vous informer s'il y a plus de neuf tomes à l'Histoire romaine par Rollin? Je ne l'ai jusqu'au neuvième; s'il s'en trouvait de plus, envoyez-les moi.' Letter of 5 October 1745, *Ungedruckte Briefe*, I: 234. There were 16 volumes in the series.

24. I quote from the 1735 English translation. The French version reads:

> Le soin de l'éducation des enfans jusqu'à l'âge dont nous parlons, roule principalement sur elles, & fait partie de ce petit empire domestique que la providence leur a spécialement assigné. Leur douceur naturelle, leurs manières insinuantes, si elles savoient y joindre une autorité douce mais ferme, les mettent en état d'instruire avec succès leur enfans.

See Rollin, *De la Manière*, 13. As on indication of the common critical purchase shared by these texts, in 1737, an edition of Locke's educational treatise bound with an English translation of Rollin's *New Thoughts Concerning Education* appeared.

25. Ibid., 6. Marcel Grandière describes this book by Rollin as one that would open the way to an education more concerned with method than Christian values. Thus its impact on the eighteenth century was enormous. Grandière also discusses Locke's influence on Rollin, one that Rollin actually acknowledged. See Marcel Grandière, *L'Idéal pédagogique en France au dix-huitième siècle* (Oxford: Voltaire Foundation, 1998), 57–62.

26. The first in a four-part allegorical series depicting the different ages of a man's life. Nicolas Guérard (d. 1719) belonged to a dynasty of master printmakers and dealers who marketed their prints on rue Saint Jacques in the seventeenth and eighteenth centuries. The date given here, 1694 or 1699, is a manuscript date inscribed by a curator in the Cabinet des Estampes, B.N.F.

27. *Mercure de France*, October 1741, 2167. Also see Grandière's *L'Idéal pédagogique* on the significance of Dumas's method, 93–100. At the court of Versailles, the Bureau was used by the dauphin and mesdames. See the *Mercure de France*, April 1732, 731.

28. *Mercure de France*, May 1731, 1022.

29. *Mercure de France*, March 1740, 469.

30. *Mercure de France*, June 1732, 1302.

31. Lovisa Ulrike to her mother, letter dated 27 June 1752, *Ungedruckte Briefe*, II: 303:

> Toutes ses études se font en ma présence, et je vois qu'il commence à profiter beaucoup. Je ne sais si la méthode que je fais observer pourra réussir, mais c'est qu'en raisonnant qu'on lui apprend l'histoire, la géographie et la théologie. Rien ne charge sa mémoire, croyant que, d'apprendre beaucoup par coeur, fait une étude machinale sans aucun jugement …

32. *Mercure de France*, January 1731, 40.

33. *Mercure de France*, November 1738, 2399.
34. Christine Théré's study of women authors in the eighteenth century who wrote about economics and demographics reveals that Lovisa Ulrike's identification with the pedagogical function of mothers after Gustav's birth is consistent with progressive feminist preoccupations of the time. See Christine Théré, 'Women and Birth Control in Eighteenth-Century France', *Eighteenth-Century Studies* 32, 4 (Summer 1999), 560. Also see Christine Théré, 'Economic Publishing and Authors, 1566–1789', in *Studies in the History of French Political Economy: From Boden to Walrus*, ed. G. Faccarelle (London: Routledge, 1998), 1–56.
35. Letter to her mother 10 February 1756, *Ungedruckte Briefe*, II: 394: 'J'ai eu beaucoup de chagrin à l'égard de l'éducation. Je me suis opposée au comte Tessin, qui n'avait rien moins en vue que d'en faire un prince éclairé, et qui m'a suggéré tous les désagréments imaginables.' Unfortunately she does not spell out exactly how her own educational objectives differ from Tessin's contemptible 'enlightened prince'. I do not mean to imply that Lovisa Ulrika banished the rod completely from her notion of 'good education'. She was determined to bring up Gustav as a Prussian: 'Je l'élèverai à la prussienne, si Dieu lui prête vie, et j'espère qu'il sera un brave homme.' This is cited in Oscar Gustaf von Heidenstam, *Une Soeur du Grand Frédéric, Louise-Ulrique, Reine de Suède* (Paris: Plon, 1897), 105, and see also 102.
36. See Michael Baxandall, *Patterns of Intention: On the Historical Explanation of Pictures* (New Haven and London: Yale University Press, 1986), 74–5, whose language I am borrowing here. I have profited greatly from Baxandall's analysis of the relation between 'vulgar Lockeanism and vision' and an eighteenth-century 'affinity' for Chardin's representations. Though I move in a different direction with the vulgar Lockeanism, Baxandall's book lies behind this essay in a myriad of ways.
37. Although known primarily to art historians as a Francophile and enthusiast of French art, Tessin was a dominant player in Swedish politics from 1739 to 1752, becoming the elected Marshal of the Diet and then Chancery-President. Between 1745 and 1749, he and Lovisa Ulrike were close allies, though after he became Gustav's governor, they would have a spectacular falling-out over the boy's education.
38. The commission is well documented in numerous published sources. For example, the relevant passages are excerpted and reprinted in the Appendix of Pierre Rosenberg, *Chardin (1699–1779)*, exh. cat., 1979 (Cleveland: The Cleveland Museum of Art in cooperation with Indiana University Press, 1979), 386–9.
39. Letter to her mother, 31 May 1746, *Ungedruckte Briefe*, I: 283:

> Je fais bâtir aussi deux galeries, qui seront ornées de tableaux que j'ai fait venir de Paris. C'est Boucher et Chardin qui en sont les maîtres. J'ai donné pour sujet au premier "Les quatre heures du jour" et à l'autre L'éducation sévère et l'éducation douce et insinuant. Ils doivent arriver incessamment. Ma très chère Maman a beaucoup d'estampes tirées d'après les originaux de ces deux peintres.

40. Print collections furnished an important visual resource for women as well as men wishing to develop their expertise about art during the eighteenth century. For example, Lovisa Ulrike writes to Amalie: 'Le goût pour les estampes encore dure, et j'en fais venir de Paris.' See *Ungedruckte Briefe*, II: 157. In her letters, Lovisa Ulrike speaks knowledgably about the Old Masters, occasionally refer-

ring to a print in her mother's collection as a reference. For instance, she writes to her mother: 'J'en ai reçu un nouvellement qui est un Wouverman. Ma chère Maman en a l'estampe dans son recueil.' See *Ungedruckte Briefe*, II: 150. She adds: 'Il est original, puisqu'il est acheté du même cabinet dont l'estampe a été gravée ... ' Or again: 'un magnifique tableau de Le Moyne dont vous avec vu l'estampe.' See *Ungedruckte Briefe*, II: 140. In addition to the prints, Lovisa Ulrike also had some first-hand knowledge of paintings by Chardin. She was at leisure to examine Chardin's masterpiece, *Le Négligé* in the collection of Carl-Gustaf Tessin, as well as painted studio replicas of *La mère laborieuse* and *Le bénédicté*, all commissioned directly from the artist by Tessin in Paris. In May of 1745, Lovisa Ulrike's husband, Adolf Fredrik, purchased a number of paintings by Chardin at the sale of Antoine La Roque's collection in Paris – *La blanchisseuse*, *La fontaine*, *L'ouvrière en tapisserie* and *Le dessinateur*, though these paintings probably arrived in Sweden many months after Lovisa Ulrike had formulated her subject for the artist.

41. Does the fact that Chardin began a representation with one intention and finished it with another invalidate my line of inquiry? I think not. Contingency often intrudes into the artistic process. A good example is Jean-Jacques de Boissieu's etching of 1796, *Self portrait Holding a Portrait of His Wife* (Los Angeles County Museum of Art). In the self-portrait, the artist depicts himself holding a copperplate displaying a profile portrait of his wife. While he was working on the print, his wife died and in the fifth state of the etching, he substituted a landscape for her portrait. Obviously the notion of a unitary 'intention' fails to explain the meaning of Boissieu's print. How the artist deals with accident, adjusting it to the expressive logic of the representation and thereby elaborating new, unexpected meanings is what interests me about Chardin's pictures for Lovisa Ulrike, although space prevents me from analyzing them in this essay. Today *Amusemens de la vie privée* and *L'Économe* belong to the collection of the Swedish National Art Museum, Stockholm. The general consensus about the last two paintings is that they are lost, although there is some debate about this. Works by those titles in The Museum of Fine Arts, Houston and the Tokyo Fuji Art Museum Collection, Tokyo are thought to be studio copies by Chardin painted for La Live de Jully and exhibited in 1753. Did Lovisa Ulrike like the pictures? When Chardin's *Amusemens de la vie privée* and *L'Économe* finally arrived in Sweden, we get a sense of her reaction via Tessin's exclamation: 'They are to kneel before ... ', or as American slang would put it, 'to die for': 'Les tableaux de Chardin sont à se mettre a genoux devant ... ' (letter 6 June 1747, excerpts in Rosenberg, *Chardin*, 388). And as Tessin puts it in the letter, because desire begets more desire, the princess wished to commission two more canvases from Chardin; her reaction to these last two, which included Chardin's formulation of a 'good' education, is not recorded. This particular model of patronage, which resembles a conversation more than a contract, also evidently guided Lovisa Ulrike's interactions with Boucher. Her commission for Boucher, which he had also received in 1745, had been to picture an allegorical series representing the four times of day. However, after producing one canvas, an elaboration on the theme 'Morning' (*The Milliner*, in Stockholm, Swedish National Art Museum), Boucher proposed to fulfill the terms of the agreement by a single canvas portraying the princess in her apartment gazing at her own portrait displayed by a painter seated in front of his easel. On the Boucher commission, see Scheffer's letter dated 21 August

1750; Scheffer, *Lettres particulières*, 214–16. Parenthetically, Lovisa Ulrike commissioned a few works from other artists, too. In September 1744, she asks her sister Amalie to convey a commission to Antoine Pesne, painter to the Prussian court at Berlin, asking him to draw 'une tête en crayon et une autre pièce de fantaisie dans le goût de Watteau', which she planned to present as a gift to Tessin 'puisqu'il a une collection des plus fameux peintres dans ce genre'. See *Ungedruckte Briefe*, I: 80. In December 1749, she also commissioned pendants from Pesne on the subject of Youth and Old Age. See *Ungedruckte Briefe*, II: 205.

42. Letter to Amalie, 25 November 1748, *Ungedruckte Briefe*, II: 140.

43. Both brother and sister are competing for the same class of collectible objects to install in their private retreats at this time. Frederick began the construction of the palace of Sans Souci in Potsdam in 1745. Especially in the 1740s, he is an enthusiast of French eighteenth-century art, particularly the work of Watteau and Lancret. During the same decade, Lovisa Ulrike remodeled portions of Drottningholm palace to form two galleries for art works. These she intended to fill with paintings of the modern French school.

44. A practice followed by another celebrated woman patron of the eighteenth century, Marie-Thérèse Geoffrin. On Madame Geoffrin as a patron, see chapter 2 in Paula Rea Radisich, *Hubert Robert: Painted Spaces of the Enlightenment* (Cambridge: Cambridge University Press, 1998).

45. This study reveals how the vision of 'good' education embodied in Chardin's 1749 representation, *La bonne éducation*, is markedly conservative, extolling the virtues of memorization, passive learning and religious values. The 1749 canvas was never exhibited, but the replica, presumably belonging to La Live de Jully, was described in the Salon *livret* of 1753 as 'une jeune Fille qui récite son Évangile', thus identifying the book depicted in the painting.

Practicing Portraiture: Mademoiselle de Clermont and J.-M. Nattier

Kathleen Nicholson

Two portraits of Marie-Anne de Bourbon-Condé, Mademoiselle de Clermont, painted by Jean-Marc Nattier (1685–1766) in the first third of the eighteenth century provide a useful window onto the complicated dynamics of female patronage and artistic response in that era (Figures 4.1 and 4.2). Despite the absence of written programs or explanatory contracts for *Mademoiselle de Clermont at the Mineral Springs of Chantilly*, 1729, and *Mademoiselle de Clermont as a Sultan after her Bath, with her Servants*, 1733, the novel thematics and presentation of the sitter in each work make it clear that this patron knew what she wanted and that her artist rose to the challenge hand-somely. In particular the paintings demonstrate the canny ways that a public identity – and traditions in portraiture – could be amended or reconfigured to serve one's social persona. In the first of the two works, we can measure the degree to which a portrait type was adapted by and for an individual to clarify and control notions about her place in the social order. The second painting is a demonstration piece of identity formation itself. A bold or even risky experiment in women's self-presentation, it provides insight into the very notion of the individual being articulated at the time.

Throughout the first half of the eighteenth century in France, portraiture, whether painted, sculpted, or verbal, served as a vital form of social currency with extraordinarily wide circulation. Indeed, it is useful to think about the person in French courtly society *as* portraiture: a set of images publicly constructed through a continual process of scrutiny, description and discussion. One important aspect of this economy was women's ready access to it. They commissioned portraits in much the same way as they ordered fine dresses or jewelry – often with complete authority, and frequently for smaller sums than those paid for clothing or ornaments. But then portraiture was a

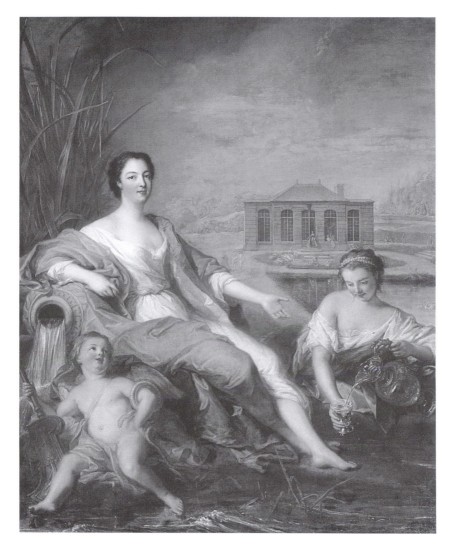

Fig. 4.1: Jean-Marc Nattier, *Mademoiselle de Clermont at the Mineral Springs of Chantilly*, 195 × 161 cm, oil on canvas, 1729, Chantilly, Musée Condé (Réunion des Musées Nationaux/Art Resource, NY)

bargain in more ways than one. It was a longstanding custom to give portraits as gifts. They were often quite portable, literally traveling when or where one could not to provide a reassuring 'presence' or make a critical first impression. And portraits could project a desired version of the self or counter an unflattering one already in circulation. Within the artistic academy and for

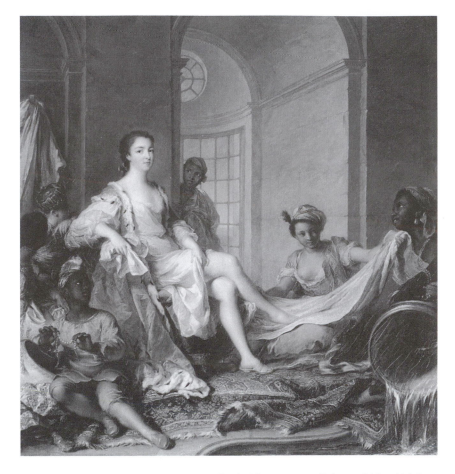

Fig. 4.2: Jean-Marc Nattier, *Mademoiselle de Clermont as a Sultana*, 109 × 104.5 cm, oil on canvas, 1733, London, Wallace Art Collection (Reproduced by permission of the Trustees of the Wallace Collection, London)

critics beginning at mid-century, these factors, and especially women's close association with portraiture, justified a lower ranking for the genre in the official hierarchy. But surely this was no more than envy over the secure and valued place portraiture enjoyed within the social landscape.

For individuals at the apex of French aristocratic society such as Mademoiselle de Clermont, portraiture was an obligation of rank, playing a crucial role in dynastic record keeping and the ongoing promotion of family prestige. A granddaughter of Louis XIV and descendant of the Grand Condé, Mademoiselle de Clermont was a *princesse de sang* – a princess of royal blood – born in 1697 to Louis III de Bourbon and Mademoiselle de Nantes, eldest

daughter of Madame de Montespan. She formally entered court society in 1710 at the age of thirteen, the same year her father died. On the occasion of the young girl's presentation to her grandfather, court gossips appraised her as 'assez petite, mais parfaitement belle.'[1] She distinguished herself through qualities beyond her beauty, however. According to one memoir, Anne de Bavière, mother of the duchesse de Maine, quickly took Mademoiselle de Clermont under her wing so that she might receive a better education than was ordinarily the case with French princesses, her tutelage including history and 'several other things suitable for her rank and sex.'[2]

Growing into young womanhood, Mademoiselle de Clermont took lessons in clavecin, guitar, dancing and singing, arts that no doubt fell into the 'suitable' category for refined young women. She learned the proper etiquette and formalities of ceremonial life at court mandated by her lineage. While she kept relatively close company with her illustrious mother, she spent noticeably less time in her younger years with her libertine older sister, Louise-Anne, Mademoiselle de Charolais. Mademoiselle de Clermont remained unmarried and, judging from the absence of contemporary gossip, unattached, despite the fantasizing of novelist Madame de Genlis at the beginning of the nineteenth century.[3] She appears to have been the *sage* daughter in the family. The dearth of suitably high-ranking potential bridegrooms and the absence of a father to broker what would have been a politically important alliance best explain her unmarried status.[4]

When her older brother, the duc de Bourbon, assumed the position of prime minister for the young Louis XV, he provided his sister with what could fairly be called a career. In April 1724, he appointed the 27-year-old Mademoiselle de Clermont to a position roughly equivalent to chief of staff for the as yet unnamed future queen. She would hold this highly visible, remunerated role as *Surintendante de la Maison de la Reine* until her death in 1741 at age 44. Ever a princess of the highest rank, she nonetheless continued to spend time with family members at Chantilly and maintained residences of her own as well. Mademoiselle de Clermont therefore had the personal independence, status and financial means to exercise her will and her discrimination, most certainly with regard to the material objects in her life.

Her formation as a patron can be assessed through signed account books that cover the years 1716 to 1730. Typically such financial records provide access to one's most intimate life. Hers record with equanimity expenditures for everything from candles (a constant and costly entry) to saddles to works of art. The princess's complicated household required payments to her staff (she had her own *dame d'honneur* and a chef worth tipping); a sizable investment in a particularly large or exceedingly expensive silver service; recurring orders for fine furniture; the purchase of quantities of wine; and for future reference, a commission from 'Briot chaudronnier' for a relatively

expensive copper bathtub.[5] She also paid her various singing and music masters, made annual contributions in support of, or for a subscription to, the *Mercure de France*, and she acquired books for a library in the tradition of her well-read mother, complete with her own coat of arms on their covers.[6]

Mademoiselle de Clermont also commissioned works of art, the preponderance of which, not surprisingly, were portraits.[7] They filled her immediate physical environment, whether at Chantilly, her mother's residence (the Palais Bourbon) or the Petit Luxembourg, the palace ceded to Mademoiselle de Clermont in 1735. As its name implies, the 'Portrait Room' of the Petit Luxembourg contained numerous images of family members and assorted royals. Still more (31!) were stacked in a storeroom, including two unframed portraits of Mademoiselle de Clermont.[8] Like all members of the court, she had been raised having her portrait made and remade according to changing fashion and her own developing taste.

Shortly after her formal introduction at Versailles, Mademoiselle de Clermont's 'image' circulated in a stock celebrity 'portrait' engraving of the sort popular since the seventeenth century. Virtually identical to fashion prints, it depicts a generic young aristocrat modelling an elaborate dress.[9] Only the letterpress beneath the image 'identifies' the subject as Mademoiselle de Clermont, as well as provides (indiscreetly?) her date of birth. In 1717, she was painted by Jean-Baptiste Santerre as a blossoming young woman, the portrait figuring among the last works by the artist before his death.[10] Mademoiselle de Clermont twice employed Pierre Gobert, who had also painted her mother in the last years of the seventeenth and first decade of the eighteenth centuries.[11] Mother and daughter had their portraits done by Rosalba Carriera when the Italian pastellist was all the rage in Paris in 1721. Mademoiselle de Clermont later hired the Swedish pastellist, Gustave Lundberg, to either copy the Rosalba portrait or to produce a version of his own.[12] She appeared allegorically as Sainte Geneviève in one oil and as a pert pilgrim in another, complete with St Jacques de Compostelle shell decorations.[13] In 1728 she paid an unnamed miniaturist for still another portrait of herself.[14]

Although the pastel by Rosalba Carriera was made at the instigation, or rather insistence, of Mademoiselle de Clermont's mother, its short history, recounted partly between the lines in the artist's terse diary, provides a fascinating insight into the perquisites of aristocratic patronage in early eighteenth-century France. The overly subscribed artist had already turned down requests for portraits during her Paris sojourn when she received not one, but two inquiries about her availability for a possible pastel of Mademoiselle de Clermont. Given this highly placed pressure, Rosalba not only relented; she went, unusually, (or was summoned?) to Mademoiselle de Nantes's residence to have an initial look at the daughter. Subsequent sittings and exceptional visits ensued. Mother and daughter, accompanied by a

retinue of duchesses, princes and assorted 'Messieurs', invaded Rosalba's studio space.[15] The beleaguered artist could hardly work quickly enough for the demanding mother. Mademoiselle de Nantes returned just three days after the portrait was begun, and then again on the fourth, to speed its progress. Whatever relief Rosalba might have felt at finishing the work would alas be marred by its sorry fate. The pastel was badly damaged in an unspecified accident, causing the 'grand déplaisir' of Mademoiselle de Clermont's mother and rendering ill the person who caused 'ce malheur', one Monsieur de Lace.[16]

While Mademoiselle de Clermont was of course the subject of all the fuss in this instance, rather than its agent, she certainly would have learned yet another a critical lesson about the privileges of patronage from the affair. When she commissioned Jean-Marc Nattier (*c*. 1729) to paint what would become a substantial image of herself, she was therefore as practiced in the art of portraiture as was he. It seems self-evident that she would have known what to expect and demand from the encounter. I am responding here to an art-historical logic embedded in the study of portraiture: a focus on the artist, who is often the better-known quantity in the portraitist/sitter equation. Such is certainly the case of Nattier, one of the most fashionable and prolific *ancien régime* painters specializing in portraits. His large body of work, initially catalogued in the early years of the twentieth century, was reviewed and reorganized in a long overdue exhibition at Versailles in 1999–2000 curated by Xavier Salmon.[17] While the show and the catalogue usefully sort out Nattier's complicated *œuvre* and track his under-appreciated development, these tasks engender a narrative of artistic creativity and an attendant rhetoric that precisely overlooks the role of the sitter.

We learn from the catalogue entry for the 1729 portrait of Mademoiselle de Clermont as the goddess of mineral waters that Nattier opted for one of the ambitious compositions on which he hoped to build his reputation. The text then switches briefly to the painting as agent: 'By its imposing dimensions and its allegorical character, the work sought to rival history painting.'[18] In the narrative Nattier returns as an artist capable of breaking with seventeenth-century allegorical portrait traditions through his introduction of a modern setting as the backdrop for Mademoiselle de Clermont.[19] Established conventions placed female sitters on a throne or in a cloud bank under the pretext of further ennobling them, a tactic employed by Nattier's father and subsequently the son in any number of his later female portraits.

While artists are entitled to such accounts that situate their artistic endeavors within the larger history of art, this approach in Nattier's case elicits several points by way of response on Mademoiselle de Clermont's behalf. First, practically the only two fully allegorical portraits of women in Nattier's *œuvre* that can make a claim for the paradoxical introduction of modernity that

Salmon notes are, tellingly, the two that depict Mademoiselle de Clermont. Second, the circumstances of the commission put Nattier in service to his sitter. He was summoned to Chantilly; Mademoiselle de Clermont did not displace herself to sit for him. One still approaches such châteaux with awe and even a little trepidation. And third, as has already been suggested, by 1729 at the then venerable age of 31 years, Mademoiselle de Clermont surely had her own ideas and her own agenda for this new portrait and for the kind of work it might be expected to do for *her* career.

For she was no ordinary princess, after all. Mademoiselle de Clermont lived her life in the eighteenth-century royal equivalent of the 'public' eye not only through her position as *Surintendante* to the queen, Marie Leczynska and as a frequent companion to her younger cousin once removed, Louis XV, but also as a highly visible representative of the Bourbon-Condés. In her case, appearance(s) always mattered. From early childhood Mademoiselle de Clermont had had to master the protocols of aristocratic comportment practiced at the various family and royal rites and funerals she attended. She must have enacted them with sufficient decorum to take on the somewhat numbing duties of *Surintendante*.[20] For example, only Mademoiselle de Clermont could hold the ceremonial napkin for the queen when she took Holy Communion, which was frequently. Only she could be in physical proximity to serve the queen as she neared childbirth (an equally frequent event). Her high rank demanded that she occupy the seat next to the queen in endless carriage rides. Mademoiselle de Clermont's most important responsibility in fact was to act as the queen designate in those ceremonies that Marie Leczynska herself could not or would not attend.

As a royal relative, Mademoiselle de Clermont had been in close contact with Louis XV since his childhood. She was present, for example, at Louis's first dinner in public. Through the period of his maturity and early mistresses, Mademoiselle de Clermont hosted suppers for the king at which political issues were sometimes discussed. She shifted her retinue from residence to residence for Louis's many hunting trips. He sought her out for strolls in his gardens when he needed calm, repose, and perhaps wise advice. She played her share of card and table games in the evenings with her sister, the king, and his current mistress, but her conduct remained unimpeachable. Indeed, she was exceptional for having survived the Regency as well as the first seventeen years of Louis XV's reign without capturing much attention from the journal and memoir writers. This was in sharp contrast to her politically controversial older brother, her notorious older sister, or her two libertine younger brothers. In the estimation of one contemporary, she was the Bourbon-Condé who combined 'real beauty with nobility, sweetness and modesty which distinguished her … she remained unassailed by slander and was always admired by the whole court for her wisdom and her virtue.'[21]

Well, almost the entire court. At her death, the duc de Luynes, the most assiduous of the memoir writers, described her somewhat less charitably: 'She was well mannered, had *esprit*, but of an unusual coldness, seeming not to care about anyone. She demonstrated this indifference even toward herself.' He closed with one last *de rigueur* refrain about her person: 'She had been perfectly beautiful, and still was.'[22] The aloofness or reserve upon which the duc de Luynes remarked no doubt came partly through the eyes of his wife, who, as a mere duchess and *dame d'honneur*, on occasion found herself subject to blood-royal prerogatives. The princess's affectlessness would also have been engrained by the exigencies of protocol. Reading about her duties at a royal funeral – an elaborate performance that required the regally gowned princess to sprinkle the deceased with holy water (one of the tasks from which the queen chose to absent herself) – one readily envisions a stately, dignified woman whose practiced decorum could easily project a corresponding lack of personal warmth. At least no one appears to have registered her affect as boredom, though the princess might reasonably have been entitled to it. That she understood verbal assessments of her remoteness, undoubtedly made during her life as well, as socially constructed, reiterated and circulated versions of a public self that she might want to counter seems the case given the two portraits of her painted by Nattier.

In selecting Nattier for a major commission rather than Pierre Gobert, the late seventeenth-century aristocrat's portraitist of choice, Mademoiselle de Clermont demonstrated her willingness to experiment. True, Nattier's father had painted for the Bourbon-Condés, including an allegorical portrait of Mademoiselle de Clermont's mother. And by 1729 Nattier *fils* would have acquired sufficient credentials of his own, as well as some cachet. Over a decade earlier he had produced competent formal portraits of Peter the Great and Catherine the First (1717) as well as imposing allegorized portraits of the maréchal de Saxe (1720) and, more recently, James Fitz-James, duke of Berwick (1723). The artist had lately branched out to handsome, informal images of aristocratic men posing after the hunt with dogs, guns and quarry on display in smaller formats. But Nattier had not yet faced the challenge of depicting a woman of Mademoiselle de Clermont's rank or position in France, nor had he done more than sketch out a formula for idealizing his female sitters that would subsequently secure his position at the court of Louis XV.

Had Mademoiselle de Clermont wanted to identify herself with other fashionable tastemakers, she might instead have hired Charles Coypel, who, in the early 1720s, painted the imposing full-length portrait that still hangs at Vaux-le-Vicomte of the maréchale de Villars, beloved younger wife of the château's second owner (Figure 4.3). Jeanne Angélique Roques de Varengeville, celebrated (only) for her beauty, was portrayed out of doors, playing an impressive lute or theribo. Charming *putti* attend and compliment her with

Fig. 4.3: Charles Coypel, *Portrait of Jeanne Angélique Roques de Varengeville, la maréchale de Villars*, 300 × 205 cm, oil on canvas, ca.1720–25, Collection Château de Vaux-le-Vicomte

garlands and a bouquet of flowers. Her music has entranced a golden-haired Apollo who listens raptly, as well as tamed a leopard (at the far right) and Cybele's lion, on which the marechale rests a tenderly licked foot. The portrait as a whole exudes a warm sensuality, its elaboration overwhelming and enchanting the viewer much as the fabled Jeanne Angélique's allure was reputed to win the hearts of men, including Voltaire's.[23] Such rococo languor and complication would not have accorded with what we know of Mademoiselle de Clermont, however *belle* she too may have been. For her initial portrait, she chose to show herself as commanding respect, not adulation, an end to which Nattier's more restrained repertory of the mid- to later 1720s was in fact perfectly suited.[24]

Mademoiselle de Clermont's account books reveal that she paid Nattier a total of 1800 *livres* for the painting between May and September of 1729, and an additional 149 for his travel expenses.[25] While this amount is roughly equivalent to her expenditures on fabric during the same period, it is relatively high for a portrait by an artist who had not yet received royal commissions. In the period between 1721 and 1727, portraitists Gobert, Simon Belle and J. B. van Loo had been paid sums in the vicinity of 500–800 *livres* by the Crown, though a high-end state portrait of Louis XV could reach 5,500 *livres* (paid to Parrocel, in 1725).[26] The largest sum Mademoiselle de Clermont had previously spent on a portrait was 700 *livres* paid to Gobert in 1722. If money speaks, it suggests she expected a significant work of art from Nattier.

Mademoiselle de Clermont definitely got her money's worth. Nattier produced a commanding image, approximately 6 ft × 5 ft (195 × 161 cm), that displayed the princess as the presiding 'goddess' of newly plumbed mineral waters on the grounds of Chantilly.[27] Recent improvements carried out by her older brother, the duc de Bourbon, had included the building of the château's famed stables, tennis court, and the pavilion for pumping iron-rich water prominently depicted at the end of a formal *bassin* in the far-right background of the portrait. Mademoiselle de Clermont is seated gracefully, indeed even regally in the foreground, in a more natural setting at the edge of a river or pond. In the lower foreground water gently splashes and foams against stones along the shore. Short reeds spring up below and tall ones behind the princess. To the right a fetching maidservant, to whom she gestures, pours sparkling water from a crystal ewer into a goblet situated just above the princess's comely bared feet. One can envision this goddess dipping a toe into water, but never submitting to the feline ministrations in Coypel's portrait of the maréchale de Villars. Mademoiselle de Clermont rests her bent arm on yet another water source, an ornate urn at the left from which water spills. Just one glowingly healthy *putto*, seated beneath the urn and entrusted with a ceremonial rudder and a winding snake, completes the foreground scene.

To give Nattier his artistic due, if the setting and occasion commemorated in the painting depended on Mademoiselle de Clermont and Bourbon-Condé initiatives, the motif of a water goddess with an urn derived from an iconographic tradition in the visual arts that had already piqued his interest. On the verso of a detailed 1728 preparatory sketch for a hunting portrait of Alexandre Borisovitch Kourakine he had drawn a rough outline of a seated woman with an urn, reeds and rudder, three-quarter length in a tightly framed oval format.[28] This portrait type, a woman '*en source*', had been introduced into the repertory of allegorical portraiture in France at least a decade earlier. A characteristic example from the Circle of Largillière dated to 1718 has been identified as Elisabeth-Charlotte de Bavière, the Princess Palatine, shown seated on the ground beside the *de rigueur* spilling urn (Figure 4.4).

The conceit had devolved into women's portraits from mythological scenes such as the Ovidian tale of Pan and Syrinx. A seventeenth-century version of the story painted by Pierre Mignard (*c.* 1690) depicts Syrinx transformed into a spring in order to preserve her virginity, a metamorphosis that underscores women's elemental purity and embeddedness in nature. Her father, a river god, is positioned at the lower center of the composition with a flowing urn as *his* attribute.[29] Over the course of the seventeenth century dryads or female river goddesses that appear in history paintings or as part of sculptural programs for fountains not only acquired urns of their own, but would seem to have appropriated the attribute altogether. In turn they were supplanted by real women who had themselves portrayed allegorically in '*en source*' portraits.[30] The theme's continuing attraction for women through the 1750s must have resided in its suggestion of 'naturalness' (the outdoor setting signaling freedom from the exigencies of aristocratic life) and in the longstanding symbolic connections of birthing and/or fecundity with water.[31] In Nattier's own versions, the dark circle of the urn's mouth is consistently, if unconsciously, positioned to parallel the seated women's gently splaying pelvic regions (Figure 4.5). Tellingly, the '*en source*' persona in French eighteenth-century allegorical portraiture was adopted by young women either on the verge of marriage or recently wed, or by demonstrably older women such as the Princess Palatine, whose fertility, though proven, was long past. Nattier redeployed the motifs in rather less nuanced allegorical series of the elements to represent 'water' as well, as in his 1751 depiction of Madame Victoire, the daughter of Louis XV and Marie Leczynska.[32]

The '*en source*' portrait type (and even the stock allegory of water) underscores the degree to which the theme of water was rationalized, de-allegorized, and put to work in Mademoiselle de Clermont's portrait, indeed exceptionally so. And yes, the passive construction just employed is meant to suspend the question of agency, but only for the moment. While common sense would assume that the portrait endeavor was always a collaborative venture between artist and sitter, here the balance would seem to tilt towards the patron and her

Fig. 4.4: Circle of Largillière, *Portrait of Elisabeth Charlotte de Bavière, the Princess Palatine*, 65 × 54 cm, oil on canvas, 1718, Chantilly, Musée Condé (Erich Lessing/Art Resource, NY)

circumstances.[33] After all, Nattier had not yet painted an '*en source*' portrait – he had only sketched a quick idea for one before he encountered Mademoiselle de Clermont and Chantilly in all its impressive splendor. Nor had he included a factual rendering of someone's domain as part of a portrait's background (and would not in the future). It seems only logical, then, that the painting derived

Fig. 4.5: Jean-Marc Nattier, *Elisabeth de Flesselles en source*, 135.5 × 103 cm, oil on canvas, 1747, Princeton, University Art Museum

more from the requirements of its commissioner at this moment and from this place in her life than from any of the artistic gestures or ploys that Nattier could have brought to the project at this stage in his artistic career.

One of the chief charms of Chantilly's setting is that it is very much a waterscape, man-made and natural, as almost all earlier painted views of it emphasized. Mademoiselle de Clermont's portrait appropriately features an array of water sources: in *bassins*; as a refreshing drink being poured from the crystal ewer; flowing from the urn; lapping against the bank. Presumably the tiny figures in contemporary dress on the steps and parterre of the distant pavilion that Xavier Salmon signaled for their introduction of modernity have come to sample its mineral waters. Another modernizing note is the charming servant towards whom Mademoiselle de Clermont gestures. The former wears plausibly contemporary clothing, and despite her slipping neckline, she is less dryad than handmaid in the act of serving her mistress a beneficial libation.

The ostensible allegorical parts of the portrait, the urn and the *putto*, are clustered to the left in tactful counterpoint to the modern elements. Mademoiselle de Clermont's demonstrative gesture relates the two 'realms,' her upturned hand linking both sources of water to the all-important third, the pavilion where the actual spring was being tapped. While the water spilling from the urn is partially blocked from view by the placement of the *putto*, its connection to the body of water below further temporalizes the scene. This more natural flow is in distinction to the disconnected, symbolic streaming urns common to Nattier's later '*en source*' portraits. And even the *putto* is put to work in a more thoughtful way than its cousins in Coypel's portrait of the maréchale de Villars. The winding snake it holds – the traditional symbol of Aesculapius, god of medicine – appropriately certifies the proclaimed medicinal values of Chantilly's spring. The *putto*'s ceremonial gold rudder, though a traditional complement to a river god (or a king), here signals Mademoiselle de Clermont's rule over not only the queen's *maison*, but Chantilly as well.

In her portrait, Mademoiselle de Clermont presents herself as a gracious chatelaine or hostess, a role she would have performed during the annual summer visits of the court to Chantilly. While she was not the titular owner, as a Bourbon-Condé daughter and sister she belonged there, as did the painting, which would hang in the château until the Revolution. The imagery's thematic idiosyncrasies indeed are nuanced by Mademoiselle de Clermont's sense of herself as a member of such an illustrious family – if also as very much her own person. And the timing of a portrait commission asserting family affiliation could not have been more inspired. In 1726, her politically inept older brother had been stripped of his post as prime minister and was exiled to Chantilly for having incurred the wrath of Cardinal Fleury, and by extension, the young king.[34] His intensive building campaign, partly recorded in the portrait's background, was just so much compensation for his actual loss of power at court.

By contrast, Mademoiselle de Clermont's official place in the royal hierar-
chy as *Surintendante* remained secure, her reputation not tarnished by
association. But for that very reason, and against the backdrop of longstanding
rivalries with the Orléans side of the royal family tree, she took this opportu-
nity, through her portrait, to reaffirm allegiance to her Bourbon-Condé dynastic
heritage while also demonstrating her own dignified command and refine-
ment. It is probably worth noting that a more formal portrait of Mademoiselle
de Clermont that would or could have commemorated her appointment or
service as *Surintendante* does not seem to exist. Perhaps such an image has
simply disappeared without a trace. But in the absence of any indications in
the family or royal account books, it would seem that for posterity Mademoi-
selle de Clermont was first and foremost a Bourbon-Condé whose proper
domain was not Versailles but Chantilly.

For all the partisan show of Bourbon-Condé solidarity – and all that this
bloodline represented historically – Mademoiselle de Clermont at the same
time held herself aloof from the patriarchal shadings of her heritage. The
specific domain she claims for herself is in marked contrast to the second
feature of Chantilly's fame: its fabled hunting grounds and the attendant
bonhomie of her brothers and cousin Louis XV during his annual visits. The
interior spaces of the château, including the apartments decorated for Louis
XV's sojourns, were filled with lavish hunting and game trophy paintings
commissioned from Oudry and Desportes. Oudry's six-foot-square canvases
vividly depicted snarling hounds attacking wolves or foxes from all direc-
tions.[35] While Mademoiselle de Clermont hunted too, or at least rode to the
hunt with the women of the court, her absences noted in the written accounts
suggest she was not as much a devotée as her older sister. From the glimpses
one catches of her in the various memoirs, it appears that when left to her
own devices, Mademoiselle de Clermont preferred a quiet stroll through a
garden or a rare afternoon spent napping in a quiet glade.

Her portrait, then, counters the manly realm of the hunt and its painted
celebration of mayhem and death with an image of calm, restoration and
health. If the temptation is simply to see her domain as differently gendered, I
would argue that at least something useful or positive occurs in the space she
claims for herself. The pavilion for pumping water may have been her broth-
er's architectural accomplishment, but in promoting physical well-being or
the pleasures of pausing for a drink of pure, fresh water, Mademoiselle de
Clermont's painted persona declares herself to be a woman of infinitely good
sense. Even the tiny contemporary figures in front of the distant pavilion,
most of them women, by association seem engaged in more purposeful activ-
ity than their counterparts in painted *fête galantes*. And as much as
Mademoiselle de Clermont's assumption of divinity might tie her to the past,
her invitation to partake of healthful spring waters was, as it has turned out,

remarkably progressive. Her choice of subject-matter also anticipated the international vogue for the curative and sensuous pleasures of the great spas of Europe – popular because classes and nationalities could begin to commingle.[36] In her portrait, of course, the privileges of rank still obtain. At ease in her noble domain, Mademoiselle de Clermont is the very picture of purpose, authority and grace.

For Nattier, the complication of the portrait and its levels of Bourbon-Condé reference represented a creative stretch, the positive residue of which was his subsequent formulation of '*en source*' allegorical portraits. He would produce at least five for different clients between 1734 and the late 1740s, his followers still more. Alas, the conceit did not age well. By the late 1750s, when both allegorical portraits and the women who sat for them came under critical attack, Charles Nicolas Cochin could only see the sitters' pretense: 'Some of these women ... appear to take pleasure in leaning on pottery jars filled with water that they overturn, apparently, to water their gardens: which makes one believe that they take great interest in agriculture, and this is confirmed since in their [fanciful] clothing, they are always shown out in the countryside.'[37] No such frivolity obtained for Mademoiselle de Clermont in 1729, given the place and meanings of Chantilly in her image. And the exceptional nature of the commission for Nattier seems to be recorded in a small but revealing detail in the painting – the delicate reflection of the *putto*'s foot held out over the water in the bottom-left corner – an observation or flourish for which he never again seemed to have the time or inclination.

When patron and painter engaged in a creative rematch just a few years later, the result was the extraordinary portrait now in the Wallace Collection: *Mademoiselle de Clermont as a Sultana, after her bath, with her servants*, signed and dated 1733.[38] This work broke new ground for Mademoiselle de Clermont's self-assertion, since she appears not only as a woman of privilege and taste, but as someone confident of her sensuality and sexuality. In this latter respect Nattier was pushed into artistic territory for which he should have long ago received recognition. It seems reasonable to attribute to him the first true odalisque in Western art: Mademoiselle de Clermont's portrait is a grandmother to Gerard's fetching portrait of Mme Recamier, and great-great grandmother to Manet's *Olympia*. With her steady outward gaze, Mademoiselle de Clermont exhibits much the same panache as her artistic progeny, if less actual skin, though the bold show of bared legs and even some thigh is remarkable by earlier eighteenth-century standards for portraiture.

The painting's significance as an early example of European fascination with the exotic East, as well as its intersection with contemporary cultural discourse, are the topics of a future essay. The discussion of patronage here would be incomplete, however, without at least a brief account of this second

sitting to a portrait by Mademoiselle de Clermont. One might be tempted to
see the painting as a prime example of rococo playfulness or fashionability
were it of almost any other aristocratic woman in early eighteenth-century
France. However, the appropriateness of orientalizing subject-matter in ad-
dressing issues intimately related to the princess's life at court suggests that
she once again played a key role in the resulting work. And since Nattier
never painted anything even remotely similar for the rest of his career, it
seems safe to argue that this unusual portrait served the patron's specific
needs rather than the painter's desire to advance his career. The stakes were in
effect too high.

In truth, the details of the second commission are less certain than they
were for the Chantilly portrait. There is no record that the Wallace Collection
painting was in the family's possession – nor secure evidence that it was not.
Nattier had access to the portrait the year after Mademoiselle de Clermont
died, for he showed it at the Salon of 1742. The painting appeared at the sale
of the duc de Saint-Aignan's collection in 1776 but no longer identified as a
portrait; rather, it was listed simply as *Une Sultane au Bain*.[39] While such
revisions are not uncommon in the long history of many portraits, in this
instance the new title signals the unconventional nature of the imagery as
well as its appeal in the subsequent vogue for Turkish themes. During Mad-
emoiselle de Clermont's lifetime, therefore, the owner of the painting remains
uncertain, as does its location or likely audience. But given the princess's
high rank, it seems unlikely that anyone else could have commissioned such
an exceptional image without at least her participation or authorization. Since
Nattier continued to paint other members of the Bourbon-Condé family, he
surely would not have jeopardized such high-level patronage to satisfy just
anyone's whim.

Mademoiselle de Clermont's account books in fact note an unspecified
second set of payments to Nattier for nearly 1200 *livres*, from December
1730 through January 1731. They are slightly problematic date-wise, falling
as they do between the completion of the two portraits. But given the exist-
ence of two elaborate, idiosyncratic portraits (the second of considerably
smaller size at 109 cm × 104.5 cm); a total expenditure to Nattier of just over
3000 *livres* – too great a sum for a single painting given the prices cited
above; and, most tellingly, two separate accounting entries for gilded frames,
it seems a reasonable assumption that Mademoiselle de Clermont was at least
financially responsible for the commission.[40]

To be fair, perhaps creative 'ownership' was more nearly shared between
patron and painter in this instance. Each needed the other's realm of expertise
to pull off so daring a venture, with credit for its instigation assigned to
Mademoiselle de Clermont. The scenario was certainly more dynamic than
Xavier Salmon allows in positing that when Nattier again staged Mademoi-

selle de Clermont ('*mit à nouveau en scene*'), by 'making her a Sultana at her bath surrounded by her servants and eunuchs, the master acquiesced [or paid service] to the fad for *turquerie*.'[41] At the risk of compounding one generalization with another, it would seem that the full-blown mania for things Eastern in the visual arts of eighteenth-century France, understood and employed as an excuse for exoticism – or eroticism – *post-dates* Mademoiselle de Clermont's portrait. The quantities of 'Turkish' porcelain, the use of colorful masquerade costumes that in turn inspired fashionable dress, and the paintings and drawings by Boucher and van Loo that more often featured a sultan attended by his harem, appeared in the 1740s and 1750s.[42]

The literary and visual sources on which everyone drew were readily available, beginning with the *ur*-source translation of the *Thousand and One Nights* by Antoine Galland in 1710. Illustrated travel literature had also whetted interest in the Orient from at least the mid-seventeenth century on. Novels such as the *Lettres Persanes* (1721) at the high end of the cultural curve and entertaining romances detailing the intrigues of the *seraglio* at the other further fueled the European imagination.[43] Some combination of these sources surely inspired the ambiance of Mademoiselle de Clermont's portrait. For help with the composition Nattier would have turned to the 1714 *Recueil de Cent Estampes répresentante differentes Nations du Levant*, a set of 100 engravings made after paintings by the Flemish artist Van Mour commissioned by French ambassador to the Levant, Charles Ferriol (the deluxe, hand-colored version of which I would like to imagine as having been in Mademoiselle de Clermont's library). Artists knew and reused these images in their orientalizing scenes throughout the eighteenth century and beyond. Ingres was still relying on the Ferriol engravings as viable templates for his Turkish bath images over 100 years later. The plates provided useful indications of setting and details about clothing as well as commentary on the presumed mores of the East.[44] In one of the Ferriol plates depicting a harem woman after her bath, much is explicit as well as implied (Figure 4.6). She is depicted alone, lounging against cushions, her legs splaying in a way that suggests sexual availability. And in seeming to nap, she allows the very voyeurism that the idea of the harem provokes. In the twentieth century, Matisse would update this sultry image with uninhibited pleasure.

Mademoiselle de Clermont and Nattier set more ambitious goals as they negotiated their way through the various themes associated with the allure of the East: the seclusion of women in the harem, the social customs and sexual habits of the sultans, or the curiosity of the Turkish bath later immortalized in Lady Mary Wortley Montagu's published letters, to list but the obvious examples. The strikingly original image of Mademoiselle de Clermont as a sultana exceeds its literary and pictorial precedents. Another Ferriol plate depicts a very young woman after her bath, seated and stiffly upright, having her hair

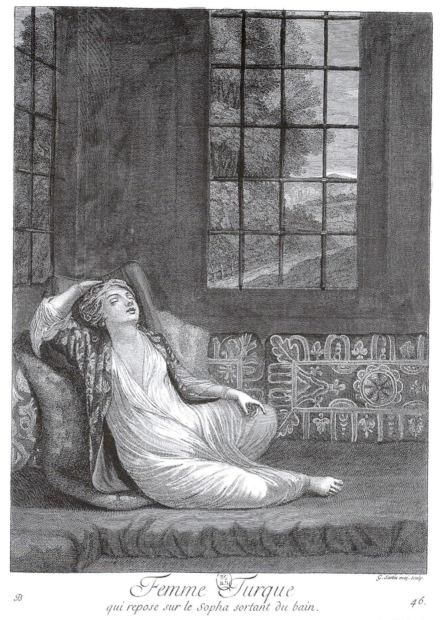

Femme Turque qui repose sur le Sopha sortant du bain.

Fig. 4.6: 'Femme turque qui repose sur le Sopha sortant du bain', 1714 engraved by
G. Scotin for Charles Ferriol, *Recueil de cent Estampes représentant differentes
Nations du Levant* (Paris, 1714), Paris, Bibliothèque Nationale (Bibliothèque
Nationale)

combed. Rather than copy the scene, Nattier, to his credit, enriched his composition and the larger moment through reference to the art historical lineage of painted bathers, ranging from Susannas and Dianas to the more frivolous contemporary bathing scenes by Pater. He thereby produced an entirely modernized bather, freed from the burden of moralizing yet someone with whom to reckon.[45]

For her part, Mademoiselle de Clermont would have brought to the project an aristocrat's understanding of the burgeoning interest in the East. Perhaps she mused over the analysis of French behavior in the *Lettres Persanes* as well as enjoyed the humor of popular contemporary novels like Madame Ville-Dieu's *Mémoires du Sérail, sous Amurat Second* (published 1710–20). While the main characters and narrators of the latter typically are the various men connected to the sultan, at least some of the women and particularly the current 'favorite' sultanas, appear as sympathetic characters – or no more ridiculous than the easily duped men (at least to a present-day female reader). On the serious side, Mademoiselle de Clermont would have participated as a royal cousin and front-row spectator in the world of affairs that included the Effendi's lavish state visit to the court in 1721 or the ongoing politics of Turkish military presence in Europe. Both topics were much discussed over dinner tables and in the various memoirs. Pierre Denis Martin's 1722 painting of *The Turkish Ambassador Leaving the Royal Audience in 1721* (Musée Carnavalet) confirms that such events, like the hunt at Chantilly, were manly displays indeed, replete with horsemen, arms, banners and all the commotion raised by a military parade.

For her portrait, Mademoiselle de Clermont once again removed herself to a more congenial – dare one say feminine/feminized? – space. But rather than just playing out, or to, one's fantasies, the imagery cannily assimilates fascination with Eastern behaviors to aspects of a lived life, if an exceptional life for the time. This reputedly cool, distant, ever-responsible woman, now a very mature 35 years of age, shows herself to be someone with much more texture and perspective than the de Luynes of the court could observe in their day-to-day contact with her. Her portrait mines the subject-matter of *turquerie* not for its decorative effect but to present a woman's view of the nature of 'celebrity', of the harem-like environment of Louis XV's court, and of voyeurism of a more public variety. Mademoiselle de Clermont asserts a different kind of rank and privilege in this instance: she presents herself as a self, an active subject capable and desirous of orchestrating her own identity.

Mademoiselle de Clermont conveys some of her perceived missing warmth and intimacy by affording us the normally forbidden view into the harem and, perhaps equally shocking to the soap-and-water-phobic French aristocracy, the pleasures of a private bath. Water in this setting splashes not from a symbolic urn, but from an oversized brass pot with which the adoring servant

refills the pool at the painting's lower edge (recall the purchase of that expensive copper tub!). Mademoiselle de Clermont confronts the viewer's potential voyeuristic pleasure in the scene by looking straight out, as if in answer to the repeated lament about harems in travel accounts that Turkish women were 'narrowly kept and Eyed; so that it may be said that not a Man has ever seen the Face of one of the Sultanas belonging to the Seraglio during his stay there'.[46]

Mademoiselle de Clermont, used to being eyed as *Surintendante*, emphasizes her self-possession not only through *her* gaze, but through the display of shapely legs – even hitching her robe a notch higher to reveal more. Note, though, that they remain crossed at the knee, as befits a European princess. The erotic locus of the scene is refracted from Mademoiselle de Clermont to the sidelines, signaled in the adoring face of the servant at the right, enacted in the delicate fingering of the pearls by the young boy in the lower left, and displayed through the exposed breast of the servant at the right who handles the bathing sheet. The deliberate array of darker skin colors among the servants suggests that the princess commands a territory as wide and various as the Levant itself. The entirely Western, classicized architectural decor, perhaps recalling the interior of the Chantilly pumping pavilion, allows the image to hover between fact and fiction, but at a level of dignity proper to the sitter.[47]

Another cue to immediate reality comes from the second sheet hanging on the wall in the upper left, a compositional device that nonetheless underscores the mundane nature of bathing. In so courageously displaying her body, Mademoiselle de Clermont qualifies it as a body that is corporeal – that needs bathing and drying. She thereby positions herself against the bodies of fictitious harem women or even the Susannas and Dianas offered up for unqualified delectation in painting after painting at the fictional end of the imagistic spectrum. In removing most of her royal finery to expose the natural, real person underneath (the ermine-lined mantle a pointed reminder of rank nonethless), Mademoiselle de Clermont also distances herself from the overdressed, hoop-skirted bodies of the court (at least by day), and in particular those of the queen's *maison*, a kind of harem in its own right.[48] The assuredness of her pose and the audacity of the moment challenge viewers to reconsider what they know or *think* they know about Mademoiselle de Clermont, and to encounter a woman secure enough in her own identity that she can appropriate this new, modern, alluring persona with utter confidence and a keen sense of irony about the supposed sanctity (or presumed *libertinage*) of a blood-royal body.

Through their contrasting presentations of the same woman, the two commanding portraits of Mademoiselle de Clermont painted by Nattier offer an early eighteenth-century visualization – or fulfillment – of the emerging

sense of self that Montaigne had posited over a century earlier. In his *Essays* he proposed that 'If I speak of myself in different ways, that is because I look at myself in different ways. All contradictions may be found in me by some twist and in some fashion. Bashful, insolent; chaste, lascivious; talkative, taciturn; tough, delicate ... '[49] Mademoiselle de Clermont was clearly self-possessed enough as a person and as a patron to put such identity-shaping dualities on view through her adept, inspired practice of portraiture.[50]

Notes

I would like to thank Madame Nicole Garnier-Pelle and the staff at the Musée Condé for their kind assistance with the archival materials, and Vivian Cameron and Beth Lauritis for their close readings of the essay.

1. *Mémoires du marquis de Sourches, sur le Règne de Louis XIV*, ed. Gabriel-Jules le comte de Cosnac and Edouard Pontal (Paris: Hachette, 1893), 13 vols, 12 (1892), 427, entry, for 30 December 1710. The presentation of the king's 'rather too petite but perfectly beautiful' granddaughter took place in the apartments of the marquise de Maintenon.

2. Marguerite Jeanne Cordier, Madame de Staal-Delaunay, *Mémoires de Madame de Staal-Delaunay sur la société française au temps de la Régence* (Paris: Mercure de France, 1970), 95–6. Her initial education had been at the prestigious convent school at Fontevraud, where the daughters of Louis XV would later be sent as well.

3. Madame de Genlis published her novelette *Mademoiselle de Clermont, Nouvelle Historique* in 1802. Following literary conventions, the author claimed to be recounting facts communicated by a close friend of the long-dead Mademoiselle de Clermont. The literary plot involves a love affair between the princess and a man beneath her rank, the duc de Melun, whom she marries clandestinely, *à la* Romeo and Juliet. The inappropriate bridegroom conveniently dies in a hunting accident at Chantilly shortly thereafter, leaving the princess to grieve in good Romantic fashion. While anything is possible, and a duc de Melun indeed died while hunting at Chantilly, there are a number of problems with the novelette's purported veracity, not least of which is the total absence of any early eigntheenth-century corroboration. Moreover, protocols of court precluded either the freedom of circulation de Genlis allows the duc de Melun, or the closeness between Mademoiselle de Clermont and the still lower-ranking Madame de Pussieux (or Puisieulx-Sillery), de Genlis's relative and purported source of information. Madame de Pussieux herself is largely absent from the various memoirs and journals. More likely the author confounded gossip about Mademoiselle de Charolais and an equally fictitious secret marriage with the duc de Richelieu, accounts of which *did* circulate in the early eighteenth century, with the otherwise blank-slate Mademoiselle de Clermont. The literary fiction passed into 'history' when it was subsequently recounted in a footnote in P.-E. Lémontey, *Histoire de la Régence et de la Minorité de Louis XV jusqu'au ministère de Cardinal Fleury* (Paris: Paulin Libraire, 1832), 2 vols, 2: 136. The historian asserted that the real-life incident inspired the novelette, but of course his only source for the story was the novelette itself.

4. The equivalent princesses from the rival the Orléans/Conti side of Louis XIV's family tree were married off to Spanish royals. Mademoiselle de Clermont's youngest sister, Elisabeth, Mademoiselle de Sens (1705–63) made the short list of potential brides for Louis XV.

5. Archives of the Musée Condé, Chantilly, Ms XVIII A 15, Levée de la Maison. Entries for wax and candles appear each year. Between May 1725 and April 1726 Mademoiselle de Clermont paid 26,000 *livres* for her silver service from 'Germain, orfevre,' p. 6. She paid 9,327 *livres* for horses, carriage and saddles, p. 6a. An entry for 12 May 1729 records the payment to Briot for the tub, which cost 362 *livres*, p. 195a. For comparison, note that two painted miniatures recorded that same year cost 120 *livres* each, p. 196.

6. Joannis Guigard, *Nouvel Armorial du Bibliophile* (Paris: Emile Rondeau, 1890), 2 vols, 1: 114 notes that Mademoiselle de Nantes compiled an impressive library in her residence, the Palais Bourbon, adding that she had a true taste for literature, the arts and science. She supposedly read a great deal and annotated her books, which included Locke's *Essay on Man*. An inventory of Mademoiselle de Clermont's library does not seem to have survived.

7. Payments in the Levée de la maison for works of art other than painted portraits include 98 *livres* to 'Peran, Sculpteur' in 1719, p. 128; 1326. 10 *livres* to 'Thibaut, Sculpteur' in 1723, p. 133a; and, from 1722 through 1729, a series of small payments to one 'Cau, peintre', entries that more often appear in the sections entitled 'Payments for the Ecurie,' suggesting something well short of works of art. Nicole Garnier-Pelle, in *Chantilly, Musée Condé, Peintures du XVIIIe siècle* (Paris: Editions de la Réunion des musées nationaux, 1995), 86–87 discusses a likely commission from Christophe Huet by Mademoiselle de Clermont for a decorative suite of animal paintings for the Petit Luxembourg in 1735.

8. Archives of the Musée Condé, Chantilly, 'Hotels et Maisons Registres,' Le Petit Luxembourg, 16 July 1735: Salle des portraits, pp. 15–17; for the works in the garde-meubles, pp. 210–12. The entry for the two unframed works notes that one shows her wearing a type of gown called an *Espagnolette* while the other includes a flower garland, p. 210, entry #1462. The 'Chambre d'Hyver' contained another set of family portraits depicting Mademoiselle de Clermont (her portrait being an overdoor) and a selection of her siblings, p. 21.

9. The print, an example of which is in the collection of the Musée des Arts Decoratifs, Paris, was sold by Nicolas Bonnart, fils. The figure models a jewel-encrusted dress with a long train, carries a fan, and is posed on a terrace with a parterre and fountain behind. A similar dress – and face – featured in a fashion print by 'N. Bonnart' captioned 'Fille de qualité en habit garni de pierreries' (Bibliothèque Nationale, micro Oa 50 pet. fol. c. 665). H. B. Bonnart advertised on the bottom of some of his fashion plates that he had for sale 'Touts [*sic*] les Portraits de la Cour.'

10. A copy by Gustave Lundberg after Santerre is illustrated in W. Lundberg, 'Quelques portraits de Marie-Anne de Bourbon-Condé,' *Revue de l'art ancien et moderne*, LXVIII (1930), 143–7. It may correspond to the garde-meubles portrait since it has a flower garland.

11. Levée de la maison, 1719, p. 128 records one payment to 'Gobert, peintre, 310 livres,' and a second 'A Gobert, peintre 700 Livres.' in 1722, p. 131a. Gobert may have first painted Mademoiselle de Clermont in bust length, at the age of nine in 1706; Garnier-Pelle (1995), 51.

12. Levée de la maison, 1726, p. 59 'à Lundberg, Peintre, pour le prix d'un portrait en pastel de S.A. S. [Son Altesse Serenissme], le cadre et la glace, 150 [*livres*].'

13. The first of these two works is known only from its mention in 'Hotels et Maisons Registres,' p. 73, as hanging above a fireplace in an unspecified building, and recorded as 'S.A.S. Mademoiselle de Clermont en Sainte-Geneviève.' A photograph of the second painting is in the Musée Condé picture file for Mademoiselle de Clermont.

14. Levée de la maison, p. 150, August 20, to 'P[e?]n[ele?] peintre pour un Portrait de S.A.S. en mignature, 135 livres.' A subsequent entry for July through October 1729, p. 196 records payments to 'Sr. le Brun, peintre pour deux portraits en mignature,' each at 120 *livres*, without identifying the sitters.

15. Alfred Sensier, *Journal de Rosalba Carriera pendant son séjour à Paris en 1720 et 1721* (Paris: J. Techener, 1865), 324. The visit by Rosalba to Mademoiselle de Nantes occurred on 18 February 1721. What may have been a sitting in Rosalba's studio took place on 20 February, with a second visit the following day, 325.

16. Sensier, 357; the entry is for 7 March 1721. Bernardina Sani, *Rosalba Carriera: Lettere, diari, frammenti* (Florence: Leo S. Olschki, 1985), 2 vols, 2: 779 identified the man responsible for the damage as 'M. Lace'. The writing of the name in the journal is nearly indecipherable.

17. *Jean-Marc Nattier 1685–1766*, exh. cat., Musée national des châteaux de Versailles et de Trianon, October 1999–January 2000 (Paris: Réunion des musées nationaux, 1999). Prior to the exhibition, the most complete study of Nattier was Pierre de Nolhac, *J.-M. Nattier peintre de la cour de Louis XV*, 1905; re-edition 1925 (Paris: Librairie Fleury).

18. Salmon, 78: 'Nattier avait eu recours à l'une de ces compositions ambitieuses à l'aide desquelles il tentait d'asseoir son renom. Par ses dimensions imposantes et son caractère allégorique, l'oeuvre cherchait à rivaliser avec la peinture d'histoire.'

19. Ibid., 80.

20. For Mademoiselle de Clermont's day-to-day life at court I have relied on the extensive references in Charles-Philippe d'Albert, duc de Luynes, *Mémoires sur la cour de Louis XV (1735–1758)* (Paris: Firmin Didot Frères, 1860–65), 17 vols, as well as memoirs covering the period cited elsewhere in these notes. A biography of Mademoiselle de Clermont that will include complete documentation is in progress.

21. Charles-Louis Pöllnitz, *Lettres et memoires du Baron de Pöllnitz* (Frankfort, 1738) 5th edn, 3 vols, 3: 21–22: 'Mademoiselle de Clermont joint à beaucoup de beauté un air de noblesse, de douceur et de modestie, qui la distingue de toute ce qu'il y a de plus grand à la cour. La médisance, qui ne respecte pas toujours le sang royal, n'a pu répandre son venim sur cette princesse, et toute la cour à toujours admiré sa sagesse et sa vertu.'

22. *Mémoires sur la cour de Louis XV (1735–1758)*, 3: 450: 'Elle étoit polie, avoit de l'esprit; mais d'un froid singulier, paroissant ne se soucier de personne; elle portoit cette indifférence jusque sur elle meme. Elle avoit été parfaitment belle et meme elle avoit encore de la beauté.'

23. Jean-Marie Pérouse de Montclos, *Vaux-le-Vicomte* (Paris: Éditions Scala, 1997), 182. For a discussion of the portrait see Thierry Lefrançois, *Charles Coypel: Peintre du roi (1694–1752)* (Paris: Arthena, 1994), 183–84.

24. It is interesting to consider that Mademoiselle de Clermont may have seen the

Coypel portrait before deciding to commission a new portrait of her own, since the queen paid an official visit to Vaux le Vicomte in 1728, commemorated in an anonymous painting in the collection of the château, Pérouse de Montclos (1997), 182.

25. Levée de la maison, 194a and 196.

26. Fernand Engerand, *Inventaire des tableaux commandé et achétee par la Direction Générale des Bâtiments des Roi (1709–92)* (Paris, 1900), xliii–xliv.

27. Since the painting was never exhibited, it never acquired a printed title. When Nattier exhibited a drawing related to the painting in the Salon of 1737, the title given in the salon catalogue was 'Un Dessein représentant Mademoiselle de Clermont en Déesse des Eaux de la santé,' *Explications des Peintures, Sculptures, & d'autres Ouvrages de Messieurs de l'Académie Royale* (Paris, 1737), 20.

28. Reproduced in Salmon (1999), 76. The drawing is in the collection of the Fogg Art Museum (inv. 1955.1).

29. The Mignard painting is in the Louvre (R.F. 1979–19). The sexual symbolism of the urn for a male river deity is clear in earlier Italian art, for example Annibale Carracci's *c.* 1594 full-frontal, frame-filling version, now in the Capidomonte, Naples. Donald Posner identified the work as an academic study, but one prized enough to have been in the Palazzo de Giardino in Parma through 1708, and then in Naples since 1734; *Annibale Carracci* (New York: Phaidon, 1971), 2 vols, 2: 34. When Greuze depicted a river god seen from behind in a *c.* 1769 finished drawing (the figure derived from another French seventeenth-century Pan and Syrinx image), he included a flowing urn to the right, but then added a masculine touch through the inclusion of a rather phallic rudder handle artfully positioned behind the figure's lower torso, pointing upward and to left. The drawing is part of a group connected to Greuze's painting, *Votive Offering to Cupid*, shown in the Salon of 1769; reproduced in Edgar Munhall, *Greuze the Draftsman* (London: Merrell Publishers Ltd, 2002), 180.

30. Two images by Watteau figure in this transition: an attributed early work, *La Nymphe de Fontaine*, which features a half-length nymph, centered in the canvas, her arms resting on a prominent urn in the left corner (private collection) and, in a somewhat humorous turn-about, so to speak, the *Fête Galante in a Park* (Dresden), in which the nymph is a garden statue seen from behind, being inspected by a well-dressed male.

31. On the antiquity of associating women with water, see Susan Guettel Cole, 'The Uses of Water in Greek Sanctuaries,' *Early Greek Cult Practice*, ed. R. Hagg, *Acta Instituti Atheniensis Regni*, Ser. 4, 38 (1988), 161–5.

32. The painting is in the collection of the Museu de Arte de Sao Paulo Assis Chateaubriand, São Paulo, Brazil, inv. 50.

33. For a thoughtful argument about the cooperation necessary in portrait production between artist and patron, see Angela Rosenthal, 'She's got the look! Eighteenth-century female portrait painters and the psychology of a potentially "dangerous employment,"' in *Portraiture: Facing the Subject*, ed. J. Woodall (Manchester and New York: Manchester University Press, 1997), 147–66.

34. Peter R. Campbell, *Power and Politics in Old Regime France 1720–1745* (London: Routledge, 1996), 93–109.

35. For the hunting-scene commissions, see Garnier-Pelle (1995), 33–4; 101–4.

36. From an anonymous, comedic novel entitled *Amusemens des Eaux d'Aix-la-*

Chapelle (Amsterdam: Pierre Morier, 1736) 2 vols, 1: 161, we learn that 'the equality established in these fleeting "societies" that were formed by chance and out of necessity produced this supreme Liberty ... In a word, it was only necessary to approach the Fountain of Aix once to become republican ["devenir Républicain"].'

37. 'Société de gens de lettre de l'année 2355,' 151–4, cited in Salmon (1999), 267 and 270.

38. When Nattier exhibited the painting at the Salon of 1742, the work was listed in the Salon *livret* as 'Un Tableau représentant le Portrait de feuë Mademoiselle de Clermont, Princesse du Sang, Surintendante de la Maison de la Reine, représentée en Sultane, sortant du bain, servie par des Esclaves,' *Explications des Peintures, Sculptures, & d'autres Ouvrages de Messieurs de l'Académie Royale* (Paris, 1742), no. 63, 15.

39. Xavier Salmon, 'Jean-Marc Nattier à Chantilly,' *Le Musée Condé* 56 (October 1999), 31, n. 12.

40. Levée de la maison, 244a: two payments are listed together, one for 23 January 1730, 720 *livres*, and one for 28 January 1731, for 452 *livres*. Since the accounting is for the year 1730, as recapitulated on page 275, perhaps the date 1731 is an error. The entries that immediately follow are for a frame, dated 24 January 1730, 150 [*livres*] and for its gilding, 27 January 1730, 143 [*livres*]. Philippe Renard, in *Jean-Marc Nattier (1685–1766)* (Château de Saint-Rémy-en-l'Eau: Éditions Monelle Hayot, 1999), 55 proposes that the second set of payments is for portraits of Mademoiselle de Clermont's sisters, but offers no evidence in support of this assertion. My assumption is that Nattier added the signature and date at a later time, and incorrectly remembered the date. The price of the frame and its gilding seems consistent with a relatively major painting. In the accounting for the Chantilly portrait, the entries for its frame similarly occur in proximity to payments to the artist, including his travel expenses. One hundred and fifty *livres* were paid to construct that frame and 140 *livres* for its gilding; p. 196.

41. Salmon, *Jean-Marc Nattier 1685–1766*, 81: 'En faisant de la princesse une sultane au bain ... le maître sacrifiait à la mode de la turquerie.' I presume here the double sense of capitulated to the fad, and made an offering to it.

42. See, for example, the discussion of Carle Van Loo's 1748–51 works in Perrin Stein, 'Madame de Pompadour and the Harem Imagery at Bellevue,' *Gazette des Beaux-Arts* 123 (1994), no. 1500, 29–44, or the still later, mid-1770s *turquerie* in the same author's 'Amédée Vanloo's Costume Turc: The French Sultana', *Art Bulletin* 78 (September 1996), 417–38.

43. Susanne Pucci, 'The Discrete Charms of the Exotic: fictions of the harem in eighteenth-century France,' *Exoticism and the Enlightenment*, eds G. S. Rousseau and Roy Porter (Manchester and New York: Manchester University Press, 1990), 145–74.

44. For a discussion of the engravings, see Maria Elisabeth Pape, 'Turquerie im 18. Jahrhundert und der "Recueil Ferriol" in *Europa und der Orient 800–1900*', exh. cat., Berlin, Martin-Gropius-Bau, 28 May–27 August 1989, 305–24.

45. There is an interesting and probably related treatment in later seventeenth-century prints of aristocratic women 'bathing' by fountains, with figures of these 'Dame[s] de qualité' alternating as personifications of water in series on the elements or as 'Afternoon' in series on Times of Day, many of them sold by H. Bonnart. The dress is contemporary and the seated poses are similar to that

taken by Mademoiselle de Clermont. A much less decorous pose is held by Psyche in Charles Natoire's *Toilette of Psyche*, *c*. 1735, now in the New Orleans Museum of Art.

46. C. LeBruyn, *A Voyage to the Levant* (London, 1702), 30–31, cited in Marcia R. Pointon, *Hanging the Head: Portraiture and Social Formation in Eighteenth-Century Britain* (New Haven: Yale University Press, 1993), 256, n. 60.

47. Pierre de Nolhac, caught up in the sensory pleasure of the oriental carpet, the beautiful fabrics, and the ermine trim of Mademoiselle de Clermont's mantle, came to a similar conclusion about the mix of fantasy and reality in his brief description of the painting. He found the combination 'more interesting, in sum, than an allegory;' *Nattier: Peintre de la Cour de Louis XV*, 77. The harem conceit is itself an allegory, of course, if more modern than the others Nattier employed in his portraits.

48. Dress figures as part of the series of protocol squabbles early in Marie Leczynska's reign. At one point the problem centered on overly wide skirts taking up too much space at the theatre. Perhaps Mademoiselle de Clermont's *déshabille* is her tongue-in-cheek answer to the voluminous fashions being ridiculed in popular prints of the era. She may also have been distancing herself from the royal but perpetually pregnant body of the queen. While hardly the 'sultana' or favorite of Louis XV's court, Mademoiselle de Clermont ruled the equivalent of his harem, especially in her later years. To invoke the *serail* in the way the portrait does was to openly flirt with its salacious assumptions/associations – something Nattier would not have risked on his own. See, for example, *Correspondance Complète de Madame duchesse d'Orléans*, ed. M. G. Brunet (Paris, 1904), 2 vols, 1: 239 where on 29 May 1716, the writer affirms that she 'can no longer deny that my son has a real inclination for women; he has a queen sultana [une sultane-reine].'

49. Michel de Montaigne, *The Complete Essays of Montaigne*, trans. Donald M. Frame (Stanford, CA: Stanford University Press, 1958), 242.

50. Clearly the significance of the work Nattier had done *for* Mademoiselle de Clermont was not lost on the artist. Included among a small handful of highly finished drawings he kept for himself is the one he exhibited at the 1737 Salon of the Chantilly portrait and another of the Wallace Collection portrait. Salmon, 'Jean-Marc Nattier à Chantilly,' 31, n. 13 notes that the drawing related to the Wallace Collection painting was on the market in 1975. See also his article, 'The Drawings of Jean-March Nattier, Identifying the Master's Hand,' *Apollo* 429 (November 1997), 3–11.

CHAPTER FIVE

Commerce in the *Boudoir*

Jill H. Casid

> In our times, exhibitions happen no longer but in the Salon, meanwhile it is being reduced to some *boudoir*.[1]
>> *Lettre sur le Salon de peinture de 1769 par M. B****

In its critique of the crown-sponsored, free, public exhibition of works of art at the Salon du Louvre in Paris, the anonymous pamphlet 'Letter on the exhibition of painting of 1769' relies on a then comparatively novel word *boudoir* to impute that a boundary has been eroded and that the Salon has been diminished or brought down. The implicit historical narrative of degeneration condensed in the phrasing resonates with the most intransigent characterization of the eighteenth century in France: the mythological reign of the woman patron from her *boudoir*.[2] The word concept *boudoir* with its inextricable connotations of the effeminizing dominion of women was itself an invention of the eighteenth century and played across such painted scenes as P.-A. Baudouin's *The Exhausted Quiver* (Figure 5.1).[3] Sometime before 1730 the word *boudoir* was derived from the verb *bouder* to designate, 'par plaisanterie', the place where one would go in order to pout.[4] From its recognition by the Académie Française around 1740, the word was codified to denote, with a certain ostensibly playful yet cutting irony, a place in which a particular figure of woman is located, the woman patron who exercises control over culture through tactical use of (hetero)sexuality.[5]

To define the *boudoir* as a room set aside for the purposes of pouting arrests the woman patron's public influence on the arts to the fetishized but also risible figure of a pair of perpetually pursed and protruding lips. However, despite the biting critique in the naming itself, for a woman patron to reserve a space for pouting was to defy the dictates of the kind of pious functionality attributed, for example, to the *laboratoire* or room set aside for the labors of experimentation and invention. An affect or way of doing something as much as a type of action, to pout in one's *boudoir* was a *way* of

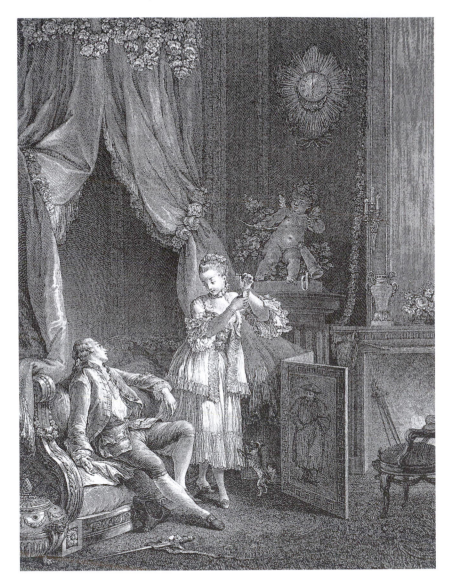

Fig. 5.1: Nicolas Delaunay after Pierre-Antoine Baudouin, *The Exhausted Quiver*, engraving, 1775, New York, The Metropolitan Museum of Art (Elisha Whittelsey Collection, 1954 [54.533.23])

playing the game of patriarchal capitalism, participating in erotic commerce and commercial exchange between men by way, however, of a certain teasing delay. But to pout also signified its opposite, a withdrawal from involvement

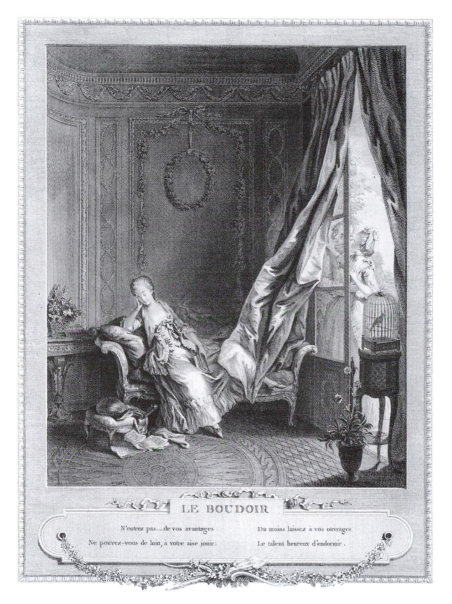

Fig. 5.2: Pierre Maleuvre after Sigmund Freudeberg, *The Boudoir*, engraving, 1774, Washington DC, National Gallery of Art, Rosenwald Collection

or seemingly apolitical boycott from the private space of the *boudoir*. The woman who closed the door and amused herself with one of those 'books one

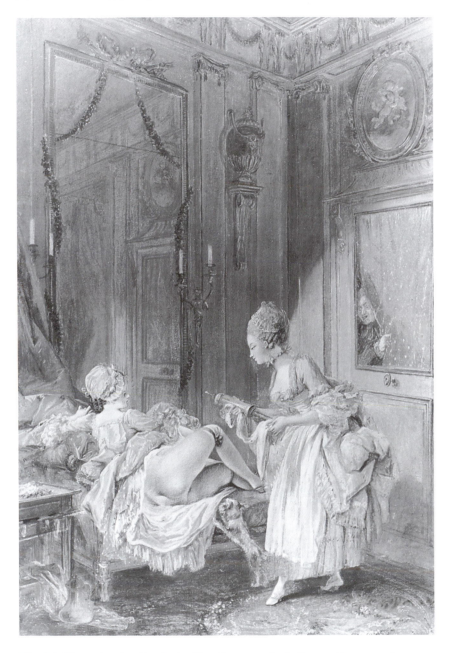

Fig. 5.3: Pierre-Antoine Baudouin, *The Clyster or the Indiscreet One*, gouache on
paper, eighteenth-century, New York, Sotheby's

read with only one hand' as imagined, for example, by Freudeberg's *The Boudoir* (Figure 5.2), the women together of Diderot's *La Religieuse* or even Sade's *La Philosophie dans le boudoir*, and the woman who, in innumerable pornographic prints, turned her back only to reveal and revel in her backside as in, for instance, Baudouin's *The Clyster or the Indiscreet One* (Figure 5.3) shared, at least, one thing in common: a defiant and arguably political refusal, however momentary, of the demands of the spaces of heterosexual reproduction.[6] Reducible neither to the sex rooms or *foutoirs* of pornography nor the privatized obverse of the public centers of finance or *comptoirs* of industrial capitalism, the *boudoir*'s prescribed critical function may be read elsewhere than in the various forms of pouting from affect to action.

The question of the function of the *boudoir* returns us to the constructive ambitions, the performative labors of the joke in the epigraph about the Salon being reduced to some *boudoir*. The joke attempts to make us accept that the Salon is the only space of exhibition. By invoking the prospect of collapse, we are to assume that the Salon has *already* become a public space distinct in character from that of the *boudoir*. I suggest we view this temporality with some suspicion, for the task of such criticism was not, I would argue, empirical description of what was, but the production of what might be: a distinct masculine-gendered public sphere for the kind of art that would make new (virile male) citizens. Figured as the domain of the woman patron, as a bad, between-space neither sufficiently public nor properly domestic, the *boudoir* was a critical device for this task.

The *boudoir* makes a crucial, critical trespass in the introduction to art historian Thomas Crow's *Painters and Public Life in Eighteenth-Century Paris* (1985), his well-known class-based account of the development of the Salon into an 'artistic public sphere' capable of producing a new social and political group, a public. Crow's story of this 'artistic public sphere' positions the Salon as a space that would lay the ground for the social and political force of the bourgeoisie. Crow opens this history with an analysis of the political role of newly emergent art criticism in positioning the Salon du Louvre as not just an 'artistic public sphere' but also, eventually, an integral part of what philosopher Jürgen Habermas would call a '*bourgeois* public sphere'.[7] Crow's tentative conclusions regarding the problem of the Salon's public proceed from an anatomization of a citation from Louis-Sébastien Mercier's critique of the 'Sallon de Peinture' in his *Tableau de Paris* (1782– 88). At first glance the passage would appear to do no more than bemoan the quantity of portraits on display:

> What is wearying and at times revolting is to find a crowd of busts and
> painted portraits of nameless people, and more often those engaged in
> anti-popular pursuits. What are we to make of these financiers, these
> middle-men, these unknown countesses, these indolent marquises ... as

long as the brush sells itself to idle opulence, to mincing coquetry, to snobbish fatuousness, the portrait should remain in the *boudoir*; but it should never affront the vision of the public in the place where the nation hastens to visit![8]

But what Crow interprets as evidence of a general and increasingly pervasive concern with the Salon's inappropriate mixture of private (read 'oppressive') and public (as in popular and potentially democratic) rests on a politicized, spatializing opposition of Salon and *boudoir* that Crow's study overlooks. The development, in Mercier's critique, of the potential of the Salon as the place for the generation of particular national subjects (defined negatively as *not* idly opulent mincing coquettes and fatuous snobs) depends on a displacing containment of their apparent inverse, representatives of commercial capitalism and aristocracy that we are told should 'remain in the *boudoir*'. If the Salon is to reflect back to the gaze or vision of the public the imago, the ideal image or vision, of that public, then painting must not become prostituted to the representatives of financial capital. At stake in this image of the emasculated brush is more than the fear of castration: the very production of gendered citizens, the public of that nation that does not yet see itself because it does not yet exist.

Feminist historians and art historians of eighteenth-century France have analyzed how visual culture as a purveyor of gender ideology worked to deny virtue and authority to women's actions in the emergent public sphere. Studies have built on Habermas's theorization of the structural transformation of the public sphere to argue that in the second half of the eighteenth century in France a bourgeois public sphere emerged from, but in opposition to, what they have designated as the absolutist or aristocratic public sphere.[9] Histories of the development of a bourgeois public sphere often retell wittingly or unwittingly a story about a transition from rococo to neoclassicism as a major shift in French art from painting designed for private, intimate spaces to works produced for a public audience (that is, the usual art-historical tale of a progressive rupture between François Boucher and Jacques-Louis David). This story of a radical break is also a tale of patronage in which women patrons, particularly Madame de Pompadour, are made responsible for the rococo style. Acceptance of this myth naturalizes diatribes against women's dominion over politics and culture as understandable reactions against the assumed superficiality and aristocratic nature of rococo.

The published art criticism from the 1760s and 1780s that fought over what constituted properly neoclassical art production betrays as great an obsession with the supposed degenerate effects of women's influence on culture as do the early to mid-eighteenth-century critiques of rococo from Voltaire to La Font de Saint-Yenne. Critics endeavored to incite a transformation in patronage and, hence, in art-making. Criticism worked to persuade that such a change de-

pended on the production of binary gender and separated spheres effected, it was hoped, by a displacement into, and politicized boycott of, the *boudoir*.

After decades of feminist commentary, it has by now become a commonplace that the culture of print, and visual culture more generally, gendered the spaces of the emergent bourgeois 'public sphere' and styled the 'public' as a masculine republic of men.[10] But the passage in Mercier's critique of the Salon, for example, calls on us to rethink this relation between the Salon and the vision of the public, bodies and architecture the other way round, that is, to understand the production of new gendered (and, as I will discuss at the conclusion of this essay, racialized) subjects as a spatial practice.[11] Returning once more to the brochure with which I began and its joke about the Salon being reduced to some *boudoir*, it was not that the Salon was on the verge of ruin, but rather that it promised to become a public space for the production of new gendered citizens only by the imagined threat of its negative double, the *boudoir*. This space of trouble, this between-space of potential breakdown (women on top of men and each other, confused gender, feared 'racial' mixture or *métissage*, non-reproductive sex, dispersed value) held out the possibility not of housing preconstituted gendered French national subjects but of building a binary system of sexed and raced bodies and separated spheres.

This essay focuses on the rhetorical use of the *boudoir* as a spatial trope in art criticism published between 1769 and 1789. I argue that this spatial trope operated as a condensed joke the purpose of which was to produce two separate but mutually reinforcing moral, educational and regenerative domains for the production of gendered and racialized citizens (feminine mothers and masculine political actors linked in a heterosexual reproductive economy): the private space of the home and the public civic space of the state. By 1760, as a comparatively small cabinet located in the most secluded apartments of a private building, the *boudoir* had become a marked and distinctive feature in transformations toward greater intimacy in the design of domestic architecture. However, at the same time, the *boudoir* was constructed in representation as neither the proper private domestic space of heterosexual reproduction nor the public civic space of homosocial bonds.

The *boudoir* was configured as a locus of conspiratorial plotting on the part of women, a dangerous site of feminine influence and erotic commerce between and threatening to upset the idealized spheres-in-formation of 'private' and 'public'. For example, architect Le Camus de Mézières's *Le Génie de l'architecture* (1780) conflates the operation of the space of the *boudoir* with the aesthetic and cultural effects of the public woman as high-class prostitute:

> The boudoir is regarded as the abode of sensual pleasure; it is there that she appears to meditate her plans; where she indulges her inclinations ... Give to this show-piece of a room a tone of dignity and of pretension ... it is a little mistress to adorn.[12]

Both the *boudoir* and its inhabitant (sensual pleasure) are personified as a specific feminine figure, a woman whose influence on cultural production is dependent on a relation to a male patron, the addressee of the text, who may be persuaded to waste his implied energies in adorning her. Such characterizations traded in and yet endeavored to minimize the often potentially transformative effects of women's patronage of and influence on the arts by reducing the woman patron to a dependent and derivative figure, a little mistress, rather than connoisseur, of appearances and one who only appears to mastermind her projects. As a show-piece herself, like the *boudoir* which she both inhabits and resembles, the woman patron's effects were hinged to the politics of adornment, that is, to the elements of culture understood to be additive, superfluous, mobile or fluid, and potentially infectious. In my analysis of the numerous pamphlets of art criticism from the 1760s to the Revolution that turn on the joke of the *boudoir*, I argue that this spatial trope worked to construct the public exhibition space of the Salon as an essential site for the regeneration of '*la nation*' by a virile and autonomous culture. The joke played on the techniques of enlightenment to expose to public judgment the improperly private, perverse space in which patriarchal, heterosexual power relationships were supposedly overturned. In doing so, it endeavored to displace the feminized commerce of women's patronage into a locus that promised the possibility of containment.

Boudoir exhibitions

From its first deployment as a device in published art criticism in a satiric piece by Cochin which appeared in the *Mercure de France* in 1755, the condensed joke of the *boudoir* concerned the role of the design, disposition and decoration of the spaces of the city in producing gendered subjects educated in the exercise of manly civic virtue. Cochin's critique invokes such (re)generative sites by comic reversal. The critique is put in the mouths of an invented 'Society of Architects' who mount an ironic defense of trends in contemporary architecture by asking rhetorically:

> Why go searching very far for that which one can find at home? We amuse as we instruct. Can we not develop good taste in exposing to view our designs for boudoirs, 'garde-robes', pavilions in the Turkish style, and 'cabinets' in the Chinese taste?[13]

Cochin's critical piece turns on a recurrent inversion of enlightenment public education as, instead, the public display or penetration of an eroticized, encrypted space of secreted commerce. But this turn-about also puts on exhibit the maligned anti-types of the space of the nation, the public sphere in the making, exposing the penetration of the private by the exotic (pavilions in the 'Turkish style', cabinets in the 'Chinese taste') to censuring view.

As the anti-type of the Salon exhibition space of the nation-to-be, the *boudoir* represented the disavowed traffic of empire, the attempted containing locus of what was to be taken as foreign. If the Salon was to be typified by the exhibition of grand-scale paintings, small pictures, *tableaux de chevalet*, particularly paintings imported from Flanders or done in the Flemish taste were to characterize the *boudoir*'s collaboration with the projected outside of the nation.[14] Their small size and fluidity of exchange invited a comparison with coins and, hence, were employed to represent foreign commerce, the draining of the national coffers into imported luxury objects that, in taking the place of hard currency dissipated not just wealth but symbolically the imagined national substance. Paintings by Flemish artists, even those working in Paris, such as Watteau had become, censured the abbé Laugier in his manual of taste, *Manière de bien juger des ouvrages de peinture* (1771): 'like the little coins of painting, by their abundance, their dispersion in a thousand places, and by the commodity that they are in their capacity to fill voids and facilitate exchanges.'[15] Distinguished by their finish, their polish, these little Flemish paintings were used to signify the negative version of a refined nation, a state, in its place, of 'effemination' and one exemplified by the *boudoir* exhibition.[16] The critical device in Laugier as in Cochin performed a mock collapse of spatial distinction between a here and a there, the nation and its imagined exotic outside (that is, the enforced difference between France and the Netherlands, Turkey or China), sacred and profane, heroic and frivolous in order to draw boundaries between them.

The aim was to situate the exhibition of paintings at the Salon as a privileged site for the generation of a nation defined by its imagined purity. To accomplish this task, criticism counterposed the *boudoir* exhibition, the place of display contaminated by financial capital and colonial commerce (that is, the traffic of empire signified by the '*à la Turque*' and '*le goût Chinois*') and their representatives, the woman patron and her supposed dupes. The Salon becomes a public sphere for instruction as moral education only by contrast with what is improperly neither public nor private: the *boudoir* exposed or, rather, the *boudoir* exhibition.

While the Salon was to produce the male citizen of virtue, public man, the *boudoir*'s subject was to be his negative counter-face, the *femme publique*, the woman prostitute or performer. To make this desired outcome appear a *fait accompli*, criticism focused, for example, on the *maison* of Mademoiselle Guimard built by the neoclassical architect Claude-Nicolas Ledoux in 1770 (Figure 5.4) for the famous dancer and mistress of the duc d'Orleans. A pamphlet on the Salon of 1773 composed as a mock script for a play sets the scene of a virtual tour of Paris. A Frenchman acting as guide conducts an Italian connoisseur and a British 'milord' out of the Salon du Louvre and the exhibition of 1773 through the streets to the *maison Guimard*. This itinerary

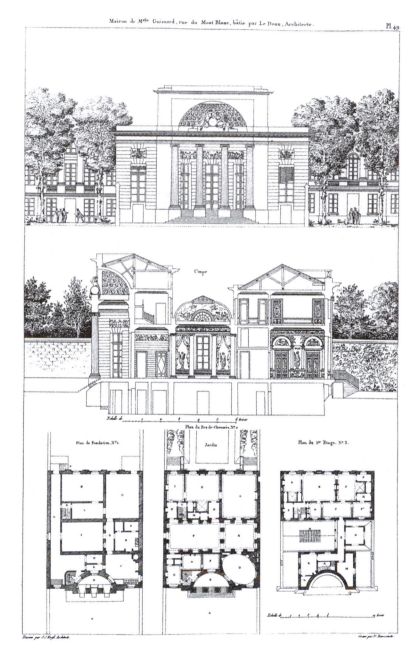

Fig. 5.4: Nicolas Ransonette, engraving, *Façade, Cross-Section and Plan of Maison Guimard* in Johann-Carl Krafft and Nicolas Ransonette, *Plans, coupes, élévations des plus belles maisons et hôtels construits à Paris et dans les environs* (Paris, 1801–1802) pl. 49

of departure – leaving the Salon to arrive at the *maison Guimard* – spatializes the tale of the imagined loss of the Salon as the very public space these critiques aim to produce:

> I see clearly that one must give up everything which is a monument and a public thing: but that leaves me a point on which I am going to avenge myself. It is the distribution of our *hôtels*, of our *cabinets*, the bathing rooms, and the *boudoirs*.[17]

With this spectacle of a lost public sphere and a fallen monument replaced by the *boudoir*, the Parisian guide admits defeat to the other character, a British milord visiting the capital. '*Bien petite vengeance*', the representative of British masculine liberty retorts with the implication that French male citizens capable of responding have been reduced or do not yet exist, as even their available tactics are petty. Situating the problem of the production of good national subjects in terms of Anglo-French imperial competition, the pamphlet makes the character of a virile British 'milord' the mouthpiece for the delineation of the urban architectural program that promises to generate the French nation:

> Continue your quays, multiply your squares, enlarge and align your streets, clear your bridges, have fountains, churches, big ideas, and abandon the ignoble glory of the small. I will remember always the Invalides, the Louvre, and I will surely not carry with me to England the memory of pretty 'cabinets' and the boudoir*s* of your women.[18]

The tour retraces its steps, going back to the Louvre that now represents the future nation. Claiming that the future was always already there involves not only abandoning but also consigning to oblivion the Paris *boudoirs* and the Frenchwomen now placed in them. This forward and backward movement strives to make the construction of the French nation and its male citizens an internal affair, a retrieval of an already extant inside or essence. But the Salon as space of the nation is produced exotically, that is, by going outside itself. The Salon's potential public, its male citizens, claim the future only to the extent that their monuments migrate in and as memory across the borders of that imagined nation to England.

Unhomely gender and the *boudoir* brush

Eighteenth-century art criticism from the 1750s to the Revolution claimed to find its masculine public sphere for the nation only by transporting its readers to the *boudoir*. Critiques of the Salon paint the scene of the production of virtuous public man not at the Salon du Louvre but by an excursion through that anti-domestic between-space of dangerous luxury where the male artist,

at once negative mirror and ostensible agent of change, was to have been exposed at the feet of his art patrons. Such exposure was to reveal that patronage from the *boudoir* had a deforming influence on the corpus of work and potentially on the body of the artist as well. In 'The influence of luxury on the fine arts' (1767), Diderot's violent scripting of this scene, patrons associated with luxury 'exercise the paintbrush of the Artist, strangle his genius in little frames and shrink it into elegant figures of 18 inches in proportion'.[19] The scene rearticulates the effects on painting of the luxury associated with the space of the *boudoir* and its patrons as a virtual castration. From something beyond representation, the artist's genius, like the paintbrush controlled by his patrons, is made vulnerable by conversion into an imagined and projected extension of the artist's body. As an assailable part of the artist's body, genius, now metaphorically objectified, is strangled, shrunken in size, and indistinguishable from little 'elegant figures'. Using the example of Lagrenée *l'aîné*'s submission to the Salon of 1767, the joke of the *boudoir* exhibition was to have exposed not just the debasing exercise of the artist's brush but ostensibly the ideal imago of the nation estranged into a foreign form (the Flemish *bambochades* or little genre scenes of drunken revelry or debauchery) and brought down and disfigured to fit the confines of the *boudoir* of a representative of commercial trafficking and foreign exchange:

> Don't forget among the obstacles to the perfection and the enduring character of the fine arts, I don't speak of the richness of a people, but this luxury that degrades the great talents, in absorbing them in little works, and in reducing grand subjects to little scenes of revelry (the '*bambochade*'); and to convince us, look at Truth, Virtue, Justice, and Religion adjusted for the boudoir of a financier.[20]

The cycle of four paintings (Figure 5.5) by Lagrenée *l'aîné* for the *maison particulier* of *the trésorier des États de Languedoc*, Monsieur Mazade, was to have represented an ideal ordering of the state into the clergy, the nobility of the sword, the magistrature, and the Third Estate.[21] The critique claims an image of truth, virtue, justice and religion for the nation by locating its counter-faces in the *boudoir* of a financier.

However, in Salon criticism, the most common representative not only for this class but for commerce and luxury in general was the female patron figured as a *boudoir* Omphale, seductive thief of the authorizing brush redirecting its use not only to the decoration of her *boudoir* but to the *boudoir* as one layer of an elaborate tissue of self-adornments. As a woman who paints (herself) with her commissions, the woman patron represented not just the work of art (around whom the *boudoir* and its painted elements of decor assume the subsidiary role of mere accessories) but a rival artist. In the face of such rivalry, *Reflexions sur la peinture et la gravure* (1786) by Joullain *fils*

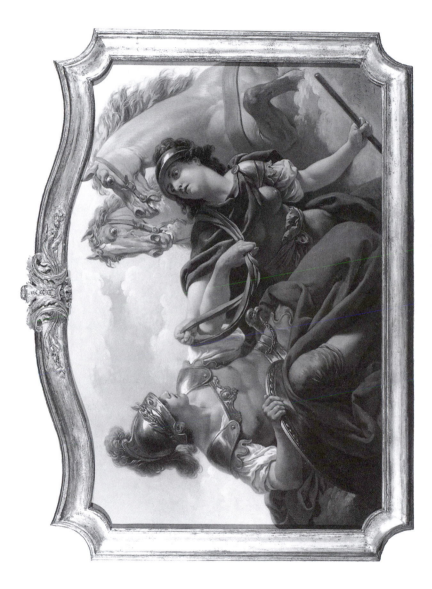

Fig. 5.5: Louis-Jean-François Lagrenée l'aîné, *Bellona Presenting the Reins of her Horses to Mars*, 99 × 145 cm, oil on canvas, 1766, Princeton, Princeton University Art Museum, John Maclearn Magie, Class of 1892 and Gertrude Magie Fund

attaches the inability to discriminate on any basis but the visceral seduction of color to the *petite maîtresse* so as to differentially produce and disentangle her supposed opposites, the male painter and his patron, the man of taste:

> Leave it to these mediocre artists, entirely indifferent to the opinion and the judgment of their compatriots, the pains of decorating boudoirs with their tasteless compositions. The crash of their color can impose on a *petite maîtresse*, but will never seduce a man of discerning taste.[22]

Such *boudoir* jokes were to engender a masculine subject, the male citizen of judgment, who could be extricated in theory from this restricted domain of women's influence. Though held in the grip of the woman patron, these male artists were, at the same time, not to be held generally responsible. As subjects who had been diverted from the projected public trajectories they were to pursue by the seductions of the woman patron in the *boudoir*, these male artists were to be exposed, humiliated and released into the public sphere such critical jokes worked to construct.

The image of the brush taken from the authorizing hand of the male artist, leaving the artist reduced to shaming display object, was to have operated to displace blame. In 1781, for example, one anonymous critic employed the device of an epistle to a lady to make the sort of 'joke', not uncommon by the 1780s, which would expose the negative exemplum of the male artist showing himself off in the *boudoir*: 'M. La Grenée will never show himself to advantage in the great churches nor in the grand galleries, but well in the boudoirs, the little chapels consecrated to voluptuousness.'[23] Couched in the rhetoric of a reaction to the pornographic tale and its exploits on the couch, it is not that the virtual representative, the privileged subject of the grand gallery of the Salon as space of the nation, the male painter as model citizen, had actually been profaned by the promiscuous reach of voluptuousness. Rather, this imagined threat promised to produce such a new political body.

The body of the artist as agent of the nation-to-come was to have been exercised from a state of effemination – as in the old signification of being too much in the company of women. The satirical pamphlet *Momus au Sallon* (1781), for example, stages a farcical exposure of Lagrenée *l'aîné* and Pierre Alexandre Wille *le fils* showing themselves not as painters but '*peintres des femmes*', who by working in and for the *boudoir* might as well be '*belles de jours*'. The character 'La Marquise', true to the literary convention, demonstrated the critical judgment and taste ascribed to the *boudoir* patroness. 'How I love these little paintings!' she was represented to exclaim over the exhibited works of Lagrenée.[24] To insure that the point of the 'joke' would not have been missed, the character 'L'Abbé' located whose influence on art production and consumption was being satirized: 'Oh! yes, it's the women's Painter.'[25] Standing before *Les Étrennes de Julie* by Wille *le fils*, the character

'Le Peintre' confronts and humiliates his negative mirror-image, the deroga-
torily qualified 'Peintres à la mode':

> Choose subjects dictated by good taste / Piquant or naive, & decent
> over-all, / This was the old method. / Follow the advice of our 'belles de
> jour' / Treat subjects that make cupid blush / And in the boudoir rel-
> egated without return; / *Voilà* our fashionable Painters.[26]

This was less a program for transformations in contemporary art production
founded on an emulation of a particular construction of the 'old method' than
a rehearsal of an old trope, trading in the very practices of adornment such
critique decried. The pamphlet itself paints a scene of shaming displacement
of blame into the *boudoir* to make its targeted painters of fashion blush with,
we are to imagine, another kind of desire, desire to become their opposite, the
as yet unqualified painters of the nation.

But the ease with which such criticism alienated the brush from its imag-
ined place, the male painter's body, also menaced. Thus the phrase 'And in
the boudoir relegated without return' is charged with several legislating tasks
at once. It works to map the *boudoir* as a site of exile. A punishment for a
high crime against the body politic, exile is only legible as a forced ejection
from the privileged confines of the state. Thus, to say that painters of fashion
have been relegated to the *boudoir* without return is to posit by presupposi-
tion that another space already exists. The phrase 'and in the boudoir relegated
without return' works to produce that public sphere as a pre-existing civic
space from which painters who fail to act out a proper form of membership
by producing 'subjects' in 'good taste' might be expelled. But though the
performative exiling may suggest no return for these painters, this rhetorical
casting out is enacted by a subject called simply '*Le Peintre*'. This character's
very act of standing at the Salon pronouncing the injunction of exile without
return works to make consignment to the *boudoir* a prospective sentence at
the same time that it stages the potentiality that the male painter does not
permanently reside in the *boudoir*, that he has another place to which he can
claim to belong. The male painter as public citizen makes the very ground on
which he stands his conditions of possibility by the abjection of not just the
'*peintres à la mode*' but the '*belles-de-jour*'. While both are figures of ephem-
eral beauty (for example, the flowers that open only during the day) consigned
to a terminal exile, it is the women patrons figured as prostitutes, or '*belles-
de-jours*' in the related sense, whom the criticism works to produce and
confine to this space which is neither the civic domain of the state nor the
affective, hetero-reproductive sphere of domesticity.

Pamphlets such as the one published in 1777 that claimed to account for
the 'actual state of the arts in France' phrase the *boudoir* joke to make the
ultimate target of the expulsionary threat quite clear:

> In effect in this amiable century, I dare say a little frivolous, the gran-
> deur that one esteems and takes for granted, is banned everywhere. Its
> grave and majestic canvas scares away our fickle graces, who only call
> on painting for the decoration of their boudoirs.[27]

The pamphlet endeavors to turn women patrons into 'fickle graces' easily frightened off and into a potential space of confinement, the *boudoir* as space of exile, terminal zone for anti-civic genders. But the spatializing techniques of this critical device depended on the very threat of reversal it activated: the possibility that the woman patron might exert such a persuasive cultural call that the effects of a ban from the *boudoir* would reverberate 'everywhere'. The *boudoir*, the between-space for the production of the binary genders of public male citizens and domesticated mothers, circulated some uncanny figures of unhomely gender, figures that were critically effective only to the extent that they were set in motion, disrupting decorum and trespassing across the imagined boundaries between a fantasized present state of effemi-nation and the future nation that was to be found already in the past. The staying power of the *boudoir* joke, its very present intelligibility, suggests the extent to which the critical device was not so easily managed.

Despite its sentences of exile without return, the device of the *boudoir* exhibition threatened to generate more indelibly vivid subject types than history painting managed to project. Joseph-Marie Vien was chastised for failing to make of the scene of *Hector Taking Leave of Andromache* (Figure 5.6) the kind of neoclassical history picture that would give the illusion of a new public sphere for the nation.[28] The story of Hector and Andromache (parents of Astyanax, the defender of Troy) conventionally proposed the delineation of two types for the nation, man as martial hero and woman as sacrificing mother out of the spaces that would buttress their distinct charac-terization, the civic sphere of the city and the domestic domain of reproduction. The scene of Hector taking leave of Andromache further promised the narratival and spatial illusion of their clear separation and independence. The critical description outlines these expectations at the same time that it enu-merates a list of the ways in which Vien's version was insufficient:

> That M. Vien has not given Hector enough nobility, that he is much too
> young, that his figure is not nearly martial enough, nor animated enough,
> and little expression, that she has no decided character, that one would
> take the defender of Troy for a young French officer who leaves the
> boudoir of his mistress ('belle'), & gives her the tenderest farewell.[29]

Out of the judged failure of Vien's representation, its inability to project from the scene of the defense of Troy the called-for civic ground for a new contem-porary Paris, the critique attempts to set up the possibility of such a sphere by conjuring a vision of just the kind of subject picture it denounced, a scene of the fall of Troy into the *boudoir* of some contemporary Parisian *belle Hélène*.

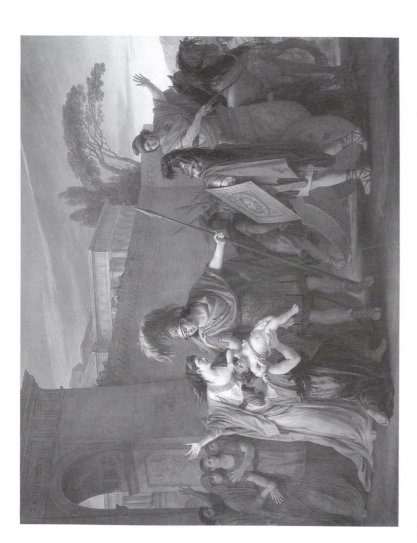

Fig. 5.6: Joseph–Marie Vien, *Hector Taking Leave of Andromache*, 329 × 425, oil on canvas, 1787, Paris, Musée du Louvre (Réunion des Musées Nationaux/Art Resource, NY)

But, in this particular critical scenario, Paris is re-imagined making a departure from the *boudoir*. However, the leave-taking is not without the 'tenderest farewell', suggesting, at the same time, that the *boudoir* may not be so easily left behind by the young French officer. By extension, what he is supposed to produce by defending, the French nation beyond the between-space of 'undecided character' and its citizens, may not be so readily distinguished from those unhomely genders, those haunting gendered and racialized familiars exiled to the *boudoir*.

Boudoir, imperial *miroir, torturoir*

> From deep within their *boudoir*s these crowned sirens will rule over the marching of armies, the fate of colonies.
> Louise Robert, *Les Crimes des reines de France* (1791)

I have discussed the device of the *boudoir* in art criticism as a joke. But, as I have outlined, it is a joke with consequences in its attempted use to construct spaces for the production of binary gender, in its devaluation of the labors of women patrons, women connoisseurs, self-fabricators and rival artists, and in its deployment to position the Salon as a public civic sphere for the nation. Art criticism's *boudoir* exhibitions may, nonetheless, appear as insubstantial and remote from the 'real' spaces of daily life as the smoke and mirrors, those tricks of décor, that art criticism claimed to deplore. And, indeed, it is the closed door, upholstered *lit de repos* or day bed, and book-in-hand version of the *boudoir*'s apparent remove as a space for reverie and dreaming that makes it a contemporary locus for what postcolonial critic and anthropologist Renato Rosaldo might call 'imperial nostalgia'.[30] French literary critic and translator of Sade, Michel Delon's recent publication *L'Invention du boudoir* (1999) concludes with a chapter calling for 'the right to the boudoir'.[31] The room and its 'evanescent things' *('biscuit ou parfum, blanc d'oeuf sucré')* are made equivalent with locating a space in time for erotic suggestion and poetic allusion. But this 'right to the boudoir' claims possession of not just any dreaming but a form of reflection that evades translation. We are reminded that the word '*boudoir*' has no equivalent in any language besides French.[32] And yet, even the metaphors that are to underlie what is distinctive about the *boudoir* and what we have supposedly lost, those sugared egg whites, send us back across the illusory divide of the Atlantic Ocean.

Like *îles flottantes*, floating islands, adrift in seas of English cream, the metaphor of sugared egg whites operates as a vehicle taking us across the waters of forced African diaspora and repressed imperial history to the Salon du Louvre's constitutive other side, the between-space of the *boudoir*. At the same time that painting was supposed to mirror a new public, critiques such

as La Font de Saint Yenne's *Reflexions sur quelques causes de l'état present de la peinture en France* (1747) attributed the loss of an independent public sphere for the arts to the *boudoir* lined with mirrors, emblem of feminine vanity fleshed out by the woman patron who subsumed painting as only one more decorative element within the larger project of refashioning herself as the ultimate art object:

> Vanity, the empire of which is yet more powerful than that of fashion, had the art to present to the eyes and above all to those of the Ladies, mirrors of themselves that are all the more enchanting because they are less true.[33]

The 'empire of vanity' and its 'art' of making over places and peoples so as to reflect back some desired ideal image took its legibility as a metaphor for relations of power from another form of empire, that colonial commerce, that traffic with the projected foreign outside of the nation that criticism worked to displace into the *boudoir* and onto the woman patron and consumer as its principal cause and terminal figure. For, as in the epigraph with which I began this conclusion, it was the woman in the *boudoir* who was imagined to rule 'over the fates of colonies'.[34]

At the same time, colonial discourse set up the *mulatresse*, the freed woman born of colonial desire or what the racializing caste system referred to as *métissage* or miscegenation, as the symbol of luxury that had, in the words of Moreau de Saint-Méry's *Description de Saint-Domingue*, been 'pushed to the limit'.[35] The *boudoir* was the space of undecidable mixtures of all kinds imagined as degeneration. Its ultimate figure was the *mulatresse*. Though associated especially with bodily adornment and the consumption of luxury fabrics, the making of herself an art piece, the *mulatresse* was fanta-sized as most dangerous because of her application of connoisseurial study and collecting practices to the transformation of pleasure into an art in itself:

> [T]hese women, naturally more lascivious than European women, flat-tered by their ascendancy over white men, have collected in order to preserve all the sensual pleasures they are capable of. '*La jouissance*' has become an object of particular study, the object of a refined and at the same necessary art with worn-out or depraved lovers who simple nature can no longer delight and who do not wish to renounce its benefits.[36]

Colonial discourse figured the *mulatresse* as a patroness of pleasures whose art or skill constituted the means to 'ascendancy over white men'. Such characterizations implied that the *mulatresse* had the capacity to use the tools of patronage (the cultivation and application of aesthetic judgment, study and collection) to transform a situation of claimed possession (concubinage and prostitution) into a physicalized threat of possession ('ascendancy') not just over individual men (as in 'worn-out or depraved lovers') but the body politic

of the colonial regime itself (the unnamed system that connected 'European women', 'white men' and the '*mulatresse*'). This fantasized threat of possession worked to produce the racialized degrees of 'lasciviousness' or, rather, danger (that is, European versus non-European women) and gendered and racialized oppositions of 'white men' and 'non-European women' that it invokes.

The *boudoir* was not just the metropolitan locus of the disavowed traffic of empire but also the colonial site of the 'perfumed nightmares' of tropical slavery, colonial fantasies of the *mulatresse*, and the very real transmutational practices for turning humans into animals and these humans *cum* beasts of burden into the white sugar, flows of coins, and luxury commodities that connected as they transformed metropolitan France and the colonial sugar plantations of the Caribbean.[37] The dialogues of Sade's *Philosophy in the boudoir* (1795) is described as a 'delightful *boudoir*' covered entirely by mirrors so that, as the libertines Madame de Saint-Ange and Dolmancé explain to their student Eugénie, the reflections of their postures become the *tableaux*, exposing all to view and multiplying these exhibitions to a delirium of infinity.[38] One may see in these mirrored displays a reflection of empire's demands for flesh to yield the positions of master and slave even as other hierarchies might seem to be overturned in the *tableau* of the student and daughter Eugénie using a dildo as weapon on the mother but under the declared authorizing signature of the father. Without distinction on the basis of color, *Philosophy in the Boudoir* brought the disavowed tortures of the slave colonies back into the metropolitan 'pleasure-salon' or what might rather be renamed, to borrow Rétif de la Bretonne's term, the *torturoir*.[39]

Colonial discourse, however, insisted on producing and eroticizing such distinctions of color on the site of their dissolution. Moreau de Saint-Méry's *Description de Saint-Domingue*, for example, represents the *mulatresse* as the embodiment or luxury artefact and seductive agent of adulterating mixture (the furthest reaches of luxury) that threatens as it forges a transatlantic public sphere for the imagined imperial nation. The arch-figure for what Moreau de Saint-Méry's *Description* calls 'illegitimate commerce' is incarnated by one famous but un-named 'courtisane-Mulatresse' who becomes more of a type by the excision of her name. Her studied refinement and longtime pursuit of not just 'pleasure' and 'fortune' but also 'curiosity' (the hallmark of the connoisseur) took her from Saint Domingue to France. The account of this transatlantic trajectory connects the *mulatresse* and her *boudoir* to the potential public sphere of the imperial nation as it punitively divides them by taking the '*courtisane-mulatresse*' from the most 'sumptuous' of mansions on Saint-Domingue to France and finally to the port town of Bordeaux (built by the returning wealth from the triangular trade) where she is left 'abandoned to perish amidst the horrors of a prison'.[40] And the account

concludes with a lethal, little joke about what happens to those who believe they can fool their creditors with the same impunity as their lovers. Such techniques of displacing commerce into the *boudoir* made this between-space a zone for the production of binary race and gender through the threats of erosion, the effemination and miscegenation it was to cut off from the emergent imperial nation by turning the *boudoir* into a prison, a place of exile and horror, the *torturoir*. Though the joke about the Salon being reduced to some *boudoir* attempted to create some kind of autonomous, gendered sphere for art separated from the colonial trade and erotic traffic in not just commodities but people (as things), the between-space of the *boudoir*, despite itself, irrevocably links the Salon, the history of eighteenth-century art production and its story of patronage, with its disavowed yet haunting gendered and racialized familiars, the woman patron, the '*courtisane-mulatresse*.'

Notes

Versions of this material were presented at the Courtauld, ASECS, and Harvard. For their comments and suggestions, I am particularly indebted to María DeGuzmán, Mary Sheriff, Norman Bryson and Katie Scott. And, for their excellent suggestions regarding revision, I am grateful to the editors of this collection, Melissa Hyde and Jennifer Milam.

1. *Lettre sur le Salon de Peinture de 1769 par M. B**** (Beaucousin), (Paris: 1769), Collection Deloynes, vol. 9, no. 119, 54. The translation of this passage and all subsequent translations are my own.

2. See, for instance, Edmond and Jules de Goncourt, *La Femme au XVIII siècle* (Paris, 1862).

3. For a study of the naming of the *boudoir* that assumes a binary sex/gender system and connects the development of the *boudoir* as a space in which a 'lady' may retire when 'she is a little moody' to attitudes regarding 'premenstrual tension,' see Ed Lilley, 'The Name of the Boudoir,' *Journal of the Society of Architectural Historians* 53 (June 1994), 193–8.

4. Oscar Bloch and W. von Wartburg, *Dictionnaire étymologique de la langue française*, (Paris, 1964), 5.

5. Adolphe Hatzfield and Arsène Darmsteter, *Dictionnaire général de la langue française* (Paris, 1924), 1: 265: 'Dérivé de bouder parce que les dames se retirent dans leur boudoir quand elles veulent être seules. / XVIIIe s. Ducerceau, Poésie. dans Trev.'

6. See Jean Marie Goulemot, *Ces Livres qu'on ne lit que d'une main: lecture et lecteurs de livres pornographiques au XVIIIe siècle* (Aix-en-Provence: Alinéa, 1991).

7. Jürgen Habermas, *The Structural Transformation of the Public Sphere: An Inquiry into a Category of Bourgeois Society* (Cambridge, MA: MIT Press, 1989).

8. Louis-Sébastien Mercier, 'Sallon de Peinture,' in *Le Tableau de Paris* (Amsterdam, 1782–88), 203–6, as quoted in Thomas Crow, *Painters and Public Life in Eighteenth-Century Paris* (New Haven: Yale University Press, 1985), 21.

9. Joan B. Landes, *Women and the Public Sphere in the Age of the French Revolu-*

tion (Ithaca and London: Cornell University Press, 1988) and Madelyn Gutwirth, *The Twilight of the Goddesses: Women and Representation in the French Revolutionary Era* (New Brunswick: Rutgers University Press, 1992).

10. See, for example, Abigail Solomon Godeau, 'The Body Politics of Homosociality,' in *Male Trouble: A Crisis in Representation* (London: Thames & Hudson, 1997), 43–97.

11. See, particularly, Elizabeth Grosz, 'Bodies–Cities', in *Space, Time, and Perversion* (New York: Routledge, 1995), 103–10 and Judith Butler, *Bodies that Matter: On the Discursive Limits of 'Sex'* (New York: Routledge, 1993).

12. Nicolas le Camus de Mézières, *Le Génie de l'architecture* (Paris, 1780), 116: 'Le boudoir est regardé comme le séjour de la volupté; c'est là qu'elle semble méditer ses projets, ou se livrer à ses penchans … Il est essentiel que tout y soit traiter dans un genre où on voie régner le luxe, la mollesse, & le goût … Donnez à cette pièce un ton de dignité & de prétention, c'est une petite maîtresse à parer.'

13. Charles-Nicolas Cochin, 'Lettre à M. L'Abbé R*** sur une très mauvaise plaisanterie qu'il a laissé imprimer dans le Mercure de Décembre 1754, par une société d'Architectes, qui pourroient bien prétendre être du premier mérite & de la première réputation, quoiqu'ils ne soient pas de l'Académie,' in *Recueil de quelques pièces concernant les arts extraites de plusieurs Mercures de France* (Paris, 1757), 39: 'Pourquoi aller chercher bien loin ce qu'on peut trouver chez soi? Nous amusons en instruisant. Ne peut-on pas se former le goût en voyant nos desseins de boudoirs, de garde-robes, de pavillons à la Turque, de cabinets à la Chinoise?'

14. *Dictionnaire de l'Académie Françoise*, 1: 297: 'On appelle tableaux de chevalet, un petit tableau, ou un tableau de moyenne grandeur, qu'on a travaillé & fini avec soin.'

15. Marc Antoine Laugier, *Manière de bien juger des ouvrages de peinture par feu M. l'Abbé Laugier, mise au jour et augmentée de plusieurs notes intéressantes par M*** (Charles-Nicolas Cochin), (Paris, 1771), 195: 'comme la petite monnoie de la peinture, par leur abondance, leur dispersion en mille lieux, & par la commodité dont ils sont pour remplir les vuides & faciliter les échanges.'

16. Ibid., 196–7.

17. *Dialogues sur la peinture*, Collection Deloynes, vol. 10, no. 147, 218: 'Je vois bien qu'il faut renoncer a tout ce qui est monument & choses publiques: mais il me reste un point sur lequel je vais me venger. C'est la distribution de nos hôtels, dont les cabinets, les salles de bains, les boudoirs … '.

18. Ibid., 219: 'Continuez vos quais, multipliez vos places, élargissez & alignez vos rues, dégagez vos ponts, ayez des fontaines, des églises & des grandes idées & abondonnez l'ignoble gloire des petites. Je me rappellerai toujours les Invalides, le Louvre, & je ne porterai surement pas en Angleterre le souvenir des jolis cabinets, & des boudoirs de vos femmes.'

19. Denis Diderot, 'L'influence du luxe sur les beaux-arts Salon de 1767' in *Diderot: Salons*, eds Jean Seznec and Jean Adhémar (Oxford, 1957–67), 3: 54: 'qui exercent le pinceau de l'Artiste, étranglent son génie dans de petits cadres, & le rapetissent dans des figures élégantes de 18 pouces de proportion.'

20. Ibid., 56: 'N'oubliez pas parmi les obstacles à la perfection et à la durée des beaux-arts, je ne dis pas la richesse d'un peuple, mais ce luxe qui dégrade les grands talents, en les assujetissant à des petits ouvrages, et les grands sujets en les réduisant à la bambochade; et pour nous en convaincre, voyez la Vérité, la

Vertu, la Justice, la Religion ajustés par La Grenée pour le boudoir d'un financier.'

21. On the paintings, see Marc Sandoz, *Les Lagrenée: I. Louis-Jean-Francois Lagrenée, 1725–1805* (Paris, 1983), cat. no. 174, 206–7, 212.

22. C. F. Joullain *fils ainé, Réflexions sur la peinture et la gravure* (Paris, 1786), 23: 'Qu'il laisse à ces artistes médiocres, et entièrement indifferent sur l'opinion et le jugement de leurs compatriotes, le soin de décorer les boudoirs de leurs fades compositions. Le fracas de leur coloris peut en imposer à la petite maîtresse, mais ne séduira jamais l'homme d'un goût délicat.'

23. *Lettre d'Artiomphile à Madame Mérard de St. Just sur l'exposition au Louvre en 1781, des tableaux, sculptures, gravures, et dessins des artistes de l'Académie royale (par M. Mérard de St. Just)* (Paris: 1782), Collection Deloynes, vol. 12, no. 277, 666: 'M. La Grenée ne se montrera jamais avec avantage dans les Temples ni dans les grands galeries, mais bien dans les boudoirs, les petites chapelles consacrées à la Volupté.'

24. *Momus au Sallon, Comédie-critique en vers et en vaudevilles suivie de notes critiques,* Collection Deloynes vol. 13, no. 292, 361: 'Que j'aime ses petits Tableaux!'

25. Ibid.: 'Oh! oui c'est le Peintre des femmes.'

26. Ibid., 375: 'Choisir des sujets dictés par le bon gout, / Piquants ou naifs, & décents sur-tout, / Faire des Tableaux qu'on put placer par-tout, / C'étoit l'ancienne méthode. / Suivre les avis de nos belles de jour. / Traiter des Sujets qui font rougir l'amour, / Et dans les boudoir relégués sans retour; / Voilà nos Peintres à la mode.'

27. *État actuel des arts en France et de celui a qui leur administraion est confié,* Collection Deloynes, vol. 10, no. 170, 831: 'En effet dans ce siècle aimable, je n'ose dire un peu frivole, le grand que l'on estime et que l'on admise encore, est proscrit de toutes parts. Son ais grave et majestueux effarouche nos graces légères, qui n'appellent la peinture qu'à la decoration de leurs boudoirs.'

28. See Thomas W. Gaehtgens and Jacques Lugand, *Joseph-Marie Vien, Peintre du Roi (1716–1809)* (Paris: Arthena, 1988), no. 261, 204–5.

29. *Promenades d'un Observateur au Salon de l'année 1787,* Collection Deloynes, vol. 15, no. 372, 119: 'Que M. Vien n'a pas donné à Hector assez de noblesse, qu'il est beaucoup trop jeune, que sa figure n'est point assez martiale, ni assez animée, & peu d'expression; qu'elle n'a point de caractère décidé, qu'on prendroit le defenseur de Troie pour un jeune officier françois qui sort du boudoir de sa belle, & lui fait les plus tendres adieux.'

30. Renato Rosaldo, 'Imperialist Nostalgia,' *Representations* 26 (Spring 1989), 108–9.

31. Michel Delon, *L'Invention du boudoir* (Cadeilhan: Zulma, 1999), 131–4.

32. Ibid., 11–12.

33. La Font de Saint Yenne, *Reflexions sur quelque causes de l'état present de la peinture en France,* Collection Deloynes, vol. 2, no. 21, 23–4: 'L'amour-propre, dont l'empire est encore plus puissant que celui de la mode, a eu l'art de présenter aux ieux & sur tout à ceux des Dames, des miroirs d'elles-memes d'autant plus enchanteurs qu'ils sont moins vrais.'

34. Louise Robert, *Les Crimes des reines de France depuis le commencement de la monarchie jusqu'à Marie-Antoinette* (Paris, 1791), 438–9.

35. Médéric Louis Elie Moreau de Saint-Méry, *Description topographique, physique, civile, politique et historique de la partie française de l'isle Saint-Domingue,*

eds Blanche Maurel and Étienne Taillemite (1797; Paris: Société de l'histoire des colonies françaises, 1958), 1: 1, 105: 'Le luxe des Mulâtresses est poussé au dernier terme.'

36. Justin Girod de Chantrans,*Voyage d'un Suisse dans les colonies d'Amérique*, ed. Pierre Pluchon (1785; Paris: Librairie Jules Tallandier, 1980), 153: '[C]es femmes, naturellement plus lascives que les Européennes, flattées de leur ascendent sur les Blancs, ont rassemblé, pour le conserver, toutes les voluptés dont elles sont susceptibles. La jouissance est devenue pour elles l'objet d'une étude particulière, d'un art très recherché et nécessaire en même temps avec des amants usés ou dépravés, que la simple nature ne peut plus émouvoir, et qui ne veulent pas renoncer à ses bienfaits.'

37. In 'Sade, Lejeune, and the Manual,' Joan Dayan reminds us that the one 'living model' for Sade's philosophic machines designed to push the mind's flesh beyond the limits of the laws, taboos and conventions constituting the human was the actual practice of slavery in the French Antilles. See Joan Dayan, *Haiti, History and the Gods* (Berkeley: University of California Press, 1995), 212–19.

38. Comte Donatien-Alphonse-François de Sade, *La Philosophie dans le boudoir*, in *Oeuvres* (1795), eds Michel Delon and Jean Deprun, vol. 3 (Paris: Éditions Gallimard, 1998), 14, 20.

39. Nicolas-Edme Rétif de la Bretonne, 'Fausse immoralité de la liberté de la presse,' in *Monsieur Nicolas* (1797), ed. Pierre Testud (Paris: Éditions Gallimard, 1989), 1034. See also 'Rétif, lecteur de "l'après-boudoir,"' in Sade, *Oeuvres*, 1278–81.

40. Moreau de Saint-Méry, *Description topographique*, 105: 'On en a cependant vû quelqu'unes qui poussaient la recherche beaucoup plus loin et qui avaient des maisons somptueuses, mais ce genre n'est pas commun à Saint-Domingue, quoiqu'il ait rendu assez fameux le nom d'une courtisane-Mulâtresse qui suivirent long-tems le plaisir, la curiosité et la fortune [et qui, abandonnés par eux, a péri au milieu les horreurs d'une prison à Bourdeaux pour avoir cru qu'on trompait aussi impunément les créanciers que des amans].'

Matronage and the Direction of Sisterhood: Portraits of Madame Adélaïde

Jennifer Milam

As a 'daughter of France', the sixth child born to Louis XV and Marie Leczynska, Marie-Adélaïde sat for celebrated court portraitists throughout her life.[1] She was depicted in modes appropriate to each stage of youth and adulthood, at first as an enticing, attractive girl in the guise of the Diana, and then as a mature woman, increasingly absorbed by her seriousness of purpose, dignity and rank. As an adult, Madame Adélaïde had intellectual and artistic interests.[2] She was a well-educated woman, considering her position, with an amateur's understanding of science and mathematics. Having studied Italian with Goldoni and music with Guignon and Beaumarchais, Adélaïde is depicted in full-length court portraits, whether by Jean-Marc Nattier (Figure 6.5) or Adélaïde Labille-Guiard (Figure 7.1), as a woman of taste and learning. In both of these formal, yet naturalistic depictions of the princess, her activity and expression suggest a lively mind, while her pose and dress convey a stately demeanor. This is no doubt the way that the sitter wished to be portrayed for her contemporaries and posterity.

Most portraits of Madame Adélaïde, however, were not intended to be viewed as discrete images. They were typically joined with portraits of her sisters, presenting beholders with an idea of position secured by the bonds of family above all else. Moreover, as a group, the sister portraits define femininity in a manner that increasingly diminishes the importance of sexual attractiveness among the qualities of being a woman. This is surprising, considering that it was the duty of a princess to secure ties with foreign states through marriage. Yet Louis XV did not actively pursue marriages for his daughters (with the notable exception of the duchess of Parma), either due to

his estimation of Bourbon superiority (only a future king was good enough) or for reasons of economic necessity (the cost of providing dowries for his numerous daughters was always a concern). Consequently, the pendant portraits of the daughters of France pursue an ideology of sisterhood that claims alternative modes of female power for the spinster branch of the Bourbon line.

Sister portraits of the daughters of France were most commonly ordered to decorate the private rooms of the royal family at Versailles, Choisy and Bellevue, among others. Copies were also sent to family members living outside of France, namely to hang at the residence of the eldest daughter, married to the duc de Parma. In the context of the private space of the royal home, a display of the ties of blood was of the highest significance, mixing feelings of familial affection with ideas of superior lineage. Many of the sister portraits, however, were also displayed in the public space of the Salons, where a wider audience determined additional meanings that might have been outside the primary intentions of the sitter and the artist.

Adélaïde's position as the leading female member of the Bourbon line gave her the authority to manage her private and public image.[3] It also gave her the platform from which to direct the performance of sisterhood. Certainly, Adélaïde's power at court was linked directly to the favor she carried with kings – her father first and then her nephew, Louis XVI. It is the sister relationship, however, that is most commonly foregrounded in her portraits, not because of any internal iconography, but due to the fact that they were linked in spirit to similar portraits of her sisters, often but not always hanging side by side. The traditional function of the court portrait to aid the process of memory and maintain the bonds of blood during long periods of absence takes on a different cast with these sister portraits. In the extreme – portraits of the duchess of Parma made after her demise to correlate with similar depictions of her sisters, Adélaïde, Henriette and Victoire – the sister portraits contend that sisterhood is a defining relationship that holds strong even after marriage and death.

While scholars have regularly referred to various sister portraits as important works that secured the reputations of individual artists[4] – like Nattier, Heinsius and Labille-Guiard, who all gained royal appointments after painting the daughters of France – they have not been discussed in terms of what the paintings have to say about the sitters' relationship to each other as sisters. While I am concerned with the sister portraits as a group, this essay specifically explores the development of Adélaïde as a maker of her own image, responding to and building upon the conventions and meanings associated with imaging sister relationships.[5] It considers how the theme of sisterhood was first formulated in works commissioned by Marie Leczynska, Louis XV and the dauphin, to be later solidified and expanded through large-scale

commissions controlled by Adélaïde in her position as Madame. My aim in bringing new attention to the sister portraits is twofold: first, to explore a non-traditional understanding of patronage in order to estimate the role of the sitter when her position as a 'patron' is either not on record or contested; and, second, to determine the specific means by which Adélaïde claimed and directed a type of female power most appropriate to her situation through the pairing of her own portrait with those of her sisters.[6] In this regard, I have chosen to use the word matronage, rather than patronage, to suggest the need for a new consideration of creative influence extending from a woman's role as subject (the 'mother' of her own image), rather than from a purely monetary-based evaluation of control established through commission and payment, which were arguably paternal concerns in eighteenth-century France, as men often acted in this capacity on behalf of women.

An unusual aspect of the patronage story in connection with these sister portraits is that many of the pendant images were ordered to join an existing portrait. This is true of Madame Adélaïde in the guise of Diana, painted to complement the *Portrait of Henriette as Flora* by Nattier; the formal court portraits of Adélaïde and Louise-Élisabeth by Nattier painted to accompany the earlier *Portrait of Henriette with a Bass Viol*; and also of Labille-Guiard's portraits of Victoire and Louise-Élisabeth ordered, completed and exhibited two years after the full-length *Portrait of Madame Adélaïde* had been exhibited at the Salon of 1787. It is as if the daughters of Louis XV could not appear without their sisters. They gained status and power through their display in concert.

Nattier's portrait of *Madame Adélaïde as Diana* (Figure 6.1) depicts the princess at age thirteen. It emphasizes traditional qualities of femininity, such as beauty and sexual desirability, albeit caged under the allegorical rubric of a chaste goddess. Commissioned in 1745 by Marie Leczynska to act as a pendant portrait to her older sister, *Madame Henriette as Flora* (painted in 1742; Versailles, musée national du Château), the painting shows Adélaïde to be an attractive young princess with a rosy complexion and blue-gray eyes, part mortal and part goddess. Such a fanciful conception of Adélaïde was no doubt chosen for her, in accordance with the most popular mode of female portraiture in court circles.[7] Even so, the seductive pose, dreamy expression and direct gaze given to Adélaïde by Nattier serve to entice the beholder while at the same time maintaining distance and authority, dissuading any imagined transgression.

Adélaïde reclines in a landscape setting, the grotto-like enclosure suggestive of Ovid's description of Diana's sacred haunt of Galgathie. A strong central axis runs from the sitter's right hand in the lower foreground up through her hips and left hand to the edge of the rocky outcrop that divides the virgin goddess's enclosure from the forest beyond. Adélaïde's right hand,

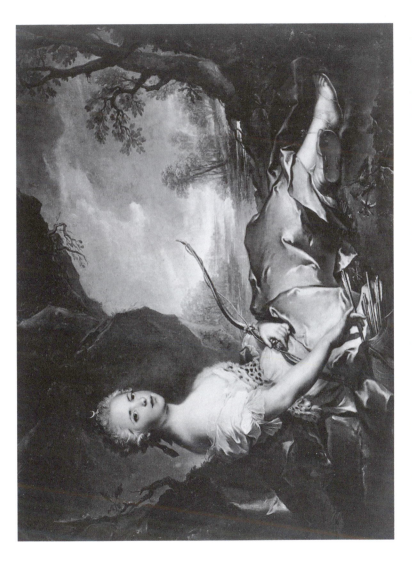

Fig. 6.1: Jean-Marc Nattier, *Portrait of Madame Adélaïde as Diana*, 97.3 × 123.9 cm, oil on canvas, 1745, Versailles, Musée national du Château (Réunion des Musées Nationaux)

effortlessly angled, pinkie raised, delicately fingering an arrow (with its obvious phallic associations) simultaneously leads up the flesh of her arm, across the tactile folds of her sleeve, which in turn sets off the softness of her naked shoulder and the supple curves of her breast and back. The beholder is effectively seduced by this image of the young princess, even led to covet her body, but at the same time, through the chosen guise of Diana, who punished Actaeon for his unintentional trespasses, reminded that any sexual transgression will result in punishment.

These sister pendants were painted at a time when Louis XV was considering suitable alliances through marriage for his children. Henriette's twin, Louise-Élisabeth, married a prince of Spain shortly before Henriette's portrait in the guise of Flora was commissioned. After this match, however, the king did not continue to pursue marriages for his daughters. Contemporary memoirs and historical studies conjecture that this was due to reasons of economy and status. The royal purse could simply not fund the dowries of numerous daughters, and a future king was the only man worthy of a Bourbon princess. But certainly at the time of commission, the queen and her eldest daughters of a marriageable age, Henriette and Adélaïde, would have considered matrimony as their ultimate goal and desired images that enhanced their beauty.[8] Portraits of noble women were often used to aid in the process of securing an appropriate suitor at a distant court. While these two portraits were not made for this specific purpose, it is likely that the paintings were created and viewed with the idea of their marriageability in mind.[9] Read together, the pendants present the daughters of France as models of femininity (in the guise of Flora) and chastity (in the guise of Diana), qualities that improved their value as commodities of exchange. Indeed, this was the function of portraiture for unmarried female sitters.

Traditionally and historically, however, the role of the portrait at court was to aid with processes of memory and to signal familial, political and social alliances. As Martin Warnke's study of the court artist has shown, noble portraits were considered to be counterfeit copies of royal sitters, making the absent present, standing in place of the original.[10] Portraits in general helped ease the sense of loss experienced when family members lived at foreign courts, or in the case Adélaïde's younger sisters, at a convent. Adélaïde was introduced to this particular function of court portraiture through a commission extended by her father only two years after her portrayal in the guise of Diana. Louis XV dispatched Nattier to the Abbaye de Fontevrault to complete a series of portraits of his youngest daughters almost a decade after their arrival, as an 'agreeable surprise' for Marie Leczynska.[11] At same time the queen was redefining her own role in 'retirement'. No longer the sexual partner of the king, having served France through the production of a male heir, Marie Leczynska is shown in Nattier's *Portrait of Marie Leczynska*

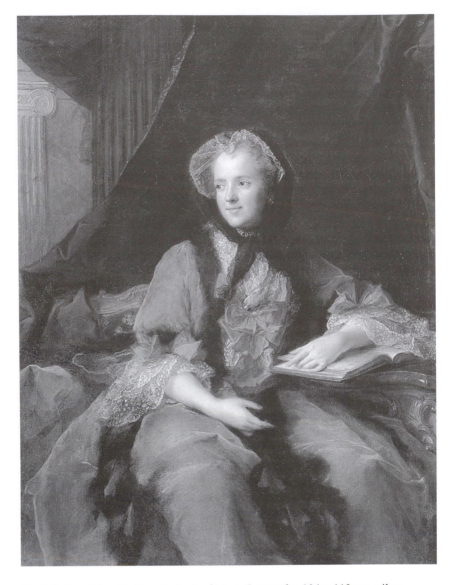

Fig. 6.2: Jean-Marc Nattier, *Portrait of Marie Leczynska*, 104 × 112 cm, oil on canvas, 1748, Versailles, Musée national du Château (Réunion des Musées Nationaux, Photograph, Gérard Blot)

(1748; Figure 6.2) as an unassuming private woman with her Bible, distanced from the public affairs of court life. Painted in the same year, the portraits of the daughters at Fontevrault (for example Figure 6.3) do not go to this devout

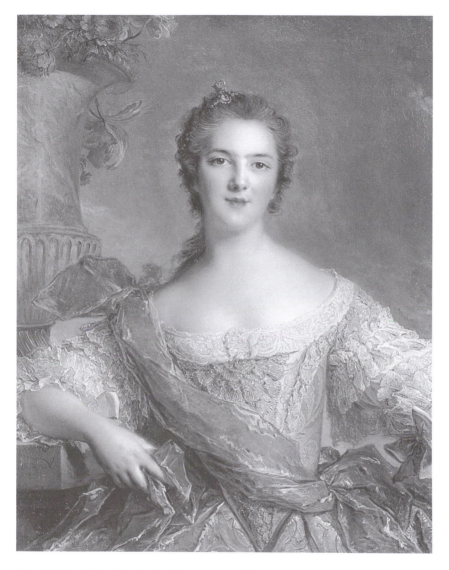

Fig. 6.3: Jean-Marc Nattier, *Madame Victoire de France at Fontevrault*, 81.5 × 64.2 cm, oil on canvas, 1748, Versailles, Musée national du Château (Réunion des Musées Nationaux)

extreme, despite the location of the sitters in a convent. Still, there is a consistent impression of retreat from the theme of sexual desirability among the wife and daughters of Louis XV. In the case of the sister portraits, a more sober record of appearance replaces the earlier portrayal of the daughters of

France as marriageable commodities. The bust-length portraits are effectively effigies, physical reminders of absent family members. Indeed, the paintings were made as counterfeit substitutions keeping the daughters present at court, even after it became financially impossible for them to remain physically. Once completed, the paintings were hung in the private, royal apartments at Versailles.

By the mid-1750s, the Fontevrault sister portraits are recorded in the dauphin's rooms, signaling the multiple function of these images in picturing and maintaining familial bonds of emotion and status.[12] In their physical absence, these portraits visualized sibling attachments in the private residence of their brother. Moreover, they did so collectively as sisters, bound together in a series, repetitive in size, pose and form. Sisterhood takes precedence over all other issues, including more conventional notions of femininity such as beauty and sexual desirability that we might otherwise expect in youthful female portraiture from this period.

Rapidly approaching the age of twenty, almost a decade after her older sister, Louise-Élisabeth, was married to the infant of Spain (the only daughter to be married), the prospect of not being a wife or mother, indeed not being sexually active, would have seemed a distinct possibility to Adélaïde. She would have no doubt wished to avoid a predictable future in which society would consider her to be 'an unpleasant figure in the world' as an older, unmarried woman.[13] To avoid such an impression of herself through the pictorial imaging of her identity, traditional modes of representing femininity and sexual desirability in portraiture would need to be replaced by other concepts that signaled an appropriate and rightful role of status, power and influence. Adélaïde had already witnessed how a copy of *Madame Henriette as Flora* and the original portrait of herself as Diana had been commissioned and placed at the king's château at Choisy, a place of privacy and relaxation.[14] Soon after this commission, a set of copies was ordered and sent to her sister at the court of Spain.[15] These acts of production and re-production emphasized her value as a daughter and sister. Moreover, hanging in the respective royal residences, the pendant copies marked her position as a blood relation to the king of France and the infant of Spain.

The most appropriate path of influence open to a daughter of Louis XV began to aim towards the performance of sisterhood, linking a group of unmarried women to the ruling men of France (as daughters, sisters and, later, under Louis XVI, aunts). In 1750 the dauphin (father of Louis XVI) commissioned a series of allegorical portraits of his four eldest sisters from Nattier via the *Directeur des Bâtiments* for his private rooms at Versailles.[16] The series depicts Louise-Élisabeth as Earth, Henriette as Fire, Adélaïde as Air, and Victoire as Water.[17] Such imagery is of an older order, connected with Grand Manner painting, in which the children of France are marked

publicly as demi-gods. In the intimate space of the dauphin's apartment, however, they demonstrated the close relationship of a potential future king of France to his sisters, who thereby retain important positions in the royal and court hierarchies through their bonds to the dauphin.

While these demonstrations of influence indicate how kinship could be displayed and maintained via pendant portraits, it is the court portraits of the mid-1750s that suggest a new direction for the performance of sisterhood, one that would be actively pursued by Adélaïde, indicating bonds of blood and hierarchies of position. The first of the large-scale sister portraits in court dress again originated with a single portrayal of Henriette (Figure 6.4), begun in 1748 and finished after the death of the princess in 1752. This painting was commissioned by the queen. While she is not recorded as the patron, Marie Leczynska urged the progress of the portrait the year her daughter died.[18] After its completion, however, the portrait did not hang in the queen's apartments at Versailles, but in the rooms of Madame Adélaïde. The process of commission and display, then, is much more complex than we might expect from traditional patronage. Ordered through the Directeur des Bâtiments, it was a mother's will that saw the work to completion for the possession of another daughter. This is quintessential matronage: a conception that focuses primarily on family relationships, rather than an individual, involving a network of women that consequently features the ties of gender (mother, daughter, sister). If the work can be considered as a gift from mother to daughter, as it very well may have been, it then encapsulates the ideas that connect Bourbon women. The fact that the portrait remained in Adélaïde's possession and was transported to Bellevue upon her removal from Versailles suggests the attachment that she had to this work. It can be considered as the building block from which she went on to construct an ideology of sisterhood through commission, collection and display.

In 1755, Nattier submitted a request to Madame Adélaïde for the painting of Henriette to be exhibited at the Salon.[19] There the painting was displayed between portraits of Madame de Pompadour and the marquis de Marigny. Elise Goodman has analyzed this arrangement as a statement of ambition on the part of the king's official mistress and her brother.[20] Goodman's proposals are certainly persuasive, yet the arrangement can also be explored in terms of what it conveyed to Adélaïde. Indeed, the association claimed by the portraits of Pompadour and Marigny was as much to the Bourbon sisters as a group, as it was to the dead Henriette. Moreover, as the owner of the painting, Adélaïde was even more directly involved in the meanings set up between Henriette's portrait and its neighbors. Pompadour and Marigny's portraits asserted the status and influence they enjoyed with the king via the parity of their physical placement at the Salon next to the body of a blood relation to Louis XV – specifically a daughter of France. For Adélaïde, the arrangement presented a

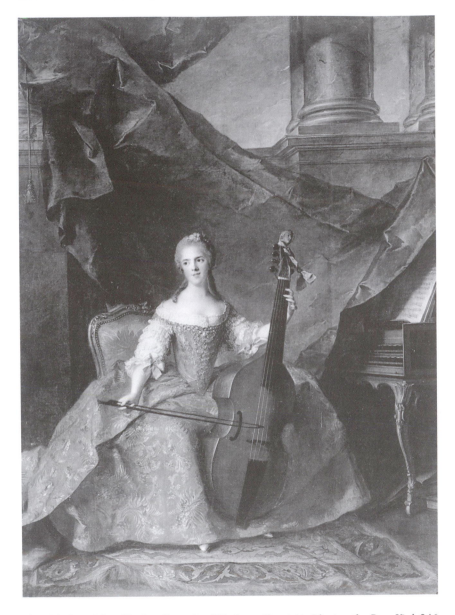

Fig. 6.4: Jean-Marc Nattier, *Portrait of Madame Henriette Playing the Bass Viol*, 246 × 185 cm, oil on canvas, 1754, Versailles, Musée national du Château (Réunion des Musées Nationaux)

vivid example of how meaningful alliances and public claims to power could be effectively seized, manipulated and declared through juxtaposition and pendant display.[21]

The opportunity to pursue meanings through pendant relationships was presented when the duchess of Parma visited Versailles in 1757. At that time a full-length portrait of Adélaïde was begun (Figure 6.5). There is no recorded patron, but it is likely that on the occasion of her visit Louise-Élisabeth requested a portrait of her younger sister.[22] The actual format of the painting was developed from a head study for an earlier, smaller work, *Madame Adélaïde Making Knots* (Versailles, musée national du Château), which was commissioned for the duchess of Parma in 1756. That painting was not completed as a formal court portrait, as originally intended, for financial reasons.[23] A year later, however, Nattier copied the face and frontal pose from the bust-length depiction into this court portrait, undoubtedly conceived as a pendant to *Madame Henriette Playing the Bass Viol*.[24] It is conceivable that Louise-Élisabeth wanted a more current pair of portraits to update the pendant copies of Henriette and Adélaïde made in 1745, which she already had in her possession, and that this idea came to her during her visit in 1757, when she would have seen the large portrait of Henriette for the first time. Whatever the reason for the commission, it acts as a sister pendant in both theme and design.

In the portrait, Adélaïde holds a book of music, a counterpart to the depiction of her sister playing the bass viol, and gives the impression of reviewing the musical score rather than singing.[25] Her hand is raised as if counting out the cadence of notes, demonstrating her musical training in her ability to read music and hear sounds in her head.[26] A stringed instrument and sheet of music sit on the table at her side, inclusions that contribute to the idea that she is a woman who is capable of both playing music and directing its performance. This concept of Adélaïde as a conductor is supported by her direct gaze and fully frontal pose that combine to command the beholder's attention. Henriette's body, her shoulders and torso in particular, are also frontally posed, but her head is tilted to one side with her eyes gazing in the same direction, as if towards an unseen audience, reinforcing her place as a performer. Adélaïde appears to be much more in control of the beholder and her image.

In general, Adélaïde's portrait directs the viewer to recognize her authority and position as Madame, the title given to the most senior-ranking female member of the royal family at court after the queen. Adélaïde gained the title after the death of Henriette, and due to the fact that her elder sister was married to the duc de Parma and living abroad, she became the senior-ranking sister at Versailles. But the painting does not simply evoke this position in connection with her sisters. The style of Adélaïde's dress, with its

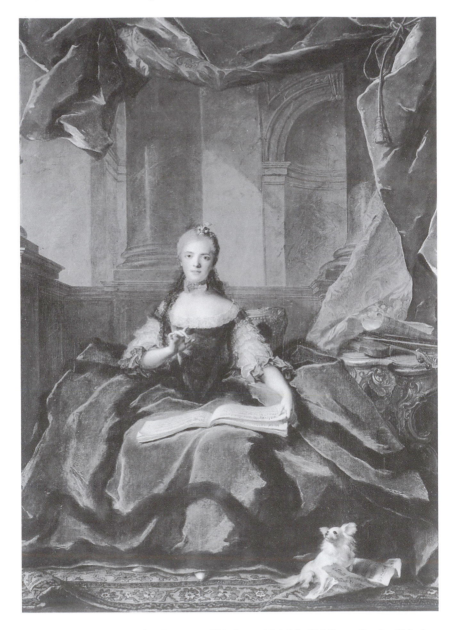

Fig. 6.5: Jean-Marc Nattier, *Portrait of Madame Adelaïde Holding a Book of Music*, 222 × 148 cm, oil on canvas, 1759, Versailles, Musée national du Château (Réunion des Musées Nationaux)

fur trim and lace sleeves and bodice, recalls the dress worn by her mother in Nattier's portrait of 1748 (Figure 6.2). This garment directly associates Adélaïde with the matriarch of her family and reinforces her position as the next 'matron', the eldest daughter present at court following the death of Henriette and in the absence of Louise-Élisabeth.

Similarly, with *Portrait of Louise-Elisabeth, Infanta of Spain, then Duchess of Parma* (Figure 6.6), the sitter is depicted at an angle, seated towards the left side of the canvas, with her face turned at three-quarters towards the viewer.[27] The depiction harks back to Rigaud's state portrait of Louis XIV (1701; musée du Louvre, Paris), although the duchess is seated, rather than standing. Still, the robe, crown and even the fan which she holds with her left hand recall the signs of authority in that image of her great-great-grandfather. The position of these elements along pivotal compositional lines indicates to the beholder their conceptual importance. The duchess sits at the center of the composition, establishing a strong vertical anchor for the scene, something that is further emphasized through the pilasters in the architectural background. Her dress and turned position, however, counter the extreme vertical by creating a pyramid structure, her knees then directing the beholder down along her front in a diagonal, which is paralleled by the flowing *fleur-de-lis* and ermine cape. The line of this latter diagonal is picked up again by the fan, a feminine substitution for the scepter of rule, which leads the eye across to the left of the canvas, along the table and line of the book (indicating her learning and leisure pursuits, the only element that connects with the domesticity of her sisters' portraits), back to her crown.

In relation to the images of her sisters, the painting is of similar size and concept, although, in contrast, she is not depicted in connection with the theme of music. The duchess's feminine talents are more directly linked to her position as the wife of a ruler. Her claim to authority is more direct, and in terms of the portrait, linked visually to Bourbon lineage and absolutism. Yet, when considering the works as pendants, the portrait of the duchess does not overwhelm or displace the portrait of Adélaïde. While her direct gaze and the symbols of authority cause the beholder to acknowledge her position, the figure depicting the duchess of Parma does not demand the same sort of attention as the commanding portrayal of Adélaïde in full-frontal pose.

The impetus for the commission of this portrait of the duchess of Parma, generally made in service to the king, was to honor a recently departed Daughter of France. Louise-Élisabeth died on 6 December 1759, with the portrait completed approximately one year later. It is difficult to know which member of the king's family actually desired the work, but it is tempting to believe that Adélaïde was involved in some way. As a group, the portraits of the two eldest sisters, both of whom were dead, essentially frame Adélaïde and, through their memory, sanction her status as the 'reigning' sister and

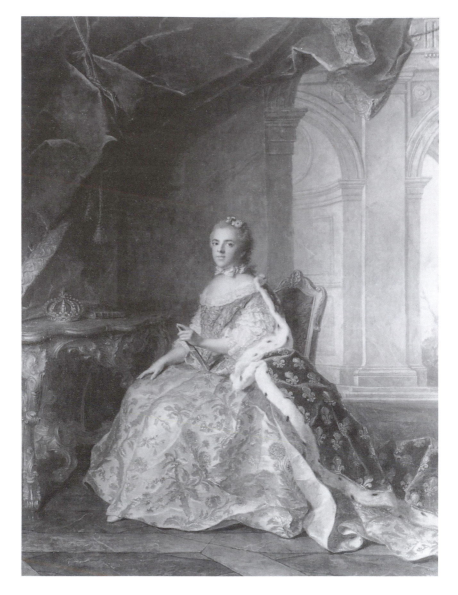

Fig. 6.6: Jean-Marc Nattier, *Portrait of Louise-Elisabeth, Infanta of Spain, then Duchess of Parma*, 240 × 184 cm, oil on canvas, 1762, Versailles, Musée national du Château (Réunion des Musées Nationaux)

urge the beholder to value her life. The poses of her sisters in their respective portraits make the arrangement of the three portraits obvious, so that Adélaïde would be placed in the center, framed by her older sisters, in fact or in idea. This centrality suggests Adélaïde's dominant role, with her position empowered in the portrait series by her elder sisters, who are painted to sit literally by her side. The portraits of the deceased Henriette and Louise-Élisabeth remind the beholder, a subject of the kingdom, that these two daughters of France had been lost to disease. The public did, after all, have an official attachment to the king's children. An entry in the *Encyclopédie* explains the traditional reference to the female offspring of the king as the Daughters of France in terms of devotion: 'all the subjects of the kingdom have a personal interest in their survival.'[28] Yet the pendants do more than simply cause the beholder to grieve. In concert, they work to energize the beholder's concern for Adélaïde.

Another commission extended to the sculptor Houdon indicates the problems of determining agency in royal portraits of this period. In 1777, Victoire summoned the sculptor to make her portrait. When he arrived, the princess persuaded Adélaïde to have her portrait made as well.[29] Houdon was still trying to get paid in 1789, when he appealed to the sisters. Adélaïde refused and stated that she had never ordered the bust to be made, essentially denying the role of patron and refusing to pay for the image from her personal funds. Houdon then went to the office of the *Directeur des Bâtiments* and Louis XVI eventually authorized payment. Such a path to payment does not clarify the issue of patronage. Because the request for a bust was apparently verbal and at the urging of her sister, Adélaïde is not exactly a 'patron' in a traditional sense of the word. However, the story does suggest how a 'matronage' of art may have functioned, following the pattern of sister portraits already set by earlier pendant commissions. Indeed, it is difficult to think of a portrait of one of these daughters of Louis XV without involving the idea of sisterhood, either through an actual pendant or via a request for a portrait to be made. Sisterhood is enacted through the very commission, whether as patron of record or not.

In her portrait by Labille-Guiard, Adélaïde assumes the position of sitter, patron and artist simultaneously, the matron of the visual memento of her family, past and present.[30] The *Portrait of Madame Adélaïde* (1787; Figure 7.1) undoubtedly conveys the princess's idea of herself. Standing before a medallion triple portrait of her father, mother and brother that she claims as her own, surrounded by sumptuous furnishings, of which she was known to be a important collector, dressed in elegant velvet, lace and silk, Adélaïde shows herself to be at once a faithful member of the Bourbon family line, an amateur artist, a patron of note, and a lady of fashion: in sum, the perfect image of a Daughter of France. At the same time, in the place that it occupied

at the Salon of 1787, it became a direct challenge to statement of regal motherhood pictured by Vigée-Lebrun's *Portrait of Marie-Antoinette and her Children* (Figure 8.1).[31] By depicting the queen as a 'real' mother, the role of France as the metaphorical mother of the king's children was effectively usurped.[32] Consequently, this image of Marie-Antoinette threatens the traditional role of women as vessels for the kingdom of France. Adélaïde, unmarried and childless, remains above all else a Daughter of France in her portrait, serving the memory of France by picturing her devotion to the Bourbon family line. The full extent of the claims being made by Adélaïde's image in this challenge to that of Marie-Antoinette – involving the performance of proper, noble femininity and claims of power – is only revealed through the more expansive message extending from pendant pictures of her sisters, which followed in the next Salon.

The full-length *Portrait of Victoire with a Statue of Friendship* and the posthumous *Portrait of Louise-Élisabeth of France, the Duchess of Parma and her son* (Figures 6.7 and 6.8) appeared in the Salon of 1789. The three portraits foreground the 'proper' roles assumed by women linked to the reign of Louis XV, more than to that of Louis XVI, and claim difference in regard to Marie-Antoinette. Collectively, they maintain that service to France extends beyond the duties of reproduction (although even motherhood is suggested by the pendants through the inclusion of the duchess of Parma). They are the true Daughters of France who have served the 'father' as daughter, sister, mother, aunt and friend.

With this in mind, it is perhaps not surprising to discover that the portraits of Adélaïde and Victoire enact the remembered virtues of their father's mistress, Madame de Pompadour, in the latter sister's homage to friendship and the former's activity as an amateur artist.[33] The specter of Pompadour must have never seemed far off to these two women. The sisters lived in her former residence, Bellevue, which they bought after inheriting substantial sums from their mother in 1768. Later, when tensions between Marie-Antoinette and the king's aunt were high, Louis XVI ordered Adélaïde to retire to Bellevue, a move that physically demonstrated the demise of Madame's influence over her nephew. Adélaïde may have even followed Pompadour's example in her support of the decorative arts, particularly with commissions for Bellevue.[34]

It is Victoire's portrait, however, that most directly links with the identity of Pompadour. Standing in a garden, understood to be at the residence she shared with her sister, Victoire gestures towards a statue of friendship. This is not Pigalle's famous portrait of Pompadour as *Amitié*, which was commissioned by the Favorite for the gardens at Bellevue, but it still recalls that work of sculpture and the statement it once made in that space. Connected with the shift in Pompadour's relationship to the king from that of sexual partner to that of friend and trusted confidante, the piece did more than simply mark this change.

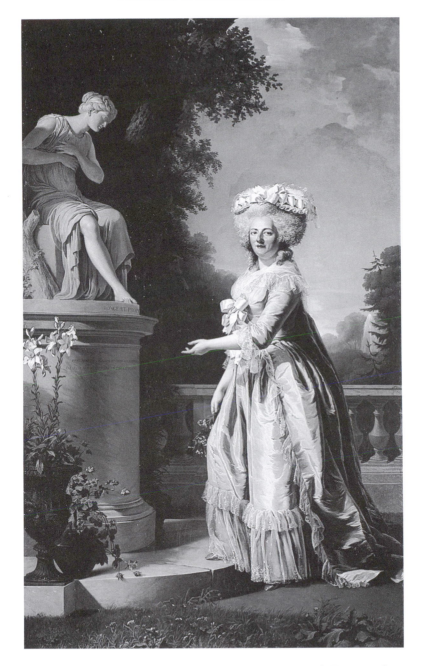

Fig. 6.7: Adélaïde Labille-Guiard, *Portrait of Madame Victoire de France with a Statue of Friendship*, 271 × 165 cm, oil on canvas, 1788, Versailles, Musée national du Château (Réunion des Musées Nationaux, Photograph: Arnaudet)

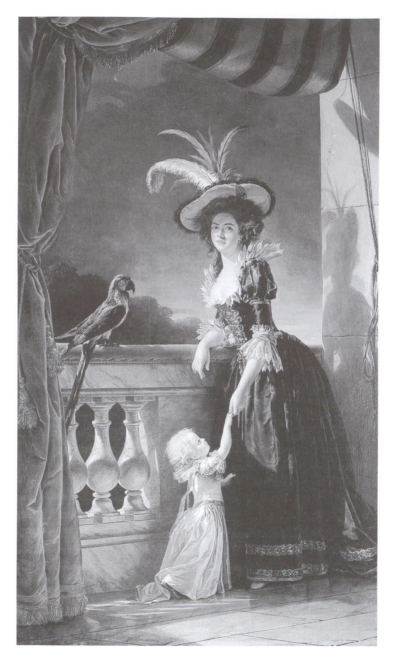

Fig. 6.8: Adélaïde Labille-Guiard, *Portrait of Louise-Élisabeth of France, the Duchess of Parma and her Son*, 272 × 160 cm, oil on canvas, 1788, Versailles, Musée national du Château (Réunion des Musées Nationaux, Photograph: Arnaudet)

It aimed to maintain her position through the recognition of a new type of influence resting on love in friendship rather than sexual love.[35] This message was directed at Queen Marie Leczynska, among others, who was shown the area of the garden where the statue stood and told that what was once the *Bosquet de l'amour* was now the *Bosquet de l'amitié*.[36] As Katherine Gordon has shown, the allegorical reference to the maintenance of power via friendship was uniquely connected with the biography of Pompadour in the second half of the eighteenth century.[37] Victoire's portrait then revives this idea of alternative feminine authority, without reference to sexuality. The iconography of friendship in Victoire's portrait recasts a non-sexualized route to influence within an ideology of sisterhood unique to the Bourbons and similarly challenges the power of the current queen, Marie-Antoinette.

The portrait of the duchess of Parma, who had been dead for almost thirty years, adds another dimension of meaning to the sister portraits.[38] Such a late posthumous portrait is out of the ordinary, but Louise-Élisabeth was the only sister to marry and become a mother. Her inclusion in this sister series is thereby essential to the collective performance of noble femininity, which necessarily included the production of heirs. While Adélaïde and Victoire assume the imagery of Pompadour through artistry and friendship, their deceased sister, the mother of an heir to a European throne, connects with the memory of their own mother, who so selflessly served the kingdom of France in childbirth. Together the sisters take on the characteristics of their father's wife and mistress, roles assumed by a single woman, Marie-Antoinette, under Louis XVI. The pendant portraits depict the royal woman's role as defined through sister relationships and present a new ideology of feminine virtue that draws from friendship, motherhood and memory – but it can only exist collectively. Female power is therefore divided and non-threatening to the 'rightful' male order sanctioned by Salic Law.

As with the portrait of Marie-Antoinette and her children, the themes of motherhood and royal lineage are foregrounded in the posthumous portrayal of Louise-Élisabeth and her son, Ferdinand, who became the Duke of Parma after the death of his father. Yet these are not the only meanings that run throughout the portrait. The compositional line that links Ferdinand to his mother (running diagonally from the bottom left corner of the canvas, across the top of his head to the duchess's elbow), is paralleled by a shorter line that connects her face and hat to the parrot. An unconventional inclusion in paintings of this time, the parrot is connected by Cesare Ripa to the attribute of quiescence.[39] This reference to inertia can be related to the duchess's deceased state, something that is reinforced on the other side of the painting by the shadow, which also symbolizes death. Read another way, however, both the parrot and the shadow suggest the traditional role of portraiture in making the absent present. In this context, just as the origin of portraiture

existed in the outline of a departing lover's shadow,[40] the painted portrait 'speaks' for the absent person, mimicking their presence as a parrot mimics sound. The idea of the role of art in honoring the memory of those who have departed, first raised by Adélaïde-as-artist in her portrait exhibited at the Salon of 1787, is completed by Adélaïde-as-patron in the portrait of her sister in the Salon of 1789. Such a reading is urged through the process of visual memory itself – the beholder at the Salons who would remember seeing that earlier portrait on display two years before.

With this pendant series, Madame Adélaïde claims her position as a muse, inspiring the production of art that aids the public memory of Bourbon family line. Furetière's *Dictionnaire universel* (4th edn, 1727) describes how the muses (the daughters of Jupiter) and the furies (the daughters of Hell) are poetically referred to as the daughters of memory.[41] Adélaïde's matronage, then, is the act of a daughter of Jupiter, which on one level, she could assume to be as the daughter of Louis XV, descendant of the gods, a modern-day Jupiter in eighteenth-century France. Adélaïde's portrait foregrounds her dedication to the family and by extension France. This is epitomized by the inscription that she authors below the medallion portrait of her father, mother, and brother: 'Their image is still the delight of my life.' In contrast, Marie-Antoinette – a nemesis for Adélaïde at this point, who was also attempting to use portraiture to sway public opinion about herself – becomes a fury in France, the daughter of a foreign state and a negative influence on the Crown, inspiring rage. Through the sister portraits and the challenge that they make to the image of Marie-Antoinette constructed through portraiture, Adélaïde demands to be seen as the leading Bourbon 'matron', not in the customary sense of a married woman, but in the alternative meaning of a woman who is in charge of the domestic affairs of an institution – in this case the institution of the French monarchy – the rightful protector of the Bourbon family line.

Notes

1. This essay expands on my brief study of Madame Adélaïde in the *Dictionary of Artists' Models* (London: Fitzroy and Dearborne Press, 2002).
2. The most useful biographies of Adélaïde and her sisters are Edouard de Barthélémy's *Mesdames de France, filles de Louis XV* (1870), C. Stryienski's *Mesdames de France: Filles de Louis XV* (Paris, 1911) and Simone Poignant's *Les filles de Louis XV. L'Aile des Princes* (Paris: Arthaud, 1970).
3. Adélaïde was the third surviving daughter of Louis XV, but she claimed the lead role once her older sisters were no longer present at court (following the displacement of Louise-Élisabeth at her marriage to the duc de Parma and the death of Henriette).
4. Anne-Marie Passez, *Adélaïde Labille-Guiard 1749–1803. Biographie et catalogue raisonnée de son œuvre* (Paris: Arts et Metiers Graphiques, 1973); Pierre

de Nolhac, *J.-M. Nattier: Peintre de la cour de Louis XV* (Paris, 1925), 119–83; Xavier Salmon, *Jean-Marc Nattier 1685–1766* (Paris: Réunion des musées nationaux, 1999); Philippe Renard, *Jean-Marc Nattier (1685–1766). Un artiste parisien à la cour de Louis XV* (Château de Saint-Rémy-en-l'Eau: Éditions Monelle Hayot, 1999); H. H. Arnason, *The Sculptures of Houdon* (London: Phaidon Press, 1975), 37–41; Charles Oulmont, *J.-E. Heinsius (1740–1812). Peintre de Mesdames de France*, in *Oeuvres complètes de Charles Oulmont*, vol. 19 (Strasbourg and Paris: Istra, 1970).

5. The imaging of sister relationships has received scant attention from art historians. For a notable exception, see Jerrine E. Mitchell, 'Picturing Sisters: 1790 Portraits by J.-L. David', *Eighteenth-Century Studies* 31(1997–98), 175–97.

6. It is worth noting here that I am often less interested in who commissioned specific paintings than the use that Adélaïde made of the images, not simply determining her direct involvement in their creation or hanging (or lack thereof), but instead assessing how she may have indirectly derived the visual material to put forth an ideology of sisterhood in commissions that she clearly oversaw, such as those given to Adélaïde Labille-Guiard.

7. See Philip Conisbee, *Painting in Eighteenth-Century France* (Oxford: Phaidon Press, 1981). It is interesting to note that Madame de Pompadour was painted by Nattier in the guise of Diana at approximately the same time. Goodman has suggested that the choice of Diana for Pompadour was intentional, connecting her to a long line of French royal mistresses who had been represented in this guise. See Elise Goodman, *The Portraits of Madame de Pompadour. Celebrating the Femme Savant* (Berkeley, Los Angeles and London: University of California Press, 2000), 13–14.

8. Louise-Élisabeth was twelve when she married. At the time their respective portraits were painted, Henriette was fourteen and Adélaïde was thirteen. In the case of Adélaïde, there was talk of marriage to the Prince de Conti and Prince Xavier, the brother of the dauphine.

9. Kathleen Nicholson has analyzed how such allegorical portraits urged viewers to search for 'a play of meanings' involving the identity of the sitter and her chosen guise. See her 'Ideology of feminine "virtue": the vestal virgin in French eighteenth-century portraiture,' in *Portraiture. Facing the subject*, ed. Joanna Woodall (Manchester and New York: Manchester University Press), 56–7.

10. Martin Warnke, *The Court Artist: On the Ancestry of the Modern Artist*, trans. David McLintock (Cambridge: Cambridge University Press, 1993).

11. For further discussion of the paintings and their history, see Salmon, *Jean-Marc Nattier*, cat. nos 49–51. In 1738, Louis XV sent his four youngest daughters to live at the Abbaye de Fontevrault. The decision was based on financial necessity, as it was too expensive to keep the girls at court. Victoire, Sophie, Felicity and Louise ranged in age from five to just under one year old. The queen's sense of loss as a mother was no doubt acute and long lasting. Adélaïde was meant to go as well, but she appealed directly to her father at the last moment before departure, begging him to allow her to stay. Touched by her appeal, the king did allow Adélaïde to remain at court, and she began to have a great deal of contact with him. In 1746, a year after the Diana portrait was completed, she hunted with the king five days a week.

12. Salmon, *Jean-Marc Nattier*, 194.

13. The definition of *fille* in Antoine Furetière's *Dictionnaire Universel* indicates

the social stigma attached to an unmarried woman: 'C'est dommage que cette personne veuille demeurer fille toute sa vie. Une vieille fille fait une vilaine figure dans le monde.'

14. Salmon, *Jean-Marc Nattier*, 156–7 and 177–80.
15. Ibid., 156.
16. Ibid., 223–30.
17. All four paintings are held at the Museu de Arte, São Paulo.
18. Salmon, *Jean-Marc Nattier*, 251.
19. The correspondence is quoted and discussed in Nolhac, *J.-M. Nattier*, 170–71.
20. Goodman, *Portraits of Madame de Pompadour*, 31.
21. Eighteenth-century beholders drew meanings from paintings that were on view together, in private or public spaces. See Andrew McClellan, *Inventing the Louvre: Art, Politics, and the Origins of the Modern Museum in Eighteenth-Century Paris* (Cambridge and New York: Cambridge University Press, 1994), 31 and 47, and Colin B. Bailey, 'Conventions of the Eighteenth-Century *Cabinet de tableaux*: Blondel d'Azincourt's *La première idée de la curiosité*', *Art Bulletin* 69 (1987): 433–4.
22. There was controversy over the original and copies. Pierre de Nolhac believed that the original painting was lost and that the works at Versailles and the Louvre were copies. More recently, however, Xavier Salmon has argued that the superior quality of the Versailles version, in comparison with the version in the Louvre, determines the former work as the original. See Nolhac, *J.-M. Nattier*, 179 and Salmon, *Jean-Marc Nattier*, 281.
23. Ibid.
24. These paintings are of a domestic variety of court portraiture popular in this period, combining the monumental scale of formal, state portraits with the informality of a private activity or personal pursuit. See George T. M. Shackelford and Mary Tavener Holmes, *A Magic Mirror: The Portrait in France, 1700–1900*, exh. cat. (Houston, 1986), 10–11. In regard to the pendant relationship, Nattier described the portrait in a letter to Marigny as 'le grand portrait de Madame qui doit faire pendant à celui de Mme. Henriette.' *Archives nationales*, Paris, vol. 1, 1909, doc. 7, quoted in Salmon, *Jean-Marc Nattier*, 282.
25. Nolhac quotes a letter written by Nattier, in which the artist describes the figure of Adélaïde as 'faisant l'action de quelqu'un qui chante'. I do not believe that this statement of the artist's perception in any way discounts the visual reception of the image that I am outlining here. See Nolhac, *J.-M. Nattier*, 179.
26. According to the memoirs of the duc de Luynes, the king presented a violin to Adélaïde during a private concert, which she then proceeded to play alongside the professional musicians. She was certainly well trained, having been taught by Jean-Pierre Guignon. The violin in the painting is most certainly the instrument made for Adélaïde by Nicola Gagliano. See A. P. de Mirimonde, *L'Iconographie musicale sous les rois bourbons. La musique dans les arts plastiques: XVIIe–XVIIIe siècles* (Paris: Picard, 1977), 2: 53 and illustration 26. For the importance of music in the life of the daughters of Louis XV, particularly during adolescence, see Poignant, *Les filles de Louis XV*, chap. 4.
27. The portrait was painted in service to the king at the order of Marigny during 1761. Once thought to have been sent to the duc de Parma, Xavier Salmon has recently demonstrated that the work was cited in the inventory of paintings in the *cabinet du roi* at Versailles in 1784. See Salmon, *Jean-Marc Nattier*, 291.
28. 'Les fils & filles du Roi de France sont appellés fils & filles de France, parce

que tous les sujets du royaume ont un intérêt particulier à leur conservation.'
*Encyclopédie, ou Dictionnaire raisonné des sciences, des arts et des métiers,
par une société de gens de lettres. Mis en ordre & publié par M. Diderot ... &
quant à la partie mathématique, par M. d'Alembert,* 17 vols (Paris, 1751–65).
See vol. 6, entry *Fille*.

29. Victoire's portrait bust is now held in the Wallace Collection, London, while
 that of Adélaïde is in the Louvre. For further discussion of the problems experi-
 enced by Houdon in getting paid for these portrait busts, see Arnason, *The
 Sculptures of Houdon*, 37–40.
30. See Melissa Hyde's essay in this collection (Chapter 7) for a careful reading of
 this painting and what it claims for the artist, Labille-Guiard, as much as for
 Madame.
31. An engraving by Martini shows the proximate hanging of the two paintings,
 encouraging Salon visitors to view the two works in tandem. Pictured as illus-
 tration 5 in Jean Cailleux, 'Portrait of Madame Adélaïde of France, Daughter of
 Louis XV,' *The Burlington Magazine* 22 (March 1969), i–vi.
32. Mary Sheriff has perceptively analyzed the displacement of the queen of France
 as mother and wife by the *royaume*, to whom the king was metaphorically
 married. In effect, I am turning this displacement around to consider the prob-
 lematic reception of Marie-Antoinette's image as an attempt to displace the
 traditional role of the kingdom of France as mother to the king's children.
 Sheriff, *The Exceptional Woman: Elisabeth Vigée-Lebrun and the Cultural Poli-
 tics of Art* (Chicago and London: University of Chicago Press, 1996), 156. See
 also her essay in this volume, 'The cradle is empty: Elisabeth Vigée-Lebrun,
 Marie-Antoinette, and the problem of intention' (Chapter 8).
33. Pompadour's printmaking activities are pictured in the lower left corner of
 Boucher's *Portrait of Madame de Pompadour* (1756; Munich, Bayerische
 Staatsgemäldesammlungen, Alte Pinakothek). Boucher also painted Pompadour
 standing before an easel, with her hand on a portfolio of drawings, although
 that work is now lost. For more on the picturing of Pompadour as an artist and
 maker of her own image, see Melissa Hyde, 'The "Makeup" of the Marquise:
 Boucher's Portrait of Pompadour at Her Toilette', *The Art Bulletin* 82: 3 (Sep-
 tember 2000), 453–75. Elise Goodman has also discussed the depiction of
 Pompadour as an engraver within portraits by Boucher and La Tour. See
 Goodman, *Portraits of Madame de Pompadour*, 128–31.
34. Goodman has discussed Pompadour's activities as a patron of the arts at Bellevue
 in terms of mimicking the habits of Louis XIV's mistress, Madame de Montespan.
 See Goodman, *Portraits of Madame de Pompadour*, 60. It is tempting to con-
 sider the actions of Adélaïde as similarly following a path laid by these powerful
 mistresses.
35. See Katherine K. Gordon, 'Madame de Pompadour, Pigalle, and the Iconogra-
 phy of Friendship', *Art Bulletin* 50 (1968), 249–62; and, more recently, Goodman,
 Portraits of Madame de Pompadour, 16.
36. Pierre de Nolhac, *Louis XV et Madame de Pompadour* (Paris: Calmann-Lévy,
 1903), 143 and Gordon, 'Madame de Pompadour,' 261.
37. Ibid., 257.
38. The duchess of Parma died in 1759 from smallpox. Adélaïde and Victoire
 commissioned this portrait together. However, as with the three portraits com-
 pleted by Nattier, it is Adélaïde who appears to direct the artistic performance.
39. See Christopher Johns's discussion of the potential meanings associated with

parrots in his essay, ' "An ornament of Italy and the premier female painter of Europe": Rosalba Carriera and the Roman academy', also in this volume (Chapter 2). I would like to thank Roger Benjamin and Michael Hill for drawing my attention to this parrot in the discussion that followed my paper on the sister portraits at the annual meeting of the Australian Art Association in 2001.

40. According to Greek legend, the first portrait was made by a young woman of Corinth who traced the shadow of her lover's face prior to his departure to war and certain death.

41. See the entry under *Fille*.

Under the Sign of Minerva: Adélaïde Labille-Guiard's *Portrait of Madame Adélaïde*

Melissa Hyde

> Nothing, in any case, could be more appropriate than to represent in the form of the Goddess of the Arts, the illustrious person who, in our time, has demonstrated all the advantages and the talents that we attribute to Minerva.
> Préface, *Suite d'estampes gravées par Madame de Pompadour*, 1782

The Salon of 1787 saw one of the few programmatic attempts on the part of the court of Louis XVI to mobilize the visual arts in defense of a monarchy that was coming under increasingly virulent attack in the aftermath of the Diamond Necklace Affair, the disastrous Calonne ministry and the convocation of the Assembly of Notables. A remarkable aspect of this recuperative intervention is that its most conspicuous and significant manifestations came from the 'distaff side' of the Academy and the royal family, the one camp as historically diminutive as the other was mute – in the public sphere, at least. Adélaïde Labille-Guiard was one of the painters enlisted for this initiative. It would occasion one of her most important and ambitious works, the magnificent state portrait of Madame Adélaïde (Figure 7.1), the eldest surviving daughter of Louis XV, and aunt of Louis XVI. While a portrait of the reigning king's spinster auntie may seem an improbable vehicle for a serious defense of Bourbon honor and legitimacy, there is much about the picture to suggest it was intended to perform precisely that function.[1] What is more, within the political and cultural climate of 1787, depicting Madame Adélaïde in a *portrait d'apparat* intended for public view meant engaging with many issues besides the vexed status of the Bourbon monarchy. These ranged from broad, politically charged questions concerning the social role of women, and their

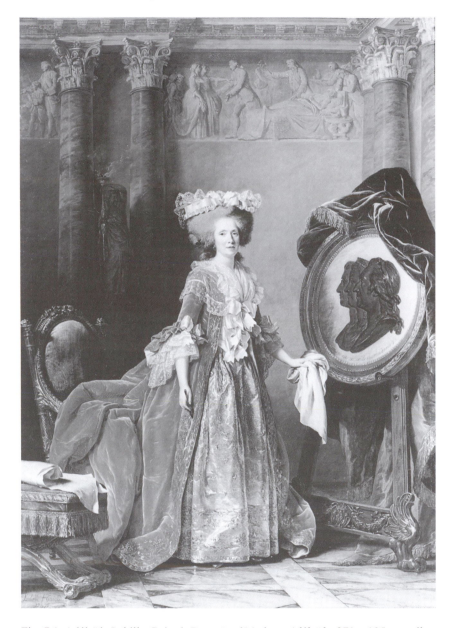

Fig. 7.1: Adélaïde Labille-Guiard, *Portrait of Madame Adélaïde*, 271 × 195 cm, oil on canvas, 1787, Versailles, Musée national du Château (Réunion des Musées Nationaux/Art Resource, NY)

involvement in the public sphere, to local problems of how to contrive an appropriate iconography for a spinster princess of the blood, and how to make a portrait of that formidable princess discursively meaningful. In this essay I examine some of the pictorial strategies that Labille-Guiard devised to perform the task of representing Madame Adélaïde in 1787 – strategies that revolve around the artist's deft adaptation of seventeenth-century allegorical imagery that was both highly appropriate to the project and semiotically rich. I will end by offering some reflections on the ways in which the *Portrait of Madame Adélaïde* can be understood in light of the artist's own self-representations and issues relating to the woman artist, as well as the intersubjective processes involved in the act of portrayal.

The image of Adélaïde: representing Madame

When she was commissioned to paint Madame Adélaïde in 1786, Labille-Guiard's star was rising – it had been since her election to the Académie royale de peinture et de sculpture three years earlier. An honor for any artist, Labille-Guiard's admission to that elite company was an especially brilliant professional victory, given that women's membership had always been exceptional and their numbers highly restricted. However, two weeks before the opening of the Salon in August of 1787, the artist would be awarded an even rarer distinction: on the strength of Madame Adélaïde's portrait,[2] Labille-Guiard was named First Painter to 'Mesdames Tantes', that is, to Adélaïde and her sister Victoire, whose portrait Labille-Guiard had just begun by the time of the 1787 Salon. A pastel study of Victoire hung near the portrait of Adélaïde, along with another of Louis XVI's sister, Madame Élisabeth, also by Labille-Guiard.[3] The artist's new title was conspicuously appended to her name in the Salon *livret* which offered a lengthy description of Adélaïde's *portrait d'apparat* – significantly, a practice usually reserved for history painting.

This life-sized painting shows the 55-year-old princess standing in an enclosed gallery adorned with Corinthian columns and intricately inlaid floors of colored marble. The cool colors, muted tones and spare elegance of the setting are played off against the brilliant color and opulence of the princess's raiments and the luxurious furnishings that surround her. Madame Adélaïde is sumptuously attired in a formal robe of red velvet with a pearl-gray silk petticoat, both embellished by fine gold embroidery; a lace fichu encircles her shoulders, more lace adorns her ruffled sleeves, a ladder of white satin bows covers her bodice and a frilled butterfly cap of prodigious proportions crowns her fashionably outsized coiffure. If the fussy toilette accedes to conventional feminine vanities, the treatment of the face does not. One of the

extraordinary things about the portrait is that Labille-Guiard did not prevaricate about the princess's age or flatter her sitter overmuch with cosmetic improvements (though she did conceal such infelicities as Madame's complete lack of teeth, but for the front two).[4] It presents Madame Adélaïde, *sans fard*, both literally and figuratively. The princess comes across as a woman of a certain age who, with her slackening jaw line and slightly bulbous nose, was no beauty. But she also appears as a commanding, even authoritative presence, as she stands perfectly centered in the composition, her slender form rigidly vertical. The gracility of her body is at once counterbalanced and grounded by the voluminous, conical skirt of her gown. To her proper left is an ornate easel, which supports an oval-framed canvas with medallion portraits of her father, the late King Louis XV, her mother, Queen Marie Leczynska and brother, the dauphin (both also dead). In her right hand Madame holds a port-crayon, and has just inscribed the words, 'Their image is still the delight of my life' below the cameo portraits, which are made to look like bronze bas-relief. Behind Adélaïde the statue of a vestal virgin holds her eternal flame aloft. The mood of this image is elegiac, retrospective, melancholic – even a little lachrymose, as contemporary viewers understood Madame Adélaïde to be holding in her left hand a handkerchief to stanch the tears inspired by her reflections on the effigies before her.

There are two other significant details of the painting that should not be overlooked: the sculpted bas-reliefs on the wall behind the princess, and the architectural plan that unfurls on the *tabouret* in the left foreground. The bas-relief directly above her depicts a poignant deathbed scene that took place nearly fifteen years before, during the last hours of Louis XV. When their father had fallen fatally ill with smallpox, the daughters flew to his side, and courageously insisted on attending him, heedless of the grave risks to themselves. 'Happily we are only princesses,' they exclaimed.[5] Being 'only princesses', they were expendable and could afford to perform such perilous acts of 'filial' duty without endangering France's patrilineage. It is clear that the intelligent and ambitious Adélaïde had often chafed at being 'only a princess'. In a land ruled by the law of the father, the limitations imposed upon her were multifold, making the opportunities for a mere daughter to act – heroically or otherwise – conspicuously scarce.[6] Thus the bas-relief seizes upon and makes the most of Adélaïde's shining hour, giving us only a fragmented glimpse in the adjacent bas-relief of the dauphin with his father at the battle of Fontenoy (one of Louis XV's greatest military triumphs). The deathbed scene underscores Adélaïde's status as loyal, brave and self-sacrificing princess. Her religious virtue and beneficence are alluded to through the architectural plan, which is recognizable as an Augustine convent near Versailles whose construction Madame Adélaïde sponsored and oversaw. The portrait, then, presents her as charitable, pious, dutiful, courageous and more

than a little imposing. It also points to Adélaïde's appreciation for the fine arts, her cultivated taste as a collector of furniture and her love of beautiful clothes.[7] In all ways it identifies her as a daughter of France, from the style of her dress (she is dressed in the semi-formal, traditional *robe à la Française* still worn at court), to the accouterments and attributes with which she is shown.

Critics of the time recognized this picture as being close to a history painting, not only because of its large scale, compositional and iconographic complexity, but also because of the quasi-narrative nature of its content, which is quite explicitly political. Beyond being a remarkably frank likeness of Madame Adélaïde and her attributes and noble deeds, it is practically a manifesto of traditional Bourbon virtues, patrilineage and authority. Its traditionalism is visible in its adherence to compositional formulae that, along with the descriptive inventory of resplendent costumes and possessions, invoke long-standing conventions for formal state portraiture. (One thinks of the official images of her mother, Queen Marie Leczynska, in full court regalia by Carle Van Loo, for example.)[8]

As the eldest member of the royal family who came of age in an era of relatively unchallenged monarchy, Madame Adélaïde was staunchly old-fashioned and politically conservative. She was therefore ideally suited to figure the traditional character and values of the Bourbons, and to celebrate their storied past. A partisan of the *dévots* and close to her nephew, Louis XVI, Adélaïde was a force to be reckoned with at court, where she was also the guardian of custom. Her vigilance extended to the minutiae of daily life; so fanatical was she about observing the fixed rituals and tortured protocols of Versailles that the court wags referred to her as '*Monsieur*' – a reference to the similar zealotry of the brother of Louis XIV.[9] Her status as straight-laced upholder of tradition perhaps finds pictorial expression in the rhymings between Adélaïde and elements in the painting that perform supporting functions: the easel, the Corinthian columns (which not only echo the verticality of her body, but are crowned with a similarly frilly cap). It is also implied in this picture that like the vestal virgin holding a torch in the background, she too is a faithful keeper of the flame.

Madame Adélaïde was more than pleased with her portrait. She commissioned additional copies from Labille-Guiard, which she gave to her intimates. The painting must have held special significance for the artist herself since she kept a full-sized replica of the work for the rest of her life.[10] The portrait was given pride of place at the Salon and was well received by the critics. However, a few days after the exhibition opened Labille-Guiard's picture was cast in the shade by another state portrait of the same dimensions that was hung next to it (or almost), depicting the most famous woman in the realm.[11] This painting was also described as closer to history than portraiture, was

also highly political and was also painted by a woman. The portrait was Élisabeth-Louise Vigée-Lebrun's *Marie-Antoinette and her Children* (Figure 8.1).

Much was made at the time of the rivalry between Labille-Guiard and Vigée-Lebrun. Admitted to the Academy on the same day, both were renowned as portraitists and enjoyed the patronage of the royal family – particularly of the most prominent women in the royal family, who at times were very much at odds with one another. (Among other things, Adélaïde did not approve of Marie-Antoinette's rejection of the pomp and circumstance of court life in favor of a more privatized, aristocratic, but unqueenly, existence.) The two painters were constantly compared to and measured against one another, as they continue to be in current art histories. Perhaps the rivalry between them was real – there is evidence at least that Vigée-Lebrun regarded Labille-Guiard with a certain animosity.[12] However, my purpose in comparing works by these artists is to make a point about the way in which Vigée-Lebrun's painting throws into relief the rather unconventional image of womanhood portrayed by Labille-Guiard, even as they presented at the Salon a united front of Bourbon nobility, goodness and legitimacy that extended along the entire axis of its past, present and future.

As the scholarship on Vigée-Lebrun's painting has shown, *Marie-Antoinette and her Children* (Figure 8.1) must be understood against the background of the growing hostility towards the queen in the 1780s, which took on a particularly venomous tone after the Diamond Necklace Affair (the scandal which implicated the hapless queen – if only in the minds of her subjects – in the theft of the most infamous piece of jewelry in France, a diamond necklace worth one and a half million *livres*).[13] Mary Sheriff offers a superb new interpretation of this multivalent painting in the present volume (Chapter 8), so I will not dwell on it here, except to highlight a few points about its iconography: the portrait alludes to images of the Holy Family, while also evoking references to the exemplar of the Roman matron – Cornelia, mother of the Gracchi, who famously disavowed the frivolities of jewelry by declaring her children to be her most precious adornments.[14] Vigée-Lebrun's painting sought to define Marie-Antoinette as an exemplum of tender, affectionate and dutiful motherhood, and, at the same time, as domesticated queen in the great French tradition – precisely what the fashionable and unconstrained Marie-Antoinette had never been.[15] For all its regal grandeur, Vigée-Lebrun's painting also situated the queen (however uneasily) within the bounds of new Enlightenment ideologies of the loving family, which equated motherhood and confinement to the domestic sphere (or in this case, the queen's quarters at Versailles) with political virtue. Whether or not the painting successfully achieved its ends, I want to emphasize that it calls up an ideal of womanhood that transcended class lines, as attested by Vigée-Lebrun's *Self-Portrait with*

her Daughter Julie (Paris, Louvre), shown at the same Salon, along with other images like *The Marquise de Pezay with the Marquise de Rougé and her Sons* (National Gallery, Washington, DC), both of which present a similarly clear picture of maternal love and fulfillment.

As an unmarried, aging princess, Madame Adélaïde could have no recourse to these consoling Enlightenment ideals of femininity (and as custodian of the flame of tradition, might not have not have wanted to align herself with such new-fangled notions – there seems to be little trace of them in the fanciful posthumous portrait of the duchess of Parma, the eldest of Louis XV's daughters, that Labille-Guiard painted for Mesdames in 1788 to accompany their completed portraits) (Figure 6.8). It is possible that Adélaïde's circumstances, so different from those of the queen, did not urgently call for such reassurances. Yet, in an era when women's involvement in the public sphere was a highly charged matter, and ideals of womanhood were coming to be defined so heavily in terms of maternal virtue, representing Madame Adélaïde and her *raison d'être*, which did not fit with any of the normative categories of womanhood, must have presented a challenge – not only on a conceptual level, but in terms of iconography. Being neither queen, nor wife, nor mother; not a widow, a nun, an intellectual nor a beauty, there were very few truly appropriate models (iconographic or otherwise) for Adélaïde.

Before I say anything about how Labille-Guiard dealt with the task of representing her patron, I want to consider the question of what correctives Adélaïde's portrait was meant to offer and on whose behalf. While it is clear that the portrait asserts the probity and honor of the Bourbons in general, I want to suggest that there is another agenda at work in the painting that is specific to Adélaïde, and more akin to the remedial purpose of Vigée-Lebrun's portrait of Marie-Antoinette than might appear.[16] Where seditious pamphlets and prints had cast the queen as an adulterous, conniving wife, rumors had cast Adélaïde as culpable daughter and unnatural mother. The princess had been unusually indulgent and generous towards one vicomte de Narbonne, the son of Adélaïde's *dame d'honneur*. Madame 'made enormous sacrifices to his caprices', as one of her contemporaries put it.[17] This solicitude fueled speculations that the young vicomte was actually Adélaïde's son – the shameful issue of her incestuous relationship with her own father.[18] The portrait, which insists explicitly on Adélaïde's virtue with the inclusion of the vestal virgin and offers an unambiguous statement about her unsullied condition, should perhaps be understood as a riposte to this bit of calumny. (Without wishing to stretch the point too far, it is worth noting that *Tuccia*, the most famous of vestals and the paragon of female chastity, was wrongly accused of incest.) The emphasis on Adélaïde's devotion to her mother and father and brother, the pointed reference to her general beneficence and charitable habits, may also have been related to the refutation of the incest rumor. Ironically,

if Salon-goers had forgot the slander, they would have been reminded of it by the presence of Labille-Guiard's portrait of the comtesse de Narbonne hanging nearby. Like the jewel case in Vigée-Lebrun's portrait of the queen, Labille-Guiard's work may have evoked – if only inadvertently – the very scandal it was meant to deflect.

Adélaïde's image and the tradition of 'representing' women

Turning then, to the visual rhetoric of the portrait itself and the strategy devised by Labille-Guiard to represent this difficult subject (difficult in every sense). Labille-Guiard's answer to the challenge was, I think, quite brilliant – but also unusual, and a reflection of herself as much as of Madame Adélaïde. This image, so carefully composed, is meaningful in its every detail. And yet the essential conceit of the picture is always passed over without comment: the portrait represents Madame Adélaïde *as an artist*, as a woman who, herself, represents. Since she holds a port-crayon rather than a paintbrush in her hand, it might be argued that Adélaïde ought to be understood as having produced nothing more than the inscription below the images on the easel. But Labille-Guiard's words, published in the Salon *livret*, make clear how she conceived of the scene: 'The princess, who is assumed to have painted [the medallion portraits] herself, has just written the words: "Their image is still the delight of my life"'.[19] And contemporary viewers treated the work as picturing Adélaïde as the author of the images within the image. The Salon of 1787 in the *Mémoires secrets* describes the work in this way:

> Standing upright before her artwork (*ouvrage*), she holds in her left hand a handkerchief, with which she is about to wipe the tears wrung from her by her thoughts, and which she has repressed during her work (*travail*); she still holds in her right hand the crayon which she has just been using.[20]

So central is Adélaïde's status as artist that when Labille-Guiard made a reduced copy of the picture (now in the Phoenix Art Museum), the bas-reliefs in the background were deemed expendable; but even more importantly, she left out the inscription, which removes any uncertainty about who is supposed to have made the picture on the easel.

The decision to depict Adélaïde as an artist warrants examination. It is a seemingly peculiar and unprecedented choice for a formal portrait of a royal princess. As the pendant to the portrait of the sweet and retiring Madame Victoire, who is shown pointing to a statue of Friendship (by all accounts an apt emblem of her personality) (Figure 6.7), the logic of representing Adélaïde as a maker of images is not obvious. For one thing, it alludes to an acquired manual skill rather than an attribute of her character or personality. It was

also an odd choice in view of the fact that it could have made the princess vulnerable to the charge of derogating herself, since the portrait implies that she worked with her hands – even if it was for the exalted purpose of making art. As one commentator would claim some years later in another context (that is, a vituperative critique of Madame de Pompadour, in which her artistic practices were taken to be an incontrovertible sign of her bourgeois origins): 'It is well known that people of quality do not have talents [for making art]; it is said that they are born to judge the fine arts and to enjoy them, but such people are not art makers.'[21] This assertion does not conform to reality – even the saintly Marie Leczynska took painting lessons from Jean-Baptiste Oudry and practiced the art as one of her favorite pastimes.[22] Still, when Jean-Marc Nattier painted his remarkably informal portrait of the queen in 1748 (Figure 6.2), he showed her reading the Bible. The proprieties were observed, even though this is a portrait where the queen could almost be mistaken for a bourgeois matron but for the palatial setting and the *fleur-de-lis* motif visible on her chair.

Undoubtedly, the codes of decorum governing representations of Marie Leczynska's daughter were not so stringent; Nattier did portray the young Adélaïde in a formal portrait doing handiwork. In other images he emphasized her musical talents (Figure 6.5), which leads me to another reason that Labille-Guiard's construction of Adélaïde as an artist is surprising. It would have been more accurate to present her as a musician, for throughout her life she cultivated her talents in that domain much more assiduously than her painting skills. Her sisters were better known for their painterly accomplishments. What are we to make, then, of the choice to depict Adélaïde as an artist? One possible answer is that it would have been difficult to make a serious political statement out of a representation of Adélaïde playing the violin – partly because a representation of a woman at her music could be assimilated all too readily into the category of accomplishment arts, those purely ornamental and feminine skills designed to attract prospective husbands.

The same difficulty could attend representations of women as artists. An especially germane example of this is to be seen in an enamel miniature of Adélaïde sketching a portrait of her sister (Figure 7.2). This image, probably copied from a lost painting by Hubert Drouais, forms the lid of an exquisite little gold box with portraits of the other *enfants de France*. The presentation of Adélaïde's artistic enterprise in the context of the dauphin holding a kite, and another child blowing bubbles, suggests the spirit in which noble female artistic practice tended to be understood. The original Drouais painting would not have had the same pictorial context to anchor its meanings as the miniature copy on the box. Nevertheless, Drouais's painting situated the amateur artist within the social order in a certain way. As Ann Bermingham observed

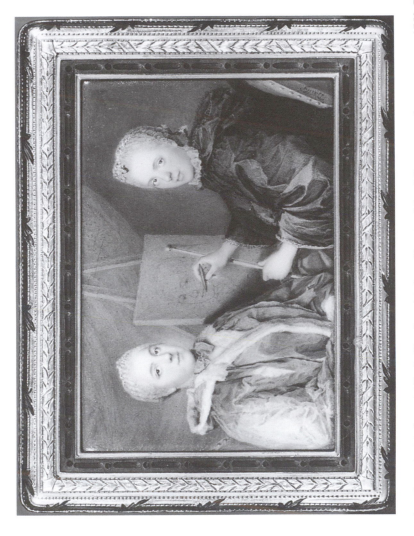

Fig. 7.2: After Hubert Drouais, *Madame Adélaïde Sketching Madame Victoire*, 6.3 × 5.0 cm, enamel on copper, ca. 1750, Baltimore, The Walters Art Museum

of George Romney's painting of *Caroline, Viscountess Clifton and her Sister Lady Elizabeth Spencer* (1794, Huntington Art Gallery), which deals with a similar subject, such images make a distinction between the image of the amateur shown sketching and the professional artist's skillfully wrought oil painting that gives form to that image and subsumes it.[23] In other words, the professional artist's skill is contrasted with that of the amateur, whose sketching is secondary and inferior to it.

As a figuration of feminine accomplishment, the miniature accords with other representations of princesses and aristocratic women engaged in genteel pastimes – a body of images in which painting and sketching are equivalent to needlework or music making. But Labille-Guiard's portrait of Madame Adélaïde as artist does not situate the princess within the context of this exemplary femininity. It is of an order altogether different from the images of accomplished ladies.

For one thing, its ambitious scale, the political import of the imagery, and the impressive quality of the faux-bronze bas-relief she has supposedly painted do not present her as a mere dilettante. Because of her age and settled status as a spinster, her artistic enterprise can scarcely be understood as seeking to enhance her attractiveness to men or to otherwise aid in the project of matrimony – there are other issues at stake here. Madame Adélaïde's image is not glaringly contrasted with the rest of the painting produced by the professional Labille-Guiard. There is a kind of parity between Madame Adélaïde's work within the painting, and the painting itself by Labille-Guiard. The parity between them is suggested most pointedly by the *trompe-l'œil* bas-reliefs painted by each: those in the background authored by Labille-Guiard match the ones on the easel by Adélaïde.

Dibutadis and the goddess of the temple

Jennifer Milam suggestively points out in her essay on the portraits of Mesdames that Labille-Guiard evoked the myth of Dibutadis through her use of the dramatic shadow in the *Portrait of the Duchess of Parma* (Figure 6.8), the third major work commissioned by Mesdames Tantes. Derived from Pliny, the story of Dibutadis (the Corinthian Maid), and her act of tracing the profile of her departing lover – the originary act from which painting sprang – was a favored subject in later eighteenth-century painting.[24] Because it places the thematics of love, loss and commemoration at the heart of the activity of painting itself, and figures all of these through the act of a woman limning a profile, the trope of Dibutadis presents clear analogies to the *Portrait of Madame Adélaïde* as well.[25] On one level Madame's performance of a very specific kind of artistic act of loving remembrance identifies her with the Corinthian Maid, and may go

some way to explaining the unusual iconography of the princess/artist. On another level, read as an allusion to Dibutadis, the picture also evokes a story in which a woman who draws is emblematic of painting itself, making it a veiled allegory of Labille-Guiard's own artistic practice; making it what Sheriff would call a 'self-portrait of painting'.[26]

I will return to the question of allegorical references in the picture in due course. What I want to point out here is that the lack of pronounced distinction between the work of the amateur artist and the professional is due partly to the fact that Madame Adélaïde is not presented as an amateur at all. On the contrary, the painting is much more akin to images of professional women artists, such as Antoine Vestier's portrait of his daughter Nicole exhibited at the Salon of 1785 (Figure 7.3).[27] More importantly, it bears a striking resemblance to Labille-Guiard's own superb *Self-Portrait with Students* (Figure 7.4) – shown at the same Salon as the Vestier.

Like the subsequent portrait of Madame Adélaïde, Labille-Guiard's *Self-Portrait* earned the praise of critics and connoisseurs. It prompted one enthusiast to proclaim with all the hyperbole one expects from an eighteenth-century encomium: 'Giving her august lessons,/It is the goddess in her temple/ Who presents at once the precept and the example.'[28] The painting found an admirer at court too. The *Année littéraire* of 1785 reported that Madame Adélaïde was so enchanted by Labille-Guiard's *Self-Portrait* that she offered to buy it for the dazzling sum of 10,000 *livres*.[29] The princess's interest in the work is not hard to understand. It is exquisitely executed, of course – who could fail to be attracted by the ravishing costumes, the luminous self-possession of the teacher, the loveliness of her rapt students? But Madame Adélaïde found more to appreciate in this picture than its obvious aesthetic attractions. She must have been struck by a portrait that so exceeded the expectations of the genre that critics of the time likened it to history painting.[30] In attesting to Labille-Guiard's achievements as a gifted and successful artist with students of her own, the painting engaged critically, yet artfully – in every sense of the word – with the gender politics of the Academy. Painted two years after the membership of women had been limited to four, here was a picture that made an eloquent appeal for the inclusion of women in that institution, and did so by presenting Labille-Guiard's own artistic talents in terms of womanly charms and propriety. The two sculptural works in the background identify the artist with the impeccable feminine virtues of the dutiful daughter and more symbolically with those of the vestal virgin. The bust visible just beyond the canvas on which Labille-Guiard works is Augustin Pajou's portrait of her father. Just behind it stands Houdon's *Vestal Virgin*. Taken in the context of the artist attended by her students, the inclusion of Houdon's statue would seem to present Labille-Guiard as a vestal virgin herself, teaching her acolytes to tend the sacred fire of the painting profession.[31] Can it be pure

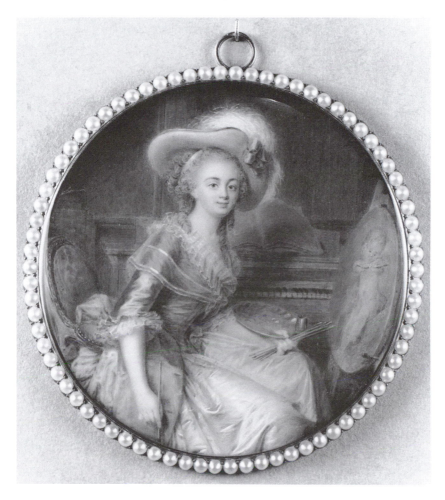

Fig. 7.3: Antoine Vestier, *Marie-Nicole Vestier*, .075 cm, gouache on ivory, ca. 1785, Baltimore, The Walters Art Museum

coincidence that the princess who would have herself represented as the personification of virtue sought out a painter who so persuasively touted her own wholesome nature; who at the time signed her name, somewhat enigmatically, as *Adélaïde des Vertus*; a painter whose portraits of other women when shown at the same Salon were praised for their purity, modesty and moral rectitude (where Vigée-Lebrun's galant women were likened to harem girls)?[32] In any case, Labille-Guiard's ability to make a powerful portrait that vied with history painting in its import and scale must have factored into Madame Adélaïde's enthusiasm for her work.

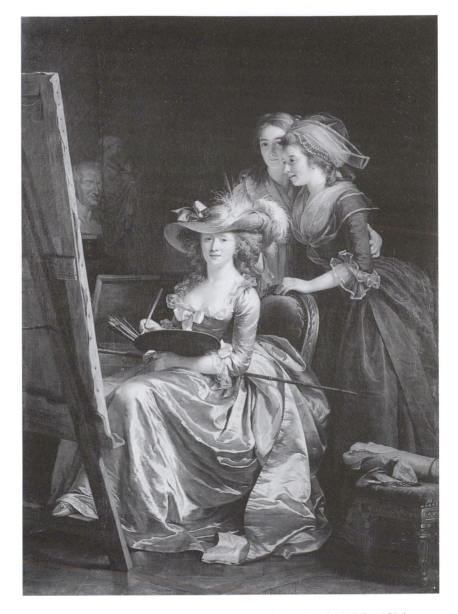

Fig. 7.4: Adélaïde Labille-Guiard, *Self-Portrait with Two Pupils*, 210.8 × 151.1 cm, oil on canvas, 1785, New York, The Metropolitan Museum of Art, Gift of Julia A. Berwind, 1953 (53.225.5)

As it happens, Madame Adélaïde's bid for the painting was refused. Labille-Guiard's *Self-Portrait* would hang in her studio until her death. However, the princess's wish to acquire the picture can, I think, begin to account for the kinship between that work and the portrait she commissioned from Labille-Guiard the following year. In the broadest sense, Madame Adélaïde's portrait is a similarly 'historiated' image with a discursive, politically motivated meaning.[33] Meaning in each case is achieved through similar iconographic and compositional means. In both, the artist is situated before her easel; each picture presents elegant, though not beautiful, women whose personal attributes include great filial piety; both are identified with the vestal virgin. And there are formal similarities, such as the staging of the figure in the center of the composition, body posed at an oblique angle, the head turned to address the viewer directly, there is the large easel, the fashionable furnishings, the *tabouret* seen at an angle in the foreground, with a roll of drawings perched upon it, and the white cloth in hand (suggesting this detail is not so much a handkerchief in Adélaïde's portrait as another painterly implement).

And yet, it would not be right to say that the portrait of Madame Adélaïde presents her as a professional artist. The social impossibility of such a proposition aside, this is no working studio: the medallion portrait is finished and framed, the elegant swag of gold-fringed plush velvet, the red lacquered easel look more like ornate furniture than a painter's props; the whole image has a ceremonial ersatzness about it. This ceremonial atmosphere is reinforced by the lack of correspondence to the facts of Adélaïde's actual artistic practices. The ambience of formality further underscores the fact that this painting is not simply about likeness or facts of daily life. Its visual rhetoric evokes a whole complex of additional, though related, pictorial formulae and allegorical associations (beyond the Corinthian Maid).

Minerva's shield, veiled allegory and the portrait within the painting

The imagery to which the *Portrait of Madame Adélaïde* refers evolved during the reign of Louis XIV, and enjoyed its greatest currency then – though the paradigm lasted into the eighteenth century.[34] What I have in mind here is the iconography and formal vocabulary associated with the allegorical *portrait en tableau*. The pictorial device of showing a portrait inscribed within a larger image and being presented by an allegorical figure had been used in representing Louis XIV and other important personages, particularly after 1670. Because it allowed artists to show something beyond simple likeness, it proved a commodious rhetorical tool for spelling out the impeccable character, achievements and import of the sitter.[35] Very often the tutelary deity who

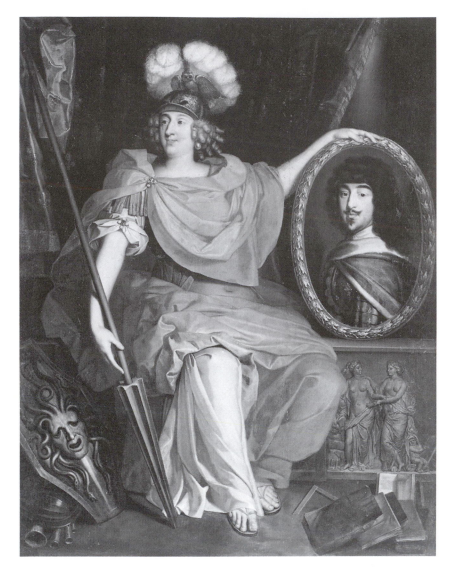

Fig. 7.5: Pierre Bourguignon, *Duchesse de Montpensier as Minerva*, 175 × 148 cm, oil on canvas, 1672, Versailles, Musée national du Château (Réunion des Musées Nationaux/ Art Resource, NY)

presided over the *portrait en tableau* was Minerva, as in Pierre Bourguignon's *Duchesse de Montpensier as Minerva* (Figure 7.5). It is with these Minerva images that the *Portrait of Madame Adélaïde* resonates the most.

The Bourguignon image offers an especially instructive comparison. It was painted in 1672 as his *morceau de reception* – and so was an image Labille-Guiard would surely have known. Rather than a purely allegorical *portrait en tableau*, this is a portrait within a portrait, though its mode is nonetheless allegorical. Bourguignon's painting shows 'La Grande Mademoiselle', the Frondeur cousin of Louis XIV and one of France's most infamous daughters, as Minerva; and, following the conventions of this particular genre, the duchess displays a portrait – in this case, of her father, Gaston d'Orléans (the uncle of Louis XIV). The representation of the duchesse de Montpensier as Minerva, the goddess of wisdom, learning, the arts and just wars, signifies in two registers at once: as an allegorical figure, the duchess personifies and celebrates the virtues of her father – his wisdom, his courage, his fight for just causes and so forth; but at the same time, La Grande Mademoiselle's mythological guise must be understood to represent her own qualities and accomplishments. Surely the fact that she herself incarnated the goddess of war when she commanded Orléanist troops during the Fronde is being referenced here. (My point here is that this allegorical mode and its pictorial conventions allow for a certain discursive complexity.)

As a courageous, bracingly unconventional 'maiden' princess who was deeply loyal to her father, La Grande Mademoiselle might on some level have offered a suggestive precedent for Madame Adélaïde. But, having aided in the attempt to overthrow the young Louis XIV, the duchesse de Montpensier and her martial past would have presented obvious shortcomings as a model for emulation by a Bourbon princess. But the same can not be said for the duchess's guise, or the pictorial format in which she appears: the virgin goddess Minerva, daughter of the king of the Gods, in her aspect as deity of Wisdom and patroness of the arts, was a highly appropriate symbol for Adélaïde. And in fact, she did have herself represented as Minerva, probably during the 1780s (Figure 7.6). This Minerva is one who loves books, keeps cute little pets, and lacks any of the bellicose undertones that must have attended the image of the duchess.

We are far from monumental state portraiture here: this was a small gouache – a private, personal image that formed the frontispiece of the lovingly hand-lettered catalogue of Adélaïde's library. Nevertheless, the image suggests the possibility that Adélaïde felt some personal affinity for Minerva (a possibility that seems even more plausible when one considers the interesting fact that in 1767 she had her apartments in Versailles decorated with a selection of René-Antoine Houasse's *Minerva* series painted originally for the Grand Trianon). So it is not unthinkable that Madame might have had herself represented in the guise of Minerva in an official portrait, had it been fashionable at the time – but it wasn't. By the 1780s the disguised portrait – so popular in the seventeenth century and even into 1770s – was decidedly *passé*. Still, if

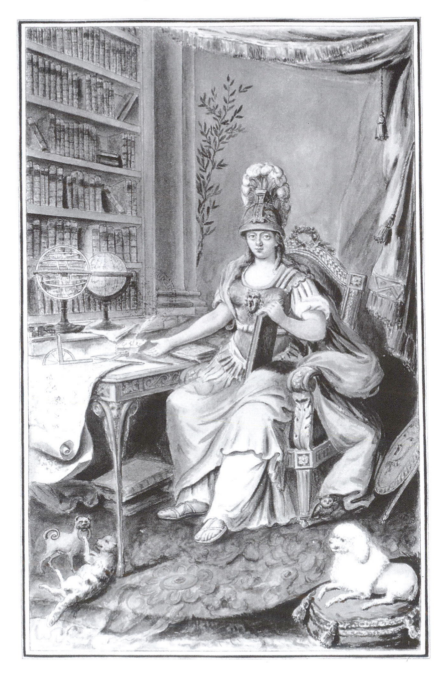

Fig. 7.6: Anonymous. *Madame Adélaïde as Minerva*, 45 × 29 cm, watercolor on paper, before 1786, Paris, Bibliothèque de l'Arsenal (Bibliothèque Nationale)

Marie-Antoinette could be the new Cornelia, Madame Adélaïde could be a modern Minerva. The mythological guise has disappeared, but its props and the pictorial paradigm remain, along with the traces of their meanings. As an inherently retrospective image, it is almost as if this picture demands to be read through the palimpsest of its overtly allegorical antecedents.

I should emphasize here how readily eighteenth-century viewers would have resorted to such allegorical or metaphorical interpretation of images. They were entirely accustomed to reading images of one subject as representations of another – even when likenesses were not involved (they readily understood the representation of say, Apollo as their king; Venus as the king's mistress or even the queen).[36] Viewers were no less accustomed to reading allegorical import into 'straightforward' images. Recall, for example, the poet who referred to Labille-Guiard as 'the goddess in her temple'. Antoine Vestier's 1788 portrait of his daughter was regarded as an *Allegory of Art*.[37] Given the proclivities of the time, the reference to Adélaïde's artistic patronage of the convent building alone would have been enough to evoke associations with Minerva as patron goddess of the arts. But the allusions to Minerva are more pointed and complex than this, in terms of both pictorial codes and content.

One of the most marked references to Minerva in the Labille-Guiard painting is the goddess's presentation of the oval painting within the painting – iconography exemplified by Bourguignon's portrait of La Grande Mademoiselle. The oval painting, homologous to and often represented interchangeably with Minerva's more traditional accouterment, the shield, was included in many images as an attribute of the goddess as unique to her as her plumed helmet. The Minerva shown wielding a painting as her shield signals her guise as '*Minerva ergane*' – patron goddess of the arts – and seems to have achieved particular currency in France, as in the *morceau de reception* by Nicolas Loir (1666, Château de Versailles) and Antoine Mathieu before him (1664, Versailles).[38] Mathieu's painting of *Henriette d'Orléans as Minerva* includes a palette and brushes at the feet of the goddess and thereby points to a further dimension of this 'artsy' Minerva. She herself was sometimes figured as an artist. In certain cases, such as Pierre Rabon's *Allegory of the Arts*, Minerva-as-artist is clearly intended to personify Painting.[39] In other images, the implications are more nuanced. For example, in an anonymous engraving from around 1664 (Figure 7.7), the goddess actually limns the image of the king. The significance of this act is explained by the inscription on the banner flying from Fame's trumpet: 'Who could paint such a wise king. In vain his portrait is taken. Minerva had to be the one to make this work, in order to render it perfect.' The claim being made is that only the virtuous Minerva is worthy and capable of capturing the likeness of so great a king. To show Minerva as the maker of the image was to mark powerfully the connection between the model and his

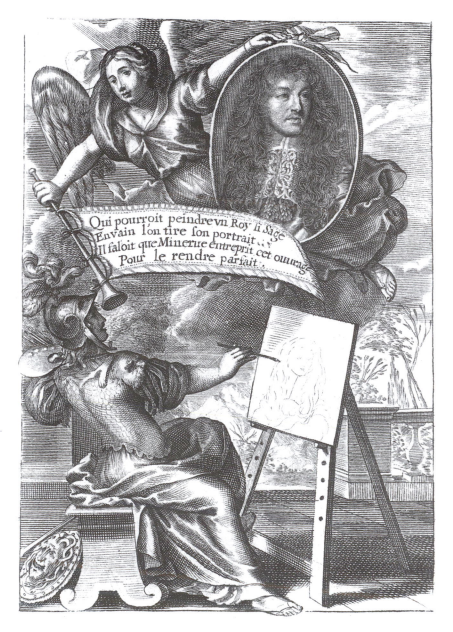

Fig. 7.7: Anonymous, *Allegorical Portrait of Louis XIV*, after 1664, Paris, Bibliothèque Nationale, Departement des Estampes et de la Photographie (Bibliothèque Nationale)

tutelary deity, for it presented her qualities as the constitutive elements of his person. Depicting Adélaïde as an artist who renders the likeness of her father, mother and brother calls upon this trope of the virtuous goddess–artist and its implications. As I began to suggest a moment ago, this is disguised portraiture with all the content and none of the disguise. It is, to use a term coined by Courbet a century later, a 'real allegory'.[40]

The modern Minerva: a tale of two Adélaïdes

Given the cognate features of Labille-Guiard's *Self-Portrait* and her *Portrait of Madame Adélaïde*, it is worth noting here that the imagery of the portraitist at work owes a debt to the same Minerva iconography evoked in the state portrait. It bears mentioning, too, that such iconography amounts to an indirect acclamation of the actual painter of the actual *tableau*, for even while the pictorial rhetoric asserts that only Minerva can truly paint the king (for example), he is portrayed by the actual painter right and good, so that, in the end, the painter is likened to Minerva, as much as the sitter who is depicted as Minerva within the painting.

In the eighteenth century, Minerva frequently was identified with women artists – critics poetically referred to Vigée-Lebrun and Labille-Guiard as 'modern Minervas'.[41] And some women artists adopted Minerva as an apt symbol for their own artistic practices. (To name a few: in Marie-Victoire Lemoine's *Portrait of Vigée-Lebrun* in the Metropolitan Museum of Art, a young woman is shown working on a canvas that depicts two votaries before a statue of Minerva; Angelica Kauffman made reference to Minerva in several of her self-portraits;[42] while the English artist, Mary Beale, represented herself as Minerva in a lost self-portrait.) What I am suggesting here is that if Madame Adélaïde is identified with Minerva in this portrait, on a number of levels she is identified with Labille-Guiard as well. Labille-Guiard's portrait of this other woman is in some sense self-referential.

Thinking in a related vein about the relationship between Vigée-Lebrun's self-portrait of 1787 and the other images of mothers she exhibited that year (which included the portrait of the queen and her children), Paula Radisich has argued that Vigée-Lebrun's showing her self-portrait in the context of those other images of motherhood lent them all a certain autobiographical force.[43] A similar manifestation of the painter-subject, Vigée-Lebrun, in a representation of the sitter-object can be seen in her portrait of her friend, the flower painter, the Marquise de Grollier, which Vigée-Lebrun soon translated into an actual image of herself.[44] I would argue that a dialectic between other and self informs Labille-Guiard's representation of Madame Adélaïde. Like Vigée-Lebrun's shared traits with her sitters (whether as artists or mothers), there were numerous

congruencies in the lives of Labille-Guiard and Madame Adélaïde: both had to define their identities in terms of less than conventional ideals of femininity – neither was known for her feminine charm or beauty, neither was a mother; for both the thematics of daughterhood and relationships to the father seem to occupy a central place, and last and probably least, relations between Labille-Guiard and Vigée-Lebrun were as cool as those between Madame Adélaïde and the queen. All of these correspondences were reinforced by a process of intersubjective exchange that is intrinsic to the operations of portraiture itself. This exchange, 'the intersubjective encounter', as Angela Rosenthal has termed it, involves an oscillation between subject and object that effectively conflates the two.[45] Marcia Pointon has described the process in this way: 'portraiture sets up a perpetual oscillation between observer and observed. Artist and sitter are both affected by the event of portrayal which has, as its outcome, an image which is recognized to involve the naming of two individuals rather than one.'[46] That the reciprocities of the act of portrayal call for the naming of two individuals whose names, in this case, are both Adélaïde seems too curious to pass without comment. In any event, Madame Adélaïde must have seen something of her ideal self in Labille-Guiard's public self-fashioning; and for Labille-Guiard, to figure the princess, another unconventional woman, as an artist was to represent herself. Thus, in certain respects, the portrait of Madame Adélaïde as modern Minerva is just as much a portrait of Madame Adélaïde Labille-Guiard, who was also a modern Minerva.

Notes

My thanks to Paula Radisich and Angela Rosenthal for their thoughtful readings of this essay. I am also grateful to the Dept. of Art History & Group for 18th-Century Studies at Northwestern University and to the Department of Art History at University of California Santa Barbara, where I presented earlier versions of this work and received very useful and insightful comments.

1. Laura Auricchio, 'Portraits of Impropriety: Adélaïde Labille-Guiard and the Careers of Professional Women Artists in Late Eighteenth-Century Paris' (Ph.D. diss., Columbia University, 2000); Jean Cailleux, 'Portrait of Madame Adelaide of France, Daughter of Louis XV,' *Burlington Magazine* III (1969), suppl., i–vi; Vivian Cameron, 'Adelaide Labille-Guiard,' in *Dictionary of Women Artists*, ed. Delia Gaze (London and Chicago: Dearborn Publishers, 1997), 2: 815; Whitney Chadwick, *Women, Art and Society* (London: Thames & Hudson, 1990), 156–64.

2. *Les Salons des 'Mémoires secrets' 1767–1787*, ed. Bernadette Fort (Paris: École national supérieure de Beaux-arts, 1999), 322.

3. See Chapter 6 in this volume for Milam's discussion of these portraits and representations of sisterhood.

4. *Memoirs of the comtesse de Boigne 1781–1814*, ed. Charles Nicoulaud (New York: Scribner's Sons, 1907), 1: 64.

5. *Les* Salons *des 'Mémoires secrets'*, 322.
6. For a discussion of Salic Law and its effect on the role of women in the French court, see Mary Sheriff, Chapter 8 in this volume.
7. Madame Adelaide's interest in furniture is addressed by James Parker, 'French Eighteenth-Century Furniture Depicted on Canvas,' *The Metropolitan Museum of Art* (January 1966), 177–92. The comtesse de Boigne records in her memoirs that Madame Adélaîde was 'très occupée de sa toilette avec une grande disposition à la coquetterie', quoted in Anne-Marie Passez, *Adélaïde Labille-Guiard, 1749–1803: Biographie et catalogue raisonné de son œuvre* (Paris: Arts et Métiers Graphiques, 1973), 184.
8. Mary D. Sheriff, *The Exceptional Woman: Elisabeth Vigée-Lebrun and the Cultural Politics of Art* (Chicago: University of Chicago Press, 1996). Chap. 5 discusses the Van Loo portrait.
9. Casimir Stryienski, *Mesdames de France. Filles de Louis XV* (Paris, 1911), 87.
10. Passez, *Adélaïde Labille-Guiard*, 186.
11. The arrangement of pictures exhibited in the Salon of 1787 is visible in P. A. Martini's engraving, reproduced in Richard Wrigley, *The Origins of French Art Criticism From the Ancien Régime to the Restoration* (Oxford: Clarendon Press, 1993), Pl. VII.
12. Élisabeth Vigée-Lebrun, *Souvenirs* (Paris: Charpentier, 1869), 2: 231–2.
13. See Sheriff, Chapter 8 in this volume, and Joseph Baillio, 'Le dossier d'une oeuvre d'actualité politique: Marie-Antoinette et ses enfants par Madame Vigée-Lebrun', *L'Oeil* 308 (March 1981), 34–41, 74–5, and 310 (May 1981), 53–60, 90–91.
14. Baillio was the first to argue that the references to this story were intended as a corrective to the allegations raised by the Diamond Necklace Affair; like Cornelia, the queen's children are meant to be understood as her jewels. The elaborate jewel box in the background would seem to underscore that. (See note 13 above.) For the Cornelia theme in Kauffman's work see Roworth, Chapter 9 in this volume.
15. I say 'domesticated' because this portrait evokes the traditions of less formal portraits of the uncontroversial Marie Leczynska – namely, Jean-Marc Nattier's famous painting of her, seated, wearing a red fur-trimmed dress (Figure 6.2) – thereby asserting Marie-Antoinette's conformative queenliness and her belonging to the Bourbon family.
16. See Milam, Chapter 6 in this volume, for a different reading of the relationship between the portraits of the queen and Madame Adélaïde.
17. *Memoirs of the comtesse de Boigne*, 1: 50.
18. The rumors of incest first began to circulate in the 1750s and would haunt Adélaïde's reputation for most of her adult life. In addition to the *Memoirs of the comtesse de Boigne*, see Bruno Cortequisse, *Mesdames de France. Les Filles de Louis XV* (Paris, 2000), 202–4, and Stryienski, *Mesdames de France,* 69 for discussion.
19. Citing the passage in the Salon *livret*, *Les* Salons *des 'Mémoires secrets'*, 322 states that the description of the painting is Labille-Guiard's own.
20. Ibid., 322–3.
21. Jean-Louis Soulavie, *Mémoires historiques et anecdotes, pendant la faveur de la Marquise de Pompadour* (Paris: A. Bertrand, 1802), 273.
22. For Marie Leczynska as a painter see Marguerite Jallut, 'Marie Leczinska et la peinture,' *Gazette des Beaux-Arts* 73 (May–June 1969), 305–22.

23. Ann Bermingham, 'The Aesthetics of Ignorance: The Accomplished Woman in the Culture of Connoisseurship,' *Oxford Art Journal* 16:2 (1993), 3–20.

24. Ann Bermingham, 'The Origin of Painting and the Ends of Art: Wright of Derby's *Corinthian Maid*,' in *Painting and the Politics of Culture: New Essays on British Art, 1700–1850*, ed. John Barrell (Oxford and New York: Oxford University Press, 1992), 135–65; Victor Ieronim Stoichita, *A Short History of the Shadow*, trans. Anne-Marie Glasheen (London: Reaktion Books, 1997).

25. A 1783 Salon pamphlet has Dibutadis make an appearance at the exhibition in order to comment on the paintings there. In response to her admirers the inventor of painting demurs: 'If I am an inventor then it is of the *silhouette portrait*, for I have just heard called by that name a profile in black made by tracing the shadow of a young person. It is exactly the same procedure that love inspired in me and for which you claim to admire me.' Quoted and discussed in Sheriff (1996), 73. It is tempting to think that the similarities to Labille-Guiard's rendering of the silhouettes were meant to recall the self-described work of Dibutadis. Sheriff (1996) chap. 7 has shown that Dibutadis was invoked masterfully by Vigée-Lebrun in her 1790 Uffizi *Self-Portrait* as well.

26. Ibid., 234.

27. The Vestier portrait is reproduced in Anne-Marie Passez, *Antoine Vestier: 1740–1824* (Paris: Fondation Wildenstein: Bibliothèque des Arts, 1989). The painting is in a private collection in Buenos Aires; we reproduce here a miniature copy in the Walters Art Gallery.

28. 'Vers à Madame Guyard sur le Salon de 1785,' (Collection Deloynes, vol. 14, pièce 362), 899.

29. *Année littéraire*, 1785 (Collection Deloynes, vol. 14, pièce 349) 796. My thanks to Vivian Cameron for calling this important fact to my attention and for her generosity in providing me with the citation.

30. 'Ce portrait dans le genre de l'histoire dans lequel on reconnait une touche vigoureuse, fait honneur au talent de l'artiste.' See 'Observations critiques sur les tableaux du Salon' (quoted in Passez, *Adélaïde Labille-Guiard*, 158), Collection Deloynes, vol. 14, pièce 326. See also *Avis important d'une femme sur le Sallon de 1785* par Madame E.A.R.T.L.A.D.C.S (Paris, 1785), 28ff. and *Les Salons des 'Mémoires secrets,'* 297.

31. On the vestal virgin as a sign of the female artist, see Vivian Cameron, 'Woman as Image and Image Maker in Paris During the French Revolution' (Ph.D. diss., Yale University, 1983), 71, 200–206. For a discussion of the broader cultural significance of the vestal virgin, see Kathleen Nicholson, 'Ideology of feminine "virtue": the vestal virgin in French eighteenth-century painting,' in *Portraiture. Facing the Subject*, ed. Joanna Woodall (Manchester and New York: Manchester University Press, 1997), 52–72.

32. *Les Salons des 'Mémoires secrets'*, 297–9.

33. '*Historié*' is the term used to describe Labille-Guiard's self-portrait. 'Salon of 1785' in the '*Mémoires secrets,*' 297.

34. For example Antoine Boizot's 1763 *Allegory of History* shows a Minerva presenting an oval bas-relief portrait of Louis XV. In 1775, J.-B.-A. Gautier-Dagoty's formal *Portrait of Marie-Antoinette* (Versailles) was exhibited in the Galerie des Glaces. Presiding over the picture, in the background, is a figure of Minerva/France holding an oval profile portrait of Louis XVI.

35. My discussion of the *portrait en tableau* is much indebted to Emmanuel Coquery's illuminating treatment of the subject in *Visages du Grand Siècle. Le*

Portrait français sous le règne de Louis XIV 1660–1715 (Paris, Somogy, Nantes: Musée des beaux-arts, 1997).

36. There is a passage in *Avis important d'une femme sur le sallon de 1785*, where the author imagines that the ideal portrait of Marie-Antoinette would show her in the guise of Venus.

37. See reproduction in Didier Aaron, *Galerie de portraits* (Paris: Didier Aaron & Cie, 1999), n. 16.

38. The 1644 French edition of Cesare Ripa's emblem book, *Iconologia*, similarly proposes a synonymy between painting and shield. The allegorical figure of Painting holds her canvas in precisely the same position as the figure of Minerva depicted within that painting. See also Nadia Tcherny, 'Domenico Corvi's Allegory of Painting: an Image of Love', *Marsyas* XIX (1977–78), 23–7.

39. Reproduced in Coquery, *Visages du Grand Siècle*, 18.

40. Mary Vidal's use of the eighteenth-century concept of 'natural allegory' is also applicable here. See Mary Vidal, 'David Among the Moderns: Art, Science, and the Lavoisiers,' *Journal of the History of Ideas* 56 (1995).

41. *Les* Salons *des 'Mémoires secrets'*, 298, for example.

42. For discussion of Kauffman's *Minerva (Pallas Athena) Preparing to Arm Herself* see Roworth, Chapter 9 of the present volume. For Kauffman's treatment of Minerva in her portraits see Angela Rosenthal, *Angelika Kauffmann: Bildnismalerei im 18. Jahrhundert* (Berlin: Reimer Verlag, 1996).

43. Paula Rhea Radisich, 'Que peut définir les femmes?' *Eighteenth-Century Studies* 25 (1992): 450.

44. Reproduced in Joseph Baillio, *Elisabeth Vigée Le Brun*, exh. cat. (Fort Worth: Kimball Art Museum, 1982).

45. Angela Rosenthal, 'She's got the look! Eighteenth-century female portrait painters and the psychology of a potentially "dangerous employment,"' in Woodall, ed. (1997): 147–66, and esp. 148.

46. Marcia Pointon, 'Kahnweiler's Picasso: Picasso's Kahnweiler,' in Woodall, ed. (1997), 193.

The Cradle is Empty: Elisabeth Vigée-Lebrun, Marie-Antoinette, and the Problem of Intention

Mary D. Sheriff

The youngest child squirms on his mother's lap (Figure 8.1). He wriggles forward and reaches back, his fingers grasping for a hold on the queen's red velvet gown. He need not fear toppling over, for Marie-Antoinette supports him firmly, her left arm around his waist, her right draped gently over his legs. The eldest child, a daughter, stands at her mother's right side. Leaning into the queen's body, she embraces her mother's arm and presses a cheek against her shoulder. While these three form a compact unit in the visual field, the middle child stands a little apart. Surely he is singled out because he is the dauphin of France, and hence the most notable. With one hand he lifts up a drape to reveal an empty cradle; with the other he directs our eyes to his mother, sister and brother, pointing at them as he looks toward us, his audience.

Stability seems to rule this painted scene, known today as *Marie-Antoinette and her Children* (1787, Versailles, Musée du Château). With a swath of dark drapery to increase its visual weight, the empty cradle balances the family group even as it mimics the seated mother's pose in its curved upright top, extended body and articulated leg. Next to and behind the mother and cradle is a third simple form, the rectangular jewel box whose elaborately decorated surface is darkened and hence subordinated to overall shape. A sharply lit and defined left edge aligns it with the dauphin's upright body to create a continuous vertical axis that stops the eye. Enhancing the orderly scene is a general serenity of mood. Passion scarcely ruffles this Marie-Antoinette, who sits amidst her children, and she is as motionless as the cradle and jewel case beside her. Her restraint extends to the children, for she contains the baby's squirm and absorbs her daughter's embrace. The only pointed gestures are

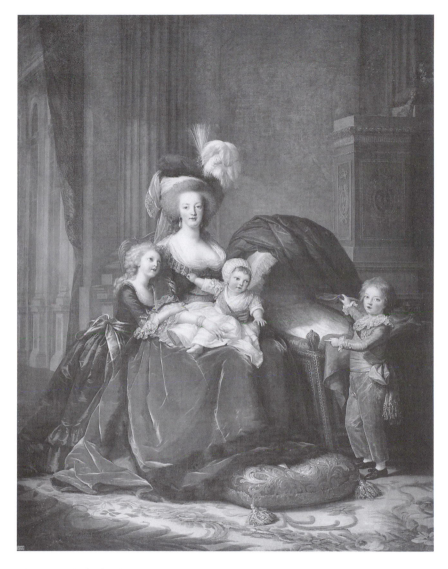

Fig. 8.1: Elisabeth Vigée-Lebrun *Marie-Antoinette and her Children*, 275 × 215 cm, oil on canvas,1787, Versailles, Musée du national Château (Alinari/Art Resource, NY)

those of the dauphin, and although they lack drama, they lend a decided theatricality, a self-consciousness, to this carefully arranged group portrait.

Marie-Antoinette and her Children is arguably Élisabeth Vigée-Lebrun's finest work – and certainly her most important commission since it came

through the Bâtiments du roi.[1] It is the only easel painting that agency ever ordered from a woman. The first request for the work came from Marie-Antoinette in September of 1785, and it was entangled with paintings shown (and not shown) at the Salon that had recently opened. There hung a portrait of the queen destined for Gustave III, king of Sweden. It had been commissioned in 1784 from the Swedish artist Adolf Ulrik Wertmuller, and showed the queen walking in the gardens of Trianon with her two older children (1785, Figure 8.2). By all accounts, Marie-Antoinette found the work appalling, as did Salon critics. The *Mercure de France* said flatly that the painting was 'so weak that nothing could excuse it'.[2] The queen stopped short of demanding that Wertmuller's portrait be withdrawn from the Salon, but in a letter dated 12 September 1785, the Academy's first painter, Jean-Baptiste Marie Pierre, notified the Director, Charles Claude Flahaut, comte d'Angiviller, that: 'The queen has just informed me, Monsieur, that she wants the portrait Madame Lebrun made for the Baron de Breteuil placed in the Salon.'[3] The artist apparently took this request to mean that the queen wanted to counteract Wertmuller's image, and she responded by saying that she would provide the work but 'would not tolerate Monsieur Wertmuller's displacement'.[4] The commission for Vigée-Lebrun to paint another portrait of the queen and her children came with Marie-Antoinette's request, which also suggests a desire to distance herself from Wertmuller's unfortunate image. Here is the commission as Pierre explained it to d'Angiviller: 'The queen also plans to have Madame Lebrun make a life-size portrait [*portrait en grand*] with her three children. I have generally apprised the artist, but it is appropriate that you communicate to her the queen's intentions.'[5] Viewing Vigée-Lebrun's subsequent portrait of Marie-Antoinette and her children from the perspective of 1785 suggests that *amour propre* motivated the queen's commission – that she wanted a portrait to erase the impression of a likeness she, and others, found ugly and artless. But like any assessment of intention, this explanation remains speculative.

The question of intention

I raise the question of intention because the current understanding of Vigée-Lebrun's portrait paints it as a deliberate attempt to change the queen's public image. Following Joseph Baillio, Simon Schama has assumed that the work '*was meant* to offset her [the queen's] scandalous reputation as a woman of extravagant tastes', and it was '*deliberately* designated to launder this soiled reputation'.[6] And for these interpreters, the artist's further intention was to fulfill this goal by combining the *bourgeois* ideal of maternal bliss with the image of absolutist monarchy. Schama is certain about it: 'In making the

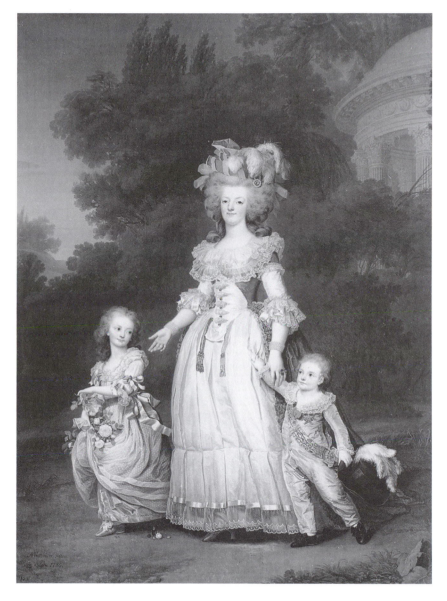

Fig. 8.2: Adolf Ulrik Wertmuller, *Marie Antoinette in the Gardens of Trianon with her Two Children*, 276 × 194 cm, oil on canvas, 1785, Stockholm, Nationalmuseum

portrait of Marie-Antoinette with her children *there is no question that* Vigée-Lebrun tried to do the impossible by offering what was simultaneously *meant* as a regal and a domestic image'.[7] And Baillio claims that the image '*vainly tried* to resolve a conflict of values' and that the finished work is torn between representing the ideology of divine right kingship and the bourgeois ideal of maternal happiness.[8] For both of these historians, this goal was elusive: trying to do the impossible, the artist produced a work that 'lacks cohesion', and is an 'awkward compromise'.[9]

The issue of intention has been closely entwined with this painting's interpretation since 1787, a point that emerges in reading the Salon criticism. But intention enters the criticism in different ways. Consider first the commentary in *L'Ami des artistes au Sallon*, which is typical on several counts. Like most of the Salon criticism, its review of Vigée-Lebrun's portrait is generally positive. The assessment compares the work favorably to her other Salon entries, noting: 'Here she gets hold of a more imposing scene and it is with the most brilliant success.'[10] But like other Salon writing that regularly noted a painting's strengths and weaknesses, these comments mix praise and blame. One of the faults – the lack of *intention* (that is, intention, purpose, meaning) in the queen's expression – others would repeat. Here it is put in the context of the work's many praiseworthy features, which the critic enumerates at some length:

> These august persons are grouped with an intelligence that would honor the greatest artists. The queen, whose image is perfectly resembling, appears there with all the dignity of her rank and the brilliance of her beauty. The pose of Madame, contemplating her mother, is full of expression, of candor, and nobility. The features of Monsieur the dauphin, also very resembling, bring together all that sweetness and goodness can add to an amiable boyhood. The choice of the materials is in the best taste; they are rendered with a truth and a magic that equals all that art can attain. The colors form the most touching harmony; the tones of the flesh are true and agreeable, as in her other works.[11]

He adds to this list the common complaint: 'that the queen, in the middle of her children, does not have any intention in her gaze.'[12] Her expression, in other words, does not announce what emotion she is feeling, or rather, what emotion the artist imagined her to feel, for the flaw is with the artist's depiction, and not the sitter's emotion.

If some critics found the queen's look lacking 'intention', others found the same flaw elsewhere. *L'Année littéraire*, for example, calls the painting 'superb', but transfers the lack of intention from the queen to the dauphin, finding 'equivocation' in his figure. This equivocation is entwined with the empty cradle:

> People who do not know when the work was begun will find perhaps a little equivocation in the figure of Monsieur the dauphin who seems to

uncover an empty cradle [*berceau*]. But this composition once had an-
other interesting feature before the death of Madame, last daughter of
the king. This young princess was represented asleep in the cradle and
Monsieur the dauphin, a finger on his lips, seemed concerned lest any-
one trouble her sleep.[13]

The critic goes on to explain: 'The artist believed it necessary to efface the
infant in the cradle and to change the action of the left arm in the figure of the
dauphin.'[14]

We do not know Vigée-Lebrun's – or her patron's – original intention in
this regard, nor do we know when or if it changed. Determining the intent,
original or otherwise, is not my goal, and it would be immaterial to my
particular argument if radiographs did show the ghost of a baby lying in that
cradle. I am concerned with how the issue of intention framed contemporary
discussions of the painting, and how it is useful in interpreting what we see
on the canvas.

With these goals in mind, I now turn to the longest and most negative
assessment of Vigée-Lebrun's portrait, which appeared in the '*Mémoires
secrets*'. That publication had already shown itself hostile to Vigée-Lebrun,
and the journal regularly spread nasty gossip about Marie-Antoinette.[15] In
this case, their critic is troubled by the equivocation, the lack of a clear
intention throughout the painting. He contends that:

> The airs of the heads respond to nothing in the situation. The queen,
> troubled, distracted, seems to experience affliction rather than the ex-
> pansive joy of a mother who is pleased to find herself in the midst of her
> children. The serious air of the daughter leads one to suppose that since
> she has already reached an age when she is liable to share her mother's
> sorrows, she seeks to console her with tender affection. The Duke of
> Normandy, far from having the expression of an infant ... shows no
> gaiety. One judges him sad if not through reflection at least through
> sympathy. Finally, the gesture of the dauphin is outside the event, which
> isolates him from this interesting scene.[16]

It is no surprise that this critic also finds an explanation for the equivocation
in the empty cradle. He describes how the painting's defects have been
explained away by a supposition (he doesn't tell us whose) 'perhaps more
ingenious than true': that the painting was commissioned to perpetuate the
memory of the queen's youngest child and the cradle's emptiness symbolizes
her death. By drawing our attention to the empty cradle, the dauphin partici-
pates in the scene, and the general sadness makes sense. The critic contends
that although such an interpretation lends a desirable coherence and clarity to
the scene, it is a fantasy. He goes on to rebut this (alleged) supposition by
repeating with a negative twist the explanation offered in *L'Année littéraire*:
that the artist at first showed the tiny princess asleep in the cradle and the
dauphin warning the audience not to wake her. After the baby's death, she

effaced the infant and changed the dauphin's gesture. Our critic for the *Mémoires secrets* then adds that this more plausible explanation makes the defect he first detected – the misfit between the queen's situation and her expression – all the more evident.[17] Faulty as it may be, his logic is this: after removing the child's image, the artist adjusted *only* the gesture of the dauphin and left the queen with her original expression. If Vigée-Lebrun had in her initial conception showed the babe in her cradle, then she should have highlighted the queen's maternal happiness. For this critic, it is not that the queen's look lacks ' intention', but that Vigée-Lebrun gave her the wrong emotion in what the critic assumes to have been the original state of the painting. But there are yet other turns to the logic, and the critic advances the following proposition: if Madame Lebrun had conceived the work before the death of the youngest child, then showing a sad queen becomes an even more egregious mistake if we consider that the artist obviously knew how to depict maternal tenderness. This skill he takes as clearly displayed in a self-portrait with her daughter shown at the same Salon.[18] His implication is not that Vigée-Lebrun intended to display maternal tenderness in the portrait of Marie-Antoinette, but that she should have and could have, but chose not to.

Now this is a provocative remark, especially since Vigée-Lebrun's self-portrait garnered high praise for its depiction of maternal tenderness. Yet the seemingly positive assessment of that painting in the *Mémoires secrets* is hardly unequivocal. The critic comments that her self-portrait has a *mignardise* (affectation) that all artists, amateurs and men of taste criticize as odious: a smile that shows her teeth. This affectation, he claims, is out of place in a mother.[19] What for me makes this intervention especially pointed is that other Salon critics who comment on this aspect of her work contradict the *Mémoires secrets*. Far from condemning Vigée-Lebrun, they praise her ability to show a smile or a laugh with the mouth open, which does not slide into a grimace.[20] The critic's use of the phrase '*montre les dents*' I take as a play on words; saying that someone shows his or her teeth is saying that they express menace. And if for that critic there is 'menace' in Vigée-Lebrun's self-portrait, he discerns a more problematic threat in her painting of Marie-Antoinette, which denies viewers the right to know the work's intended meaning.

As we read on in the commentary, it becomes evident that the significant point is not whether the queen is happy or sad, or whether she expresses maternal tenderness, but that the portrait does not make clear the artist's intention. Indeed, the critic specifically chastised Vigée-Lebrun for not developing her 'intention' in the *livret*, and, in particular, for not explaining the empty cradle: 'there will always remain a regrettable equivocation around this child's bed, which gives the work the sense of an enigma.'[21] Hammering home the point, the critic compares the work unfavorably with Adélaïde Labille-Guiard's portrait of the king's aunt, Madame Adélaïde (Figure 7.1), a

painting whose iconography the artist described quite explicitly in the Salon *livret*, as Melissa Hyde shows in the previous chapter of this volume. That painting, the critic contends, admirably illustrates its iconography and successfully displays the appropriate emotions.

As I have argued, the empty cradle has a prominence in contemporaneous commentary on Vigée-Lebrun's portrait of Marie-Antoinette and her children. Recent interpreters, in contrast, have mentioned it only in passing. And while those who wrote about Vigée-Lebrun's painting in 1787 found elements unresolved, unreadable, or downright enigmatic, two centuries later historians have been certain of the work's intentions. Operating between these two sets of viewers, I return to the problem of the cradle. By looking anew at that prominent element, I again ask if anything in this painting remains equivocal, and why. I do not argue it was Vigée-Lebrun's intention to create an equivocal painting, but rather that in spite of any intentions she (or her patron) might have had, the work remains uncertain because there is equivocation in the discourses – both visual and political – that the portrait invokes.

Rocking the cradle

Whether or not Vigée-Lebrun intended to place a sleeping child in her picture, the cradle mimics the queen's body in its posture and shape. What does this visual association imply? Used figuratively, the word *cradle* (*berceau*: defined as a small baby's bed, sometimes with draperies, and that usually can be rocked) indicates the place where someone is born or the place where something begins.[22] As queen of France, Marie-Antoinette is figuratively the cradle of monarchy, the site from which issue forth French kings. She is, in effect, the dauphin's cradle, and, in the image, his gestures associate cradle with queen. Notice how he simultaneously lifts the drapery from the cradle and points toward his mother, revealing one and drawing our attention to the other.

In figuring Marie-Antoinette as the cradle of France, Vigée-Lebrun's painting presents on the surface a very conventional notion. The portrait shows the queen at Versailles in her official function – that of producing heirs to the Bourbon throne. The dauphin's prominence in the scene resonates with earlier paintings of queens with their first-born sons and allies this image with a well-established tradition. Henri and Charles Beaubrun, for example, painted a full-length portrait of Marie-Thérèse of Austria with the dauphin (*c*. 1665, Madrid, Prado). The queen and the heir are here dressed for some sort of masquerade (she holds a mask, he a tiny sword) and they stride across a colonnaded terrace, using the architecture as both frame and stage. Equally theatrical is Alexis Simon Belle's portrait, *Queen Marie Leczynska and the Dauphin*, which Louis XV commissioned (1729, Figure 8.3). He presents the

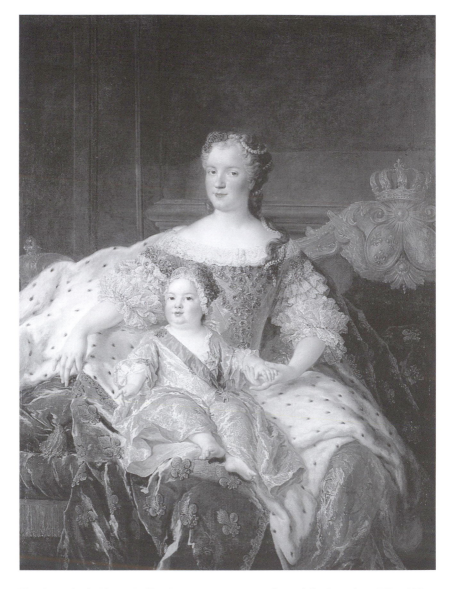

Fig. 8.3: Alexis Simon Belle, *Queen Marie Leczynska and the Dauphin*, 170 × 139 cm, oil on canvas, 1730, Versailles, Musée national du Château (Réunion des Musées Nationaux, P. Bernard/Art Resource, NY)

queen and dauphin as a secularized Madonna and Child enthroned, with each looking out of the picture to solicit the viewer's gaze. The dauphin sits on his

mother's lap as if he were already a small monarch, and he is draped in the blue cordon of the order of Saint Esprit. Marie Leczynska is dressed, as records tell us, '*en costume de sacre*', and in a sense she is now securely the queen, for giving birth to a dauphin crowns her position in a way no ceremony could. Across the queen's lap, Belle has draped a throw that invokes the coronation robes, and he shows it so both sides are visible, one of royal ermine, the other of blue velvet embroidered with gold *fleur-de-lis*. And behind the queen and dauphin, prominently displayed to their right, is the royal insignia: the French crown posed atop two heraldic shields.[23] Neither Belle's portrait nor that made by the Beaubruns originated in the desire to bolster a queen's sullied reputation; both followed established convention. Since in 1785 there was no state portrait of Marie-Antoinette alone with the dauphin, it is possible that she wanted Vigée-Lebrun's painting to fulfill a similar function.

Yet in representing Marie-Antoinette with three of her children, Vigée-Lebrun has also appealed to other portrait conventions. Her work, for example, recalls images of royal families, for example, Pierre Mignard's *Portrait of the Grand Dauphin and his Family* (1687) (Figure 8.4), which shows the dauphine with three of her offspring. In this painting the dauphine, like Marie-Antoinette, is seated against a column and closed blank ground, her feet resting on a large cushion. More reminiscent still is the eldest son who, like the dauphin in Vigée-Lebrun's portrait, enters the composition at the far right, turning to engage the audience. While the eldest is already a little man, the youngest child is very much a squirming baby at his mother's side. An obvious difference between this image and Vigée-Lebrun's portrait of Marie-Antoinette, of course, is the father's presence, and the dauphin dominates the open left side of Mignard's composition.

More closely connected to what we see in Vigée-Lebrun's portrait are paintings of the king's official mistresses with his natural children. Unlike the images of the queen with the dauphin, these works often show two or more siblings surrounding their mother. Such portraits date from the reign of Louis XIV, who legitimated the illegitimate children shown in these portraits, which are now collected together at Versailles.[24] Thus in each of these works, the king's mistress sits with children the king recognized as his own. Mignard shows Louis XIV's fertile mistress, Madame de Montespan, reclining in a woodland setting amidst her children (Versailles, Musée du Château), and in a portrait attributed to Charles de La Fosse, she sits in an architectural setting with her sons and daughters at her side (Versailles, Musée du Château). The mistress Montespan replaced, the duchesse de la Vallière, Mignard posed in a loggia with her two legitimated children (Figure 8.5). Rather than engaging with them, the *duchesse* gazes out at the audience with a vague look that calls to mind the lack of 'intention' that critics found in Marie-Antoinette's expression.

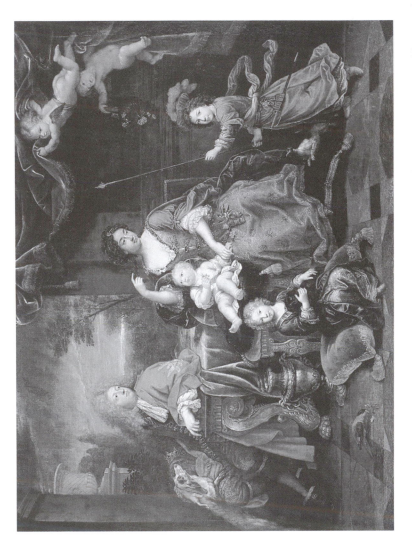

Fig. 8.4: Pierre Mignard, *Portrait of the Grand Dauphin and his Family*, 232 × 304 cm, oil on canvas, 1687, Versailles, Musée national du Château (Réunion des Musées Nationaux/ Art Resource NY)

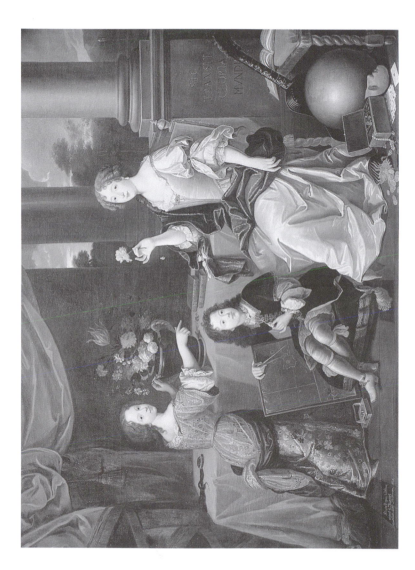

Fig. 8.5: Pierre Mignard. *The Duchess de la Vallière and her Children*, oil on canvas, Versailles, Musée national du Chateau (Réunion des Musées Nationaux/ Art Resource NY)

Vigée-Lebrun's Marie-Antoinette thus hovers between traditions. Like images of the queen with the dauphin, Vigée-Lebrun's portrait privileges the first-born son, but like representations of the royal mistresses, it includes all the queen's children. Showing all of them – something the queen desired from the start – may have been 'intended' to advertise the well-known Habsburg fertility, especially since the king's physical problems delayed the production of an heir, which many, nevertheless, blamed on the queen. Whatever the intended meaning, the visual language appeals to established conventions that set into play a range of associations. The painting could imply, for example, a coincidence of queen and mistress, a reading that would have some import in 1787. Since Louis XVI had no titled mistress, the equivocation between conventional types could suggest that Marie-Antoinette consolidated in herself the power ordinarily divided between the queen and the royal favorites. It could also imply that the queen, like many a royal favorite, was an adulteress. There were certainly rumors about the dauphin's legitimacy, and pamphlets slandering Marie-Antoinette often presented her as sexually profligate, a troubling charge indeed.[25]

There were other reasons, aside from the question of legitimacy, to make the king's connection to his children evident in a portrait of the queen with her offspring. And in this case, it is the official title of the painting that emphasizes the paternal line: 'The queen holding on her lap Monsieur the Duke of Normandy, accompanied by Monsieur, the dauphin and Madame, the king's Daughter.' This is how the title appeared in the Salon *livret*, and how contemporary critics and journalists named the painting. The official title points out that the children belong to the king's children, and it tacitly appeals to the mythology of Salic Law, a law considered first among the fundamental laws of France and constitutive of the nation.[26] Salic Law determined kingship by the right of succession and excluded from succession females and males descended in the female line. Thus where there were queens of France, there were no French queens; queen of France signified the wife of the king, and 'queen' had no meaning except in relation to 'king'. Although magisterial power passed through the body of the queen, she did not partake of it – except, of course, through her son if she should become regent, which was the case repeatedly in the sixteenth and seventeenth centuries. Producing sons, therefore, could generate a contradiction. Although it was a queen's primary duty to provide the kingdom with an heir, underage sons also represented the potential ruling power of the queen, and a queen's rule – even as regent – hardly held to the spirit of Salic Law.

Queens and queen regents often had themselves depicted with their sons. The most remarkable image of the potential ruling power of women, a power transformed into a distaff lineage, is Charles and Henri Beaubrun's *Anne of Austria, Marie-Thérèse of Austria and the Dauphin, c.* 1665 (Figure 8.6).

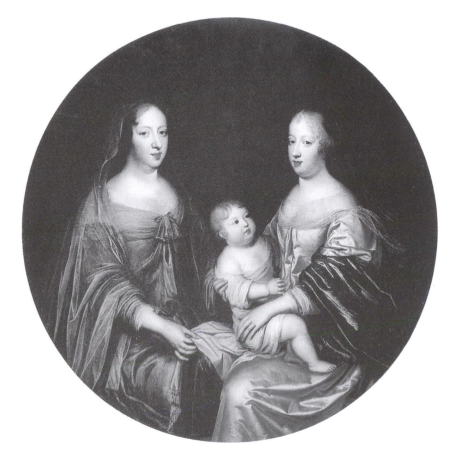

Fig. 8.6: Charles and Henri Beaubrun, *Anne of Austria, Marie-Therese of Austria and the Dauphin*, c. 1665, Niort, Musée Bernard D'Agasci

This work shows Anne of Austria, the former regent and mother to the reigning king, Louis XIV, with the dauphin and his mother, Marie-Thérèse of Austria, who was Louis XIV's wife as well as Anne's niece and daughter-in-law. These two Spanish Habsburg princesses had both been married to French monarchs to guarantee peace between the Catholic powers; indeed, Simon Renard de Saint-André made a double allegorical portrait of the two queens as Peace and Concord (1664, Versailles, Musée du Château). But the Beaubruns' image is singular, and quite telling in its iconography. Marie-Thérèse holds the dauphin on her lap, which is exceptional for the period, for then the heir was usually shown standing on a nearby *taboret* or table, as in an anonymous image of a seated Anne of Austria presenting her infant son,

Louis XIV (before 1643, Versailles, Musée du Château). In the case of the Beaubruns' portrait, placing the child on the mother's lap makes an explicit reference to traditions for showing the Virgin and Child. Including Anne of Austria extends the reference and transforms the portrait into a holy kinship, with the king's mother appearing as Saint Anne, her patron.[27] The holy kinship, of course, traces the matrilineal heritage of Jesus. On the one hand, the portrait implies that if the queen/mother plays the part of the Blessed Virgin, then the king who impregnated her takes the role of God the Father. There was, of course, precedence for such an analogy in the ideology of divine-right monarchy. Yet the virgin birth implies a mother and son relation that excludes any mortal father, and the holy kinship strengthens this meaning by highlighting Mary's relation to her mother.

In the French imaginary, however, the king's children belonged to him and to France or the kingdom, long figured as the king's privileged spouse. When the king is married to the nation, and his children are the children of France, the queen is – at least metaphorically – displaced as mother of the future king.[28] This construction offers male autogenesis in place of virgin birth. The myth, more importantly, deflects the threat that even the most legitimate of French kings issued from an alien site, that the cradle of France was foreign to the nation. It replaces the queen imported from another realm with France herself.

It is in the heart of the French state that Vigée-Lebrun locates Marie-Antoinette, positioning her not at Trianon (which she treated as her private domain) but in the palace at Versailles, and specifically in the Salon de la Paix. We recognize the place where Marie-Antoinette sits because Vigée-Lebrun is at pains to include at the left side of the canvas the alcoves of the Galerie des Glaces, which joined the Salon de la Paix to the Salon de la Guerre on its other side. Including those *percées*, incidentally, left the artist open to criticism, for it was widely believed that they disrupted the harmony of the composition. The remarks in the *Correspondence littéraire* summarized this opinion: 'We find that the alcoves of the gallery destroy the general effect. We believe that if the background had been more tranquil, the composition would have provided a more restful backdrop for the heads and the whole painting would have been infinitely improved.'[29] Was including the gallery simply an error – a compositional miscalculation on Vigée-Lebrun's part? Was opening the composition on the left important to the work's meaning? Or was it that locating the exact site where Marie-Antoinette sits had a particular significance to artist or patron?

As well as holding balls and *fêtes* in the Salon de la Paix, Marie-Antoinette met important foreign visitors there. It was not a room where she received her children, however. Maternal visits took place in the elegant drawing room, the inner or gold room, of her private apartments. There she would also greet her friends and hold musical gatherings, and there she reportedly sat for

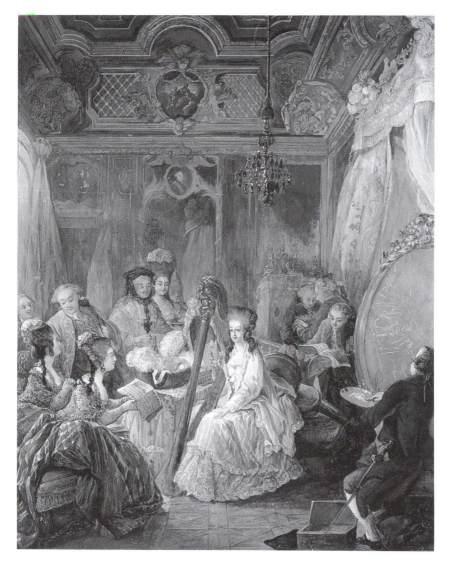

Fig. 8.7: Jean-Baptiste André Gautier-Dagoty, *Marie-Antoinette Playing her Harp*, gouache on paper, 1777, Versailles, Musée national du Château (Réunion des Musées Nationaux, P. Bernard/Art Resource, NY)

Élisabeth Vigée-Lebrun. Jean-Baptiste André Gautier-Dagoty shows us the uses of this room, perhaps somewhat imaginatively, in his gouache portrait of Marie-Antoinette playing her harp (1777, Figure 8.7). Although the children are out of sight on this occasion, we see Marie-Antoinette seated between her

harp and dressing table as if she were occupied with both activities simultaneously. Around her are gathered her friends and those who served her, for example, her *modiste* Rose Bertin (or someone who plays the part of *modiste*). We also see an artist – Gautier-Dagoty himself? – tucked into the right-hand corner and recording the scene. It is, however, an element in the background – the jewel box – that connects this work to the portrait of Marie-Antoinette and her children. It is the same jewel cabinet, the one the city of Paris gave Marie-Antoinette, that appears in Vigée-Lebrun's image.[30] Gautier-Dagoty's work shows us this furnishing in a more appropriate and plausible location. In Vigée-Lebrun's portrait, however, the jewel box, much like the children, has been trucked in for the occasion, brought from the inner, private apartment to the state rooms of Versailles. And like the children and the jewel box, the cradle is also out of place in the Salon de la Paix. That the elements of this composition are brought together in a room where they would not actually be found suggests their metaphoric or symbolic function. Far from signaling the domestic or the real, the furnishings both point to the theatrical and alert us to their signifying potential.

As the first room of the queen's state apartments, the Salon de la Paix could be cut off from the Galerie des Glaces by a curtain and screen, although on ceremonial occasions it would be opened to form a suite with the Galerie and its mirroring room – the Salon de la Guerre. In Vigée-Lebrun's painting we see that the Salon de la Paix has been opened up; the curtain drawn back. Are we to presume this is a ceremonial occasion? Would a ceremonial occasion account for this work's theatricality? Not only does Marie-Antoinette seem as if she is on stage, waiting to be seen, but the queen is also dramatically lit. Although no swag of fabric flutters over Marie-Antoinette, the upper part of the canvas is darkened, its shadow almost an extension of the drapery drawn back at the opening of the mirrored gallery. The dauphin's gestures increase this theatricality by directing attention to the queen and raising the drapery, the curtain, on her symbolic double. The space seems set with props and the actors look posed. Even the daughter's embrace has a studied quality about it. For what audience is the queen waiting? To whom will she grant an audience? Or is the making of a royal portrait itself a ceremonial occasion? Does this work play on Gautier-Dagoty's image by replacing the more private apartments with the Salon de la Paix, and an artist at his easel with one whose presence is only suggested?

As soon as we can imagine an artist or an audience located offstage, in front of the queen, then the opening to the Galerie des Glaces begins to seem less of a miscalculation. Now we can also imagine someone approaching from that direction. Is the composition open here so we can envision the king walking onto the scene from his state apartments? Or does the arrangement suggest an open corridor of power between Bourbon and Habsburg territory?

THE PROBLEM OF INTENTION 181

We know that Marie-Antoinette represented her Habsburg lineage in her state apartments, for example, in the state bedroom, the place where the 'children of France' were actually born. Marie-Antoinette decorated that space with the combined emblems of Austria and France, alternating the two-headed Habsburg eagle with the arms of France and Navarre. She also installed there portraits in Gobelins tapestry of her mother, Empress Maria Teresia, her brother, Emperor Joseph I and her husband, King Louis XVI.

If we step from the queen's bedroom back into the Salon de la Paix, we see that the room Vigée-Lebrun shows us is not decorated to resemble the Salon. To reproduce its elaborate ornaments, its mirrored walls and elegant *boiserie* carvings would surely have distracted from this composition, reduced to simple forms. But if the room's decoration does not look like that of the Salon de la Paix, how do we account for the mirrored gallery that critics found disruptive to the composition? Does the artist create an imagined space that through its proximity to the gallery brings to mind the Salon de la Paix? Is the Salon's decoration recalled by its absence? Absence, after all, is central to this painting. The empty cradle suggests the princess who died; the mirrored gallery, a king who is not there.

It is worth noting that the decoration of the Salon de la Paix has a clear relation to the image Vigée-Lebrun shows. The iconography touts the benefits of peace as the chamber's name suggests, but in the Salon peace has a particular source. Charles Le Brun's image in the cupola (1686) shows a victorious France offering an olive branch to the powers organized against her. This France rides in a chariot drawn by doves, to symbolize the marriages that united France to Bavaria and Spain. In 1729, François Lemoyne added to the room an image of Louis XV making peace. We see the French monarch offering an olive branch to Europe represented as a richly dressed queen. At the same time, allegories of Fecundity and Piety (suggestions of Marie Leczynska virtues?) bring to Louis his newly born twin daughters. These are the 'daughters of France', and where a marriage with Marie Leczynska did little to insure the balance of power, her daughters could be useful in forging political alliances.

The imagery of the Salon de la Paix suggests that peace with formerly hostile powers comes through marriage alliances. In such a scenario, the mother's family would have some claim on the children, who become then not only '*les enfans de France*' but living symbols of the alliance between France and a foreign state. This meaning shadows the painting's official designation: *Portrait of the Queen Holding on her Lap Monsieur, the Duke of Normandy, Accompanied by Monsieur the Dauphin and Madame, Daughter of the King*. Although it might trouble some that these children do not belong only to France, such a notion emerged in comments on Wertmuller's portrayal of Marie-Antoinette and her children. I turn again to the *Mémoires secrets*,

and its paraphrase of another pamphlet, the *Réflexions impartiales sur les progrès l'art en France* (1785) now attributed to Abbé Soulavie. Here is the pertinent part of his analysis, quoted directly from the *Réflexions*: 'This portrait is not very resembling; it is necessary here to represent the queen as mother of the children who surround her, as presenting these august children to the nation, and as a sovereign.'[31] The critic goes on to admit, however, that it is difficult to combine the necessary qualities of 'majesty, benevolence and charm' in a single image.

In referring to this assessment, the *Mémoires secrets* reports that 'a judicious critic' advised Wertmuller to show the queen presenting the children to the nation, directing attention and affection to the children, and 'reasserting more strongly than ever, by these precious promises (*gages précieux*), the union between France and Austria'.[32] Thus in the Salon before the one in which Vigée-Lebrun showed her portrait of Marie-Antoinette and her children, the *Mémoires secrets* conceives the queen's maternity in political terms, as is evident in their recasting of the Abbé Soulavie's comments. Judging from the general disdain for the queen obvious in the *Mémoires secrets*, calling her children the '*gages précieux*' of a Franco-Austrian alliance may, in fact, have been inflammatory, especially for those who feared such an alliance.

Such an alliance was also read in unexpected places, for example in the rug we see on the floor in Vigée-Lebrun's portrait. A ribbon of roses woven into the carpet winds around Marie-Antoinette's feet, and this garland both frames her and names her since her signature flower was the rose and her marriage to Louis XVI, engravers figured as a bouquet of roses and *fleurs-de-lis*, a blending of two different flower families.[33] In this portrait with her children, the queen's red velour dress repeats and intensifies the rose color, transforming Marie-Antoinette into the most brilliant flower of this indoor scene, which she shares with her three children. In fact, the king's children are figured in the painting not on the carpet, but on the jewel box as three *fleur-de-lis*, three flowers of France. A Salon pamphlet in 1787 entitled *Le Bouquet du Sallon* played on the horticultural metaphor. Here is how the poet/critic begins the commentary on Vigée-Lebrun's portrait: 'But raise your eyes, see these lilies/growing in the shade of this rose/The last of the three rests on the breast that has borne them.'[34] More overtly than Vigée-Lebrun's painting, the poem appeals to the magic of Salic Law, but by what horticultural art can a rose bring forth lilies? And what lilies can bloom in the shade?

That the *fleur-de-lis* are emblazoned on the jewel box draws our attention back to that furnishing. For those who see this portrait as intended to sanitize the queen's public reputation, the jewel box needs explaining since it would seem that any positive portrait of Marie-Antoinette, coming on the heels of the notorious Diamond Necklace Affair, might want to avoid reference to the

queen's jewels. In Vigée-Lebrun's portrait, Marie-Antoinette wears few jewels, which was also the case for other queens depicted with their sons. Here the jewelry is limited to a pair of pearl earrings and a pearl bracelet. Although the artist avoids showing any diamonds, the pearls she does portray are not easy to interpret, for pearls have many possible meanings, all familiar to eighteenth-century painters and their audiences. Pearls abound, for example, in images of Venus, goddess of beauty and love, who is often seen putting on pearl earrings in scenes of her toilet. Cleopatra's pearl earring is a symbol of reckless and wanton expenditure when at her banquet she dissolves it in a glass of wine, which she then offers to Marc Anthony. On the other hand, pearls could identify the dutiful *bourgeois* wife and mother in family portraits, and suggest that she is a '*perle*', a valued person, a treasure.[35] What Marie-Antoinette's pearls signify is open to question, as is the import of the jewel case, which fills the right background in Vigée-Lebrun's painting.

To explain the presence of the jewel box, Baillio has suggested that Vigée-Lebrun shows Marie-Antoinette as the virtuous Roman matron Cornelia, mother of the Gracchi, who when asked to show her jewels, pointed to her sons.[36] Now this is an attractive idea, and one that adds resonance to the work. But here again the painting is equivocal since within the image it is not the queen who shows us her children, but the dauphin who presents his mother and siblings to the audience. It might be rather that Marie-Antoinette is the jewel of France; or it might be that the jewel box-as-container provides another image of Marie-Antoinette in whose womb the jewels of France were lovingly coated with nacre. This reading recasts Cornelia's story, but it also obviates the need for the Roman matron. More importantly, perhaps, the particular jewel cabinet has a special resonance beyond the story of the virtuous ancient.

The furnishing we see would have been recognizable to many both in and out of court: it is the jewel box the city of Paris offered Marie-Antoinette when she was dauphine (the jewel case is now lost and known only through descriptions). By all accounts this work was a true and famous marvel, well known in its day.[37] What interests me is its particular iconography. On the understructure of the cabinet, on its center stretcher, was the gilded eagle of Austria. With wings outstretched and a garland of flowers in its beak, this emblematic bird rested on a sun-bedecked shield, symbolizing France. Ornaments referring to the alliance of France and Austria embellished the entire construction, with specific references to Louis XVI and Marie-Antoinette as dauphin and dauphine. There were medallion portraits of the royal couple, and the box was topped with a crown supported by eight dolphins.

When Louis XVI ascended to the throne, Marie-Antoinette had the jewel cabinet redecorated, and that is how we see it. The Austrian eagle remained, but the dolphins were banished and the crown at the top became royal. The

armorials of the dauphin gave way to the escutcheon with *fleurs-de-lis* on a field of azure, a sign reserved for reigning sovereigns of France. Although the royal insignia of France are clearly visible on the jewel box, in Vigée-Lebrun's portrait we do not see the Austrian eagle. Is this merely an accident of the composition? Is the occlusion deliberate, intentionally yielding up one meaning to emphasize the Salic fantasy? Does this piece of furniture replace the king? It is, after all, crowned and marked with his insignia – and it is visually related to the open gallery on the left that leads to the king's domain. Although at right angles to one another, these two rectangular shapes enframe the mother and cradle. Moreover, in Salic Law only the king's body – or those of his sons – contained the seeds of the family jewels, since status could be passed to the next generation only through the semen. The son of a king's son could inherit the throne; the son of a king's daughter could not. In Vigée-Lebrun's portrait it is the dauphin who is closely allied with the royal jewel box; his body and its right edge form a continuous line.

If the king is represented by a piece of furniture, stolid and rectangular, it is the curving and covered form of the cradle that represents the queen, Marie-Antoinette. Although this cradle seems perfectly still, we know that by definition cradles usually rock from one side to the other. In French the term is *balancer*. Figuratively, *balancer* means to be uncertain, to hesitate, to be ambiguous.[38] And this cradle is doubly ambiguous, for it is not even clear that it rocks. We don't really see what is underneath the cradle, any more than we see what is underneath the jewel box. Would the cradle rock from side to side if I pushed it a little this way and that, in the way I have pushed from one side to the other the possible readings of this image?

Marie-Antoinette rocks from queen to mistress, from mother to cradle; she is situated in the Salon de la Paix even though the space around her does not resemble that chamber. She wears jewels that could signify either her virtue or her extravagance. Her oldest son represents both the queen's submission to duty and the possibility of her power. Her children belong to France yet they issue from a foreign place. They are hers, they are not hers, they are the king's, they are the nation's. They are the lilies of France, the children of France, its pearls, its jewels, and at the same time they embody a political alliance and belong to the house of Habsburg, if not in mythology or in law, in natural fact. That the power and fate of the French ruling dynasty depended on a woman imported from an alien realm was a reality Salic Law helped to obscure. It is the queen's maternity, the possibilities and contradictions inherent in it, that this painting represents. This would be the case for any image of the French queen with her children, but it is perhaps more intensely the case for this portrait of Marie-Antoinette.

The queen's children are secured as legitimate only by decree, by the father–king accepting them as legitimate. With the queen, as with any woman,

there was always the danger that she had been impregnated illegitimately. Maternity could be guaranteed simply by viewing a royal birth; paternity could not. There were certainly rumors about the dauphin's paternity, but even in the absence of rumor, who could be certain that no imposter rocked in the cradle of France? And in a sense an imposter always slept there, for never were the queen's children of pure French blood, never were they true children of mother France. The queen's children are always composed of – contaminated by – alien matter, by the substance of the maternal body.

Heralding the naturalness of maternal love perhaps put extra pressure on the Salic fantasy toward the end of the eighteenth century. That at least one commentator claimed to see motherhood in Vigée-Lebrun's portrait of Marie-Antoinette is no surprise, and the pamphlet, *Le Bouquet du Sallon*, ends with this sentiment: 'Of the Sovereign Majesty/Contemplate the gracious features/ One reads on her face, I am queen/And I am mother in her eyes.'[39] Such a response, however, was not shared by other critics, some of whom could read nothing in Marie-Antoinette's gaze, and many of whom saw in her eyes only what they wanted to see – or what their particular position enabled them to see.

Looking again at the portrait, the queen's expression does, in fact, seem to lack any definite 'intention'. Although the queen directs her look outside the picture, the artist keeps the expressive features in neutral. The eyebrows are not raised; the mouth turns neither up nor down; the eyes are not open wide nor are they dramatically cast in one direction or another. Marie-Antoinette looks straight on, her brow uncreased, her head neither tilted up nor down, her expression calm and unarticulated. No matter what the artist intended, the queen's blank look, like the empty cradle, abets the viewer's projection. Each withholds absolute meaning, each calls for interpretation.

Also open to interpretation are the conventions, traditions and histories this portrait engages, as well as the objects, sites and signs the artist mobilizes. In Vigée-Lebrun's *Portrait of the Queen Holding on her Lap Monsieur, the Duke of Normandy, Accompanied by Monsieur the Dauphin and Madame, Daughter of the King* neither Salic Law nor the queen's maternity nor the meaning of these children is absolute. Even if we could be certain of the artist's or the patron's or the monarchy's intentions, the visual language easily betrays any purpose. Looking for intention is like looking for the absent child who may or may not have once been in the empty cradle. For if we locate the child or pinpoint the intention, we have still not found the meaning of either the cradle or the visual image in all their complexity. What history – including the specific history of this painting – tells us is that viewers constantly make different meanings from the possibilities a work presents. So, like a cradle, meaning glides easily back and forth, to and fro, put into play or brought to a halt by the hand that rocks the cradle.

Notes

All translations are my own. This essay has greatly benefited from the questions and comments of audiences at the University of Iowa, Northwestern University, James Madison University, and the Art Gallery of New South Wales. I am equally indebted to colleagues who discussed the painting with me at Versailles: Vivian Cameron, Kathleen Nicholson, Joan Landes, Katie Scott and Susan Taylor-Leduc, and to Keith Luria, for his astute reading of the manuscript. I thank Melissa Hyde and Jennifer Milam for their continued help and support, and for giving me the occasion to complete an essay I abandoned in 1996. I dedicate this essay to the memory of Rose Sheriff.

1. The most important essay on this painting is Joseph Baillio, 'Le dossier d'une oeuvre d'actualité politique: Marie-Antoinette et ses enfants par Mme Vigée Le Brun' (1e partie) *L'Oeil* 308 (March 1981), 34–41 and 74–5, and 2e partie, *L'Oeil* 310 (May 1981), 53–60 and 90–91. The painting is also discussed in Simon Schama, 'The Domestication of Majesty,' *Journal of Interdisciplinary History* 17 (1986), 155–84.

2. *Mercure de France* 40 (1 October 1785), 34. On Marie-Antoinette's response to the work, see 'Lettre II. Sur les peintures, sculptures et gravures exposées au Sallon du Louvre le 25 Aout 1785', *Mémoires secrets pour servir à l'histoire de la république des lettres en France*, 36 vols (London: Chez John Adamson, 1780–89), 30: 190.

3. *Nouvelles Archives de l'Art Français*, 3rd ser., 22 (1906), 132.

4. Ibid., 133.

5. Ibid., 132.

6. Schama, *The Domestication of Majesty*, 178 (Sheriff's italics). He follows Baillio's argument here.

7. Ibid., 179 (Sheriff's italics).

8. Baillio, 'Le dossier', 2e partie, 59 (Sheriff's italics).

9. Ibid., and Schama, *The Domestication of Majesty*, 178.

10. *L'Ami des artistes au Sallon par M. L'A.R.* (Paris, 1787), 33 (Collection Deloynes, vol. 15, no. 379). For other commentary: *Mercure de France* (22 September 1787), 175–6; *Journal de Paris* 23 (September 1787), 1152; *Tarare au Sallon de Peinture* (Collection Deloynes, vol. 15, no. 376) 17–18; *Correspondance littéraire, philosophique et critique par Grimm, Diderot, Raynal, meister, etc.* ed. Maurice Tourneux, 16 vols (Paris: Garnier Frères, 1877–82), 15: 163–4; *La Bourgeoise au Sallon* (Collection Deloynes, vol. 15, no. 384), 15, and 'Lettre I. Suite des observations sur les Peintures & Sculptures exposées au Salon du Louvre', in Elie Catherine Fréron, *L'Année littéraire*, 16 vols (Paris: Chez Mérigot, 1751–89), 7: 4–6.

11. *L'Amie des artistes*, 33–4.

12. Ibid., 34.

13. *L'Année littéraire*, 7: 5.

14. Ibid.

15. On this point see Sheriff, *The Exceptional Woman*, 103–5; 128, 130, 145.

16. 'Première lettre sur les peintures, sculptures & gravures exposées au Salon du Louvre', *Mémoires secrets* 36: 298–9.

17. Ibid., 36: 299–300.

18. Ibid.

19. Ibid., 36: 301.

20. See, for example, *Correspondance littéraire*, 15: 164 and *L'Ami des artistes*, 35.
21. *Mémoires secrets*, 36: 300.
22. Paul Robert, *Dictionnaire alphabétique et analogique de la langue française* (Paris: S.A.F.O.R, 1958), 1: 454.
23. This image is discussed in Fabienne Camus, 'Alexis-Simon Belle portraitiste de cour (1674–1734),' *Bulletin de la Société de l'Histoire de l'Art français Année 1990* (Paris, 1991), 38–9.
24. I know of no such portrait from the reign of Louis XV; neither Madame du Pompadour nor Madame du Barry bore the king natural children. For a discussion of Mignard's works, see Lada Nikolenko, *Pierre Mignard. The Portrait Painter of the Grand Siècle* (Munich: Nitz Verlag, 1983). Although she accepts Figure 8.5 as a copy after a lost Mignard portrait of Madame de la Vallière and her children, Nikolenko also points out that historically the names of Louis XIV's mistresses have been attached to many portraits of women and children (28–33). For my essay, her conclusions about which specific portraits do or do not represent these women (conclusions made in the absence of secure documents) are less significant than the more general observation that portraits of a lady with a child or children have historically been viewed as portraits of either La Vallière or Montespan with the king's children.
25. The literature on the slander directed against Marie-Antoinette is vast; Baillio discusses some of it in 'Le dossier.' See also Chantal Thomas, *La reine scélérante: Marie-Antoinette dans les pamphlets* (Paris: Seuil, 1989).
26. Sheriff, *The Exceptional Woman*, chap. 5.
27. *Visages du grand siècle. Le portrait français sour le règne de Louis XIV 1760–1715* (Paris: Somogy éditions d'art, 1997), 199.
28. Sheriff, *The Exceptional Woman*, 155–7.
29. *Correspondence littéraire*, 15: 164.
30. On this jewel box, see Juliette Niclausse, 'The Jewel-Cabinet of the Dauphine Marie-Antoinette,' *The Journal of the Walters Art Gallery* 18 (1955), 69–77, 91, and Germain Bapst, 'Notes et souvenirs artistiques sur Marie-Antoinette,' *Gazette des Beaux-Arts* (1893), 381–91.
31. Abbé Soulavie, *Réflexions impartiales sur les progrès de l'art en France* (Paris and London, 1785) (Collection Deloynes, 1787), vol. 15, no. 14: 295.
32. 'Lettre II. Sur les peintures, sculptures et gravures exposées au Sallon du Louvre le 25 Aout 1785,' *Mémoires secrets* 30: 190.
33. See, for example, *Les Sentimens de la Nation* engraved by F. Janinet after J. B. Huet and issued to commemorate the birth of the dauphin on 22 October 1781.
34. M. Demoustier, *Le Bouquet du Sallon* (Paris, 1787) (Collection Deloynes, vol. 15, no. 388), 6.
35. On the meaning of pearls, see Mary Sheriff's essay, 'A Rebours: Le problème de l'histoire dans l'interprétation féministe,' in *Où en est l'interprétation de l'oeuvre d'art*, ed. Régis Michel (Paris: Ecole nationale supérieur des beaux-arts, 2000), 212. Marie-Antoinette was figured as Venus in Augustin Pajou's *Allegory of the Birth of the Dauphin in 1781* (1781, Versailles, Musée du Château) in which the queen, as Venus, holds the dauphin, figured as Cupid, in her arms.
36. Baillio, 'Le dossier', 2e partie, 58.
37. See Niclausse, 'The Jewel-Cabinet', 71–4 and Bapst, 'Notes et souvenirs', 382–4.
38. Robert, *Dictionnaire alphabétique*, I: 395.
39. M. Demoustier, *Le Bouquet du Sallon*, 6.

CHAPTER NINE

Ancient Matrons and Modern Patrons: Angelica Kauffman as a Classical History Painter

Wendy Wassyng Roworth

Angelica Kauffman (1741–1807) stands out among women artists of the eighteenth century as a painter who achieved both critical acclaim and financial success as a history painter in Italy, where she first acquired her skills and established herself as such, and in England, where she became a popular painter of subject pictures and portraits during the fifteen years she lived in London, from 1766 and 1781. She was one of only six artists designated as 'history painters,' among the original thirty-six Founding Members of the Royal Academy of Arts in London in 1768, a rare accomplishment for a woman and evidence of her importance as one of the few artists in England trained in the academic tradition of classical narrative painting. During her years in England, Kauffman exhibited numerous paintings of themes from ancient literature, history and mythology, often with striking originality and to great acclaim, and though some British critics noted the 'effeminacy' of Kauffman's male figures or lewdly questioned the extent of her direct knowledge of male anatomy, such prurience was balanced by the praise she received for promoting the art of history painting in England.[1]

Kauffman was able to take advantage of the opportunity to advance her career in Britain, for as compared to Italy, where there was a long tradition of patronage for antique as well as religious subjects, the situation in England was quite different. The British public had little interest in narrative pictures of classical themes except for Old Master works imported from the Continent or paintings by foreign artists purchased abroad. While there was great demand for portraits, landscapes and sporting pictures of horses and dogs, it took the efforts of several generations of British artists to encourage the

practice and patronage of history painting and to promote the establishment of an art academy under royal patronage.[2] Angelica Kauffman arrived in England at the right moment to take advantage of this situation; thus despite her status as both a woman and a foreigner, Kauffman's training and experience acquired in Italy made her a desirable asset to Joshua Reynolds and other supporters of the foundation of a Royal Academy of Arts.

History painting, according to academic theory developed in Renaissance Italy, was considered the loftiest, most elevated genre, considered to be above portraiture, landscape, still-life and scenes of everyday life because it represented noble, heroic human actions that embodied moralizing or instructive themes from scripture, ancient and modern history, literature, or mythology through narratives or allegorical representations. Thus, history painting required knowledge of history and literature as well as training in perspective and anatomy, the very instruction that women artists were generally denied. In fact, proficiency in drawing the male nude was probably the single most important element in the education of a history painter, and it was at the very core of the theoretical and practical program of art academies from their earliest institution in Italy, France and later England. Kauffman managed to overcome that restriction by learning to render male anatomy by copying drawings and engravings of nudes made by her male colleagues and through the study of antique statuary and sixteenth- and seventeenth-century paintings by greatly admired artists such as Titian, Raphael, Correggio, Domenichino and Guido Reni.[3]

As a young woman Kauffman traveled throughout Italy with her artist father to develop her skills in the public and private collections in Milan, Venice, Bologna, Parma, Florence, Rome and Naples. Under the influence of the German antiquarian Johann Winckelmann in Rome, and with the encouragement of British artists she met in Florence, Naples and Rome, in particular Gavin Hamilton, Benjamin West and Nathaniel Dance, who were already painting classical subjects, Kauffman declared her ambition to become a history painter. In May 1765, she was honored with membership in the Accademia di San Luca and donated her reception piece which represented an allegory of Hope personified as a pensive young woman – a reference perhaps to her aspiration to achieve fame as a history painter.[4]

Angelica Kauffman was not the first woman artist to portray classical subjects. In Bologna in the late sixteenth and early seventeenth century Lavinia Fontana had made paintings of mythological subjects, including a standing nude *Venus and Cupid* (1585) and *Minerva in the Act of Dressing* (1613) (Figure 9.1). Later in the century another Bolognese painter, Elisabetta Sirani, portrayed several women from ancient history, including Timoclea and the heroic *Portia, The Wife of Brutus Proving Her Courage by Wounding Herself in the Thigh* (1663), while in Florence and Naples Artemisia Gentileschi achieved fame for her powerful representations of the Roman matron Lucretia, the

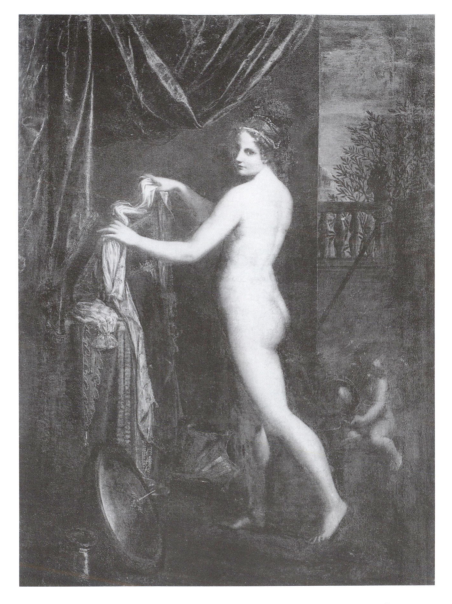

Fig. 9.1: Lavinia Fontana, *Minerva in the Act of Dressing*, 260 × 190 cm, oil on canvas, 1613, Rome, Galleria Borghese (Alinari/Art Resource, NY)

Egyptian queen Cleopatra, and other strong yet tragic women of antiquity.[5] Kauffman, however, stands out from her predecessors not only for her ambition to take up history painting as a profession, but also for her productivity, the variety of her compositions, and the significant role she played in the development of history painting in England and international neoclassicism.

Kauffman's biography written by her friend Giovanni Gherardo De Rossi and published just a few years after her death, helped to situate her within the history of art as a rare female history painter and ensured that she would be remembered for this accomplishment.[6] Though during her life Kauffman's illustrious reputation was based as much on her popularity as a fashionable portrait painter, De Rossi, no doubt reflecting Kauffman's own views, stressed the significance of her identity as a history painter and her decision to pursue the difficult career of 'pittrice Storica.'[7] De Rossi made a particular point of praising Kauffman in language generally employed by Italian writers of artists' biographies, including Giorgio Vasari, Giovanni Pietro Bellori and Carlo Cesare Malvasia, to describe the positive attributes of male artists. For example, De Rossi cited her extensive knowledge of history and literature and the elegance of her inventions, and he lauded the strength, sureness, frankness and freedom of her handling, deliberately choosing words suggestive of male mastery and power (*sicurezza, franchezza, libertà*). De Rossi went even further to contrast Kauffman's strengths with what he characterized as the weaknesses of other female artists: their timidity (*timidezza*), affectedness and studied diligence (*ricercata diligenza*), and he praised Kauffman's originality while declaring that Lavinia Fontana and Elisabetta Sirani, though worthy artists at their time, were essentially followers and imitators of their male peers. Throughout the biography he consistently underscored Kauffman's ambition to enter the masculine realm of history painting, which few women had done, to stress her choice at an early age to acquire the skills and knowledge to become a history painter, and to establish her as exceeding the expectations for women artists.[8]

Whether Kauffman shared De Rossi's view of her female predecessors, or if she felt any sisterly kinship with them, is not known, but she must have been well aware of her place in the history of art as one of the few women artists to portray classical subjects and her role as successor to the celebrated woman artists of Bologna, including Fontana and Sirani. In an undated painting, possibly made while she was still in Rome or shortly after her move to England in 1766, Kauffman represented the unusual subject of *Minerva (Pallas Athena) Preparing to Arm Herself*, a scene from the *Iliad* (V, 733–47) in which the warrior goddess removes the elaborate dress she has woven for herself, dons her father Jove's (Zeus) war tunic and armor, and rides off with Juno (Hera) in her chariot to aid the embattled Greeks[9] (Figure 9.2). Kauffman portrayed the goddess wearing her helmet and a lavish gold embroidered dress, which falls to

Fig. 9.2: Angelica Kauffman, *Minerva (Pallas Athena) Preparing to Arm Herself*, 128 × 192 cm, oil on canvas, ca. 1766–69, private collection (*Angelika Kauffmann e Roma*, Edizione De Luca, Rome)

reveal her breasts, just as she is beginning to untie her girdle and turn to look over her shoulder at the maid who presents a golden cuirass wrapped in red cloth. This work is strikingly similar to Lavinia Fontana's provocative painting of virtually the same subject, *Minerva in the Act of Dressing* (1613, Rome,

Galleria Borghese), cited above.[10] The precise meaning or source of Fontana's painting has not been determined, nor has Kauffman's painting previously been connected with it. Nevertheless, tantalizing similarities shared by the two paintings permit speculation regarding a relationship between them.

Fontana depicted a completely nude Minerva turning her body demurely away from the picture plane so she is seen from the back and side, yet the goddess gazes seductively over her shoulder at the viewer. She appears caught in the midst of changing her attire, holding up an intricately decorated dress while her breastplate, shield, gorget and helmet lie beside her on the floor. This painting, commissioned by the great art patron Cardinal Scipione Borghese, appears provocatively ambiguous, for it is unclear whether Minerva has just removed the garment or is about to put it on.

Was Fontana's more frankly erotic painting Kauffman's inspiration? There is no firm evidence, but Kauffman would very likely have known Fontana's painting in the Borghese collection in Rome. Moreover, Kauffman was undoubtedly conscious of her position as heir to Fontana, a female painter who challenged convention through the portrayal of classical subjects, received commissions from aristocratic patrons, and enjoyed the praises of her fellow artists. One hint of a possible connection between the paintings is the presence in Kauffman's picture of a small winged *putto*, which cannot be directly accounted for in the textual source. This smiling little figure holds Minerva's shield and playfully points at the goddess, just as Cupid frequently appears beside a standing nude Venus in sixteenth-century paintings, including Lavinia Fontana's *Venus and Cupid* (1585). In Fontana's Borghese *Minerva in the Act of Dressing* a very similar *putto* in the background toys with Minerva's helmet before an open doorway to a balcony, where the goddess's symbolic owl, lance and olive tree can be seen.

Kauffman appears to have followed Fontana's lead in her depiction of Minerva. This rare subject, in which the ordinarily chaste and virtuous warrior-goddess Minerva transforms herself from an uncharacteristically Venus-like female seductress into a Mars-like masculine warrior, may be understood as a metaphor for the conflicted nature of the female history painter's equivocal identity. As wise Minerva conflated with beautiful Venus dons the armor and takes up the weapons of Mars and Jove, so too the woman artist must employ her wit and charm to master the manly art of history painting.

While Kauffman represented a variety of subjects throughout her career, ranging from classical, Renaissance and contemporary literature, including the works of Ariosto, Tasso, Shakespeare, Laurence Sterne, Goethe and Klopstock, to ancient and British history, a significant number of Kauffman's compositions focused on antique matrons, wives and mothers, who embodied traditional female virtues and ideals. An examination of this theme can demonstrate why Kauffman's work was so appreciated by her contemporaries in

an age that valued both morality and sensibility and also how she cultivated her identity as a learned history painter of classical themes to establish her place in the history of art among the practitioners of this genre.

 Among Kauffman's first history paintings in Rome were two pictures that formed a pair of related Roman and Greek subjects, *Coriolanus Entreated by his Mother Vetturia and Wife Volumnia* and *Chryseis (or Cressida) Reunited with her Father Chryse*.[11] Coriolanus' mother and wife beg him to cease making war on Rome, his native land, despite his unfair treatment by his own countrymen. The companion subject from the *Iliad* illustrated Ulysses' return of the captive Trojan woman, Chryseis, to her father, the priest Chryse, whose prayers to Apollo had prevented the Greek fleet from sailing. Father and daughter were reunited as a means to advance the Greek war effort, while in the pendant mother and wife confront son and husband in a plea for peace. As a pair, Kauffman's paintings represented the conflicts of divided loyalties between family members, women and men as peacekeepers and warmakers, as well as the tension between individuals and the state, themes she would return to many times in her work. In fact, her first major paintings in England were four similarly related subjects that illustrated moments in which heroic men and virtuous women, husbands and wives or doomed lovers, were torn apart by the Trojan War. Drawn from Homer's *Iliad* (Hector and Andromache) and *Odyssey* (Ulysses and Penelope[12]), Virgil's *Aeneid* (Aeneas and Dido), and the less well-known *Achilleid* by Statius (Achilles and Deidameia), they were painted for Joshua Reynolds's boyhood friend John Parker, Lord Boringdon, to decorate the new grand saloon at Saltram Park. These works have been discussed elsewhere, but it is important to note that they were the first classical subjects to be shown at the inaugural exhibition of the Royal Academy of Arts in 1768.[13]

 During the fifteen years of her residence in London, Kauffman was one of the few painters who consistently exhibited classical history paintings, and her work became widely known through reproductive prints.[14] She continued to produce and to exhibit variations on the theme of mournful women separated from loved ones by war, including *Cleopatra Adorning the Tomb of Marc Antony* (R.A. 1770), *Andromache and Hecuba Weeping over Hector's ashes* (R.A. 1772), and *Andromache Fainting at the Unexpected Sight of Aeneas at Hector's Tomb in Epirus* (R.A. 1775). These lamenting, grieving and swooning women, left to weep and sorrow for departed heroes, were typical of the sentimental subjects that became increasingly popular through the eighteenth century, and such themes were also depicted by contemporary male artists; however, Kauffman developed one subject that she made uniquely her own: Penelope, the patient, virtuous, clever and crafty heroine of the *Odyssey*. In fact one of Kauffman's first classical history paintings made in Rome in 1764 portrayed Penelope seated at her loom, mournfully awaiting

the return of her long-absent husband Ulysses (Figure 10.1).[15] Kauffman's portrayal of Penelope as devoted wife, tender mother, skilled practitioner of the domestic art of weaving, and protector of the household, was a well-considered choice for an artist who wished to promote her singular talents as a female history painter. This rarely depicted heroine, admired for her perseverance and cunning, was a suitable vehicle through which Kauffman could represent the positive attributes of a classical matron while calling attention to her own creativity and attracting potential patrons. She portrayed Penelope in various episodes from the *Odyssey*, including some recommended as especially suitable in the Comte de Caylus's influential *Tableaux tirés de l'Iliade, de l'Odyssée d'Homère et de l'Enéide de Vergile* (Paris, 1757) and others from Fénelon's popular sentimental novel about Penelope and Ulysses' son Telemachus, *Les aventures de Télémaque* (Paris, 1699), selecting scenes that highlighted Penelope's courage and loyalty to her family, including Penelope taking down the bow of her husband Ulysses before the contest of the suitors, Penelope sacrificing to the goddess Minerva for the safe return of her husband, and joyfully reunited with Telemachus (Figure 10.6).[16]

A more unusual subject from classical history, *Papirius Praetextatus Entreated by his Mother to reveal the Secrets of the Senate*, reveals Kauffman's wit as well as the complex relationship between a mother and son[17] (Figure 9.3). The young Roman matron seated before her adolescent son beseeches him through expression and gesture to disclose what was discussed at the Senate. She gazes into her son's eyes while holding his hand and reaching up to his face with the other hand to compel his attention. Papirius appears troubled, but, unwilling to reveal the secrets of the state or to betray his male superiors, he invented a story. The Senate, he told his mother, debated whether it was more advantageous for a man to have two wives or for a wife to have two husbands. The next day his mother gathered a group of women to petition the Senate to grant women the right to have two husbands. The Senators, surprised at first by this strange request, learned of Papirius' artifice to protect their secret deliberations and rewarded him with permission to attend the Senate, the only young man granted such a privilege. Kauffman's elegant composition omits any hint of the sexual innuendo or the humor in this tale that was generally understood to mock women and to reinforce their exclusion from public life. Her figures' earnest expressions and interlocked gazes suggest the power of a mother to demand her son's loyalty as well as the boy's pained anticipation of his deception.

In spite of her success in England, Kauffman returned to Italy in July 1781 with her new husband, Antonio Zucchi, and the couple settled in Rome, where her career thrived. Through the 1780s and 1790s her popularity and critical acclaim grew, and Kauffman enjoyed even more opportunities than she had in England to produce classical history paintings. Her patrons included

Fig. 9.3: Angelica Kauffman, *Papirius Praetextatus Entreated by his Mother to Reveal the Secrets of the Senate*, diameter 63 cm, oil on canvas, ca. 1780, Denver, The Berger Collection, Denver Art Museum

Grand Tour travelers who came to visit her studio from England, Ireland, the German-speaking principalities, Sweden, Poland, Austria and Russia, and she continued to send paintings to clients in England, including pictures intended for exhibition at the Royal Academy and reproduction as engravings.

Always aware of her unique position as a female history painter, Kauffman's judicious choice of classical subjects through which she could demonstrate her erudition and painterly skills while remaining within the bounds of propriety and the limits of her capacity to portray male bodies assured her continuing success. Early in 1786, when she was completing an important commission for Emperor Joseph II of Austria for a pair of historical subjects, she wrote to another client, the British print publisher Josiah Boydell:[18]

I likewise understand that you wish to have half a dozen Historical Pictures done by me, my engagements are very numerous – I am just now finishing two large Historical Pictures for his Majesty, the Emperour, and tho' I have a great number of other comyssions [*sic*], I shall as soon as I can be mindful of yours, and chuse such subjects which may be pleasing and interesting. I generally prefer to paint what I have not seen done by others.

Kauffman's letter declared her preference for creating exceptional subjects that had not previously been portrayed, a strategy that assured her work would receive attention. Her *Memorandum of paintings*, the dated list of her commissions in Italy from 1781 to 1798, attests to the significant number of classical history paintings she produced, including some rarely depicted subjects for important royal patrons, who included – beside Emperor Joseph II of Austria – Empress Catherine II of Russia, Queen Carolina of Naples and King Stanislaus Augustus of Poland.[19] Not all of these pictures were entirely original topics; however, Kauffman took care to make each commission uniquely suitable to the identity and highest expectations of each client.

Kauffman's representations of the Roman matron Cornelia can serve as an example of her thoughtfully considered and intelligently constructed compositions. The wife of the Tiberius Gracchus, Cornelia was highly regarded as an exemplary Roman matron through her role as a loyal widow and good mother who devoted herself to the education of her children, and her story became a popular subject in eighteenth-century painting as an instructive yet charming way to portray an ideal woman. Between 1785 and 1788 Kauffman completed three different versions of *Cornelia, Mother of the Gracchi, Pointing to her Children as her Treasures*. She essentially followed the tradition of portraying Cornelia as a model of female virtue; however, when examined in light of the circumstances surrounding each commission, including both the patron's and the artist's interests and each painting's pendants, her three representations may also be seen to reveal something more than simply the glorification of motherhood.

The first 'Cornelia' was painted in Naples in 1785 when Kauffman was a guest of Queen Carolina as one of three paintings for her British patron George Bowles, which were shown at the Royal Academy exhibition in 1786[20] (Figure 9.4). In addition to Cornelia, they depicted *Virgil Writing his Own Epitaph at Brundisium* (private coll.) and *Pliny the Younger with his Mother at their Villa in Misenum at the Eruption of Vesuvius* (Art Museum, Princeton), and as a group they represented stories of exemplary figures from Roman history associated with the kingdom of Naples.[21] Cornelia stands in the center of the picture clad in white and gold beside a table that holds her workbasket, while her seated visitor, dressed in brilliant red, shows off her jewelry. The contrast between the women is highlighted by the colors of their garments as well as their postures and accessories – the basket of needlework

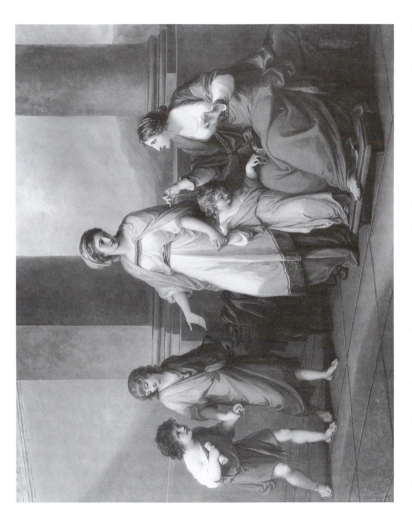

Fig. 9.4: Angelica Kauffman, *Cornelia, Mother of the Gracchi, Pointing to her Children as her Treasures*, 101.6 × 127 cm, oil on canvas, 1785, Richmond, Virginia Museum of Fine Arts, The Adolph D and Wilkins C. Williams Fund (Photograph: Katherine Wetzel)

as opposed to a casket of jewels. When the visitor asks to see Cornelia's treasures, the virtuous matron, having waited until her children returned from school, points to her two sons, Tiberius and Caius, who enter from the left of the stage-like space, and responds: 'These are my jewels.'[22] This anecdote presented Cornelia as scorning adornment in favor of her children, and she became famous for the excellent education she provided for her sons, who grew up to become political reformers and great leaders in the history of Republican Rome.

A noteworthy feature of this painting is Kauffman's inclusion of the Gracchi brothers' sister, Sempronia, who was referred to in Kauffman's *Memorandum* as 'la picciolina Sempronia.'[23] Cornelia's young daughter was not mentioned in Kauffman's textual source for this anecdote, Valerius Maximus, nor does the little sister feature prominently in most depictions of the subject; nevertheless, the artist created a distinct role for her within this moralizing story. Sempronia, who stands between the two women, holds onto her mother's hand, yet she turns away from her and cannot resist fingering the jewels in the visitor's casket, for she is too young to understand the virtues of her wise mother. To underscore this point Kauffman painted her clothing pink, a mixture of the red and white of the two women's garments, as if to suggest the moral ambiguity of this child's still unformed character.

Kauffman completed the three pictures for Bowles in Rome after she returned there from Naples. In April 1785, Giovanni Gherardo De Rossi, who later became Kauffman's biographer, published a lengthy review of *Cornelia* and its pendant *Virgil Writing his Own Epitaph at Brundisium* in the art periodical he edited, *Memorie per le belle arti*.[24] He identified the picture of Cornelia as a 'storia romana molto glorioso al bel sesso,' and he described it in detail. In particular he praised the 'erudite' artist for consulting historical sources to determine the physiognomy of the two Gracchi brothers and thus properly portraying in their features the signs of the characters they would become when they grew up. The elder Tiberius was known as mild-mannered and pious, so she showed him with tranquil eye and smiling lips, while the younger brother Caius's face suggested his impetuous, irascible nature and the fiery orator he would become.[25]

De Rossi praised Kauffman's superior talents, and he compared her favorably with women painters of the past by characterizing her abilities in terms generally applied to male painters – virtually the same comments he repeated over twenty years later in his biography.[26] De Rossi stated:

> the works of Signora Kauffman have a certain universality of beauty from which one can deduce that this woman, besides a vast and fertile genius, has received from Nature the most rare gift of the Graces. With this she adorns every part of her pictures, and she makes the physiognomy so elegant, the expressions so true and pleasing, the attitudes so

gentle and effective, and produces great harmony in chiaroscuro and color.

He concluded with reference to a famous drawing by the esteemed late baroque painter Carlo Maratti, which represented an ideal school of painting as a statement of classic academic art theory. In this drawing, which had been praised by the seventeenth-century art theorist and artists' biographer Giovanni Pietro Bellori in his life of Maratti, the three Graces hover above a group of artists and their pupils who study anatomy from a model, antique statuary, geometric figures and perspective constructions, accompanied by the words, 'Senza le Grazie indarno è ogni fatica' (Without the Graces these labors are in vain).[27] Thus, in this review of Kauffman's two pictures, which would have been read by everyone in Rome with an interest in the arts, De Rossi established his favorable opinion of her work as well as his advocacy for academic art in the classical tradition of Carlo Maratta, a most exemplary male artist, and Bellori, the influential champion of classical art and academic standards.

The success of Kauffman's paintings prompted the queen of Naples to commission another picture of Cornelia as a gift for her sister, Maria Christina, Archduchess of Sachsen-Teschen, whose husband, Albert, served as governor of the Austrian Netherlands.[28] The composition was reversed, but the poses and gestures of the figures, including the three children, are nearly identical to the Bowles painting, and only a few details of clothing and setting differ. The pendant to this picture represented another famous woman of ancient Rome, the daughter of Julius Caesar, *Julia, the Wife of Pompey, Fainting at the Sight of her Husband's Bloody Cloak* (Figure 9.5).[29] This story was also taken from Valerius Maximus' *Memorable Doings and Sayings*, in which Julia's reaction to the sight of what she believed was her husband's blood-stained garment was presented as an exemplar of conjugal love.[30] The swooning wife, supported by two women, fears that her husband has been killed. Pompey's cloak, however, was actually stained by the blood of another man slain in an election riot while Pompey remained unscathed.

This episode may be seen purely as an example of marital devotion to serve as a passive complement to the widow Cornelia's commanding presence, or, as Bettina Baumgärtel has argued, a manifestation of female sublimity – the weaker sex's frail form of heroism.[31] However, Hermann Mildenburger's interpretation of the pair of paintings supports a more complex and nuanced view of Kauffman as an artist who scrupulously researched and crafted each work to suit the particulars of the commission, especially an important one from a patron such as Queen Carolina. As Mildenburger maintains, the two subjects, Cornelia and Julia, illustrate the important role women played in ancient Rome as links between great families through marriage and childbearing. Julia married her father's one-time rival, Pompey the Great, to create

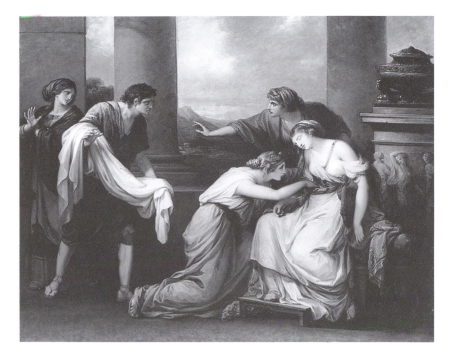

Fig. 9.5: Angelica Kauffman, *Julia, the Wife of Pompey, Fainting at the Sight of her Husband's Bloody Cloak*, 100.4 × 127.6 cm, oil on canvas, 1785, Kunstsammlungen zu Weimar (Photograph: Louis Held)

a familial union that forged a powerful political alliance. Similarly, Cornelia, daughter of the great general Scipio Africanus, wed the esteemed statesman Tiberius Gracchus, who had once been her father's enemy. This marriage also created an important bond between two powerful men, and the children of Cornelia's marriage, the younger Tiberius and Caius, subsequently played significant roles in the history of the Roman republic.[32] In sad contrast to Cornelia, who raised and educated exemplary children to serve the state, Julia died childless. As depicted in Kauffman's painting, her shock at what she believed to be her beloved husband's mortal wound precipitated a miscarriage, and just a year later, after a second pregnancy, Julia died in childbirth along with her infant daughter. These personal misfortunes for both husband and father, Pompey and Caesar, foreshadowed the grave consequences of political corruption and unrestrained struggle for power. Kauffman's source, once again Valerius Maximus, described Julia's loss, 'to the great misfortune of the whole world. For its tranquillity would not have been disrupted by the savage madness of so many civil wars if concord between Caesar and Pompey had held, bound by a tie of common blood.'[33] In Kauffman's painting Julia's

physical collapse and the blood-stained garment prefigure her early death and miscarriage and provide an ironic and tragic counterpart to Cornelia's happy situation.

Mildenburger relates this theme to Kauffman's own time in the eighteenth century when the daughters of Maria Theresa of Austria – Maria Carolina of Naples, Maria Christina of Sachsen-Teschen, Maria Amalia, the Duchess of Parma, and Marie-Antoinette, queen of France – united the powerful Habsburg and Bourbon dynasties through marriage, and, together with their brothers, Leopold, Grand Duke of Tuscany, and Joseph, who succeeded Maria Theresa as emperor, ruled over vast territories based on blood ties. The Neapolitan queen, who commissioned this pair for her sister the archduchess, must have understood and appreciated the historical parallel of their own similarly situated positions as royal wives and sisters tied to the world of politics. Thus, Julia's swoon does not simply illustrate faint-hearted female heroics, as Baumgärtel argued, but rather, the fateful consequences of Julia's emotional reaction: miscarriage, death and the ensuing political turmoil that bitterly divided her husband and her father.[34] The pair of paintings, commissioned by a queen for her noble sister, suggest both the pathos of women's lives and the importance of blood bonds between mighty dynastic families. Thus Kauffman's choice of subjects perfectly suited the unique particulars of this royal commission.

Kauffman's third version of Cornelia as mother of the Gracchi was commissioned by Prince Stanislaus Poniatowski of Poland when he visited Rome 1788.[35] (Figure 9.6). This unpublished and previously unstudied painting, formerly known only through documentary sources, deviates in significant ways from her two earlier depictions. On this occasion Kauffman paired Cornelia with a virtuous Roman father in *Brutus Condemning his Sons to Death for Treason*, which represented the anguished parent ordering the execution of his rebellious sons for the good of the state in spite of his personal sorrow[36]. This lost painting, which is known through Kauffman's description as well as a preparatory drawing (Figure 9.7), portrayed a broad range of reactions and conflicting emotions through the expressions and gestures of the father, the sons, their servant and other male witnesses, who exhibit horror and awe at the father's stoic resolve to condemn tyranny and carry out what was best for the Roman state even if it meant becoming childless.[37]

In contrast to Brutus's traitorous sons, Cornelia's progeny were champions of justice and citizens rights, and political and social reformers. Similarly, the liberal Prince Poniatowski was an active political, educational and agricultural reformer, who advocated emancipation of the serfs and granted additional power and freedoms to the people at a time when Poland was deeply divided and at the mercy of more powerful neighbor states.[38] As pendants, the pictures served as fitting representations of Poniatowski's political ideals of

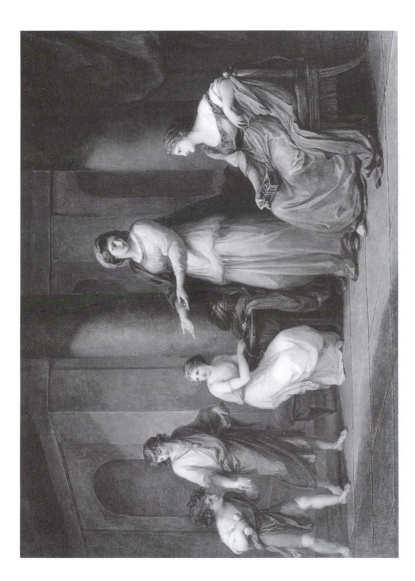

Fig. 9.6: Angelica Kauffman, *Cornelia, Mother of the Gracchi, Pointing to her Children as her Treasures*, 110 × 152 cm, oil on canvas, 1788, private collection (Photograph: Rafael Valls, Ltd., London)

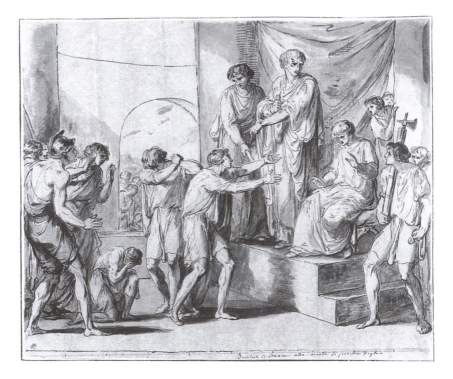

Fig. 9.7: Angelica Kauffman, *Brutus Condemning his Sons to Death for Treason*, 26 × 31.8 cm, pen and ink and wash, 1788, location unknown, formerly Christie's London (Photo: Paul Mellon Center for British Art)

liberty and justice rooted in Roman history and the values of good education and parental duty.

The placement and poses of the figures in the Poniatowski *Cornelia* differ from Kauffman's earlier versions of this subject made for George Bowles and Queen Carolina. In this third rendering Cornelia's sons, temperate Tiberius and volatile Caius, are nearly identical to those in the other two paintings except for an exaggerated height differential between elder and younger boy. The three female figures, however, differ considerably from the previous versions. Cornelia, now wearing a gold-colored garment, stands as before in the center of the composition, but her emphatic gesture, with both arms toward her sons, and the turn of her head to look at the woman who is the object of this lesson create a more determinedly didactic image. The seated woman wears a bright red dress as before, but she ignores the jewel casket in her lap, looks up to admire the children, listens to Cornelia's words, and – unlike the other paintings in which she proudly lifts a golden necklace – she

appears surprised at Cornelia's rejection of worldly goods. In the Poniatowski pendants Cornelia's posture and gesture echo Brutus's similar condemnatory pointing pose and averted gaze, while the responsive expression of the seated woman parallels the similarly seated figure of Collatinus, who reacts with amazed confusion to Brutus's command. These complementary compositions underscore the moralizing elements in both pictures and illustrate the contrast between exemplary and treacherous children, family obligation and patriotic duty, as well as gender roles.

Kauffman's portrayal of Cornelia's daughter Sempronia, sister of the Gracchi, is the most significant change in the Poniatowski version. The role of Sempronia within this family drama has not previously been examined, but the changes Kauffman made between her earlier and later versions suggest that she wanted to deliberately draw attention to this female character. In the 1788 painting Sempronia no longer appears as a tiny pink-clad child toying with jewelry and holding onto her mother's hand. Here Kauffman represented her as an adolescent girl dressed in white, and she moved Sempronia to the opposite side of the painting away from the vain woman with the jewel casket to reposition her between Cornelia and her brothers. On the table beside the girl is a basket of needlework, symbolic of the domestic arts, and she holds the distaff while looking up to her brothers as if interrupted by their return from school. This reconfiguration casts Sempronia in a new light as a more mature, morally enlightened, dutiful daughter and respectful sister. Thus Cornelia's instructive gesture towards the trio of children may be understood to include Sempronia as one of her treasures.

Kauffman's own words support this view. In her manuscript description of the painting, she wrote that Cornelia presents 'li suoi Figli' (her children). This phrase is different from the record in her *Memorandum of Paintings* of the 1785 Bowles picture which referred to the Gracchi boys as 'suoi figliuoli,' her sons, and specified the girl as 'la picciolina Sempronia sua figlia': little Sempronia her daughter.[39] The masculine plural form of children (*figli*) may include children of both genders, so Kauffman's choice of words, along with the absence of any other reference to Sempronia, strongly suggests that she intended Cornelia's words, as well as her gesture, to refer to all three children. I believe this interpretation explains Kauffman's revised treatment of this historical subject and clarifies this particular choice of paired subjects for Prince Poniatowski, a friend and patron who held enlightened views about the individual's obligations to family and country.

The real historical Sempronia grew up to become an exemplary woman worthy of her noble family, and she married a Roman hero, Scipio Aemelianus, a political and military ally of the Gracchi, just as her mother Cornelia's marriage to Tiberius Gracchus had sealed the alliance with her father Scipio Africanus. As told by Valerius Maximus in *Memorable Doings and Sayings*,

the same source Kauffman used for the anecdote about Cornelia, Sempronia survived a period of civil strife during which she was compelled to prove her courage and virtue equal to her brothers. When a threatening, clamoring crowd tried publicly to humiliate Sempronia by forcing her to kiss a man who falsely claimed to be her kinsman, she preserved both her personal and family honor by forcefully repulsing his advances.[40] Thus Kauffman's depiction of Sempronia as a mature and obedient girl serves to call attention to her future role alongside her brothers as a good Roman woman and to the familial bond between brothers and sister that benefited the family and served the public good. The modifications Kauffman made to the Poniatowski version of *Cornelia* demonstrate her consideration of the social and political circumstances surrounding each commission as well as her own sensitivity to gender issues. Kauffman's representations of Cornelia accomplish more than simply providing examples of ideal female behavior in contrast to male heroics. When paired with different pendants that highlight diverse aspects of the Gracchi family history, the three *Cornelias* assume multi-layered meanings that exceed the simple enactment of domestic virtue.

The completion of this commission for Prince Poniatowski was noted in Kauffman's *Memorandum of Paintings* in January 1788. The very next entry in the same month recorded the completion of her self-portrait for the Grand Duke Leopold of Tuscany's collection of artists self-portraits in the Uffizi Gallery in Florence.[41] Kauffman was already represented in that collection by a youthful self-portrait in the costume of the Bregenzerwald, her father's native region (*c.* 1757–59),[42] but she wanted this important collection to have a more recent image to show her at the height of her professional and artistic abilities. 'I was now more than ever convinced,' she wrote to the Director of the Uffizi, Giuseppe Pelli, 'that I should not be represented in the company of the great masters (*valenti Pittori*) by this work I considered unworthy of my merits.'[43] She proposed to donate a new portrait as early as 1782 when she resettled in Rome, but, as she explained, her many paid commissions and travels prevented her from completing it for many years.

The painting finally arrived in June 1788, and she wrote to her friend Goethe on 5 August 1788:[44]

> My portrait, or it would be better to call it the painting, which I presented to the gallery in Florence, has been accepted. I received the letters a few days ago, and that they have placed me in a good light and beside a very famous man – no less than Michelangelo Buonarroti! I wish I could stand near him, not in effigy alone, but in his works; but this is too ambitious.

Kauffman portrayed herself in pseudo-classical dress seated on the low parapet of an open loggia against a distant view of sky and mountains. At her waist she wears a Hellenistic cameo that represented the competition between

Minerva and Neptune for the control of Attica, a contest won by Minerva by her creation of the olive tree.[45] This image symbolized the triumph of female creativity, as has been suggested, but in addition, the gem itself, which once belonged to the Medici and was reproduced as a relief in the courtyard of the Medici palace in Florence, before it passed in the eighteenth century to the Bourbons of Naples – from one dynasty of art patrons to another – must also have been intended, I believe, to flatter the Grand Duke of Tuscany, who was related to both families by heritage and blood ties, and to allude to the artist's own connections with them. Kauffman's pleasure at knowing her image was positioned so near to the great artist-hero Michelangelo confirmed her identification with the 'Old Masters' and her pride in her achievements in such a masculine profession. Her ambition, choice of subjects and cultivation of influential patrons, together with the support of De Rossi's characterization of her as a rarity among women artists and his critical praise for her work in 'masculinizing' language, served to secure Kauffman's place among the ranks of history painters. Yet, in spite of Kauffman's pride in her exceptional status, her inventive interpretations of Cornelia and other ancient matrons demonstrated her sensitivity to gender concerns and the precarious role women played within the male realm of academic painting as well as history.

Notes

1. On Kauffman's career see Wendy Wassyng Roworth, ed., *Angelica Kauffman, A Continental Artist in Georgian England* (London and Brighton: Reaktion Books and Brighton Art Gallery and Museum, 1992) and Bettina Baumgärtel, ed., *Angelika Kauffmann*, exh. cat., Kunstmuseum, Düsseldorf (Düsseldorf: Hatje, 1998), and Oscar Sandner, ed., *Hommage an Angelika Kauffmann*, exh. cat., Vaduz, Liechtensteinische Staatliche Kunstsammlung and Milan, Palazzo della Permanente (Milan: Nuova Mazzotta, 1992).
2. See Sydney Hutchison, *The History of the Royal Academy, 1768–1986* (London: Robery Royce Ltd, 1986).
3. See Wendy Wassyng Roworth, 'Anatomy is Destiny: Regarding the Body in the Art of Angelica Kauffman,' in *Femininity and Masculinity in Eighteenth-Century Art and Culture*, eds Gill Perry and Michael Rossington (Manchester: Manchester University Press, 1994), 41–62.
4. Accademia di San Luca, Rome, Inv. 286. Oscar Sandner, ed., *Angelika Kauffman e Roma*, exh. cat. (Rome: De Luca, 1998), 15; Baumgärtel, ed. (1998), 146–7, 149; Angela Rosenthal, *Angelika Kauffmann, Bildnismalerei im 18. Jahrhundert* (Berlin: Reimer, 1996), 332–40; Italo Faldi, 'Dipinti di figura dal Rinasciamento al neoclassicismo,' in *L'Accademia Nazionale di San Luca* (Rome, 1974), 170.
5. For an overview of women artists in this period see Whitney Chadwick, *Women, Art and Society*, revised edn (London and New York: Thames & Hudson, 1996), 87–113.
6. G. G. De Rossi, *Vita di Angelica Kauffmann, pittrice* (Florence, 1810; Pisa, 1811). Much of the biography is based on the manuscript biography written by

Kauffman's brother-in-law Giuseppe Carlo Zucchi (Bregenz, Vorarlberger Landesmuseum). See Helmut Swozilek, ed. and trans., *Memoria istoriche di Maria Angelica Kauffmann Zucchi riguardanti l'arte della pittura da lei professata scritte da G.C.Z. (Giuseppe Carlo Zucchi)*, in *Venezia MDCCLXXXVII*, *Schriften des Vorarlberger Landesmuseums*, Series B, 2 (1999).

7. De Rossi, *Vita*, 21.
8. Ibid., pp. 2–3, 112–14; See also Wendy Wassyng Roworth, 'Biography, Criticism, Art History: Angelica Kauffman in Context,' in *Eighteenth-Century Women in the Arts*, eds F. M. Keener and S. Lorsch (New York, 1988), 209–23. In his positioning of Kauffman as a 'masculine' artist, De Rossi followed Carlo Cesare Malvasia's *Felsina pittrice, vita de pittori bolognese* (Bologna, 1678), in which the Bolognese biographer allied Elisabetta Sirani with her male peers by describing her artistic style as manly ('virile') and contrasting her with the timidity and flattery characteristic of artists of the weaker sex ('artiste femminile'). See the excellent study on gender and language in Italian Renaissance artists' biographies by Fredrika Jacobs, *Defining the Renaissance Virtuosa: Women Artists and the Language of Art History and Criticism* (Cambridge: Cambridge University Press, 1997), 26, and Babette Bohn, 'The antique heroines of Elisabetta Sirani,' *Renaissance Studies*, 16:1 (2002), 52–79.
9. Sandner, *Hommage*, 118, 261.
10. Vera Fortunati, ed., *Lavinia Fontana of Bologna, 1552–1614*, exh. cat., Washington, DC, National Museum of Women in the Arts (Milan: Electa, 1998), 108–9; Maria Teresa Cantaro, *Lavinia Fontana bolognese 'pittura singolare' 1552–1614* (Milan: Jandi Sapi, 1989); Daniele Benati, *Amor è vivo, due dipinti erotici di Lavinia Fontana* (Milan: Marco Riccomini, 2002).
11. Roworth, 'Kauffman and the Art of Painting in England', in *Angelica Kauffman, A Continental Artist in Georgian England*, ed. Roworth (1992), 24–37; Oscar Sandner, ed., *Angelika Kauffman e Roma*, exh. cat., Accademia Nazionale di San Luca/Istituto Nazionale della Grafica/Calcografia, Rome (Rome: Edizione De Luca, 1998), 14; Baumgärtel, ed. (1998), 136–9.
12. See Rosenthal, Chapter 10 in the present volume for a discussion of Penelope, and note 16 below.
13. Roworth, (1992) 'Kauffman and the Art of Painting', 42–57.
14. David Alexander, 'Kauffman and the Print Market in Eighteenth-Century England' in Roworth, ed. (1992), 141–189.
15. Museum and Art Gallery, Hove, Sussex. Illustrated in Roworth, ed. (1992) 29, fig. 12.
16. Roworth, 'Kauffman and the Art of Painting in Roworth, ed. (1992), 36–7, 45. For example, see Caylus, II, 231: *Odyssée* Livre Dix-Septième, 'Les embrassemens de Pénélope & de Télémaque. Euriclée la vieille nourrice, toutes les femmes de la reine, font au moment de l'entourer: on les voit accourir.' Kauffman's painting *The Return of Telemachus*, R.A. 1775 (The Earl of Derby, Knowlsey, Prescot), was based on this description. See also Udo Reinhardt, 'Angelika Kauffmann und Homer,' *Jahrbuch Vorarlberger Landesmuseumsverein, Freunde der Landeskunde* (Bregenz: J. N. Teutsch, 2000), 172–87, 195–7.
17. Denver Art Museum. This painting was engraved by Thomas Burke and published by William Wynne Ryland in London, 1 February 1780. See Alexander, 'Kauffman and the Print Market,' 182, and *Angelika Kauffmann und ihre zeit, Graphik und Zeichnungen von 1760–1810*, exh. cat. (Düsseldorf: C. G. Boerner, 1979), 46. The source for this story is Aulus Gellius, *Attic Nights* I, 23. A well-

known Roman statue group in the Ludovisi collection in Rome that was identified in the eighteenth century as Papirius and his mother may have provided the inspiration for this subject. See Francis Haskell and Nicholas Penny, *Taste and the Antique* (New Haven and London: Yale University Press, 1981), 288–91.

18. Waltraud Maierhofer, ed., *Angelica Kauffmann: Gesammelte Briefe in den Originalsprachen* (Lengwil am Bodensee: Libelle Verlag, 2001), 87. The paintings for Joseph II represented *The Death of Palantis, Mourned by Aeneas* from Virgil's *Aeneid* (XI, 60–80) and as its companion, *The Victorius Arminius (Hermann) Crowned by Thusnelda* Friedrich Gottleib Klopstock's epic *Hermann's Schlact* (1769). See De Rossi, *Vita*, 71; Baumgärtel, *Angelika Kauffmann*, 396–7.

19. The original Italian manuscript, in the Royal Academy of Arts, London, was published in Carlo Knight, *La 'Memoria delle piture' di Angelica Kauffman* (Rome: Edizioni De Luca, 1998); See also Wendy Wassyng Roworth, 'Angelica Kauffman's *Memorandum of Paintings*,' *Burlington Magazine* 126 (October 1984), 629–30.

20. Knight, *Memoria*, 30–31: '1785 per Mr Boweles a Londra, a Napoli li 24 Otobre ... '.

21. The painting of Cornelia is in the Virginia Museum of Fine Arts, Richmond. Roworth, 'Kauffman and the Art of Painting,' in Roworth, ed. (1992), 90–93. See also Baumgärtel, *Angelika Kauffmann*, 381–7; Sabine Schulze, ed., *Goethe und die Kunst*, exh. cat. (Frankfurt: Schirn Kunsthalle, 1994), 300–301.

22. This story is from Valerius Maximus, *Memorable Doings and Sayings (Facta et Dicta Memorabilia* (IV.4.1), trans. D. R. Shackleton Bailey (Cambridge: Harvard University Press, 2000), I, 384–5.

23. Knight, *Memoria*, 31.

24. *Memorie per le belle arti*, April, 1785, li–liv.

25. Ibid., liii: 'L'erudita pittrice ha ben consultato l'istoria prima di determinare le fisonomie dei due fanciulli Gracchi, ed ha saputo imprimer ne 'loro teneri volti i segni di ciò, che divennero adulti.'

26. Ibid., li–lii and De Rossi, *Vita*, 2–3, 112–14. See note 8 above.

27. Ibid., liv; Giovan Pietro Bellori, *Le Vite de' pittori, scultori ed architetti moderni*, Rome, 1732, ed. Evalina Borea (Turin: Giulio Einaudi, 1976), 629–31. Maratta's drawing was widely known through an engraving by Nicolas Dorigny.

28. Knight, *Memoria*, 31; Zucchi, ed. Swozilek, *Memoria istoriche di Maria Angelica Kauffmann Zucchi*, 69, 198–9, n. 174.

29. Both paintings are in the Schlossmuseum, Kunstsammlungen zu Weimar.

30. Valerius Maximus, *Memorable Doings and Sayings* (IV.6.4) I, 406–7; this episode also appears in Plutarch's *Life of Pompey* (53.3).

31. Bettina Baumgärtel, 'Die Ohnmacht der Frauen. Sublimer Affekt in der Historienmalerei des 18. Jahrhunderts,' *Kritische Berichte* 18: 1 (1990), 10–12 and *Angelika Kauffmann*, 382–4.

32. Valerius Maximus, *Memorable Doings and Sayings* (IV.2.4), I, 361–3.

33. Ibid. (IV.6.4), I, 406–7.

34. Hermann Mildenburger, 'Cornelia und Julia Las Vorbilder: Zur ikonographischen Deutung der Pendants von Angelica Kauffmann,' in *Angelika Kauffmann, Julia die Gattin des Pompeius, fällt in Ohnmacht, Cornelia, die Mutter der Gracchen*. Patrimonia 90 (Weimar: Kulturstiftung, 1996), 19–26, and Bernd Vogelsang, '"Bilder-Szenen" Kontexte der Weimerar "Historienbilder" Angelika Kauffmanns,' in ibid., 35–6.

35. Private collection. Knight, *Memoria*, 43. This painting was on the London art market in 1994.
36. A more detailed description in Kauffman's own hand appears in a list of her works compiled for her biographer G. C. Zucchi. Knight, *Memoria*, 79.
37. Valerius Maximus, *Memorable Doings and Sayings* (V.8.1), I, 532–3: Of Father's Severity Towards Their Children. See Roworth, 'Anatomy is Destiny,' 52–6.
38. Andrea Busiri Vici, *I Poniatowski e Roma* (Florence: Editrice Edam, 1971), 94–216.
39. Knight, *Memoria*, 79.
40. Valerius Maximus, *Memorable Doings and Sayings* (III.8.6), I, 324–7.
41. Knight, *Memoria*, 43.
42. Uffizi Inv. 1890, no. 4444. Sandner, *Kauffmann e Roma*, 4, no. 2.
43. Maierhofer, *Angelica Kauffmann. Briefe*, 103–4, 388–91.
44. Ibid., 112–14, 395–6. Uffizi Inv. 1890, no. 1928. See *Painters by Painters*, exh. cat. New York (Wisbech, Cambridgeshire: Balding and Mansell International Ltd, 1988), National Academy of Design 86–7; Wolfgang Prinz, *Die Sammlung der Selbstbildnisse in den Uffizien* (Berlin: Mann, 1971), I, 53, 218–19; Rosenthal, *Angelika Kauffmann*, 328–30.
45. Louise Rice and Ruth Eisenberg, 'Angelica Kauffman's Uffizi Self-Portrait,' *Gazette des Beaux-Arts* Series 6:117 (1991), 123–6; Phyllis Pray Bober and Ruth Rubenstein, *Renaissance Artists and Antique Sculpture* (London: Harvey Miller; New York: Oxford University Press, 1987), 81, fig. 41.

Angelica's Odyssey: Kauffman's Paintings of Penelope and the Weaving of Narrative

Angela Rosenthal

Angelica Kauffman's first forays into the art of history painting coincided with the publication of the first 'history of art', Johann Joachim Winckelmann's *Geschichte der Kunst des Altertums* (*History of Ancient Art*) of 1764. That same year, while travelling through Italy with her father, the 23-year-old Swiss-born artist completed her first paintings of ancient Greek and Roman subjects, which included two works for an English patron.[1] Among these early works were also two paintings showing a heroine abandoned by lovers who had sailed off to distant lands. One of these paintings – *Ariadne, Abandoned by Theseus, Discovered by Bacchus* – shows the god of wine enchanted by Ariadne, whom Theseus had left stranded.[2] The other painting represents Penelope, the virtuous heroine of Homer's *Odyssey* (Figure 10.2). The protagonist of this work appears mournful and contemplative. She sits at her loom. Since it is both the place where her story was fabricated and the site of the narrative's strategic unravelling, the loom is the instrument of both Penelope's craft and her craftiness. This painting stands out among Kauffman's ambitious early productions. It is the artist's first documented single-figure *historia*, signed and dated *Angelica Kauffman/. . . Roma 1764*. The work is remarkable not only owing to its iconographic singularity – Kauffman's painting is probably the first extant representation of this scene in modern times – but also on account of its monumental size; it measures 169 × 118 cm (66.5 × 46.5 in.).[3]

While in Rome and during the same period that she produced this extraordinary painting, Kauffman also painted the portrait of the German expatriate scholar Winckelmann (Figure 10.1). Kauffman's portrait, representing the

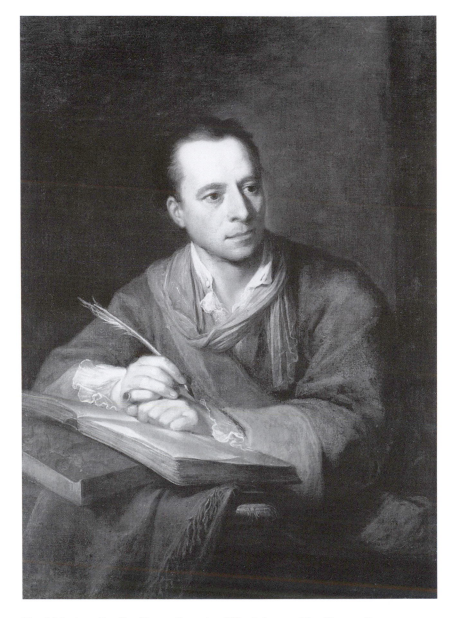

Fig. 10.1: Angelica Kauffman, *Portrait of Winckelmann*, 97 × 71 cm, oil on canvas, 1764, Zürich (Photograph © 2002 Kunsthaus Zürich. All Rights Reserved)

sitter as an inspired author, participates in celebrating Winckelmann's foundational *History of Ancient Art*. Indeed, Kauffman's portrait records Winckelmann's intense gaze and thus seems to visualize her sitter's authorial position, which represented his 'searching', as he put it, 'into the fate of works of art as far as my eye could reach.'[4]

Within Winckelmann's text and its horizon-scanning visuality, the figure of Penelope plays an important role. In a suggestive essay, Whitney Davis maintained that for Winckelmann Penelope marks a conflicted site of loss and departure, a hub around which both the Odyssean narrative and the Winckelmannian history revolve.[5] In the last paragraph of his *History*, Winckelmann invokes the figure of Penelope, mourning on the shore for her lost lover, as a metaphoric placeholder for the art historian. For her grief can be seen to echo that of the historian, gazing back across time and mourning the loss of antiquity and its material traces. Winckelmann pictures the art historian – and thus himself – as an abandoned figure, who surveys the historical horizon 'just as a maiden, standing on the shore of the ocean, follows with tearful eyes her departing lover with no hope of ever seeing him again, and fancies that in the distant sail she sees the image of her beloved'.[6] Winckelmann's longing gaze echoes structures of narrative and gender, trenchantly described by Roland Barthes: 'Historically the discourse of absence is carried on by the Woman: Woman is sedentary, Man hunts, journeys; Woman is faithful (she waits), Man is fickle (he sails away, he cruises). It is Woman who gives shape to absence, elaborates its fiction, for she has time to do so; she weaves and she sings; the Spinning Songs express both immobility (by the hum of the Wheel) and absence (far away, rhythms of travel, sea surges, cavalcades)'.[7]

Barthes's linking of gender, narrative and history – not to mention the opposition of the mechanical hum of women's work and the voyaging progress of male narrative – and Davis's recognition of the melancholic maiden's gaze from the shore as a foundational trope of art history both help to complicate prevalent interpretative metaphors that figure the male art-historical subject as surveying the feminized object of art (and craft). But how might this reading affect our understanding of the female artist/historian? What happens if the maiden who bodies forth the discourse of absence becomes a history painter? It is this accounting of female artistic and historical creativity that I wish to explore further in reference to Kauffman's narrative paintings and, in particular, her depictions of Penelope. Tracing the Odyssean theme within Kauffman's *œuvre*, I wish to see Penelope, the maker and unmaker of narrative, as a privileged avatar of female artistic agency. In painting Penelope at her loom, Kauffman presents us with more than an illustration of a figure from an ancient story; Kauffman's Penelope can be understood as a metaphorical embodiment of the female historical narrator.[8] The weaver, Penelope, is also an artist. As

such, I would like to see Penelope's complex work as a metaphor for Kauffman's own distinctive 'weaving' of narrative in her paintings.

The *Odyssey* is, of course, narrative *par excellence*. It is in some ways *the* foundational narrative text and, at least at first reading, seems to embody the established patterns of succession and causation described by Gerald Prince in *A Grammar of Narrative* as the basis of diegesis. In Laura Mulvey's succinct summary of Prince's argument, the narrative pattern

> ... begins with a point of stasis. A home characteristically marks the formal space of departure for the narrative, the stasis which must be broken or disrupted for the story to acquire momentum and which also marks the sexual identity of the hero, both male and Oedipal, as he leaves the confines of the domestic, settled sphere of his childhood for the space of adventure and self-discovery as an adult male.[9]

While such narrative – be it male and/or Oedipal – traditionally betokens the elision of female subjectivity, a closer look at Kauffman's series of paintings derived from Homer's epic poem – her 'Odyssey' – will allow us to trace an alternate adventure that makes space for female subjectivity and desire.

In Kauffman's *œuvre*, the *Odyssey* occupies a central place. The artist composed over a dozen different scenes, many of which she executed in multiple versions. And yet it is especially remarkable, that Odysseus' heroic deeds are almost entirely absent from Kauffman's Odyssean imagery.[10] Instead, the artist returns again and again to the figure of Penelope. We encounter her not only in contemplation at her loom (Figure 10.2), but also 'working & two maidens assisting her' in a large oval canvas which Kauffman presented as a gift to the antiquarian and collector Sir William Hamilton in Naples 1782.[11] In *Penelope and her Web* (engraved 1794) the heroine presents her woven tapestry to three female friends or attendants.[12] Even when the textual narrative focuses on Telemachus, Penelope and Odysseus' son, Kauffman emphasizes the mother's narrative action – as seen in *Penelope Invoking Minerva's Aid for the Safe Return of Telemachus* (Figure 10.3) and *The Return of Telemachus* (Figure 10.4) to his mother. The stress on Penelope continues in Kauffman's *Penelope Taking Down the Bow of Ulysses for the Trial of her Wooers*, and in several versions of *Penelope Weeping Over the Bow of Ulysses* (Figure 10.5) as well as in *Penelope Awakened by Eurycleia with the News of Ulysses' Return* (Figure 10.6).[13] Kauffman's repeated and consistent relations with Penelope, their shared paths in the painter's *œuvre*, allows us to plot alternative courses through Homer's *Odyssey* itself and through the painter's career, following a particular set of gendered coordinates.

Kauffman's Odyssean narratives are distinctive in that they never fully leave the home, the 'female' point of assumed stasis. For even when Kauffman expands her pictorial cruisings to include scenes of male and Oedipal journey – in particular Telemachus' adventures in search of news about his father –

the 'feminine image' and especially the maternal figure of Penelope remain essential and central. This emphasis on female agency stands in marked contrast to the narrative tendencies visible in the paintings of her male contemporaries. But Kauffman's rendition of the domestic sphere is also distinctive in its own right, for rather than providing a stable feminine backdrop for masculine adventure, Penelope's home disrupts the gendered fixity upon which such diegesis is, conventionally, predicated. For instead of only establishing the formal space of departure, the home of Kauffman's odyssey is a fictional space for the production of identity; not only the ground against which masculine figuration can take place, the home also reverses this relation, making space for the female storyteller. I would like to suggest that it was within this notional space that Angelica Kauffman negotiated her position as a female history painter, producing what Mary Kelly has called 'feminine inscriptions'.[14]

If Kauffman's paintings do mediate between the artist's own subject position and the traditional forms of history painting, they do so, also, within those iconographic, stylistic and cultural contexts traditionally adduced by art historians. For there is no doubt that her paintings participated in a broad eighteenth-century revival of Homeric themes.[15] Publications like the 1757 *Tableaux tirés de l'Iliade et de l'Odyssée d'Homère et de l'Enéide de Virgil* (*Scenes from the Iliad and the Odyssey of Homer, and Vergil's Aeneid*) compiled by the French archaeologist, collector and art critic Anne Claude Philippe de Tubières, comte de Caylus, served as influential source-books for artists. Similarly, François de Fénelon's drama, *The Adventures of Telemachus, Son of Ulysses*, praised as a major resource for modern education and politics, also offered contemporary artists – including Kauffman – a remarkably rich field from which to derive inspiration. We also know that Kauffman, like many of her contemporaries, used Alexander Pope's tremendously popular translation of Homer's *Odyssey*. For Helfrich Peter Sturz, travelling in the company of the Danish king, noted in a letter dated of 15 September 1768 describing a visit to Angelica Kauffman's studio in London that 'I found our gifted countrywoman yesterday with Klopstock's "Messiah" in her hand. Pope's "Homer" lay upon the table near her'.[16]

Kauffman's odyssey also helped to produce and conformed to certain neoclassical stylistic norms. Her heroes and heroines, classically clad, exhibit in their physical paleness and aquiline profiles the neoclassical ideals so highly esteemed within Winckelmann's aesthetics.[17] Kauffman's Homeric paintings can also be seen to have functioned within a particular social-historical moment and to have satisfied special psychological needs. Thus Albert Boime explains the popularity in Britain of subjects drawn from the *Iliad* and *Odyssey* in reference to the Seven Years' War (1756–63). Boime argues that aristocrats returning from this war could see favorable fictional reflections of

themselves in the heroes of ancient mythology who had fought in and returned home after the Trojan War.[18] While this specific social historical circumstance might explain in part the popularity for Homeric themes and their reception in the latter half of the eighteenth century, Kauffman's unique artistic interpretations will here be considered within broader cultural frames, including one accounting for women's space as a site for the production (and reception) of historical narrative. Moreover, by focusing on the particularities of Kauffman's work I would like to ask how the specific nature of her experiences as woman and an artist shaped the manner in which she chose to project an alternate Odyssean narrative and to mobilize alternate narrative modes.

Penelope's odyssey

On first reading, Homer's Penelope appears as a figure exemplifying feminine fidelity and patience. Nonetheless, her apparently static physical and moral position within the narrative, against which Odysseus' journeys are foregrounded, belies her pivotal narrative function. Feminist writers, contemporary classicists and literary historians have offered suggestive ways of rereading the Greek myth, finding in the figure of Penelope, among other things, a place for 'women as mobile, as narrators, and as travelling subjects'.[19] For it is her anti-narrative scheming – her unpicking of diegetic threads – that ensures the conditions for both Odysseus' journey and what appears to be the text's closure: Odysseus' return to Penelope.

The heroine of the *Odyssey*, Penelope was the wife of Odysseus and mother of Telemachus. When Odysseus sailed off to fight in the Trojan War he left Penelope in charge of the court of Ithaca and of their child. Penelope saw her son grow up while waiting for Odysseus' return. When her son matured, and her husband had failed to return, the household expected her to remarry. Yet Penelope refused the advances of the many princely suitors, who not only tried to persuade her that Odysseus was dead, but, living in his court, they also consumed his fortune. Penelope, remaining true to her husband and retaining her autonomy, devised a crafty plan to deflect their advances. She insisted that she could not remarry until she had woven – according to royal tradition – a shroud for Laertes, her aging father-in-law. Under the protection of Athena – goddess of the arts and of chastity – Penelope crafts her own story, weaving the shroud by day, while during the night undoing her labor 'with feminine cunning'.[20] The unraveling of the shroud is her secret, with which she both stills narrative progression and postpones narrative closure: within the text, Odysseus' travails and travels are mirrored by Penelope's active, yet stalled weaving. In Homer's text the repetitive push and pull of the

loom, and the movement of the plowing shuttle textually and rhythmically echo the lapping, 'wine-dark' waves striking the hull of Odysseus' divinely buffeted ship. While her husband's journey through textual space takes him – partly through his volition and partly through that of the gods – from island to island, Penelope fabricates her odyssey through the weaving of time and narrative. Indeed, Penelope, whose epithet *periphrôn* means 'thinking all-around', is not only compared to Odysseus, but seen to equal his cunning and cleverness.

Seeing Kauffman's woven canvases as akin to Penelope's endless shroud provides a field against which we can make narrative modes visible that contest some assumptions concerning early modern history painting and the history of art. By stating this, I do not intend to essentialize Kauffman's alternative pattern of storytelling as a language natural to women. Instead I would like to propose that we should see in Kauffman's woven histories a cultural articulation of the eighteenth-century female artist's desire for a voice and space of her own within a field that regarded – as Penelope's son Telemachus puts it – 'storytelling as the concern of all the men'.[21]

Penelope's room

With these words, the mature Telemachus challenges his mother's control over the household and her participation in public narrative discourse. At this key moment, Penelope is drawn from her chamber to join Telemachus and a group of suitors in front of the palace to hear a singer perform 'The Achaeans' Journey Home from Troy'.[22] This reminder of her own plight caused Penelope to beg the singer to choose another song; for this Telemachus reproaches his mother, banishing her from the space of narrative:

> But go inside the house,
> and take up your own work,
> the weaving and the spindle,
> and order the sewing-maids
> to busy themselves with it.
> But storytelling will be the concern of all the men,
> and especially of me, for mine is the household.
> Thus rebuked, Penelope went back inside the house in amazement.[23]

In a fascinating excavation of metaphorical layers of this scene, Peggy Kamuf suggests that it characterizes the female voice through 'control' and 'rupture'.[24] Kamuf also links Penelope's removal to her chamber to Virginia Woolf's call for 'a room of one's own'. Penelope's chamber, defined negatively against the public sphere of male discourse, represents female creative space; it is the female writer's study and the female artist's studio. In this

regard, the passage in question resonates with the cultural patterns that excluded eighteenth-century female painters from the spaces of intellectual and artistic pursuit; it also simultaneously reminds one of the pervasive relegation of women's work to the 'minor arts'. Penelope's role is to *reproduce*. Thus Telemachus plots male 'storytelling' in opposition to female manual work; he aligns Penelope's work with 'handiwork' and, concomitantly, promotes narrative as a superior male activity.[25] Linked to the manual and reproductive, women's art seems posited as the antithesis of diegesis. Yet Penelope's story also permits a deconstruction of this division. What is more, she challenges the traditional divide between her ornamental material and the intellectual discourse of the men. For she, operating from her own room, weaves a new plot line.[26] Moreover, through her art Penelope keeps her suitors at bay or in a continually unstable relationship.[27] In doing so she also 'unweaves', interrupting and undoing male narrative. In a manner akin to Penelope's unraveling of male narrative, Kauffman's history paintings seem to deconstruct the assumed norms of the genre and, therefore, to disrupt the vaunted male visual discourse of early modern painting.

It is in this light that Kauffman's *Penelope at her Loom* and her Odyssean subjects in general resonate within broader cultural coordinates on art production and gender. Shifting from the scene of Telemachus' dismissal and into Penelope's creative room, Kauffman's first Odyssean *historia* – monumental in scale – seems to announce that 'storytelling will' not be left to 'the concern of all the men' alone.

Kauffman's loom

In Kauffman's painting, the beautiful queen of Ithaca sits in a room of her own, taking a break from her work at the loom (Figure 10.2). In posing Penelope – with her head and arm resting in melancholic pose – Kauffman may have turned directly to ancient Greek prototypes of Penelope, which often depict her in such contemplative rest. The heroine is sometimes distinguished by the attribute of a basket of wool under her seat, which Kauffman depicts under the large loom at Penelope's side.[28] In Kauffman's painting, Penelope's eyes, while filled with tears, seem raised with hope. At her feet, Odysseus' dog guards both his master's bow and the chastity of his master's wife. The dog and the bow are physical reminders of Odysseus' absence. In the painting and in the Homeric text, Penelope's craft is aligned with the craftiness for which Odysseus was renowned. Her loom and Odysseus' bow frame Kauffman's heroine. The bow, a sign of absence, the proleptic sign of Odysseus' return and a sign bracketing Penelope's creativity and guile, here also serves an extra-narrative, indexical end: its tip

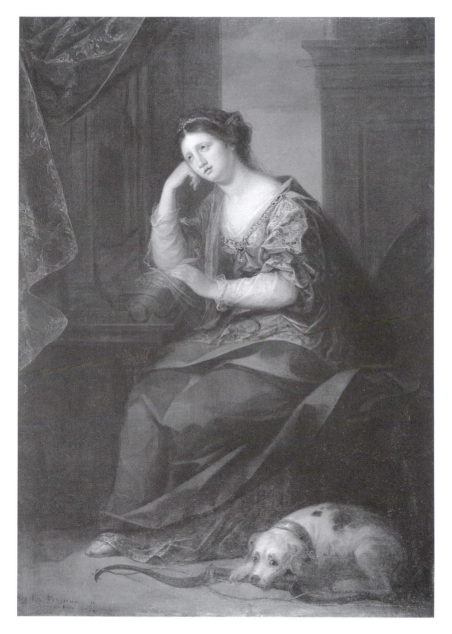

Fig. 10.2: Kauffman, *Penelope at her Loom*, 169 × 118 cm, 1764, Brighton and Hove (Courtesy of The Royal Pavilion, Libraries and Museums)

points elegantly to the painter's signature in the bottom left corner of the composition – as if the inscription was drawn by its sharp end. This Amazonic appropriation of Odysseus' bow seems to mark Kauffman's creative presence alongside Penelope. Indeed, the represented fabric that dominates the painting, suggests a deeper *paragone*, or artistic comparison, between painting and weaving.

Kauffman draws attention to the beautiful fabric and richly woven material that cloaks the ancient queen. The elaborate golden and embroidered fabric wraps around her body, contains her and seems to expand and spill over in thick folds onto a stool beside her, evoking Penelope's own production of fabric and her self-fabrication within the narrative. Indeed the name 'Penelope' echoes the Greek *pênê*, meaning 'woof' or 'loom', suggesting, as Felson-Rubin has put it, that 'she is the sort of character who actively weaves her life-story, as she does the deceit (*dolos*) of Laertes' shroud'.[29] Kauffman's Penelope is literally bound up in the material of her self-production. A stone-faced clasp fixes a long blue scarf around her shoulders. The queen's braided hair, bearing a preciously decorated diadem, is loosely tied back with a thin veil, which spills from her hair and flows over her shoulder like a stream of tears before it mingles with the shroud on her loom. This focus on fabric continues. Emerging from the upper left corner of the canvas, a thick, embroidered curtain is pulled aside to the left. This splendid material, seemingly crafted from spun wool – patiently woven and minutely decorated by the industrious hands of women – teases the eye with its palpable, physical material quality. Folded back along the top border of the actual canvas, it conveys a sense of privacy and intimacy while the curtain's shimmering, golden surface reflects light that would appear to be cast from the viewer's space. Amid this cascade of woven fabrics and their *trompe l'œil* rendering in paint, Penelope's and Kauffman's handicraft seem elided.

Indeed, Kauffman's mode of storytelling resembles Penelope's craft. For Penelope's weaving and unraveling find metaphorical parallel both in Kauffman's repeated return to certain literary scenes, and in her figural and compositional repetitions – not only of Penelope, but also of countless other iconographies. Penelope's forestalling of narrative closure might find a visual echo in Kauffman's contemplative scenes that appear to be halted and prolonged in what Julia Kristeva has called 'monumental time'.

Reviewing Kauffman's Odyssean narratives as a whole, one finds oneself wandering through the artist's *œuvre*. For Kauffman did not paint Penelope's stories during one phase of her career, nor did she produce them in their narrative order; rather, they occur and recur over a span of more than twenty years. Some of the works even belong to intertextual iconographic patterns of meaning, linked by meandering narrative threads.[30] While this diegetic weaving in itself might remind us of Penelope's craft, it also suggests that we

should not expect to find a programmatic artistic voice, but rather the traces of an artistic itinerary into subjectivity and the retelling of these journeys in paint.

Oedipal journeys

Kauffman did execute paintings from the *Odyssey* without Penelope as the main figure, but even in these works the action posits a female agent, who is linked either iconographically or physically to Penelope. For example, in more than one instance Kauffman explicitly pairs into a pendant Penelope as she weeps over Odysseus' bow (Figure 10.5) with the abandoned Calypso.[31] The protagonist of the latter echoes Penelope as she mournfully looks out from within a shallow cave to glimpse a trace of Odysseus' sail in the distant sea. A weaving frame appears behind Calypso – whose name means 'concealer' – reminding us that, in hiding Odysseus on her island for seven long years, she too interrupts the male plot. In idealizing both women, rather than emphasizing their rivalry, Kauffman's pendants refuse any explicit or facile binary judgment about the moral positions of differently placed women. Instead, Kauffman balances Penelope's and Calypso's shared, yet competing emotions, like a scale at the imaginary pivot of which the subject of their desire is held in suspense.[32] Kauffman's representation of Calypso, rather than emphasizing Odysseus' heroic deeds, rivets our attention on narrative stasis; women and their emotions yield this undiegetic point, while the pairing of the domestic Penelope and the native woman abroad constructs a femininity that 'cannot easily be contained' and fixed within traditional gender binaries.

Penelope's presence in Kauffman's odyssey is felt even when the textual narrative veers away from Ithaca. Thus, after Telemachus had secretly left Ithaca in search of news about his father, Penelope involves herself directly in Telemachus' itinerary in Kauffman's 1774 *Penelope Invoking Minerva's Aid for the Safe Return of Telemachus* (Figure 10.3). Calling upon Minerva, who accompanies Telemachus as his 'Mentor', Penelope seeks to ensure his safety after having learned about the suitors' plan to kill her son. Penelope dominates the figures assembled around a classicizing altar, bearing a full-length, miniature sculpture of the goddess to which she turns in prayer. Kauffman emphasizes Penelope's prominence by representing her stately protagonist in a resplendent white embroidered gown and in clear, classical profile, as she lifts her hand in supplication. Her four female attendants bring sacrificial gifts in a basket and vases.[33] In selecting to paint this scene Kauffman puts particular emphasis on Penelope's agency. Kauffman's work presents us with an alternative framing of narrative, one that stresses not masculine adventure

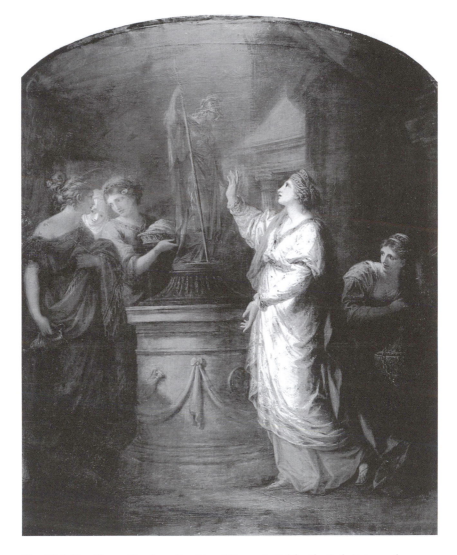

Fig. 10.3: Kauffman, *Penelope Invoking Minerva's Aid for the Safe Return of Telemachus*, 150 × 126.4 cm, oil on canvas, 1774, Stourhead, The Hoare Collection (The National Trust) (Photograph: Photographic Survey, Courtauld Institute of Art)

but the undercover activities of women, colluding to 'unravel' the mistakes – the wanderings – of men.

This unraveling of narrative can be seen in Kauffman's pendant paintings of *Telemachus and the Nymphs of Calypso*, and *The Sorrows of Telemachus*,

for which Kauffman turns to Fénelon's celebrated interpretation of the *Odyssey* in his text *The Adventures of Telemachus, Son of Ulysses*.[34] Kauffman concentrates on the mentoring of Telemachus by his virtuous tutor, whom Penelope had called upon, the goddess Minerva in disguise as a wise old man. The first painting illustrated the initial landing of Mentor and Telemachus on the island. Calypso and the nymphs still have Telemachus under their spell. Three nymphs of Calypso, who shower him with gifts and garlands, enchant him. Meanwhile the 'Goddess keeps Mentor aside to give a chance to her nymphs to delight Telemachus who has enamoured one of them (Eucasis)'.[35] Fulfilling her mentoring role, Minerva reminds Telemachus of the fate of his father, and his own duties.[36] Kauffman depicts Telemachus' change of heart in *The Sorrow of Telemachus*.[37] Telmachus' melancholic pose, rather than suggesting his decision by way of heroic gesture, instead echoes the pose of *Penelope at her Loom*. In Kauffman's scene it is Calypso who notices his sorrow and commands the nymphs to interrupt their play of music in the background. It is not the man who struggles to overcome the feminine, but women who in various situations and guises offer guidance to the hero.[38]

Indeed, Kauffman's Oedipal dramas emphasize maternal love, rather than the expected flight from the maternal bond. This is quite evident in Kauffman's *The Return of Telemachus* (Figure 10.4), which shows the moment of Penelope's reunion with her son, as she 'Rains kisses on his neck, his face, his eyes'.[39] The composition unfolds parallel to the picture plane. The spectator follows the right-to-left movement implied by Telemachus' step and that of Eurycleia, the faithful nurse, who rushes with outstretched arms to welcome him. This dynamism comes to rest, as will the boy, in the arms of Penelope, who descends the stairs that lead to her chamber.[40]

Penelope's choice

After Telemachus returns from his journeys, Penelope determines to resolve her situation and challenges the suitors to an archery contest on the feast day of Apollo; she will marry the suitor who can string her husband's great bow and shoot an arrow through a row of twelve axes – a feat which had been successfully performed only by Odysseus. Kauffman represents this decision in her painting of *Penelope Taking Down the Bow of Ulysses for the Trial of her Wooers* exhibited at a special exhibition in honour of the visit of King Christian VII of Denmark in 1768.[41]

Although in some ways a concession to the suitors, who desire her to remarry, through this action she also reasserts authority over the household.[42] She performs this reassertion of control against a backdrop of dramatic irony; for Odysseus, disguised as a beggar, has already returned

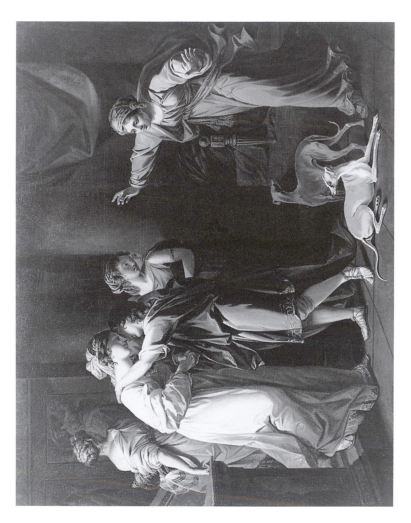

Fig. 10.4: Angelica Kauffman, *The Return of Telemachus*, 96.5 × 123 cm, oil on canvas, c.1771, Norfolk Virginia, Gift of Walter P. Chrysler, Jr., The Chrysler Museum (The Chrysler Museum)

with his son to Ithaca. After arriving, he made his identity known to his son, but to no one else. The second person to recognize Odysseus was Eurycleia, his old nurse, who caught sight of an old scar on her master's thigh; but Odysseus did not identify himself to his wife. However, Penelope's long conversations with the beggar/Odysseus, and indeed her timing in calling for a competition involving a feat that only her husband could achieve, leave room in the text for considerable ambiguity concerning her state of knowledge; to some degree in the dark, Penelope nonetheless takes actions that set the stage for her husband's victory and thus, again, seems to manage the narrative; Kauffman's artistic choices seem to emphasize Penelope's role in this regard.

On the day of the contest Penelope fetches Odysseus' great bow. Although Telemachus later reprimands his mother that 'as for the bow now,/men will see to that ... ',[43] Kauffman has Penelope contravene this rule in her 1768 painting *Penelope Taking Down the Bow of Ulysses for the Trial of her Wooers* (1768). In this work – not represented by any other artist of her time – Kauffman closely follows the Homeric scene, which opens the action-packed Book 21. In Alexander Pope's translation the scene is captured thus:

> Loud as a bull makes hill and valley ring,
> So roar'd the lock when it releas'd the spring.
> She moves majestic thro' the wealthy room,
> Where treasur'd garments cast a rich perfume;
> There from the column where aloft it hung,
> Reach'd in its splendid case, the bow unsprung.[44]

Instead of representing the 'Great Battle' or the suitors' competition, here we see Penelope at the narrative centre, taking down the bow, while one of her helpmates collects the arrows and axes from the ground.

As a woman taking up arms, Kauffman's Penelope seems to mimic Minerva, whose divine inspiration guides Penelope's brave actions.[45] Yet even at this moment of apparent agency and narrative progress, Penelope's pose seems temporally arrested. Her arms, raised to grasp the bow, appear as if they are extended in prayer. Indeed, the full-length portrayal of Penelope evokes the heroine's imploring pose in Kauffman's painting of *Penelope Invoking Minerva's Aid for the Safe Return of Telemachus* (Figure 10.3).

Kauffman similarly stalls narrative in her icon of mourning, *Penelope Weeping Over the Bow of Ulysses* (Figure 10.5), a scene which immediately follows the fetching of the bow.[46] As Pope continues in his translation of the *Odyssey*:

> Across her knees she lay'd the well-known bow,
> And pensive sat, and tears began to flow.
> To full satiety of grief she mourns,
> Then silence to the joyous hall returns.[47]

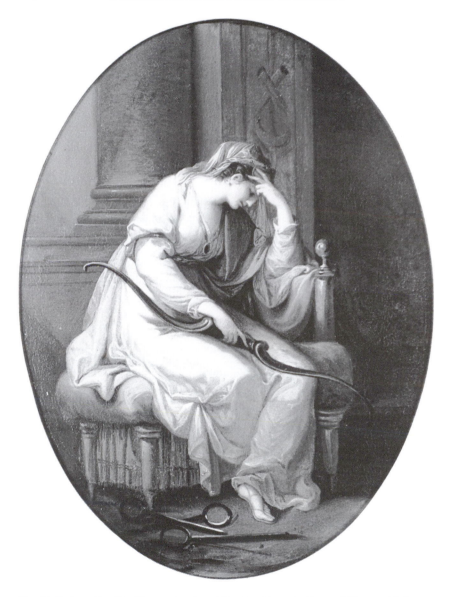

Fig. 10.5: Angelica Kauffman, *Penelope Weeping Over the Bow of Ulysses*, 25.4 × 20.3 cm, oil on copper, 1770s, Courtesy of Wolverhampton Art Gallery, England (Witt Library, London)

Kauffman visualizes the grief and silence. Penelope's body curves around the bow in mournful contemplation; her head – veiled in shadow – rests melancholically in her supporting hand, allowing Kauffman to focus our attention on the heroine's internal drama.[48] As in her painting of Penelope at the loom, the fabric spills around her solid form, gesturally externalizing her grief while providing the body with gravity and poise. Her gracefully curved foot elegantly leads our eyes to the axes scattered on the ground. The narrative tension is palpable: will she decide to advance the archery contest and thus the narrative leading to Odysseus' return?[49] The painting, however, suspends this decision.

This apparently anti-narrative approach can be seen not only as a rejection of the dominant conventions of visual narration, but also as a privileging of a form of 'monumental time'. Julia Kristeva in her essay 'Women's Time' distinguishes usefully between linear and monumental time. Linear time relates to history, economy, production and war. Monumental time, to the contrary, is linked to reproduction. In monumental time, woman distances herself from the mêlée of linear time and instead measures existence via repetition, procreativity and motherhood.[50] Penelope can be seen as emblematic of a form of monumental narrative: she is, simultaneously, a place of origin and return, the mother, both womb and tomb, and the site of narrative enunciation. What is more, Kauffman's paintings of Penelope capture – and perhaps promote – a similar sense of diegetic stalling, and repetition; indeed, Kauffman returned to this scene repeatedly, her 'copies' reproducing monumental narrative in her *œuvre*. Kauffman's repetitions cannot fully be explained by reference to conventional neoclassical trends or to market demands for history painting. Rather, Deleuze's description of repetition as the 'unconscious of representation' might here be helpful in understanding Kauffman's iterations as forming a dreamlike narrative mode quite different from the ideal, public and didactic discourse associated with neoclassical history painting.[51]

Penelope's dream

> 'Ah my friend,' seasoned Penelope dissented,
> 'dreams are hard to unravel, wayward, drifting things –'[52]

In the *Odyssey* attention is also paid to Penelope's dreams. Although Penelope is known for her cunning, which resembles that of Odysseus, much of her own desires and knowledge emerges from her dreams.[53]

Angelica Kauffman represents the moment before the beautiful queen wakes up from her sleep in *Penelope Awakened by Eurycleia with the News of Ulysses's Return* of 1772 (Figure 10.6). Dramatic chiaroscuro sets the stage

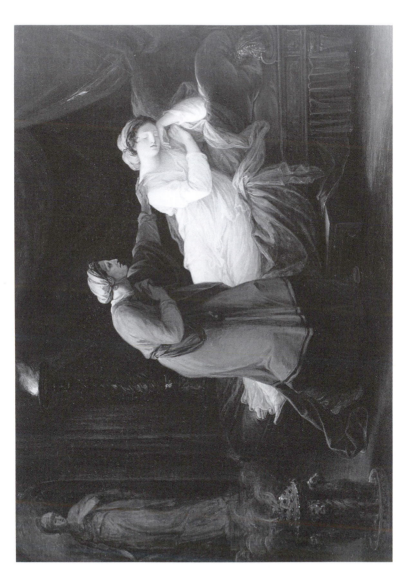

Fig. 10.6: Angelica Kauffman, *Penelope Awakened by Eurycleia with the News of Ulysses's Return*, 75 × 109.8 cm, oil on canvas, 1772, Bregenz (Vorarlberger Landesmuseum, Bregenz)

for Penelope, who lies under a canopy of thick dark-green drapery in her
bedroom in a deep night slumber. Propped up on a lush red cushion and
flowing red and golden fabrics, she has found some comfort. She dreams, but
does not yet know for sure that Odysseus has returned. Penelope's pale body,
clad in a radiant bridal white robe, which clings to her graceful form, appears
as if mysteriously illuminated from within – the source of light in this nocturnal
scene.

Kauffman chooses to represent a rather particular scene. Although Odysseus
has revealed himself to Telemachus and the nurse, Penelope remains – explic-
itly – in the dark, knowing her husband only in his guise as the beggar.
Having discussed her plans to call for the archery contest with the 'beggar',
Penelope returns to her room to lie down.[54] Rather than representing the
triumphant moment when Odysseus finally reveals himself to his wife,
Kauffman elects to paint another moment played out between the three women
who safeguarded Ithaca during Odysseus' long absence: Penelope, her guard-
ian Minerva, and the faithful maid Eurycleia. While smoke rises from the
lion-decorated brazier that shimmers warmly in the night, the golden flame of
the solitary torch flutters gently, responding perhaps to the swift movement of
the old nurse Eurycleia. Stepping forward with outstretched arm, the mater-
nal friend touches Penelope lightly on her shoulder. Her parted lips seem to
utter in whispering voice the lines from the *Odyssey*:

> Ulysses lives! arise, my child arise!
> At length appears the long-expected hour!
> Ulysses comes! the Suitors are no more!
> No more they view the golden light of day;
> Arise, and bless thee with the glad survey![55]

The animated 'statue' of Minerva seems literally moved by this scene. The
helmeted goddess, within her stony niche, clasps her heart while witnessing
the drama that unfolds before her. In electing to represent not the closure of
the marital embrace, nor even the moment of Penelope's enlightenment,
Kauffman's painting creates an arresting balance between the explicit con-
sciousness of the nurse and Penelope's dream-state. The painting proffers a
rendition of that liminal zone between knowing and wishful desire, between
palpable touch and immaterial imagining, between the real and the fictional,
and between consciousness and slumber.

Kauffman, by painting Penelope with her head resting on one arm, her
heavy thighs, crossed legs and clinging white, almost translucent fabric,
clearly refers to the celebrated sleeping *Ariadne* (also called *Cleopatra*; *c.* 240
BCE; probably Roman copy) of the Vatican collection; the artist has her
protagonist embody the 'moment' of unending sleep. The lost past as re-
imagined by Winckelmann becomes visible in her form, for in depicting
Penelope as Ariadne/Cleopatra, the painting makes the loss of the past visible

like a dream in which Penelope is suspended forever in the very moment before her awakening. The spectator imagines inhabiting Penelope's dreams, and in so doing has entered a temporal space of antiquity and, in Kristeva's terms, monumentality. Pictorial interest, here and elsewhere in Kauffman's odyssey, seems to reside less in narrative closure or climax than in the monumental time between departure and arrival that opens up space – perhaps endlessly and repetitively – for a female subjectivity.

Narrative weavings

Kauffman's continued relations with Penelope create for us a social and personal mythology concerning women's agency. Kauffman's paintings of Penelope span over two decades, during which time the artist had travelled extensively and gained considerable success in the cultural capitals of her age. Having been trained in the major artistic centers in Italy, the 25-year-old Angelica Kauffman had settled in London in 1766 and quickly established herself as a fashionable painter of portraits and narrative paintings. Frequenting elevated artistic and social circles, Kauffman, along with Mary Moser, was the only female founding member of the Royal Academy in 1768. Kauffman returned to the Continent in 1781, finally settling in Rome, where she remained until her death in 1807. Her travels, unlike those of many of her contemporaries and peers, were not departures from one acknowledged home, but reflect her constant, almost odyssean itinerary. It might even be possible to read her paintings of Penelope as reflecting Kauffman's desire for that which her mobility and professional vocation seemed to prohibit. While these paintings might negotiate and express the potential losses that her successful career may have caused – of children, of a stable home – I have also tried to suggest how these works may be seen to project a different relationship to history and narrative painting. This is not to suggest that Kauffman retells her own odyssean biography through her works, but that her imagery provided a space for a form of psychocultural contemplation of her position as a professional woman artist.

Penelope is an artist, because she is a weaver. Unlike Arachne, the other famous mythological weaver, Penelope does not challenge Minerva, but works under her constant protection and patronage. Penelope's crafty design will ensure Odysseus' return; it also secures for Penelope the rewards as the artist of *history*. Mary Sheriff has recently discussed Nancy Miller's interpretation of Arachne, who, according to Ovid's *Metamorphoses* (book 6), 'is punished for defying Minerva, whose skill at weaving Arachne not only equals but refuses to honor'.[56] Arachne represents in her tapestry the fate of women at the hands of gods and thus provokes Minerva's anger because of the subject

that she represents. As punishment for hubris she is turned into a spider and is 'denied posterity as an artist'.[57]

Kauffman's Penelope does not so much counter as supplement existing narratives. The artist uses her fictional sister – who is both similar and 'other' – to draw out those narrative strands that traditionally interrupt or halt the plot, and reweaves them so as to mark a space for female subjectivities within the cycle of production, consumption and circulation. She also, I would like to suggest, produces an alternate position for the 'art historian'.

While Winckelmann sees Penelope as an embodiment of the melancholic art-historical gaze emanating from the shores of analysis, Kauffman's visual histories look not for the necessarily absent object, but rather at the source of the analytical gaze, at Penelope herself. Kauffman's Penelope becomes more than simply a metaphor for Odysseus' absence and a sentimental evocation of loss; she becomes the expression and model for one, powerful form of female storytelling, giving mediated voice to Kauffman's own pictorial, interwoven narration. Moreover, Kauffman's Penelope provides an alternate position for the 'art historian', by presenting a model of how to craftily weave stories with the discursive strands at her disposal; and in doing so fabricating and simulta- neously undoing history.

Notes

I am grateful to Ada Cohen and Adrian Randolph for their insightful comments on earlier drafts of this essay.

1. The two paintings commissioned by the Englishman John Byng were *Chryseïs Reunited with her Father, Chryse*, and *Coriolanus Entreated by his Mother, Vetturia, and his Wife, Volumnia* (Hertfortshire, The Collection at Wrotham Park); see Wendy W. Roworth, ed., *Angelica Kauffman: A Continental Artist in Georgian England* (London: Reaktion Books, 1992), figs 11 and 16, 33ff.; Bettina Baumgärtel, ed., *Angelika Kauffmann. Retrospektive*, exh. cat. (Düsseldorf: Kunstmuseum, Ostfildern-Ruit: Verlag Gerd Hatje, 1998), cat. nos 26 and 27.

2. Oscar Sandner, ed., *Angelika Kauffmann und ihre Zeitgenossen*, exh. cat. (Bregenz: Vorarlberger Landesmuseum, Vienna: Österreichisches Museum für Angewandte Kunst, 1968), cat. no. 48; Baumgärtel, ed. (1998), cat. 25.

3. The inscription on the bottom left, *Angelica Kauffman/... Roma 1764*, is partially illegible; another word or two precedes 'Roma' on the second line. I am grateful to Andrew Barlow, Keeper of the Royal Pavilion and Fine Arts, for this informa- tion. See also the stipple engraving entitled *Perseverance* by W. W. Ryland, after Kauffman's *Penelope at her Loom* (proof 24 June 1777, publ. 9 July 1777), ill. in David Alexander, 'Kauffman and the Print Market in Eighteenth-Century Eng- land', in Roworth, ed. (1992), fig. 132.

4. Johann Joachim Winckelmann, *The History of Ancient Art*, trans. G. Henry Lodge, 4 vols (Boston: James R. Osgood, 1873), 4: 292.

5. Whitney Davis, 'Winckelmann Divided: Mourning the Death of Art History', in Donald Preziosi, ed., *The Art of Art History: A Critical Anthology* (Oxford and New York: Oxford University Press, 1998), 40–51.

6. Winckelmann, *History*, 4: 292. Bringing Winckelmann's sexual orientation to bear on the process of art-historical and aesthetic judgment, Davis (1998) proposes to read Penelope as a metaphor for Winckelmann's erotic dividedness. In her interpretation of Kauffman's early Ariadne painting, Baumgärtel, ed. (1998), cat. no. 25) refers to Winckelmann and suggests that in her pose, antiquity comes alive in the form of the Sleeping *Ariadne* (also called *Cleopatra*; *c.* 240 BCE).

7. Roland Barthes, *A Lover's Discourse: Fragments*, trans. Richard Howard (New York: Hill and Wang, 1978), 13–14.

8. For an interpretation which proposes that the *Odyssey* was composed by a woman see Samuel Butler, *The Authoress of the Odyssey* (Chicago: University of Chicago Press, 1967).

9. Laura Mulvey, 'Pandora: Topographies of the Mask and Curiosity', in Beatriz Colomina, ed., *Sexuality & Space* (New York: Princeton Architectural Press, 1988), 52–71, 55.

10. This is not to say that Odysseus never features in Kauffman's Odyssean *œuvre* (as he also does in a few scenes by Kauffman after the *Iliad*), but his presence is almost exclusively linked to three powerful women, Circe, Calypso and, always implicitly, the absent Penelope. In 1774 Kauffman exhibited at the Royal Accademy her *Calypso Calling Heaven and Earth to Witness her Sincere Affection to Ulysses, though she Assents to his Departure*, as a pendant to her earlier painting of *Penelope Invoking Minerva's Aid for the Safe Return of Telemachus.* Kauffman created, together with her future brother-in-law Joseph (Giuseppe Carlo) Zucchi, an engraving of *Calypso Calling Heaven and Earth to Witness her Sincere Affection to Ulysses*, 1776 (Baumgärtel, ed., [1998], cat. 50); another similar composition by Kauffman shows *The Oath of Calypso*, 1776, mezzotint by R. Laurie (Ruth Maria Muthman, *Angelika Kauffmann und ihre Zeit: Graphik und Zeichnung en von 1760–1810* [Düsseldorf: G. C. Boerner, 1979], cat. nos 96–7). See also her *Ulysses conducted by Calypso to the Forest Cuts the Trees to Build his Ship*, 1776, mezzotint by P. Daw, illustrated in Muthman (1979), cat. no. 105. Finally, in 1786 and 1793 Kauffman turned to the subject of Ulysses and Circe in two different compositions. See Antonio Zucchi, *Memoria delle pitture fatte d'Angelica Kauffman dopo suo ritorno d'Inghilterra che fu nel mese d'ottobre 1781 che vi trovo a Venezia*, MS, Royal Academy Library, London, translated in Victoria Manners and G. C. Williamson, *Angelica Kauffmann, R.A. Her Life and Her Works* (London: John Lane, 1924), 151 and 163.

11. Zucchi, translated in Manners and Williamson (1924), 141–74, 142.

12. The engraving by James Dumee, *Penelope and her Web*, is illustrated in Muthman (1979), cat. 108.

13. Some scholars have noted the prominence and uniqueness of Kauffman's Penelope scenes. See Peter Walch, 'Angelica Kauffman,' Ph.D. diss. (Princeton University, 1968); Ann Arbor: UMI, 1984, cat. nos 44, 45, 46, 52; see also Frederick den Broeder, 'A Weeping Heroine and a Mourning Enchantress by Angelika Kauffmann,' *Bulletin of The William Benton Museum of Art, The University of Connecticut Storrs* 1: 3 (1974), 19–28; and especially Roworth, who has pointed out that 'Penelope provided a suitable character through which

Kauffman could advertise her talents' (1992), esp. 37, 65–7. However, Kauffman's Odyssean themes have never been discussed as a whole.

14. Mary Kelly, 'On Sexual Politics and Art,' in *Framing Feminism: Art and the Women's Movement 1970–85*, Roszika Parker and Griselda Pollock, eds (London: Pandora Books, 1987), 303–12. In so doing, I am heeding Griselda Pollock's call, in her recent *Differencing the Canon*, for interpretations seeking out 'inscriptions in the feminine' and asking what the signs of difference might be in art made by an artist who is 'a woman'. Griselda Pollock, *Differencing the Canon. Feminist Desire and the Writing of Art's History of Art's Histories* (London and New York: Routledge, 1999), xv and 19. On self-inscription see also Angela Rosenthal, 'Angelica Kauffman ma(s)king claims,' *Art History* XV (1992), 38–59; and the same, *Angelika Kauffmann (1741–1807): Bildnismalerei im 18. Jahrhundert* (Berlin: Reimer, 1996), 40–55 and 271–4.

15. Dora Wiebenson, 'Subjects from Homer's *Iliad* in Neoclassical Art,' *Art Bulletin* 46 (1964), 23–37.

16. Peter Helfrich Sturz, *Schriften*, H. C. Boie, ed. (Leipzig, 1779), 1: 9.

17. Alex Potts, *Flesh and the Ideal: Winckelmann and the Origins of Art History* (New Haven: Yale University Press, 1994). This aesthetic ideal also helped establish a European sense of identity in the age of colonial expansion and odyssean travel.

18. Albert Boime, *Art in an Age of Revolution: 1750–1800* (Chicago: University of Chicago Press, 1987), 112, 115.

19. Karen R. Lawrence, *Penelope Voyages: Women and Travel in the British Literary Tradition* (Ithaca and London: Cornell University Press, 1994), 1–2. See also Peggy Kamuf, 'Penelope at Work: Interruptions in *A Room of One's Own*', *Novel* 16 (Fall 1982), 5–18; Susan Friedman, *Penelope's Web: Gender, Modernity, H.D.'s Fiction* (Cambridge: Cambridge University Press, 1990); Marylin A. Katz, *Penelope's Renown: Meaning and Indeterminacy in 'The Odyssey'* (Princeton: Princeton University Press, 1991); Nancy Felson-Rubin, *Regarding Penelope: From Character to Poetics* (Princeton, NJ: Princeton University Press, 1994); Helene P. Foley, 'Penelope as Moral Agent,' in *The Distaff Side: Representing the Female in Homer's Odyssey*, Beth Cohen, ed. (New York: Oxford University Press, 1995), 93–115; Seth L. Schein, 'Female Representations and Interpreting *The Odyssey*,' 17–28, in the same collection. I am grateful to Phyllis Katz for drawing my attention to some of these texts.

20. The importance of this story within the Odyssey is indicated by the fact that it is repeated three times in the poem. See Homer, bk 2, ll. 96–105; bk 19, lines 141–52; and bk 24, lines 131–42. In this essay I use Fagles's translation for modern language: Homer, *Odyssey*, trans. Robert Fagles (New York: Viking, 1996) and Alexander Pope's translation for specific works by Kauffman. See Homer, *Odyssey*, trans. Alexander Pope, 2 vols (Georgetown: Richards and Mallory; Philadelphia: P. H. Nicklin, 1814).

21. Homer, bk 1, ll. 357–8.

22. Ibid., 327–8.

23. Ibid., 354–60; and see Katz (1991), 36.

24. Kamuf (1982).

25. On relegation of women to the so-called minor arts see Linda Nochlin, 'Why Have There Been No Great Women Artists?,' in *Art & Sexual Politics*, Thomas B. Hess and Elizabeth C. Baker, eds (New York and London: Macmillan, 1973); and Pollock (1999), 24–5, on the canon's systematic devaluation and '(mis)-identifi-

cation with the domestic' of art made by women with textiles and ceramics. Also see Ann Bermingham, 'The Aesthetics of Ignorance: The Accomplished Woman in the Culture of Connoisseurship,' *Oxford Art Journal* 16: 2 (1993), 3–20.

26. See Kamuf (1982), 6; Sheila Murnaghan, *Disguise and Recognition in the Odyssey* (Princeton: Princeton University Press, 1987), 129; Felson-Rubin (1994), 17; Lawrence (1994), x.

27. Similarly for the female artist, marriage might threaten her artistic freedom – as countless examples of women artists forced to give up their profession for their families have revealed.

28. *LIMC, Lexicon Iconographicum Mythologiae Classicae*, s.v. Penelope, VII, 1 and 2 (Zurich and Munich: Artemis Verlag, 1994). I am grateful to Ada Cohen for drawing my attention to a number of ancient Greek Penelope representations and for discussing their iconographic characteristics with me. For illustrations see in particular *LIMC*, 2: VII, Figure 2a–I, 3, 5–10, 16–18e, 33a, 33b–e.

29. Felson-Rubin (1994), 17, 41 and 151, n. 9.

30. A painting like *Penelope Taking Down the Bow of Ulysses for the Trial of her Wooers*, for example, was conceived of and exhibited as a pendant, paired with another history painting not based on the Odyssean narrative: *Venus Showing Aeneas and Achates the Way to Carthage*, in 1768 and at the first Royal Academy summer exhibition in 1769 (Walch, 1968, cat. nos 45 and 56; and Roworth, ed. (1992), figs 23–4, 43ff. and 64ff.).

31. Den Broeder (1974), 19–28; Baumgärtel, ed. (1998), cat. nos 251–2. Kauffman exhibited *Calypso Mournful after the Departure of Ulysses* at the Royal Academy in 1778 (no. 176).

32. According to Zweig (Lawrence, 1994, 6), Calypso serves as an important figure for the way the uncanny female body threatens the whole enterprise of adventure. 'To be kalypsoed is to fall outside the poem'. See also Schein (1995), 20.

33. Homer, bk 4, ll. 760–67. This painting was exhibited at the Royal Academy in 1774 (no. 143) together with Kauffman's *Calypso calling Heaven and Earth to witness her sincere Affection to Ulysses, though she Assents to his Departure* (no. 142).

34. François de Salignac de La Mothe Fénelon, *The Adventures of Telemachus, the Son of Ulysses,* trans. John Hawkesworth (London: C. Taylor, 1792). See Katharine Baetjer, *European Paintings in the Metropolitan Museum of Art by artists born before 1865,* 2 vols (New York: The Metropolitan Museum of Art, 1980), vol. 1: 101, vol. 2, figs p. 310.

35. Kauffman painted this subject in 1782 and again in 1784. See Zucchi, trans. in Manners and Williamson (1924), 142 and 144.

36. Fénelon (1792), 6–7.

37. Ibid., 8. Kauffman painted the sorrows of Telemachus for different patrons in 1783, 1788 and 1789. See Zucchi, trans. in Manners and Williamson (1924), 143, 155, 156.

38. Another example is her *Venus Showing Aeneas and Achates the Way to Carthage*, which was exhibited in 1768 (no. 1) and at the Royal Academy in 1769 (no. 63). It also depicts a mother (in this case Venus disguised as the huntress Diana) taking actions to aid her son's return.

39. Pope (1814), 2: 92, line 49. The painting illustrated here is one of at least two known versions of the same composition. Another version of the painting discussed in this essay is in the Toledo Museum of Art, Ohio. Walch (1968), cat.

no. 52 mentions an undated engraving by W. W. Ryland entitled *Telemachus and Penelope Reunited*, that is perhaps based on Kauffman's *Return of Telemachus* of 1771. According to the legend it goes back to 'an Original Picture in Collection of Francis Baronneau, Esq.'. A *supraporta* painting of 1775, which shows next to Eurycleia a group of four other female servants, is in the collection of the Earl of Derby, Derbyshire.

40. Homer, bk 17, ll. 26–44; Pope (1814), 2: 92–3, ll. 35–55.

41. The National Trust, Saltram Collection. It was exhibited as pendant to *Venus Showing Aeneas and Achates the Way to Carthage*.

42. Katz (1991), 150.

43. A scene from Book 21 of the *Odyssey* (Homer, bk 21, ll. 352–3), recommended by the comte de Caylus (1757), 250, bk 21, *I. tableau*. Kauffman was probably the first artist in modern times to have turned to this subject (Walch [1968], 264).

44. Homer, bk 21, ll. 47–54; Pope (1814), 2: 181, ll. 51–6). A much smaller version of *Penelope Taking Down the Bow of Ulysses for the Trial of the Wooers* (oil on canvas, 89 × 69 cm) was sold at the White-Thomas Sale, Christie's London, February 1934, as a pair with a version of *Venus Showing Aeneas and Achates the Way to Carthage*. Perhaps the same painting or one of identical scale appeared again at Sotheby's, London, 16 November 1966, Lot. 111.

45. Roworth, ed. (1992), 48 has pointed out that the bow also aligns Penelope with Venus, goddess of love.

46. The artist painted numerous versions of this subject, which was also engraved; see, for example, the small composition in the collection of the Earl of Exeter, Burghley House, Stamford. Another version on copper is in the Office of the Landeshauptstadt, Bregenz and in a private collection in Italy; illustrated in Baumgärtel, ed. (1998), cat. nos 250–51. See also Den Broeder (1974), 19–28, for a probably authograph version on panel. One of these must have inspired Henry Fuseli's composition of the same subject for the frontispiece of an early nineteenth-century edition of Alexander Pope's *Odyssey* (1814), vol. 2.

47. Homer, bk 21, ll. 55–7; Pope (1814), 2: 181, ll. 57–60.

48. Delattre, 'F. Bartolozzi dirext'; (publ.) Ann Bryer (Victoria & Albert Museum, 476), 29 Sept. 1779; pendant to *Dido Invoking the Gods ...* , 10 June 1780. Ann Bryer took over her husband Henry Bryer's business in 1778/79. See Alexander in Roworth, ed. (1992), 162.

49. The single-figure *historia* can function as a placeholder for the beholder's emotions. Walch (1968), chaps 6–7; den Broeder (1974), 19–28; Baumgärtel, ed. (1998), 408–9 describes these images as *Trauerikonen*, icons of mourning, among which we can also count Kauffman's paintings of mourning Andromache, Ariadne, or her 'Insane Maria' from Laurence Sterne's *Sentimental Journey*. She argues that as projection-scenes for the viewer's own emotion, the narrative content of these images becomes almost irrelevant. See also Werner Busch, 'Das Einfigurenhistorienbild und der Sensibilitätskult des 18. Jahrhunderts,' in Baumgärtel, ed. (1998), 40–46, who discusses the single-figure history painting as a late eighteenth-century phenomenon of the sentimental age.

50. Julia Kristeva, 'Women's Time,' in *The Kristeva Reader*, Toril Moi, ed. (Oxford: Basil Blackwell, 1986), 187–213; Rosemary Betterton, *An Intimate Distance: Women, Artists and the Body* (New York: Routledge, 1996), 25ff.

51. Gilles Deleuze, *Difference and Repetition* (London: The Athlone Press, 1994), 14.

52. Homer, bk 19, ll. 560–61.

53. For example, Athena sends a phantom to the sleeping Penelope to soothe her sorrows (Homer, bk 4, ll. 795–841). Later, Penelope's dream that her geese had been slaughtered by an eagle is explained as a metaphor for Odysseus slaying the suitors (Homer, bk 19, ll. 535–59); Penelope also has a dream of Odysseus as he was, when he left for Troy (Homer, bk 20, ll. 85–90). On Penelope's dreams of the geese see Felson-Rubin (1994), 31–3.

54. Homer (1996), bk 19, ll. 600–604. 'Down her pale cheek new-streaming sorrow flows:/'Till soft oblivious shade Minerva spreads,/And o'er her eyes ambrosial slumber sheds' (Pope [1814], 2: 157, bk 19, ll. 702–4). The painting here illustrated from the Vorarlberger Landesmuseum, Bregenz, is signed and dated 1772. See Oscar Sandner, *Hommage an Angelika Kauffmann* (Milan: Nuova Mazzotta, 1992), cat. no. 26. Another version dated to 1773 was sold at Christie's, London, 17 July 1992 (illustrated in Roworth, ed. [1992], fig. 33). The subject was engraved by Thomas Burke (1773), and by W. W. Ryland (1785); see Muthman (1979), cat. nos 99 and 100.

55. Homer, bk 23, ll. 5–9, quoted in Pope's translation (1814), 2: 218, bk 23, ll. 6–10.

56. Mary D. Sheriff, 'Reading Jupiter Otherwise: Or Ovid's Women in Eighteenth-Century Art,' in *Myth, Sexuality and Power: Images of Jupiter in Western Art*, special issue of *Archaeologia Transatlantica* 16, Frances Van Keuren, ed. (1998), 79–93, 88. I am very grateful to Melissa Hyde for drawing my attention to this fascinating article.

57. Sheriff (1998), 89.

The 'Other Atelier':
Jacques-Louis David's Female Students

Mary Vidal

David's reputation as a teacher of other great artists was nearly as renowned during the Revolution and Empire as his work as a painter and political figure.[1] Yet David's training of female artists remains a relatively unexplored aspect of his role as 'father of the modern school'. A closer look at some of these exceptional women reveals a complex give-and-take with the man who could be in turn their mentor, protector, friend, political ally or adversary, and even a seeker among them of protection and patronage.

David was among the handful of academicians who responded to the increasing numbers of women seeking serious artistic training along with guidance through or around male-dominated institutions, such as the Academy and the Salon, not yet fully open to them.[2] Certain of David's contemporaries may have taught comparatively more women in all-female ateliers. Yet, as the following study shows, David's open support of women artists further demonstrates the reformist ideals that characterized his approach to art education and art practice, while complicating the canonical image of David as a painter of virile, stoic ideologies at the head of an exclusionary all-male studio. Closer attention to David's varied relationships with his female students also reveals individual circumstances that do not readily conform to standard assumptions about master–pupil, or male–female pedagogical models.

Revealing contrasts

Even if we do not distinguish between 'amateur' and 'professional' artists, it is not surprising to find for this period that David's female students were

decidedly fewer in number than his male students. Based on Daniel and Guy Wildenstein's list compiled in 1970 – which augments those of Etienne Delécluze, Jules David and David himself[3] – there were 433 male students who passed through David's atelier over the years. In contrast, Wildenstein lists a total of seventeen women, and two among those remain difficult to trace as his students. Contemporary correspondence and textual references now permit the addition of new names for an estimated total of twenty-one to twenty-three female students (see Appendix to this chapter).

It is not generally known that David accepted female students throughout his career, and that, as did David himself and most of his male students, his female students primarily practiced figure painting, including portraiture and traditional history painting (allegory, mythology, classical history, religious subjects). Many of his female students also painted genre – considered more appropriate for women than traditional history painting because it did not depend as much on the study of the nude body through life drawing – whether generalized scenes of contemporary social life or the relatively new category of historical genre (familiar or sentimental scenes taken from the lives of historical figures or from novels). While contemporary genre was rarely practiced by David's male students, historical genre was increasingly taken up by men as well as women throughout the late eighteenth and early nineteenth centuries. Some of David's female students also did landscapes, still lifes and miniatures – subjects and formats practiced by few of his male students. As did certain of his male students, David's female students sometimes produced engravings and illustrations. Many, but not all, of David's female students exhibited their works in the same public venues as men, such as the Exposition de la Jeunesse and the Salons. David often provided copy work to both male and female students and acted as a mediator for commissions, thus combining the roles of teacher and patron. Finally, as with his male students, and within the limits of eighteenth-century codes of conduct, David enjoyed personal friendships with some of his favorite female students.

Despite some similarities, however, there are three important differences between David's male and female pupils. First, due to a pre-established and already-filled quota, none of David's female students were ever admitted into the Academy. Second, all of David's female students received lessons outside of his regular teaching studio. Finally, certain of David's female students were potential patrons, the artist training women who in turn could provide commissions, favors and protection.

Ever since the original publication of Linda Nochlin's ground-breaking essay,[4] the fact that women artists did not receive exactly the same artistic training as men has been viewed as wholly disadvantageous. However, there are indications that some women, including David's students, circumvented the taboo against life drawing,[5] and that David's private lessons may have

offered women a few worthwhile, although socially imposed, tradeoffs: against the benefits of competition among men, a more personalized attention to women; against acceptance into a community of male artists (along with the overcrowding and notorious chaos and insalubrity of the male ateliers[6]), the enjoyment of orderly working conditions in a private atelier; against lessons in the male atelier that defined a more hierarchical master–student relationship, the possibility for women of lessons characterized by greater familiarity and sociability.

Early students: charity, favors and artistic identity

It is a little-known fact that David's very first students were not the men he began to teach around 1781, such as Hennequin, Drouais and Wicar, but rather two young women. According to Madame de Vandeul, the daughter of Diderot, sometime between 1768 and 1775, when David came under the protection of the playwright Michel de Sedaine (Sedaine had been protected by David's maternal grandfather), he was provided with a studio in Sedaine's extensive apartments in the Louvre. In exchange Sedaine asked David to give drawing lessons to the Guéret sisters, who, like Sedaine and David, had lost their father at a young age[7] and who, along with their mother, had also been lodged by Sedaine. We know little else about them, except that they painted portraits and genre subjects and exhibited at the Salons (1793–1801), but the information helps to partially locate the genesis of David's teaching of women (and certain men like Hennequin) as a charitable action and within a context of an exchange of favors.

David continued to demonstrate generosity and protectiveness towards subsequent female pupils. In turn, his early students sought an artistic identity openly linked to David's. Three of them – Marie-Guillemine Leroulx-Delaville (later Madame Benoist), her younger sister, Marie-Élisabeth Leroulx-Delaville and their companion Mademoiselle Duchosal – worked in an atelier above David's in the Louvre. The fourth, Mademoiselle Huin, later joined the Leroulx-Delaville sisters for lessons in their home.

Commentaries on David's supervision of these young women often suggest the superficial nature of his interest. In letters[8] to David and Suvée dated 19 July 1787, the *Directeur des Bâtiments D'Angiviller* reminded both artists that according to a royal decree of 1785, and in the name of safety and 'decency', female artists were forbidden to share studio space with male artists, or even to be present in the Louvre for lessons, if they did not reside there with family or as boarders. Soon afterwards, according to most accounts, David abandoned his training of the women, stating in a letter to D'Angiviller (21 July 1787) that he had only taken them in while their regular

teacher, Madame Vigée-Lebrun, was remodeling her studio. Supporting the idea that he was glad to be rid of them is a letter from Pierre, head of the Academy, to D'Angiviller (16 August 1787), commenting that David 'doesn't hide his relief' at sending the women away.

Yet Pierre's claim does not accord very well with David's longstanding attachment to these students, and in interpreting the correspondence, we need make a better assessment of the social codes at stake. David's response to D'Angiviller does state that he was supervising the women only temporarily, but this seems a rather evident ploy to maintain that no regulations were being broken. David never says he wishes to send the women away. Rather, he insists that he has taken great care to cloister them in a locked atelier above his own, supervised by himself and Madame David, and entirely separated from the male atelier. The overall tone of the letter is that of a fatherly defense designed to affirm the unblemished reputation of his female students as well as his own and to head off implications of impropriety, especially given the disreputable conditions of the Louvre studios so graphically described in Delécluze's biography of David.[9] The purpose of David's response is confirmed by Monsieur Leroulx-Delaville's letter on the same day to D'Angiviller. He represents his own concern for 'the honor of my family' and describes David's supervision of his daughters as proper and arising from the artist's 'friendship' for the family, noting that the lessons are free.[10]

Despite these protests, David, as well as Suvée, whose sympathy for female students has never been questioned,[11] acceded to D'Angiviller's order and closed his Louvre studio to women. It is likely that both were merely yielding to the pressure of Pierre and D'Angiviller's campaign against the incursion of women into the profession undertaken after Vigée-Lebrun's and Labille-Guiard's admission to the Academy in the same year as David (1783).[12] Yet, in spite of the administration's position, Monsieur Leroulx-Delaville's letter reveals that David had been teaching at least the younger of his daughters, Marie-Élisabeth, as early as 1783–84, that is, before David's second departure for Rome. Moreover, in her *Souvenirs*, Vigée-Lebrun comments that when she closed her atelier it was because teaching did not interest her, and her school never reopened.[13] Indeed, within two years of their departure from the Louvre, David was again supervising the work of the Leroulx-Delaville sisters in their home, along with a new student, Mademoiselle Huin, and he may well have provided lessons for them in the interim.[14]

David's official statement that the women studied in a locked atelier under close supervision is also questionable. In 1787 Madame David surely had her hands full with their own four infants, and David's female students seem to have had easy access to his studio. Alexandre Lenoir recounts that one day when David stepped out of his atelier, Marie-Guillemine took the liberty of sketching in the head of one of the daughters of Brutus that David had been

struggling with.[15] Thus David's protests that the women were segregated, that he only supervised them temporarily, and that he was 'relieved' when they left seem formulated more as a socially correct response designed to head off suspicions and gossip than as a sign of the teacher's disinterest.

Furthermore, the correspondence highlights David's continuing charity towards female pupils in financial difficulty. The Leroulx-Delavilles were an established, but impoverished family of *robins*, and their father apparently intended to develop his daughters' talents to provide for their uncertain futures and marriageability.[16] (Both women did end up well married to ambitious men who became influential under the Directory, Empire and Restoration.) Leroulx-Delaville's reference in his letter to David's 'friendship' should thus also be understood in terms of the service the artist was extending to the family by giving the women free lessons.

The cases of the Guéret sisters and of Mademoiselle Huin and her family confirms the nature of David's relationship with the Leroulx-Delavilles. His letter to Madame Huin (3 December 1789) also proposed free lessons for her daughter in the Leroulx-Delaville home with the reassurance that the family is of excellent reputation. This favor is explained by an earlier, rarely cited letter to Madame Huin (8 September 1786) in which David expressed his sympathy for her 'recent loss' (her husband?), and offered free lessons to one of her sons. In fact, both of the Huin brothers eventually became regular students in the male atelier and were exempted from the monthly fees required of other students, although David received a certain sum from the state for their lessons.[17]

David's generosity does not, of course, preclude the possibility of favors returned by the students and families concerned. One way the women themselves demonstrated their gratitude was to create a public persona as David's student, further spreading their master's fame while nurturing their own ambitions. For example, in the Salon *livrets* of 1796, 1799, 1800, 1802, 1804 and 1810, Marie-Guillemine Leroulx-Delaville lists herself (now as Madame Benoist) as an 'élève de David', and in the *livrets* of 1798, 1799 and 1801 Mademoiselle Huin does likewise.[18] This officialized association with a teacher appears to have been a choice on the part of the student. While it was a widespread practice in the Salon *livrets*, it was by no means standard from year to year for all of David's male and female students. For example, at the 1795 Salon following the end of the Terror and David's arrest, Benoist exceptionally does not list the name of her teacher, nor does Huin in 1796, an understandable disassociation given David's outspoken support of Robespierre. Family lore also tells that David refused his support and protection when Benoist most needed it, and his signature appears on a warrant to search her apartment for evidence of her royalist husband's whereabouts.[19] Yet soon enough, in 1796 for Benoist and in 1798 for Huin, David's name once more

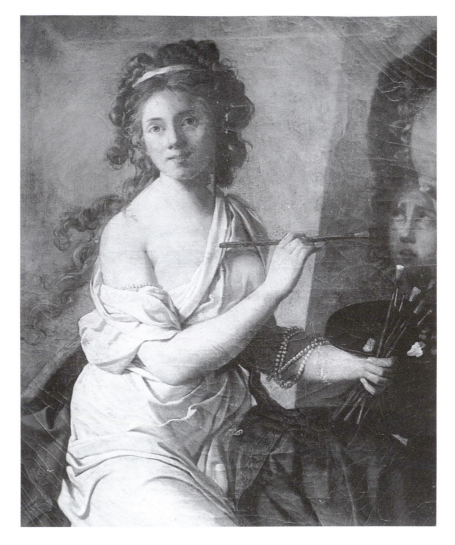

Fig. 11.1: Marie-Guillemine Leroulx-Delaville (Mme Benoist), *Self-portrait*, oil on canvas, c. 1786, private collection (Photograph: Roger-Viollet, Paris)

appears beside theirs in the *livrets*, indicating widespread efforts to forgive and forget during the Directory.

David's female students also displayed their affiliation with the style and name of their master in their art works, despite the usual risk of charges that women's paintings were largely executed by their male teachers.[20] For example, in a self-portrait (Figure 11.1, *c.* 1786), Benoist depicts herself painting a

scene copied from an earlier version of David's *Belisarius*,[21] establishing her artistic identity along with her talent for historical subjects and portraiture. Another portrait of a woman artist, very likely by one of David's female pupils, depicts a comparable genealogy (Figure 11.2). It came to its present location (Paris, Musée Marmottan) with a clipping from an early catalogue noting the painter as 'Valin' [*sic*] and the sitter as Duchosal, and it might well be by Nanine Vallain, who also worked with David. However, given its subject and style, it has also been attributed to Benoist, who thus portrays her companion Duchosal painting Sabine, one of the Horatii sisters from David's composition of 1785 probably stored in the artist's atelier when the women were working there. Interestingly, whether the artist is Vallain or Benoist,[22] the painting offers a contemporary insight into what might be called a female gaze on David's famously 'heroic' image.

Cultivating amateurs: the politics of teaching women

Rarely do studies of female (or male) artists take into consideration those who infrequently, or never, exhibited or sold their works. Yet in the late eighteenth and early nineteenth centuries, creative and learned activities often still took place at home, especially among the élite, and even men versed in a special field of knowledge were not necessarily extensively schooled in it. To protect their social standing, members of the élite still avoided practicing a skill for gain, and even certain of David's male students may not have pursued art as a livelihood.[23] One of the interests in focusing on the relationship between David and three 'amateur' women artists is that it allows us to consider relationships cultivated, whether by student or teacher, that potentially served the economic, social, political and artistic goals of both parties.

The first, Marie Lavoisier, was the daughter of Jacques Paulze, an influential *fermier-général*, director of the Compagnie des Indes, and friend of *ancien régime* economic reformers. She was the wife of Antoine-Laurent Lavoisier, also a *fermier-général*, famous then and now as the scientist who revolutionized modern chemistry. Marie Lavoisier played an exceptionally active role in her husband's work. She acquired the languages and knowledge of chemistry needed to assist him with his research and hosted in her salon the great scientific thinkers of the day, including Benjamin Franklin, whose portrait she painted. Mutual friends and social contacts of David and the Lavoisiers included in 1786 early enthusiasts of political reform such as the Trudaine brothers, and the poets André and Marie-Joseph Chénier.

Marie Lavoisier began receiving instruction from David in late 1785 or early 1786.[24] Her lessons are documented by two fine drawings inscribed with comments in David's own hand (Figure 11.3). The purpose of the les-

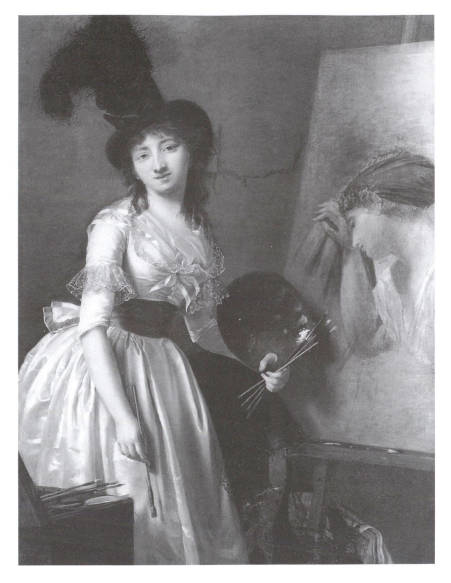

Fig. 11.2: Attributed to Nanine Vallain or Marie-Guillemine Leroulx-Delaville (Mme Benoist), *Mademoiselle Duchosal* (?), oil on canvas, c. 1787–88, Paris, Musée Marmottan (Photograph: Routhier)

sons was far from dilettantism and is consistent with Marie's other learning projects and with Lavoisier's new notions of scientific documentation. Two more drawings by Marie (Figure 11.4) record her husband's experiments in

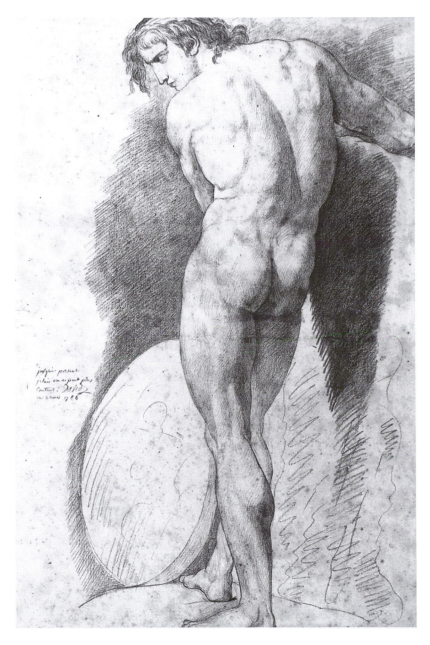

Fig. 11.3: Marie-Anne Paulze Lavoisier, *Red Chalk Drawing of a Nude with Annotation by David*, 1786, Paris, Musée National des Techniques (Photograph: C.N.A.M.)

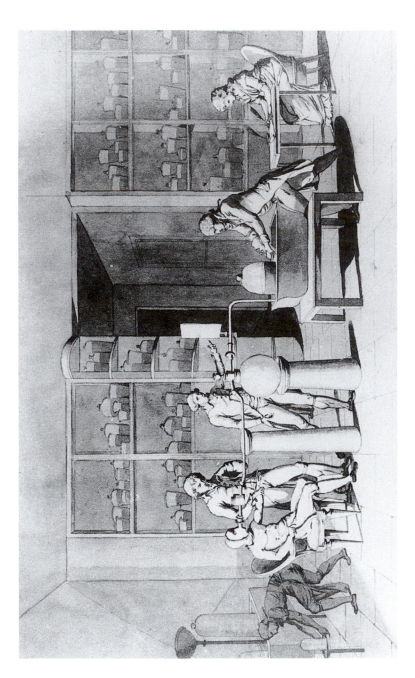

Fig. 11.4: Marie-Anne Paulze Lavoisier, *Sepia Drawing of an Experiment on Human Respiration*, 1780s, private collection (Photograph: Jean-Loup Charmet)

the laboratory with Marie as a participant. She again proudly displayed her artistic–scientific skills in a series of thirteen signed engravings for her husband's *Traité élémentaire de chimie* of 1789 illustrating the laboratory instruments he designed to conduct his revolutionary experiments.

Was it Marie Lavoisier who first requested the drawing lessons from David or was it David who suggested them? We know of other instances, and for other reasons, when David offered free instruction to a female student: to Madame Huin's daughter, to the daughter of Alexandre Lenoir, director of the Musée des monuments français and to the daughter of Boissy D'Anglas.[25] In Marie Lavoisier's case, whether or not the lessons involved payment, David was soon commissioned, probably sometime in 1787, to paint one of the most meaningful, handsome and handsomely paid portraits of his career: the full-length double portrait of the Lavoisiers. Elsewhere I have proposed that the iconography of the portrait celebrates the arts and sciences united in their service to social progress and in their admiration of Nature (as woman) represented in the dominating figure of Marie.[26] Tragically, after 1792, David's political radicalization separated him from former friends whose wealth or beliefs in constitutional monarchy made them targets of suspicion, leading Marie's husband and father, along with André Chénier and the Trudaines, to the guillotine.

David's initial interest in, and ensuing break with, the Lavoisiers was in part driven by ambition, money and politics, and it is not the only case we find of David's connection to a female student for such motives. Although the comtesse de Noailles may never have received direct instruction or advice from David, her presence (with David's knowledge, if not his approval) in and around his personal atelier in 1796–97, and under the supervision of one of his students, Charles Moreau, was politically motivated, in Delécluze's opinion.[27] Moreau had been given the temporary use of David's atelier of the Horatii while the latter was working at Cluny on his *Sabine Women*. As a novice Delécluze was also studying under Moreau, hoping for intermittent encounters with David in preparation for his acceptance into the regular male student atelier whose atmosphere, for the moment, Delécluze's parents thought too 'unregulated' for their impressionable adolescent. It may be that Noailles's puzzling apprenticeship under Moreau was arranged with similar expectations for passing on artistic advice during David's intermittent visits and/or, as Delécluze suggests, in view of an indirect association with David's name.

A beautiful and worldly amateur and collector, the countess is perhaps better known for her subsequent liaison with Chateaubriand.[28] She never exhibited at the Salons, an expected reticence for a woman of her status, although she illustrated an exhaustive study of Spanish antiquities authored by her brother, Alexandre de Laborde. During the Terror and Directory the

countess's political and social position had been precarious. She was the daughter of one of the richest bankers of the *ancien régime*, Jean-Joseph de Laborde de Méréville (whom Delécluze as a child saw executed), wife of an aristocratic *émigré*, Charles de Noailles, and sister of another *émigré* who returned to France at the moment Noailles, coincidentally or otherwise, began working in David's atelier of the Horatii.

In his biography of David, Delécluze concludes that by frequenting the atelier of a former radical, Noailles, and perhaps David himself, was demonstrating the spirit of (apparent) reconciliation typical of post-Thermidorian Paris.[29] From Delécluze's perspective, the man who only two years earlier had sworn to drink hemlock at the side of Robespierre now appeared in his atelier elegantly dressed, displaying the refined manners of the *ancien régime* towards 'a fashionable young woman', and extending his regards to those whose political opinions 'were the very opposite of his own'. Delécluze then offers the example of David's demonstrative compliment to Noailles 'on what had just happened in her family', during his visit to the atelier that occurred only a few days after the return of her brother from exile. For Delécluze, who at that point in the narrative recalls in vivid detail the execution of Noailles's father, David's show of sympathy represents the height of confusion in an age when Delécluze could witness, on the one hand, the sister of a returned *émigré*, 'seeking in some sense asylum in the atelier of the Horatii, under the protection of the terrible Republican', and, on the other, see David himself 'shedding [the image of] the Republican of 1793, protecting *émigrés* and almost courting those who bore a name'.[30]

The competing motives of sympathy and self-interest that David brought to providing lessons to influential female students, and perhaps in varying degrees to all of his students, surfaces again in the artist's late career. Once more it is at a time of relative vulnerability for David. Charlotte Bonaparte, the youngest and favorite daughter of Joseph Bonaparte – elder brother of Napoleon and former king of Spain – received painting lessons from David during the artist's exile in Brussels.[31] Charlotte, her sister Zénaïde, her mother Julie, and her cousin Julliette de Villeneuve arrived together in Brussels in July 1820. After Napoleon's downfall Charlotte's father had fled to the United States, where she joined him in 1821 for a few months' visit.

To understand the context of patronage and politics surrounding Charlotte's art lessons from David, let us first recall that her father was the eldest and wealthiest of Napoleon's brothers and would have been the regent had Napoleon's first heir ever come to power. He was also known for his prodigious spending and collecting, and a portion of David's late production was clearly aimed to please the Bonapartes and their supporters. Two paintings by David were among those inventoried in Joseph's collection of old and new masters, then housed in New Jersey.[32] An 1836 inventory lists the first ver-

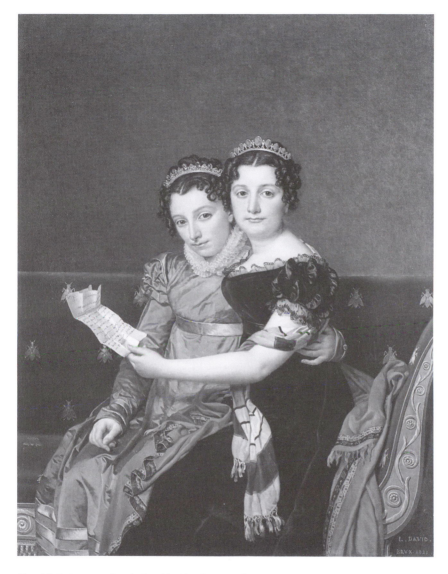

Fig. 11.5: Jacques-Louis David, *Charlotte and Zenaïde Bonaparte*, 129.5 × 100 cm, oil on canvas, 1821, Los Angeles, J. Paul Getty Museum (Copyright: J. Paul Getty Museum)

sion of David's portrait of Napoleon crossing the Alps (Malmaison) as well as the original version of David's 1821 portrait of Charlotte and Zénaïde holding a letter from their father (Figure 11.5).[33] In Brussels David also completed a

full-length portrait of Juliette de Villeneuve and finished his copy of Napoleon's *Coronation* that was to circulate at paying exhibitions organized by private investors.

Commissions and other forms of protection by Joseph were potentially involved, then, in David's encouragement of Charlotte's artistic talents. And a personal relationship with the nineteen-year-old Charlotte herself was not devoid of political and artistic prospects. In 1821 Charlotte's parents were giving serious thought to their daughters' marriages, an exceptionally ponderous matter in the months immediately preceding and following Napoleon's death at Sainte-Hélène on 5 May and with sentiments favoring a Bonapartist *coup* against the restored monarchy still alive. Indeed, with Charlotte's marriage to a close successor of Napoleon in 1824, a year and a half before David's death, she barely missed becoming Empress of the Second Empire. After the death of her husband in 1831 under mysterious circumstances, it was her husband's younger brother who became Napoleon III in 1852.[34] Thus, given David's own uncertain future and that of his family, and in view of the surprising historical reversals that had become the norm in this age of revolutions, he could hardly have remained uninterested and unaware of Joseph and Charlotte's key positions as he guided his pupil's work and commented upon her talent and progress in letters to her father.

The later years: friendships, favors, inspiration

David's relationships with two of his most talented and successful female students, Angélique Mongez and Sophie Frémiet-Rude, merged artistic concerns with friendship. David inspired and supported their work, helped with patrons, gained able assistants, and in turn may have been inspired by their work.

Correspondence between David, Angélique Mongez and her husband, along with David's intimate portrait of the couple (dated 1812, but possibly finished as late as 1824),[35] attest to an enduring friendship that may have developed as early as 1792–93. Madame Mongez's husband, who was close to David's age, was active as an antiquarian, politician and administrator throughout the periods of the Revolution, Directory and Empire. Among many other lifelong scholarly projects, from 1786 to 1794 he published his *Dictionnaire des Antiquités* (part of the *Encyclopédie Methodique*), that by 1824 would include three volumes with 380 figures drawn by his wife. In 1792 David and Antoine Mongez both played active roles in the reform of the monetary system, with Mongez eventually named Director of the Mint (1804).[36] In 1796 he was nominated to the Institut national as part of the same class as David (*Littérature et Beaux-Arts*).[37]

It could have been either the many opportunities for contact with Antoine Mongez or his wife's youthful artistic interests that initiated the couple's friendship with David. In 1793, at age eighteen, Angélique Levol married Antoine Mongez and in the same year or the following began studying art in Regnault's all-female studio.[38] However, there are no documented links between David and the Mongez couple until 1802, when Angélique, at her first Salon, identified herself officially as a 'student of citizens Regnault and David'.

By today's standards, Mongez's circumstances might seem closer to that of an amateur than a professional. Although she exhibited regularly, and worked occasionally on commission, her status and security were such that she may not have needed to sell her paintings or do portrait work. Indeed, in the Salon *livrets* she never listed her address as did other artists, suggesting that she was not in the business of painting. Like Marie Lavoisier, Madame Mongez also illustrated her husband's texts, a private collaboration perhaps commemorated in David's double portrait (the book Antoine Mongez holds could be thought of as 'their' *Dictionnaire des Antiquités*). However, there was never any ambiguity about Angélique Mongez's artistic ambitions nor about the role that David was perceived to play in her formation. Alexandre Lenoir, Director of the Musée des Monuments français, and possibly a mutual friend,[39] wrote that Madame Mongez practiced 'the historic and heroic genre, just as well as her [male] compatriots, and that Monsieur David had guided her closely on this path'.[40] Lenoir also notes that she 'broke' with Regnault to follow in David's footsteps, indicating that Madame Mongez's change of direction was carefully considered.

Her status and security may have allowed Angélique Mongez to concentrate on history painting and even in a manner that risked censure. In every Salon from 1802 to 1814, she presented a new subject drawn from ancient history or mythology, and only once during her uninterrupted exhibition record was her usual submission accompanied by a portrait (in 1806). Her ambitious specialization was openly confirmed by her alliance with David, not only in the *livrets*, but by signing her first submitted work as his student. Its subject was *Astyanax Torn from His Mother*, a sequel and tribute to her master's 1783 reception piece *Andromache Mourning Hector*.

Mongez's choice of history painting elicited both admiration and harsh criticism.[41] The scandal was the familiar one of a woman's representation of the nude figure, augmented by the controversy over David's *Sabine Women* concerning the appropriateness of representing nudes – imitating the 'purer' heroic style of Greek vase painting – in large-scale historical works. Mongez's *Theseus and Pyrithöus Clearing the Earth of Brigands, Deliver Two Women from the Hands of Their Abductors* (Figure 11.6) followed in her master's footsteps, but only partially, calling attention to what she dared to do by what

Fig. 11.6: Angélique Mongez, *Theseus and Pyrithöus Clearing the Earth of Brigands, Deliver Two Women from the Hands of Their Abductors*, drawing, 1806, Minneapolis Institute of Arts, Richard Lewis Hillstrom Fund

she dared *not* do. Reminiscent of David's *Sabine Women*, Mongez contrasted the nude figures of the heroes with the clothed figures of the brigands and women, while more modestly turning the bodies of the male nudes away from the viewer. This was enough for one Salon critic to call on her to 'renounce a genre of painting in which the demands of propriety too often contradict the most excellent conceptions', and to blame David for leading Mongez astray. Another critic insisted that a man would never have handled the composition in this manner.[42]

Whether or not David directly advised Mongez to follow him in his most controversial experiments, he supported her on this and other projects. In 1808 he mediated the sale of Mongez's *Theseus and Pyrithöus* to Prince Youssopoff, commending the collector's discernment,[43] in 1813 he openly praised Mongez's copy of his portrait of Napoleon in a letter to the director of the Musée de Lyon,[44] and, although notoriously exacting with engravers, David at least twice consented to have Mongez copy his works for prints.[45]

David's trust in Mongez as a friend and fellow artist approached that of his ties with outstanding male students, resulting in several instances of mutual aid[46] and artistic inspiration and dialogue. Among other examples, we might ask whether Mongez introduced David to the collector Sommariva or vice versa? Mongez's *Mars and Venus*, shown at the Salon of 1814, was acquired by Sommariva, who later bought David's *Amour and Psyche* (begun in Paris in 1814 and finished in Belgium in 1817). Mongez's *Mars and Venus* of 1814 also precedes by ten years David's version of the same subject in the final painting of his life. Did this subject hold a special significance for teacher and student?[47] David's painting elicited elaborate praise from the Mongez couple when it was transported to Paris for an exhibition, was confided to their care afterwards, and was still in their possession when David passed away in 1825.

Coupin, an early biographer, also proposed that Madame Mongez was responsible for the *ébauche* of David's painting of *Sappho and Phaon* of 1809, sold to Prince Youssoupoff within the same time frame as Mongez's *Theseus and Pyrithöus*.[48] Coupin's claim does conflict with David's own statements in a letter to his patron dated 27 September 1808 in which the artist refers to his trouble in composing the subject: 'I have just traced onto the canvas the subject of the sensitive Sappho ... If I have been so tardy in giving you the pleasure of it, it is because I was waiting for the moment of inspiration, I think I have found it.' However, the wording of David's letter does not eliminate the possibility that Mongez created the compositional sketch, as Coupin stated, or further refined the composition on canvas with another *ébauche* that followed the lines of David's original sketch.[49]

Another indication that her work and conversations may have inspired David in his later career is the striking consistency of Mongez's preference

for mythological subjects that preceded David's return to the representation of mythology after 1808. Although Mongez was not the only student of David's representing mythology during the Empire, she was one of his preferred students, and David saw her with great frequency during that time. He spent many evenings with the couple in their lodgings at the Mint, especially after 1808 when David and his wife moved from the Louvre to 10 rue de Seine, that is, within 500 meters of the Mongez's apartment. Jules David tells us that, 'after the theater, his principle distraction was to spend the evening with his friends, above all at the home of his neighbors at the Mint, Monsieur and Madame Mongez. The latter took care to prepare for him pencils and paper, on which, all the while talking, he drew some sketches.'[50] These regular visits continued at least as late as 1813, that is, even after David had moved farther away to the rue d'Enfer. Suau complained in a letter to his father dated 17 January 1813 that David was neglecting his male students, passing all of his evenings 'at Madame Mongez's home at the Mint, which is a few steps from the atelier'[51] (by 1811 the male atelier was located next door to the Mint in the Institut national).

The shared pleasures of antiquities and art-making solidified and sustained David's intimate friendship with the Mongez, immortalized in the Latin inscription heading their portrait. After David's exile, the friends kept up a supportive correspondence, and Madame Mongez visited David at least once in Brussels.[52] However, in Belgium, David's attention necessarily turned both to former students he found there and to newer acquaintances.

One new student in particular strove, like Mongez, to become a history painter: Sophie Frémiet-Rude.[53] She and her family offered, at least for a time, the friendship and support that David had grown accustomed to in Paris with favorite students like Mongez. Frémiet-Rude's family was originally from Dijon, where they had long enjoyed connections to the world of art. Her mother, Sophie Monnier, was the daughter of an engraver and museum conservator, and her father, Louis Frémiet, had been a government official and art lover who took in and supported the sculptor François Rude as an impoverished and orphaned young man whom Sophie would eventually marry in 1821. Active Bonapartists, the Frémiets fled Dijon after Waterloo, and moved to Brussels in 1815, leaving their established life behind.

Louis Frémiet and his family, soon joined by his future son-in-law, all needed to contribute to their recovery in exile, and David's efforts to establish his presence in Brussels would become interwoven with their own. The father found work again as an administrator and as a journalist with a special interest in the arts. Frémiet's sympathetic articles on David's new paintings helped with publicity, and a discreet means was found to secure the painter's approval. Sophie Frémiet acted as an intermediary, reading the essays and communicating David's reactions.[54] The arrangement was facilitated by Sophie

and her sister Victorine's art lessons with David which were under way probably by 1817. Again, were the lessons free, charitable and anticipating or recognizing favors returned? In any case, Louis Frémiet's positive essay on David's controversial *Cupid and Psyche* appeared in *Le Vrai Liberal* of 14 August 1817, and by the following year Sophie had become David's assistant, producing copies of his works,[55] and soon opening her own teaching atelier. Victorine served as a model for both her sister and David.[56] François Rude, who joined his adopted family after leaving his art studies in Paris, was also helped by David, who provided introductions that led to commissions in royal palaces.

Sophie's first major public success in 1820 shows how her recognition as an artist helped David's own delicate and evolving position *vis-à-vis* the Belgian art establishment. Yet ironically, after a falling out between David and the Rudes that occurred around 1823, Sophie's early success as a follower of David may for a time have effected the evaluation and acceptance of her work.[57]

All of the discussions of Sophie Rude's entry into the grand prize competition at the 1820 Ghent Salon report the details of the close contest between her painting, *Beautiful Anthia*, and the same subject submitted by Joseph Paelinck, a Belgian artist who had studied with David in Paris and was now first painter to the queen of the Pays-Bas. However, less attention has been given to the larger rivalries implied in this contest involving the French 'school of David', appreciative Belgian connoisseurs and Belgian painters who may have been less enthusiastic about the arrival in their territory of exiled French artists. Documents from the time describe the circumstances of the Ghent competition. In a long letter to a friend, Sophie Rude proudly explains that in a first round, eight out of twelve judges voted to give her the prize. However, in a subsequent round, Rude claims that influence came into play, with the prize going to Paelinck by a final vote of ten to two.

David was invested enough in the fate of both his current and former students that he discreetly refrained from attending himself. Instead he sent an observer, another former Belgian student, Odevaere, who sized up Rude's painting and the circumstances in words designed to flatter the master who had produced the student:

> My dear master, I bow before your sublime lessons and I admire the beautiful, the graceful 'Anthia' painted by your young student, who is only a woman by her clothing and who is a man by talent. The work that is opposed to hers surprises but does not move my heart. It is only the production of a laborer.[58]

However, in the delicate matter of deciding the worth of David's current French pupil versus the skill of a native son and the queen's painter, the judges chose Paelinck, while publicly recognizing, with a runner-up prize and

an eulogious speech, the merit of Rude and her teacher David.[59] In the end, we do not know if the compensatory prize was given to encourage the individual artist or the head of the 'modern school', but David's position could only have been advanced in the limelight of Rude's and Paelinck's shared success and rivalry, especially since some thought Rude's painting to be largely by David and since Paelinck may have been perceived as a direct competitor to David in terms of his own ambitions at court.[60]

Today's viewers might agree that Sophie Rude deserved the grand prize, but the outcome of the contest, ambiguous and bittersweet, would haunt her as she simultaneously gained recognition yet fell victim to the standard prejudice aimed at female painters. Three years later, and after the family's break with David, Sophie confided to her friend that 'when I did my painting of Anthia, artists and almost all those who knew me thought that the painting was by Monsieur David ... when Monsieur David no longer came to the house, it was said that I could no longer do anything ... '[61] Sophie Rude would definitely disprove such suspicions during her long and productive career. She went on to win other medals on her own, exhibiting at Salons throughout Belgium and France until her death in 1867 at seventy, when the world of art began to open its doors more widely to women.

Conclusion

The curious range and mix of relationships that David developed with women artists over his lifetime should alert us to both the challenges and possibilities that his female students faced. Being either the offspring or the apprentice of someone famous is never a simple matter, of course, and successors always suffer by comparison and relative neglect as much as they emerge from the shadows of history because of their nearness to the great. What we learn from these tenacious women is how artistic education for women was a complex affair that escapes generalizations. In diverse and sometimes contradictory ways, David's female students engaged his charitable dispositions, admiration and affections. And just as they served his personal, social, political and artistic aims, their own goals were served as far as possible at a crucial moment of historical transition when their access to artistic institutions and commissions was at once on the rise and still highly contested. In the end, David's female students advanced the status of women artists in Europe, contributing in incalculable ways, through their presence, subjects, production, teaching and 'gaze', to the transformation of nineteenth-century painting.

Appendix: David's female students

The following list builds on those of Jules David and Etienne Delécluze, combined and augmented by Wildenstein in 1970. Each student is listed according to the last name by which she was best known. Primary genres practiced (*) are given when available. In parentheses I have indicated on which list the name appears, if any: ED=Eugène Delécluze, JD=Jules David, W=Wildenstein (as in text notes 1 and 3). A list containing fuller biographical information, exhibition histories and bibliographies will be published in my forthcoming book on David.

Benoist, Comtesse Marie-Guillemine (*née* Leroulx-Delaville, 1768–1826). History, genre, portraits*. (ED, JD, W)

Bonaparte, Princesse Charlotte-Zénaïde-Julie (1802–39). Genre, landscapes*, still lifes, drawings.

Bonaparte, Princesse Zénaïde (1801–54). Studied with David *c.* 1821.

Charpentier, Madame Constance-Marie (*née* Blondelu, 1767–1849). History, genre*, portraits, landscape. (JD, W)

Chéradame, Madame Sophie (*née* Bertaud, 1793–1824). History, genre, portraits*. (JD, W)

Davin, Madame Césarine-Henriette-Flore (*née* Mirvault, 1773–1844). (JD, W)

Desaugiers, Madame Eugénie (*née* Duboys). (ED, JD, W – note: Wildenstein identifies as Desaugiers; listed as Desaubiers in ED, JD)

Duchosal, Mademoiselle. Studied with David *c.* 1787. (W)

Forestier, Mademoiselle Marie-Anne-Julie (b. 1782). History, genre, portraits. (JD, W)

Guéret sisters. Studied with David *c.* 1768–75. Genre, portraits.

Hugo, Comtesse Louise-Rose-Julie (*née* Duvidal de Montferrier, 1797/98–1869). History, portraits. (JD, W)

Huin, Mademoiselle. Salons: 1796–1801. Portraits, miniatures. (JD, W)

Kindt, Marie-Adélaïde (1804–84). History*, genre, portraits. (JD, W)

La Madeleine, Madame Zoë de. Portraits, miniatures. (ED, JD, W)

Lavoisier, Madame Marie-Anne-Pierrette (*née* Paulze, 1758–1836). Studied with David in 1786.

Lenoir, Mademoiselle Daughter of Alexandre Lenoir and Adélaïde Binard, both artists.

Leroulx-Delaville, Marie-Élisabeth (married name Larrey, 1770–1842). Portraits, drawings. (ED, W)

Mongez, Madame Marie-Joséphine-Angélique (née Levol, 1775/76–1855). History*, portraits. (ED, JD, W)

Noailles, Comtesse Natalie-Luce-Léontine-Joséphine de (née de Laborde-Méréville, 1774–1835). Studied under Charles Moreau c. 1796 with possible advice from David. Painter, watercolorist.

Pastoret, Madame Adélaïde-Louise (née Piscatory de Vaufreland, 1765–1843). (W – note: Wildenstein is the only source claiming that she was David's student)

Piètre, Madame Nanine (née Vallain, 1797–1867). History, genre, portraits. (ED, JD, W – listed twice by Wildenstein)

Rude, Madame Sophie (née Frémiet, 1797/98–1867). History*, portraits*, genre. (JD, W)

Notes

1. On David's male students see, for example, Thomas Crow, *Emulation: Making Artists for Revolutionary France* (New Haven and London, 1995); Philippe Bordes, 'François-Xavier Fabre, "peintre d'histoire",' *Burlington Magazine* 117 (February 1975), 91–8, 'Les Arts après la Terreur: Topino-Lebrun, Hennequin et la peinture politique sous le Directoire,' *Revue du Louvre* 29: 3 (1979), 199–212, and 'Antoine-Jean Gros en Italie (1793–1800): lettres, une allégorie révolutionnaire et un portrait,' *Bulletin de la Société de l'Histoire de l'Art Français* (1978), 221–44; Jerémie Benoît on Hennequin and Alain Pougetoux on Rouget in *David contre David*, ed. Régis Michel (Paris, 1993). For early sources see Etienne-Jean Delécluze, *Louis David, son école et son temps, souvenirs* (Paris, 1855; reprinted Paris, 1983), 14–105 and J. L. Jules David, *Le Peintre Louis David, 1748–1825: Souvenirs et documents inédits* (Paris, 1880), 492–505.
2. For valuable overviews see Vivian Cameron, 'Woman as Image and Image-Maker in Paris during the French Revolution,' Ph.D. diss. (Yale University, 1984); Margaret A. Oppenheimer, 'Women Artists in Paris, 1791–1814,' Ph.D. diss. (Institute of Fine Arts, New York University, 1996); and Gen Doy, 'Hidden from Histories: Women History Painters in Early Nineteenth-Century France', in *Art and the Academy in the Nineteenth-Century* (New Brunswick, NJ, 2000), 71–85.
3. See Daniel and Guy Wildenstein, *Documents complémentaires au catalogue de l'oeuvre de Louis David* (1973), 253–80; Delécluze (1983), 414–18; and Jules David (1880), 625–30.

4. 'Why Have There Been No Great Women Artists?', *Art News* 69 (January 1971), 22–39.
5. Oppenheimer (1996), 41–6; Cameron (1984), 76–7, 362, n. 57; and Mary Vidal, 'David Among the Moderns: Art, Science, and the Lavoisiers,' *Journal of the History of Ideas* 56 (1995), 613.
6. See Wildenstein, no. 1390a., Delécluze (1983), 14–15, and Suau's correspondence in 1810–12 in Schnapper, cat., 616–19.
7. Discussed in Crow (1995), 18.
8. For full texts see R. Peyre, 'Quelques lettres inédites de Louis David et de Madame David,' *La Chronique des Arts et de la Curiosité*, no. 11 (1900), 97–8 and no. 12 (1900), 109–11; J. J. Guiffrey, 'Ecoles de Demoiselles dans les ateliers de David et de Suvée au Louvre,' *Nouvelles Archives de l'art française*, 1874–1875 (reprinted Paris, 1973), 394–401; and Marie-Juliette Ballot, *Une Élève de David: La Comtesse Benoist, l'Émilie de Desmoustier* (Paris: Plon-Nourrit, 1914). See also Cameron's sound analysis of the correspondence in the context of David's encouragement of women as history painters (72–5, 80–82).
9. Delécluze (1983), 14–15.
10. Ballot (1914), 257.
11. Suvée's letter of protest to D'Angiviller of 20 July 1787 reminds the Directeur des bâtiments that he approved of the supervision and work of Suvée's female pupils only the year before (Guiffrey, 1973, 399).
12. For the politics limiting women's membership in the Academy, see Mary Sheriff, *The Exceptional Woman: Elisabeth Vigée-Lebrun and the Cultural Politics of Art* (Chicago and London: University of Chicago Press, 1996), 78–83.
13. Élisabeth Vigée-Lebrun, *Souvenirs de Madame Vigée-Lebrun*, 3 vols (Paris, 1835–37), 51–2.
14. A continuity of advice indicated by Ballot (1914), 52.
15. Lenoir (1835), 4.
16. Ballot (1914), ix.
17. Peyre (1900), 97, Jules David (1880), 57, and Schnapper, cat. 572 (December 1787). Delécluze (1983), 68 states that approximately one-half of the students in the male atelier received free lessons, but these too may have been state-subsidized.
18. 'Collections des pièces sur les beaux-arts imprimées et manuscrites recueillies par P.-J. Mariette, C.-N. Cochin et M. Deloynes,' Collection Deloynes, Paris, Bibliothèque Nationale, Cabinet des Estampes, 1745–1881 (hereafter cited as Collection Deloynes). Among David's later female students, Mongez is the most consistent in linking her name with David's, while Vallain and Davin-Mirvault do so irregularly, and Charpentier and Forestier never.
19. Ballot (1914), xxii.
20. For this type of criticism directed at Leroulx-Delaville (Benoist), see Collection Deloynes, vol. 17: 436, 16, 25; 17: 441, 44, 62.
21. See Schnapper, cat. 132, fig. 48.
22. For the attributions, see Oppenheimer (1996), 112–13, and Philippe Bordes, *Musée de la Revolution Française* (Vizille, 1996), 102–3.
23. See Wildenstein (1973), 254 and Delécluze (1983), 83. For the evolution of the idea of the 'professional' and the 'amateur' in science and art during this period, see Charles Gillespie, *Science and Polity in France and the End of the Old Regime* (Princeton: Princeton University Press, 1980), 84–92 and Ann

Bermingham, *Learning to Draw: Studies in the Cultural History of a Polite and Useful Art* (New Haven: Yale University Press, 2000), 127–81.

24. See Vidal (1995), 598, 613.
25. Peyre (1900), 97; Lenoir (1835), 4, n. 1; on Wildenstein, no. 1164.
26. Vidal (1995), 619–23.
27. Delécluze (1983), 32–44.
28. On the fascinating life of Madame de Noailles, see principally Georges Martin, *Histoire et généologie de la maison de Noailles*, n.p., n.d. (printed by Mathias La Ricamarie, 1993); Marcel Duchemin, *Chateaubriand: Essais de critique et d'histoire littéraire* (Paris, 1938), 275–8; Marquis de Noailles, *Le Comte Molé, 1781–1855, sa vie, ses mémoires*, 3 vols (Paris, 1923); and *Mémoires de la comtesse de Boigne, née Osmond, récits d'une tante*, ed. Jean-Claude Berchet, 2 vols (Paris, 1971).
29. Delécluze (1983), 39.
30. Ibid., 40–44. All translations from original French texts are my own.
31. On Charlotte see Georges Bertin, *Joseph Bonaparte en Amérique: 1815–1832* (Paris, 1893), 257–89, 415–20; Gabriel Girod de L'Ain, *Joseph Bonaparte; le roi malgré lui* (Paris: Perrin, 1970), 351–2; and Michael Ross, *The Reluctant King: Joseph Bonaparte King of the Two Sicilies and Spain* (London: Sidgwick & Jackson, 1976), 105, 256–9, 265, 270–73.
32. Bertin (1893), 415–20. Girod de L'Ain (1976, 352) notes 160 entries.
33. On the double portrait, see Schnapper, cat., 384, 530–32. A receipt from David dated 25 June 1821 notes receiving 4,000 francs for the original, exactly the price shown in Joseph's inventory. It seems to me rather likely that Charlotte herself accompanied the work across the Atlantic to her father's American residence and that it may even have been commissioned by him.
34. In June 1822, Joseph began negotiations with his younger brother Louis to marry Charlotte to one of Louis's sons by the first Empress Josephine's daughter Hortense. Louis's sons were next in line after Napoléon's own ailing heir (called the king of Rome) by the second Empress Marie-Louise. In 1824 Charlotte married Louis's second, and eldest surviving son, Napoléon-Louis (see Ross, 1976, 259). Nevertheless, neither the 'king of Rome', with Joseph as regent, nor Charlotte's husband ever came to power. When the latter died, Louis's third son came into line as head of the Bonapartist party, and following the *coup d'état* of 1851, he established the second Empire (1852–70) as Napoléon III.
35. See Schapper, cat., 478.
36. On David's role in monetary reform and protection, see Lina Propeck, 'Monnaies, sceaux: deux aspects de David sous la Révolution,' in Schnapper, cat., 30–34; see also Schnapper, cat., 578 (15 March 1792).
37. Jules David (1880), 323.
38. Oppenheimer (1996), 238–9.
39. The Musée des Monuments français, where Alexandre Lenoir and his wife Adélaïde Binard lived (both were artists), is part of the current complex of the Ecole des Beaux Arts. It was within a short walking distance to both David's house at 10 rue de Seine and the Hôtel de la Monnaie where the Mongez lived. David saw both couples with frequency.
40. Wildenstein, no. 2389, citing Lenoir.
41. Margaret Fields Denton, 'A Woman's Place: The Gendering of Genres in Post-

Revolutionary French Painting,' *Art History* 21 (June 1998), 219–46; and Doy, 75–8.
42. Collection Deloynes, 37: 1029, 37: 1035, 19–20.
43. Schnapper, cat., 612.
44. Wildenstein, no. 1670.
45. Wildenstein, nos 1640 and 1664.
46. Madame Mongez's brother, Florimond-François Levol, head accountant of the Mint, became David's personal *homme d'affairs* (Schnapper, cat., 615 and 632, 1 May 1810 and Oppenheimer, 1996, 238 and n. 411). At the outset of the first Restoration, the Mongez also made David and his wife a substantial loan (Schnapper, cat., 620, 25 July 1814). After David's exile, Madame Mongez signed the petition to approve his return to Paris (Wildenstein, no. 1776).
47. Mars and Venus represented the resolution of opposites in nature in Alexandre Lenoir's graphs for his treatise on Freemasonry and the origins and meaning of the ancients' myths: *La franche-maçonnerie rendue à sa véritable origine* (Paris: Fournier, 1814). We now know that like his friend Lenoir, David was a freemason. Was Antoine Mongez (who may have influenced both his wife's and David's approaches to myth)? Despite Navez's letter to Léopold Robert (18 July 1822) stating that David borrowed the idea for *Mars and Venus* from his assistant Dupavillon, Schnapper (cat., 541–2) raises questions about the genesis of David's last painting. The nature of Dupavillon's potential involvement with the work does not, in any case, preclude that the original idea and composition may have come from Madame Mongez several years earlier or that David was inspired by her focus on myth.
48. The 9 July commission to David is followed on 21 August by a letter to Youssoupoff mediating the sale of Mongez's *Thésée and Pirithoüs*, and then on 27 September by another letter announcing David's *ébauche* of *Sappho and Phaon*. The closeness of these dates possibly indicates a mutual aid between David and Mongez. Schnapper, cat., 440.
49. Another case confirms this studio practice. Suau claimed that David had Rouget make the *ébauche* for his *Leonidas at Thermopylae* (Schapper, cat., 619, 28 July 1813).
50. Jules David (1880), 505. The Louvre has preserved at least one sketchbook of drawings, primarily for David's *Leonidas at Thermopylae*, identified as having belonged to Madame Mongez (Schnapper, cat., 502). One wonders if other sketchbooks from this period were also compiled in the Mongez's salon.
51. Schnapper, cat., 619.
52. Schnapper, cat., 478.
53. The two best sources on Frémiet-Rude are: *Autour du neo-classicisme en Belgique*, eds Denis Coekelberghs and Pierre Loze (Brussels, 1986) and Louis de Fourcaud, *François Rude, sculpteur, ses oeuvres et son temps* (Paris, 1904), esp. 68–125, 449.
54. Jules David (1880), 541.
55. *Telemachus and Eucharis* (original 1818; copy begun in 1818 and finished in 1822; copy signed by David) and, according to Louis de Fourcaud, *Cupid and Psyche* (original 1817; copy untraced) and *The Wrath of Achilles* (original 1819; copy planned 1819, finished 1825). A portrait of the actor Wolf, called Bernard (Louvre), long attributed to David, is now documented to be by Rude. See Schnapper, cat., 17 and 663 and Coekelberghs and Loze (1968), 421.
56. Victorine modeled for Clytemnestra in *Wrath of Achilles*, for the young woman

in *La bonne aventure* (Schnapper, cat., 540–41), and for Anthia in her sister's own prize-winning painting (Coekelberghs and Loze, 1968, 254).

57. Since Sophie Rude's copy of David's *Telemachus and Eucharis* is dated 1822, their break probably occurred afterwards. A letter from Madame Rude to a friend dated 4 February 1823 contains the first mention of the quarrel in obscure terms: 'I never spoke to you about our break with Monsieur David because the details cannot be put in writing.' (Fourcaud, 1904, 116 and Schnapper, cat., 629). There is no further information on this embarrassing incident which could have arisen from a misunderstanding over any number of things: for example, over credit for Sophie's copy of David's *Telemachus and Eucharis*, an article by her father, a disagreement over politics, or even inappropriate attentions on David's part towards Sophie's sister Victorine. While the last may seem far-fetched, contemporaries declare that the aging painter was smitten by her beauty, and Sophie's discretion suggests a taboo subject. See Fourcaud (1904), 116 and Schnapper, cat., 540–41.

58. Fourcaud (1904), 104.

59. Ibid, 105.

60. For Paelinck's status in court circles see Coekelberghs and Loze (1968), 194, keeping in mind that soon after David's arrival in Belgium, he had requested a high appointment in the service of William I (Schnapper, cat., 515 and 622, n.d., after May 1816).

61. Fourcaud (1904), 449.

Goya's Portraits of the Duchess of Osuna: Fashioning Identity in Enlightenment Spain

Andrew Schulz

Francisco Goya's three-quarter-length portrait of the duchess of Osuna de-
serves to be better known (Figure 12.1).[1] Painted in 1785, this work and its
pendant of the duke mark the beginning of a relationship between painter and
patrons that would flourish into the most important of Goya's career.[2] Over
the next fifteen years, the Osunas commissioned or purchased from Goya
some thirty canvases in a range of genres, including decorative works, reli-
gious paintings and portraits in various formats.[3] Moreover, in January 1799
they bought four sets of the artist's print series, *Los Caprichos*, and may have
acquired some of his earlier prints at the same time.[4] After 1800, Goya
continued to paint occasionally for the Osuna family, but these works were
limited to portraits of the children as adults.[5]

The 1785 portrait of the duchess merits our attention not simply as the
starting-point of Goya's long and fruitful association with the Osuna family,
but also for what it reveals about the sitter, who was one of the most compel-
ling figures – male or female – of the Spanish Enlightenment. While Goya
will enter occasionally into the analysis that follows, the duchess of Osuna is
the focus of this essay. In particular, I will examine her use of a variety of
cultural patronage, most notably portraits by Goya, as a means of forging an
identity in the cosmopolitan atmosphere of late eighteenth-century Madrid.
My motivations are two-fold, for I wish to suggest that the duchess is unique
as well as representative. On the one hand, she epitomizes the notion of the
'exceptional woman', that is, one free from many of the normal constraints
placed on women during this period.[6] But, at the same time, consideration of
her cultural patronage offers a case study of how Spanish women of the

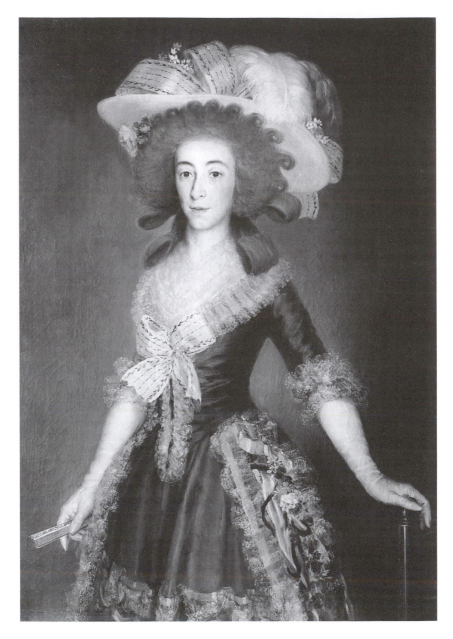

Fig. 12.1: Francisco Goya, *Portrait of the Duchess of Osuna*, 112 × 80 cm, oil on canvas, 1785, Mallorca, Fundación Bartolomé March Servera (Photograph: Institut Amatller d'Art Hispanic, Barcelona)

highest station negotiated between private and public spheres at a time when they enjoyed an unusual amount of power and a remarkable degree of autonomy, but also faced significant impediments.

As a young woman, María Josefa de la Soledad Alonso Pimentel (1752–1834) became the twelfth duchess of Benavente, heir to the extensive titles, estates and properties of the Benavente family, whose noble lineage extended back to the late fourteenth century.[7] In December 1771, at the age of nineteen, María married her cousin, Pedro Alcántara Téllez Girón (1755–1807), whom she had known since childhood. During their engagement Pedro had unexpectedly become the marquis of Peñafiel, heir to the House of Osuna, and he became the ninth duke of Osuna following the death of his father on 1 April 1787. The end of the eighteenth century has been described as the 'apotheosis' of the Osuna family, which had attained noble status in 1460 and was one of the greatest noble dynasties in Spain.[8] The nineteenth century witnessed the long, slow decline of the family's fortunes, culminating in the sale of the art collection in 1896, an event that provides an important inventory of its contents, much of which was acquired during the period under consideration.[9]

A brief survey of the activities of the duke will help to frame those of the duchess. In addition to pursuing a military career, the duke of Osuna took an active part in the intellectual and civic life of Madrid. His interest in commercial ventures and technological innovation was typical of the Enlightenment in Spain, which (as is often noted) was reformatory rather than revolutionary in nature.[10] In contrast to the wide-ranging intellectual enquiry that occurred in France and England during the second half of the eighteenth century, the Spanish Enlightenment is best characterized as a series of attempts at pragmatic reform in fields such as fiscal policy, agriculture, public health and education. These activities occurred within the framework of the enlightened despotism of two Italian-born Bourbon monarchs, Charles III (ruled 1759–88) and Charles IV (ruled 1789–1808), and often were spearheaded by members of the nobility, such as the duke of Osuna.

Although the duchess was sympathetic to the public roles played by her husband, her ability to have a meaningful voice within the discourse of reform was limited by her gender. A striking example of the policing of gender boundaries occurs in the deliberations in 1786 over whether to admit women into the Economic Society of Madrid, one of the principal organs of enlightened reform.[11] Debate on the subject was precipitated by the duke of Osuna himself, who proposed for membership María Isidra Quintana Guzmán y de la Cerda, a young noblewoman of remarkable talents. Others responded by nominating the duchess of Osuna, and both women were accepted into the organization. These events led to a debate on the admission of women into the society, which featured reports on the topic by two of the most prominent

ilustrados (proponents of the Enlightenment), Gaspar Melchor de Jovellanos (1744–1811) and Francisco Cabarrús (1752–1810). Cabarrús, a merchant and economist who acted as the principal economic adviser to King Charles III, was flatly opposed to the inclusion of women. Jovellanos, on the other hand, spoke in favor of their admittance, but he stopped short of advocating that the *socias* (female members) should attend the regular meetings of the society. After stating that *socias* could serve as examples for less virtuous women, Jovellanos employs the familiar rhetoric of decorum and physical inadequacy in order to gender the public discourse of reform as masculine:

> But let us not be deluded by a pointless illusion: women will never attend our meetings. Modesty will always keep them apart from us. How can one permit their delicate virtue to appear in a gathering of men of such diverse temperaments and conditions, and to mix in our discussions, muddling with their weak voices the din of our arguments?[12]

While their occasional presence might be permissible – at prize-giving ceremonies, for example – Jovellanos concludes that women members should meet separately in support of the goals of the Economic Society of Madrid. A Royal Order issued on 27 August 1787 sanctioned female membership, and fourteen *socias* were admitted in that year. But as Jovellanos and others had recommended, they were institutionally marginalized through the creation of a separate but unequal *Junta de Damas* (women's committee) that was charged with such activities as oversight of four *Escuelas Patrióticas* (patriotic schools), which had been established to fight poverty. The duchess of Osuna took a leading role within the *Junta de Damas*, acting as its first president from 1787 to 1790 and occupying that position again in 1801.[13]

In spite of such constraints on equal participation in enlightened debate and reform, the duchess occupied an important place in the intellectual and cultural life of late eighteenth-century Madrid.[14] In 1804, the English visitor, Lady Elizabeth Holland, described the duchess as 'the most distinguished woman in Spain from her talents, worth, and taste'[15] and, in another entry (from 1803), Lady Holland states: 'The present Duchess of Osuna is a person of greater importance than the Duque.'[16] The comparison with her husband is most apt in the realm of culture, for while the duke demonstrated a serious interest in the world of ideas and the arts, the duchess played the dominant role in shaping their cultural patronage. For example, surviving documents indicate that the duchess was the driving force behind Goya's association with the Osuna family.[17] The duke and duchess enjoyed friendships with the most significant figures in a variety of disciplines, many of whom they supported financially. Writers who formed part of the Osuna circle included Juan Melendez Valdés, Tomás de Iriarte, Leandro Fernández de Moratín and the playwright Ramón de la Cruz. In addition, the duke and duchess were deeply interested in music. They amassed an impressive library of musical

scores, maintained a personal orchestra of eighteen players and had Haydn under contract in 1783, although other commitments prevented him from writing much for them. Moreover, the duchess patronized leading actors and bullfighters of the day, often in competition with her great social rival, the duchess of Alba.[18]

In terms of the visual arts, the duchess lavished considerable attention on the decoration and furnishings of the palace into which she and her husband moved in 1781.[19] Contemporary descriptions mention the prominent *chinoiserie* decorations and French furniture and fabrics contained in its interior spaces. Although neither she nor the duke had inherited an extensive collection of paintings, their palace featured works by Van Dyck and Rubens, among others, and the Osunas commissioned works of art from a range of living artists. After Goya, the most important painter they patronized was Agustín Esteve (1753–1820), a Valencian who came to Madrid in 1770 to study at the Royal Academy. During the 1780s, Esteve emerged as one of the favorite portraitists to the Madrid aristocracy, including the Osunas. In the course of his long association with the family, which began in the late 1780s and continued until the year of his death, Esteve executed some fourteen portraits as well as a number of religious works, and he served as drawing instructor to the Osuna children.[20]

None of the portraits undertaken by Esteve or others for the Osunas is as interesting from either a visual or a cultural point of view as Goya's three-quarter-length depiction of the duchess (Figure 12.1), which is one of the artist's most carefully constructed portraits.[21] The sitter, who was 33 years old at the time the canvas was painted, commands the visual field. Her form, turned slightly to the viewer's left and silhouetted against an empty, dark greenish background, is positioned much closer to the picture plane than in other female portraits painted by Goya at this time. The viewer's gaze is drawn to the enormous hat – decorated with ribbons, flowers and a feather – and the elaborate coiffure that frames her long, oval face and angular features. Another point of focus is the bow on the dress, located near the center of the painting. Its pink color, highlighted with olive touches, matches the ribbons in the hat and contrasts with the rich blue of the dress, while its x-shape echoes the lace on the bodice and the graceful fall of the arms, providing a pivot around which the composition revolves. Finally, one's attention turns to the closed fan that the duchess holds loosely in her gloved right hand and the chair upon which her left hand casually rests. On this level of analysis, the painting is a visual display of immense wealth that defines social status through elaborate personal adornment. It is one of a number of aristocratic portraits painted by Goya during the 1780s and 1790s that operates within these parameters.

Another such work, which offers an interesting comparison, is the portrait of the marchioness of Pontejos (Figure 12.2). It is generally agreed that Goya

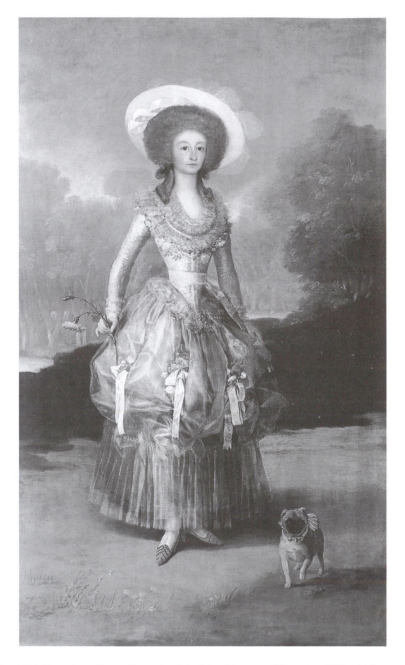

Fig. 12.2: Francisco Goya, *Portrait of the Marchioness of Pontejos*, 210 × 126 cm, oil on canvas, c. 1786, Washington DC, National Gallery of Art

painted this canvas in 1786, the year in which the sitter married Francisco Moñino y Redondo, who was the younger brother of the count of Floridablanca, first minister to Charles III and a patron whose favor Goya had sought to curry during the early 1780s.[22] The marchioness of Pontejos was of similar social standing to the duchess of Osuna, and in 1787 she was one of the fourteen women admitted into the Economic Society of Madrid. As in many of Goya's aristocratic portraits of the 1780s and 1790s, the elegantly dressed sitter is depicted full-length in a landscape setting.[23] In contrast to male portraits set out of doors, which usually contain hunting or military pretexts, such a *mise-en-scène* relies on the interplay between nature and artifice that occurs repeatedly in eighteenth-century female portraiture throughout Europe.

These two portraits exhibit important similarities in the style of both the personal adornment and the manner of painting, revealing the shared markers of aristocratic identity in Madrid during the 1780s. In each case the costume is French in design, although probably manufactured in Madrid.[24] The hairstyles also betray French influence, and that of the duchess of Osuna would have been the creation of her French *peluquero*, Monsieur Brayeu, who traveled with the family and imitated the latest creations favored by Marie-Antoinette.[25] In the journal of her travels in Spain, Lady Elizabeth Holland notes this Francophilia by stating: '[The duchess of Osuna] has acquired a relish for French luxuries, without diminishing her national magnificence and hospitality.'[26] In terms of the style of painting, the palette of pastels and the lightness of touch, particularly the virtuoso handling of the lace trim, would have reminded sophisticated viewers of French and British paintings of the same period. In particular, Gainsborough often is mentioned in relation to Goya's portraits of the 1780s, although it is difficult to pinpoint precise works (perhaps known through prints) that would have influenced Goya and his patrons.[27] Nonetheless, recognition of these stylistic allusions would have been read and enjoyed as ciphers of a shared cosmopolitan identity among members of the Spanish cultural élite.

In spite of the important similarities between these two portraits, there is a crucial difference: the duchess of Osuna does not seem overwhelmed by her costume. For example, her pose intimates a sense of self-assurance, with her arms falling gracefully toward the lower corners of the image. The dimpled chin; the long angular nose, which is accentuated by the fall of light; the self-possessed gaze; and the slightly parted lips, which seem to be curling toward a smile, combine to lend the painting a particularity of physiognomy that calls on the observer to engage with a compelling psychological presence. Contemporary appraisals describe the duchess as known not for stunning beauty, but rather for her intelligence, and these are precisely the qualities conveyed in Goya's portrait. To cite Lady Holland once again: 'She is very lively, and her natural wit covers her total want of refinement and acquire-

ment. Her figure is very light and airy.'[28] In contrast to the stiff, rather lifeless portraits that Goya had executed up until this time (and afterward, in some cases), this work merits the assessment of Valentín Carderera, who wrote in the 1830s that many of the artist's portraits 'still seem to breathe; their forms and color are so correct and true, their individual postures so natural that we can guess their disposition and character'.[29] By contrast, the facial features of Mariana de Pontejos have a generalized quality that places less emphasis on the personality of the sitter. Hers is more purely an image of fashion and status, a point that is emphasized by the pug dog, with its decorated collar that to modern eyes reads as an ironic echo of the lace and floral decorations on Mariana's dress.

The references to French culture in these portraits are present in other types of paintings by Goya, and they reflect the widespread Francophilia in Madrid during the 1770s and 1780s. A notable example is the tapestry cartoon known as *The Parasol* (Figure 12.3), which was designed as an overdoor for the dining room of the prince and princess of Asturias (the future Charles IV and María Luisa, heirs to the Spanish throne) in the Pardo Palace and delivered on 12 August 1777.[30] This canvas represents a fashionable couple whose dress and manners are inspired by French tastes. As in the 1785 portrait of the duchess of Osuna, the young woman holds a closed fan, while a flower rather than a ribbon keeps in place her rather chaste *décolletage*. The woman represented in this genre scene is not herself a member of the nobility, but rather the painted equivalent of the *petimetra*, a contemporary social type who appears as a stock character in popular literature and theater in Spain during the final decades of the eighteenth century. The *petimetra* is hopelessly under the spell of French taste and displays a superficial concern with fashion and appearance. She is absorbed with self-presentation and is flighty and fickle. A line from a popular verse written in 1787 epitomizes contemporary appraisals of the *petimetra*: 'She occupies all, but is herself occupied by nothing.'[31] The notion of occupying all alludes to the flirtatious character of the *petimetra* and hints at her sexual availability. In *The Parasol*, flirtation is suggested by the woman's coy expression and the man's attentive attitude toward her, but this work appears rather chaste beside images of young lovers by French artists such as François Boucher and Jean-Honoré Fragonard.[32]

Unlike the *petrimetras* of popular literature, or the members of the mercantile class upon whom they were modeled, the French tastes of the duchess of Osuna were not confined to personal adornment. She was not 'occupied by nothing'; rather, her orientation toward France also had a more serious dimension that linked her to leading Spanish intellectuals of the 1780s. Emulating aristocratic women in Paris, the duchess hosted a salon, or *tertulia*, that provided a site for famously extravagant musical and theatrical entertainment, as well as for the exchange of the most advanced cultural ideas among

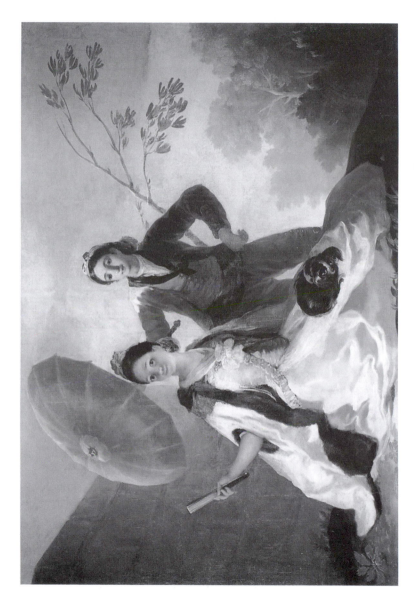

Fig. 12.3: Francisco Goya, *The Parasol*, 104 × 152 cm, oil on canvas, 1777, Madrid, Museo Nacional del Prado

the leading figures of the Spanish Enlightenment, including Tomás de Iriarte, Leandro Fernández de Moratín, Gaspar Melchor de Jovellanos, José Cadalso and Goya.[33] The chair in the lower-right corner of Goya's 1785 portrait of the duchess might be intended to allude to these gatherings. As the only spatial marker in the painting, it locates the sitter in an interior space, in contrast to Goya's frequent use of landscape backgrounds for elegantly dressed female sitters, such as the marchioness of Pontejos (Figure 12.2). Thus Goya's portrait firmly places the duchess in the realm of culture, rather than in that of nature.[34]

That said, we know that the duchess was, in fact, deeply interested in nature. At first, her *tertulia* was held in the Osuna palace in Madrid, but its location eventually shifted to her country house, known variously as *La Alameda* (Park with Poplars) and *El Capricho* (The Caprice).[35] The property, located eight kilometers east of the capital in the village of Canillejas (not far from the present-day Barajas airport), was purchased in October 1783 and renovated under the watchful eye of the duchess. She lavished most of her attention on the gardens, which have been altered by subsequent shifts in taste.[36] As with her style of personal adornment, French taste governed the construction of the landscape, or to be more precise, she favored French interpretations of English garden design. Pablo Boutelou, whose family had emigrated from France to work on the royal gardens at Aranjuez and *La Granja*, drew up plans for the gardens at *La Alameda* in 1784. Toward the end of the decade the duties of chief gardener fell to Jean Baptiste Mulot, who had been employed by Marie-Antoinette at Versailles. In the 1790s Angel Maria Tadey y Borghini and Mateo Medina constructed a stylistically diverse collection of garden structures, including an apiary, a temple to Venus, and a hermitage complete with resident monk. The juxtaposition of divergent styles of landscape architecture would have delighted and startled visitors, and it is this quality that may have caused the property to be known as *El Capricho*. Given the attachment that the Duchess of Osuna felt toward this site, it is surprising that Goya was not commissioned to depict her in its gardens, as he did in the 1799 portrait of Queen María Luisa before the gardens at *La Granja*.[37]

Like the gardens, the discussions that took place at *La Alameda* were dominated by recent intellectual developments imported from France and Britain.[38] The ability to read authors such as Rousseau and Diderot was itself a sign of privilege, as the texts of these and many other progressive writers had been banned in Spain by the Inquisition, and they would become particularly difficult to obtain in the wake of the French Revolution. But members of the nobility and the upper middle classes could gain access to them in a number of ways, including government-issued licenses to read them and clandestine import. The Osunas, who had a license to read banned books,

accumulated an impressive library that contained some 6,500 volumes on an amazing range of subjects, including agriculture, medicine, politics, philosophy, history, geography, religion, the classics, art and gardening.[39] They were advised in the selection of books by the playwright, Leandro Fernández de Moratín, and the French bookseller, Charles Pougens, whom the duchess met in Paris in 1799.[40] As Lady Holland notes in her journal, the Osunas hoped to open the library to the public, a plan rendered impossible by its contents but eventually carried out by their decedents.[41]

In addition to the fashionable and intellectual pursuits that have been outlined to this point, Enlightenment ideas infused another activity that occupied the duchess during the 1770s and 1780s: the rearing of children to carry on the family dynasty. The fragility of childhood in the eighteenth century – even among the most privileged members of society – made these efforts difficult. No heir to the Osuna title was born until 1775, by which time the couple had been married for four years. But the relief that they, and especially the duchess, must have felt at the birth of a son was short-lived, as this first child died the following year. A second son lived just a few months. The duchess then gave birth to a daughter, who died at the age of two, followed by a son, who was born in 1778 and managed to survive until the age of four.

These losses had a strong impact on the duchess and probably led to the personal attention that she paid to the education of her surviving children. Not surprisingly, her interest in their upbringing was deeply influenced by the Enlightenment ideas circulating in her *tertulia* and contained in her library. Records indicate that the Osuna library contained many volumes on education, among them important works on the subject by John Locke, the abbé de Condillac, Josefa Amar y Borbón, Lenglet du Fresnoy and others. But it was the writings of Jean-Jacques Rousseau that, above all, seem to have shaped the duchess's attitudes toward her children and convinced her of the crucial role played by environment and early educational experiences in a child's formation.[42] The keen interest that the duchess took in the education of her children is manifested in the response by Diego Clemencín to the letter appointing him their tutor: 'As a result, from this moment on I consider myself admitted into your household … convinced there could be nothing more advantageous to serving a Lady of such enlightenment, who has such a splendid way of thinking about the education of her children.'[43]

The affection that the duke and duchess felt toward their children is captured in Goya's group portrait of the family (Figure 12.4). Painted in the months following the death of the eighth duke of Osuna on 1 April 1787, this canvas commemorates the succession of the next generation to the Osuna title.[44] As in the three-quarter-length portrait of the duchess, there is little indication of the lavish surroundings in which the family lived. The absence of distracting detail invites the viewer to focus on the individual figures and

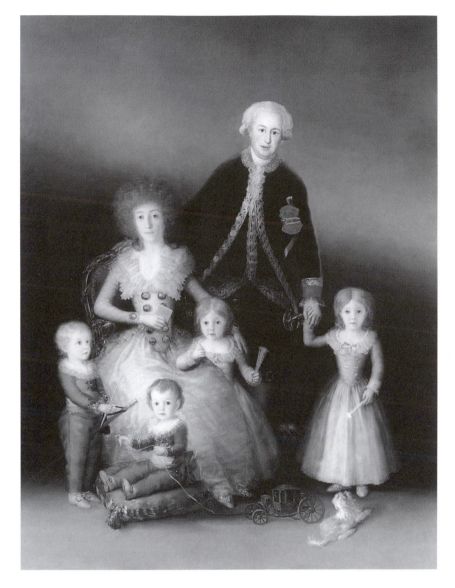

Fig. 12.4: Francisco Goya, *Portrait of the Family of the Duke and Duchess of Osuna*, 225 × 174 cm, oil on canvas, 1878–88, Madrid, Museo Nacional del Prado

the relations between them. For example, the spareness of the setting calls attention to the gendered character of the attributes held by the children. The boys, in emulation of their father, play at occupying public roles, one pretend-

ing to ride a horse, the other holding the string of a toy coach. The daughters, on the other hand, wear costumes that are miniature versions of their mother's and clutch little fans, children's versions of the one included in the 1785 portrait of the duchess. Thus the painting visualizes not only the active part played by the duchess in the upbringing of her children, but also the formation of their future social identities. One is reminded of a passage from Rousseau's *Émile* (which the Osunas owned) on the differences between the sexes – 'Boys seek movement and noise: drums, boots, little carriages. Girls prefer what presents itself to sight and is useful for ornamentation: mirrors, jewels, dresses, particularly dolls.'[45]

In comparison to other family portraits painted in Spain at this time, this canvas is notable for the informal posing of the figures, which emphasizes the affinity between the parents and their children. The unusual character of the Osuna family portrait becomes apparent in comparing it to Goya's contemporaneous portrait of the countess of Altamira and her daughter, María, painted in late 1787 or early 1788 (Figure 12.5).[46] The stiff formality of the poses in the latter work echoes representations of Virgin and Child, while the lack of personality in the face of the countess differs sharply from the psychological insight of the Osuna family portrait. Indeed, most of the painter's attention seems to have been paid to the stunning gown worn by the countess of Altamira. Moreover, this comparison indicates that the image of 'family' presented in the Osuna family portrait is not so much a lineage as it is a web of interconnections between the two generations, with the duchess at its center. This arrangement may reflect uncertainty as to which of the children would survive long enough to carry on the family line.

The relationship between the duke and duchess also merits consideration. One way to examine this aspect of the portrait is to return to *The Parasol* (Figure 12.3). As was the case with the woman in this tapestry cartoon, the man brings to mind a type who appeared at this time in both social practice and cultural representation: the figure of the *cortejo*.[47] Perhaps best translated as 'escort', the *cortejo* is a further example of foreign influence in eighteenth-century Spain, as similar types occur in French and Italian culture during this time. The unmarried *cortejo* attended to a married woman who chose him, visiting her at home and accompanying her in public. The relationship between a *cortejo* and his lady may have gone beyond friendship, although advocates of this highly ritualized social practice denied this was the case. In his book entitled *A Journey through Spain in the Years 1786 and 1787*, the English traveler Joseph Townsend recounts a story that suggests the adulterous nature of such arrangements:

> It was here [in Carthagena] that a gentleman one morning said gravely to his friends, 'Before I go to rest this night, the whole city will be thrown into confusion'. This he occasioned by going home an hour

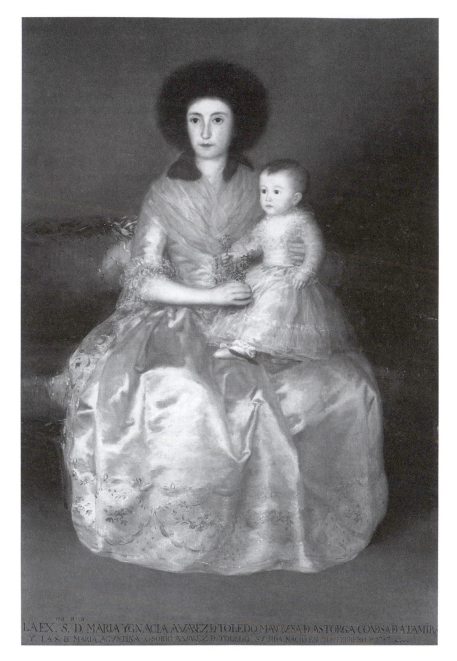

Fig. 12.5: Francisco Goya, *Portrait of the Countess of Altamira and her Daughter, María*, 195 × 115 cm, oil on canvas, ca 1787–1788, New York, Robert Lehman Collection, 1975, [1975.1.148] The Metropolitan Museum of Art

before his usual time, to the no small vexation of his wife and of her *cortejo*, whose precipitate retreat, and unexpected arrival in his own house, occasioned the like confusion there, and thus by successive and similar operation, was literally fulfilled the prediction of the morning.[48]

In the relationship between *cortejo* and *petimetra*, the woman was in a position of power, as was recognized by the English writer William Beckford during his Spanish travels in the late 1780s. In a memorable passage from his diary, Beckford describes the obligations of the *cortejo* in the following terms:

> I should not dislike being the *cortejo* of [the countess of Aranda], so full of candor and innocence, but in general the state of cortejoism is not very enviable. You are the sworn victim, as it were, of all the lady's caprices, must always be ready to attend her to whatever society, however stupid, to which she chooses to go, and can never move from her apron-string without her express permission.[49]

In Goya's painting, the woman's face is in shadow; nevertheless, it is clear that she is the dominant figure and that the man's task is to serve her.

What is significant in the present context is that the duchess of Osuna was known to have had as a *cortejo* Manuel de la Peña, the marquis of Bondad Real, whose likeness is recorded in a 1799 portrait by Goya.[50] For his part, the duke of Osuna had a reputation in courtly circles as a notorious *don Juan*.[51] None of this is particularly surprising, given the fact that their marriage had been arranged between two noble families as a means of cementing economic and political relationships. Thus, while the duke and duchess seem to have shared a deep affection for each other, sexuality (as distinct from procreation) may well have been expressed outside of the institution of marriage.

Returning to the family portrait, Goya presents the duchess as the central figure. Dressed in the latest British-inspired French fashion, she acts as the compositional anchor. Three children encircle her, their arrangement echoing the curving back of the chair in which she sits. The younger daughter, Joaquina, the future marchioness of Santa Cruz, leans against the duchess's skirts, while the two sons, Francisco de Borja, the future tenth duke of Osuna, and Pedro Alcántara, the future prince of Anglona, encircle their mother. The duke, by contrast, appears to be an intruder in this carefully constructed scene. His leaning pose, which allows him to hold the hand of the older daughter, Josefa Manuela, marchioness of Marguini, destabilizes his form, in contrast to the rigidly upright pose of his seated wife. In addition, it has been noted that the forms of the duke and duchess are differentiated stylistically, with the painterly treatment of her figure (similar to that in the 1785 portrait) opposed to the sharply modeled nature of his costume.[52] His status as outsider in this composition corresponds to the contemporary social mores just outlined, for while the *cortejo* was constantly visible in the house of his lady,

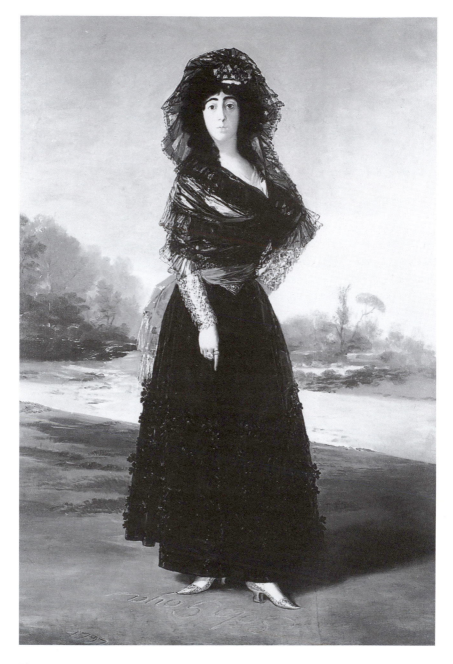

Fig. 12.6: Francisco Goya, *Duchess of Alba*, 210 × 149 cm, oil on canvas, 1797, New York, The Hispanic Society of America

the husband was noticeably invisible in his own house. Returning to Lady Holland's assessment, the canvas does suggest that, within this domestic space, 'The present Duchess of Osuna is a person of greater importance that the Duque.' In sum, this masterful work is not a mere reflection of its subjects, but rather a skillfully orchestrated representation that both reveals and conceals aspects of the sitters' identities and relationships.

The two portraits that have been the subject of this essay were executed during the second half of the 1780s. In the wake of the French events of 1789, the 1790s witnessed an important shift in aristocratic fashion, with members of the Spanish nobility adopting the dress and customs of the native urban types known as *majas* and *majos*. Within Goya's portrait practice, this shift in taste toward national costume is signaled most memorably in the 1797 portrait of the duchess of Osuna's great social rival, the duchess of Alba, adorned as a *maja* (Figure 12.6) and the 1799 portrait of Queen María Luisa wearing a mantilla.[53] For her part, the duchess of Osuna remained steadfast in her commitment to French fashion, as exemplified by a portrait drawn by Goya and engraved by Fernando Selma. In a fascinating combination of the national and the foreign, the duchess is represented wearing the Order of María Luisa, which she was awarded on 17 December 1792, but dressed in the simple manner favored in Paris during the Terror. This print served as the frontispiece for the Spanish translation of Pierre le Moyne's *Galerie des femmes fortes* (*Galería de mujeres fuertes*, Madrid, 1794), which was dedicated to the duchess of Osuna. As I have sought to indicate, the title of this book – *Gallery of Strong Women* – aptly captures the tenor of Goya's representations of this singular figure.

Notes

1. I have presented versions of this project at the Seattle University Core conference on 'Feminist Reflections: Public and Private in Feminist Studies' (2000), the Annual Meeting of the Canadian Society for Eighteenth-Century Studies (2000), the Annual Meeting of the American Society for Eighteenth-Century Studies (2001), the symposium held in conjunction with 'Goya: Images of Women' (National Gallery of Art, Washington, DC, 2002), and the Seattle University Women's Studies 'Work-in-Progress' series (2002). In all cases, I wish to thank the organizers, participants and audience members for offering valuable suggestions, many of which I have incorporated into this essay.
2. For a brief, but useful and informative overview of Goya's patrons, see Nigel Glendinning, 'Goya's Patrons,' *Apollo* CXIV (October 1981), 236–47; on the Osunas, see 239–40. The portrait of the duke is no. 219 in Pierre Gassier and Juliet Wilson, *The Life and Complete Work of Goya* (New York: Morrow, 1971) (hereafter abbreviated as *Goya*; *Goya* followed by 'no.'" indicates a work of art catalogued in this text).

3. Gassier and Wilson, *Goya*, nos 248–54, 256–61, 272–5 and 659–64; 240 and 243; 278, 679 and, possibly, 671 and 683. A documented portrait of three of the Osuna children is now lost.

4. For the relevant documents, see Gassier and Wilson, *Goya*, 383–4.

5. Gassier and Wilson, *Goya*, nos 828, 1557 and 1560.

6. On the concept of the 'exceptional woman', see Mary D. Sheriff, *The Exceptional Woman: Elisabeth Vigée-Lebrun and the Cultural Politics of Art* (Chicago: University of Chicago Press, 1996), 1–7.

7. I shall refer to the subject of this essay as the duchess of Osuna, since that has been customary in scholarship written in English. An invaluable source on her life and activities is: Condesa de Yebes, *La Condesa-Duqesa de Benavente. Una vida en unas cartas* (Madrid: Espasa-Calpe, 1955).

8. Ignacio Hernández Atieza, *Aristocracia, poder y riqueza en la España moderna: la Casa de Osuna, siglos XV–XIX* (Madrid: Siglo Veintiuno de España Editores, 1987).

9. Narisco Sentenach y Cabañas, *Catálogo de los cuadros, esculturas, grabados y otros objetos artísticos de la antigua casa ducal de Osuna* (Madrid: Viuda e hijos de M. Tello, 1896).

10. The classic narratives of the Spanish Enlightenment remain: Richard Herr, *The Eighteenth Century Revolution in Spain* (Princeton: Princeton University Press, 1958); and Jean Sarrailh, *L'Espagne eclairée de la seconde moitié du XVIIIe siècle* (Paris: Librairie C. Klincksieck, 1964).

11. On the Economic Societies that were established in various Spanish cities, see Herr, *The Eighteenth Century Revolution in Spain*, 154–63 and *passim*; and Sarrailh, *L'Espagne eclairée, passim*. The debate regarding women members in the Economic Society of Madrid has been examined in Sally-Ann Kitts, *The Debate on the Nature, Role and Influence of Women in Eighteenth-Century Spain* (Lewiston, NY: E. Mellen Press, 1995), 139–72; and Paloma Fernández-Quintanilla, *La mujer ilustrada en la España del siglo XVIII* (Madrid: Ministerio de la Cultura, 1981, 55–63).

12. Gaspar Melchor de Jovellanos, 'Memoria leida en la Sociedad Económica de Madrid, sobre si se debian ó no admitir en ella las señoras,' in *Obras publicadas é inéditas de Don Gaspar Melchor de Jovellanos*, ed. Candido Nocedal, *Biblioteca de Autores Españoles* (Madrid: M. Rivadeneyra, 1859), 56.

13. The condesa of Yebes suggests that the creation of a *Junta de Damas* was the idea of the duchess of Osuna (Yebes, 1955, 59).

14. On the cultural activities of the duchess, see Yebes (1955), *passim*.

15. *The Spanish Journal of Lady Elizabeth Holland*, ed. The Earl of Ilchester, (London: Longmans, Green and Co., 1910), 49.

16. Ibid., 195.

17. Her leading role is made clear in two invoices from Goya (Gassier and Wilson, *Goya*, 383). The first, dated 12 May 1787, begins: 'Account of the pictures that I have painted by order of her Excellency, the Marchioness of Peñafiel [one of the duchess of Osuna's many titles].' The second, dated 6 May 1798, alludes to 'various paintings that I have made for the study [*gabinete*] of Your Exellency, my lady'. Moreover, it was the duchess who commissioned the portraits of three of her children as adults (Gassier and Wilson, *Goya*, nos 828, 1557 and 1560).

18. The duchess may have commissioned Goya's portrait of Pedro Romero, the greatest bullfighter of the age (Gassier and Wilson, *Goya*, no. 671). On this possibility, see Ronda Kasl and Suzanne L. Stratton, *Painting in Spain in the*

Age of Enlightenment: Goya and His Contemporaries, exh. cat. (Indianapolis Museum of Art and Spanish Institute, New York, 1997), 253.

19. Yebes (1955), 14–16.

20. Two examples of Esteve's work for the Osunas are the portrait of three of the Osuna children, executed in the late 1780s, and the 1798 portrait of *Joaquina* (*Museo del Prado*, no. 2581). On Esteve, see Martín S. Soria, *Agustín Esteve y Goya* (Valencia: Institución Alfonso el Magnanimo, 1957); and Kasl and Stratton (1997), 279–80. On the relation between Esteve and Goya, see José Rogelio Buendía, 'En torno al atribución goyesco. La colaboración de Esteva,' in *Goya 250 año después. 1746–1996* (Marbella: Museo del Grabado Español Contemporáneo, 1996), 121–9.

21. An order for payment indicates that this canvas and its pendant, which shows the duke in military costume, were completed by 16 July 1785 (Gassier and Wilson, *Goya*, no. 383). The portrait of the duke is in a British private collection. An undated invoice states that these works, as well as Goya's lost portrait of three of the children, hung in the family's Puerta de la Vega palace (ibid.).

22. In 1783 Goya had executed a portrait of count of Floridablanca (Gassier and Wilson, *Goya*, no. 203), which may have led to the commission to paint the marchioness of Pontejos.

23. Works similar in format include the portraits of María Teresa de Borbón (Gassier and Wilson, *Goya*, no. 210; 1783), the Duchess of Alba (Gassier and Wilson, *Goya*, no. 351; 1795; and 355; 1797), Queen María Luisa (Gassier and Wilson, *Goya*, no. 775; 1799), and the marchioness of Santiago (Gassier and Wilson, *Goya*, no. 879; 1804).

24. On styles of fashion in Goya's female portraits, see Aileen Ribiero, 'Fashioning the Feminine: Dress in Goya's Portraits of Women,' in *Goya: Images of Women*, ed. Janis A. Tomlinson, exh. cat. (National Gallery of Art, Washington, DC, 2002), 71–87.

25. Yebes (1955), 18.

26. Holland (1910), 195.

27. A half-length portrait by Gainsborough, known as *Portrait of a Lady in a Blue Dress* (*c.* 1783–85, Philadelphia Museum of Art), is similar in format and dress to Goya's portrait of the duchess of Osuna. However, the easy elegance of Gainsborough's sitter contrasts with the earnestness of the duchess of Osuna. On this work, see Richard Dorment, *British Painting in the Philadelphia Museum of Art. From the Seventeenth through the Nineteenth Century* (Philadelphia: Philadelphia Museum of Art, 1986), 134–5.

28. Holland (1910), 195.

29. Trans. in Enriqueta Harris, *Goya* (London: Phaidon, 1969), 27.

30. On this cartoon, see Janis A. Tomlinson, *Francisco Goya. The Tapestry Cartoons and the Early Career at the Court of Madrid* (Cambridge: Cambridge University Press, 1989), 50–53.

31. Cited in ibid., 82.

32. Examples include Boucher's *Shepherd and Shepherdess*, Wallace Collection, London, 1761; and Fragonard's *The Happy Lovers*, Norton Simon Collection, Pasadena, *c.* 1760–65.

33. Records indicate that one dance given by the Osunas in 1794 cost 22,857 *reales* (Yebes, 1955, 68). This sum is one and a half times the annual salary granted to Goya as a painter to the king in 1786.

34. The association of women with nature is explored in the classic essay by Sherry

Ortner, 'Is Female to Male as Nature is to Culture?' in *Women, Culture and Society*, eds Michelle Zimbalist Rosaldo and Louise Lamphere (Stanford: Stanford University Press, 1974), 67–87.

35. On this property, see Carmen Añón Feliú, *'El Capricho' de la Alameda de Osuna* (Madrid: Fundación Caja de Madrid, 1994).

36. For an analysis of the garden as an expression of the duchess's cultural interests, see Juan F. Remón Menéndez, 'The Alameda of the Duchess of Osuna: a garden of ideas', *Journal of Garden History* 13 (Winter 1993), 224–40.

37. Gassier and Wilson, *Goya*, no. 775.

38. For a brief discussion of her *tertulia*, see Fernández-Quintanilla, *La mujer ilustrada*, 36–9.

39. The Biblioteca Nacional, Madrid, contains a late eighteenth-century inventory of the Osuna library.

40. The Biblioteca Nacional, Madrid, possesses an undated manuscript volume entitled 'Projet de bibliothèque dressé d'après les notes remiser par S.E. Madame Le duchesse d'Ossuna', prepared by Pougens. It lists 6,423 volumes divided into 15 subject headings. 'X's next to some of the entries would seem to indicate those volumes that the duchess wished to purchase.

41. Holland (1910), 195.

42. For a general treatment of the impact of Rousseau on Spanish ideas regarding education, see Jefferson Rea Spell, *Rousseau in the Spanish World Before 1833: A Study in Franco-Spanish Literary Relations* (New York: Gordian Press, 1969 [1st edn 1938]).

43. The letter is given in full in Jean Sarrailh, 'Diego Clemencin,' *Bulletin Hispanique* 24 (April–June 1922), 9.

44. It has recently been suggested that the duke is dressed in half-mourning, indicating that the work would have been painted between 1 July 1787 and 1 April 1788. Manuela B. Mena Marqués et al., *Goya and 18th-Century Spanish Painting* (Madrid: Museo del Prado, 2000), 208.

45. Jean-Jacques Rousseau, *Émile, or On Education*, trans. Allan Bloom (New York: Basic Books, 1979), 367.

46. On this work, see Jonathan Brown in Charles Sterling et al., *The Robert Lehman Collection*, II, *Fifteenth- to Eighteenth-Century European Paintings* (Princeton: Princeton University Press, 1998), 183. Brown points to the influence of first court painter, Anton Rafael Mengs, particularly in the treatment of the costume. On the Altamira patronage of Goya during the 1780s and early 1790s, see Glendinning, 'Goya's Patrons', 239.

47. On the figure of the *cortejo*, see Carmen Martín Gaite, *Love Customs in Eighteenth-Century Spain* (Berkeley: University of California Press, 1991).

48. Joseph Townsend, *A Journey through Spain in the Years 1786 and 1787* (London: printed for C. Dully, 1792), 145.

49. *The Journal of William Beckford in Portugal and Spain 1787–88*, ed. Boyd Alexander (London: Rupert Hart-Davis, 1954), 301; cited in part from another edn in Tomlinson, (1989), 83.

50. Gassier and Wilson, *Goya*, no. 683. This portrait, which may have been commissioned by the duchess of Osuna, shows the sitter in the uniform of the Royal Spanish Guards, standing jauntily before a background that depicts soldiers drilling in front of barracks. See Elizabeth du Gué Trapier, *Goya and His Sitters: A Study of his Style as a Portraitist* (New York: Hispanic Society of America, 1964), 18–19.

51. José Luis Morales y Marín, *Pintura en España, 1750–1808* (Madrid: Cátedra, 1994), 238.
52. The disparity in the treatment of the two figures is noted in Janis Tomlinson, *Francisco Goya y Lucientes 1746–1828* (New York: Phaidon, 1994), 74.
53. Gassier and Wilson, *Goya*, no. 775.

Bibliography

Aaron, Didier. *Galerie de portraits*. Paris: Didier Aaron & Cie, 1999.

Akerman, Susanna. *Queen Christina of Sweden And Her Circle, The Transformation of a Seventeenth-Century Philosophical Libertine*. Leiden, New York, Kobenhavn, Köln: E. J. Brill, 1991.

Amusements des Eaux d'Aix-la-Chapelle. 2 vols. Amsterdam: Pierre Morier, 1736.

Angelika Kauffmann und ihre Zeit, Graphik und Zeichnungen von 1760–1810, exh. cat., Düsseldorf: C. G. Boerner, 1979.

Arnason, H. H. *The Sculptures of Houdon*. London: Phaidon Press, 1975.

Atieza, Ignacio Hernández. *Aristocracia, poder y riqueza en la España moderna: la Casa de Osuna, siglos XV–XIX*. Madrid: Siglo Veintiuno de España Editores, 1987.

Aurelius, Eva Haettner. 'The Great Performance: Roles in Queen Christina's Autobiography.' In *Politics and Culture in the Age of Christina*, ed. Marie-Louise Rodén. Stockholm: Suecoromana IV, 1997.

Auricchio, Laura. 'Portraits of Impropriety: Adélaïde Labille-Guiard and the Careers of Professional Women Artists in Late Eighteenth-Century Paris.' Ph.D. dissertation. Columbia University, 2000.

Badinter, Elisabeth. *Émilie, Émilie ou l'ambition féminine au XVIIIe siècle*. Paris, 1983.

Baetjer, Katharine. *European Paintings in the Metropolitan Museum of Art by Artists Born Before 1865*. 2 vols. New York: The Metropolitan Museum of Art, 1980.

Bailey, Colin B. 'Conventions of the Eighteenth-Century Cabinet de tableaux: Blondel d'Azincourt's La première idée de la curiosité.' *Art Bulletin* 69 (1987), 433–4.

Baillio, Joseph. 'Le dossier d'une oeuvre d'actualité politique: Marie-Antoinette et ses enfants par Mme Vigée Lebrun.' *L'Oeil* 308 (March 1981), 34–41 and 74–5 and *L'Oeil* 310 (May 1981), 53–60 and 90–91.

Ballot, Marie-Juliette. *Une Élève de David: La Comtesse Benoist, l'Émilie de Desmoustier*. Paris: Plon-Nourrit, 1914.

Bapst, Germain. 'Notes et souvenirs artistiques sur Marie-Antoinette.' *Gazette des Beaux-Arts* 10 (1893), 381–91.

Barthélémy, Edouard de. *Mesdames de France, filles de Louis XV*. Paris: Didier, 1870.

Barthes, Roland. *A Lover's Discourse: Fragments*. Translated by Richard Howard. New York: Hill and Wang, 1978.

Baumgärtel, Bettina, ed. *Angelika Kauffmann. Retrospektive*, exh. cat., Kunstmuseum Düsseldorf, Ostfildern-Ruit: Verlag Gerd Hatje, 1998.

⸻. 'Die Ohnmacht der Frauen. Sublimer Affekt in der Historienmalerei des 18. Jahrhunderts.' *Kritische Berichte* 18:1 (1990), 10–12.

Baxandall, Michael. *Patterns of Intention: On the Historical Explanation of Pictures*. New Haven and London: Yale University Press, 1986.

Beaucousin, Christopher Jean François. *Lettre sur le Salon de Peinture de 1769 par M. B****. Paris: Chez Humaire, 1769. Collection Deloynes, vol. 9, no. 119, 54.

Beckford, William. *The Journal of William Beckford in Portugal and Spain 1787–88*, ed. Boyd Alexander. London: Rupert Hart-Davis, 1954.

Bellori, Giovan Pietro. *Le Vite de' pittori, scultori ed architetti moderni*. Rome, 1732, ed. Evalina Borea. Turin: Giulio Einaudi, 1976.

Benati, Daniele. *Amor è vivo, due dipinti erotici di Lavinia Fontana*. Milan: Marco Riccomini, 2002.

Bermingham, Ann. 'The Aesthetics of Ignorance: The Accomplished Woman in the Culture of Connoiseurship.' *Oxford Art Journal* 16:2 (1993), 3–20.

⸻. 'The Origin of Painting and the Ends of Art: Wright of Derby's *Corinthian Maid*.' In *Painting and the Politics of Culture: New Essays on British Art, 1700–1850*, ed. John Barrell. Oxford and New York: Oxford University Press, 1992.

⸻. *Learning to Draw: Studies in the Cultural History of a Polite and Useful Art*. New Haven: Yale University Press, 2000.

Bertin, Georges. *Joseph Bonaparte en Amérique: 1815–1832*. Paris: La Nouvelle revue, 1893.

Bettagno, Alessandro. 'Rococo Artists.' In *The Glory of Venice: Art in the Eighteenth Century*, exh. cat., ed. Jane Martineau and Andrew Robison. New Haven and London: Yale University Press, 1995.

Betterton, Rosemary. *An Intimate Distance: Women, Artists and the Body*. New York: Routledge, 1996.

Bjurström, Per and Görel Cavalli-Björkman. 'A Newly Acquired Portrait of Anton Maria Zanetti by Rosalba Carriera.' *Nationalmuseum Bulletin* 1 (1977), 45–7.

Bloch, Oscar and W. von Wartburg, *Dictionnaire étymologique de la langue française*. Paris: 1964.

Bober, Phyllis Pray and Ruth Rubenstein. *Renaissance Artists and Antique Sculpture*. London: Harvey Miller, New York: Oxford University Press, 1987.

Bohn, Babette, 'The antique heroines of Elisabetta Sirani,' *Renaissance Studies*, 16:1 (2002), 52–79.

Boigne, Comtesse de. *Memoirs of the Comtesse de Boigne 1781–1814*, ed. Charles Nicoulaud. 2 vols. New York: Scribner's Sons, 1907.

Boime, Albert. *Art in an Age of Revolution: 1750–1800*. Chicago: University of Chicago Press, 1987.

Bordes, Philippe. *Musée de la Revolution Française*. Vizille: Le Musée, 1996.

──────. 'Antoine-Jean Gros en Italie (1793–1800): lettres, une allégorie révolutionnaire et un portrait.' *Bulletin de la Société de l'Histoire de l'Art Français* (1978), 221–44.

──────. 'François-Xavier Fabre, "peintre d'histoire".' *Burlington Magazine* 117 (Feb. 1975), 91–8.

──────. 'Les Arts après la Terreur: Topino-Lebrun, Hennequin et la peinture politique sous le Directoire.' *La Revue du Louvre* 29:3 (1979), 199–212.

Bowron, Edgar Peters. 'The Paintings of Benedetto Luti (1666–1724).' Ph.D. dissertation. New York University, 1979.

──────. 'Benedetto Luti's Pastels and Coloured Chalk Drawings.' *Apollo* 111 (1980), 440–47.

Bridenthal, Renate, S. Mosher Stuard and M. Wiesner, eds, *Becoming Visible: Women in European History*. Boston: Houghton Mifflin Company, 1998.

Broeder, Frederick den. 'A Weeping Heroine and a Mourning Enchantress by Angelika Kauffmann', *Bulletin of The William Benton Museum of Art, The University of Connecticut Storrs* 1:3 (1974), 19–28.

Buendía, José Rogelio. 'En torno al atribución goyesco. La colaboración de Esteva.' In *Goya 250 año después. 1746–1996*. Marbella: Museo del Grabado Español Contemporáneo, 1996.

Butler, Judith. *Bodies that Matter: On the Discursive Limits of 'Sex.'* New York: Routledge, 1993.

Butler, Samuel. *The Authoress of the Odyssey*. Chicago: University of Chicago Press, 1967.

Cabañas, Narisco Sentenach y. *Catálogo de los cuadros, esculturas, grabados y otros objetos artísticos de la antigua casa ducal de Osuna*. Madrid: Viuda e hijos de M. Tello, 1896.

Cailleux, Jean, 'Portrait of Madame Adélaïde of France, Daughter of Louis XV.' *The Burlington Magazine* 22 (March 1969), i–vi.

Cameron, Vivian. 'Adelaïde Labille-Guiard', in *Dictionary of Women Artists*, ed. Delia Gaze. 2 vols. London and Chicago: Dearborn Publishers, 1997.

──────. 'Woman as Image and Image-Maker in Paris during the French Revolution'. Ph.D. Dissertation, Yale University, 1984.

Campbell, Peter R. *Power and Politics in Old Regime France 1720–1745*. London: Routledge, 1996.

Camus, Fabienne. 'Alexis-Simon Belle portraitiste de cour (1674–1734).' *Bulletin de la Société de l'Histoire de l'Art Français Année 1990* (Paris 1991), 38–9.

Cantaro, Maria Teresa, *Lavinia Fontana bolognese 'pittura singolare' 1552–1614.* Milan: Jandi Sapi, 1989.

Cessi, Francesco. 'Il ritratto di Rosalba Carriera dipinto da Sebastiano Bombelli per l'Accademia di San Luca.' *Arte Veneta* 19 (1965), 174.

Chadwick, Whitney. *Women, Art and Society.* London: Thames & Hudson, 1996.

Chantrans, Justin Girod de. *Voyage d'un Suisse dans les colonies d'Amérique,* ed. Pierre Pluchon. Originally published 1785. Paris: Librairie Jules Tallandier, 1980.

Cherry, Deborah. *Painting Women. Victorian Women Artists.* London: Routledge, 1993.

Cochin, Charles-Nicolas. 'Lettre à M. l'Abbé R*** sur une très mauvaise plaisanterie qu'il a laissé imprimer dans le Mercure de Décembre 1754, par une société d'Architectes, qui pourroient bien prétendre être du premier mérite & de la première réputation, quoiqu'ils ne soient pas de l'Académie.' In *Receuil de quelques pièces concernant les arts extraites de plusieurs Mercures de France.* Paris, 1757.

Coekelberghs, Denis and Pierre Loze, eds. *Autour du neo-classicisme en Belgique.* Brussels: Crédit communal, 1986.

Colding, Torben Holck. *Aspects of Miniature Painting: Its Origins and Development.* Copenhagen, E. Munksgaard: 1953.

Cole, Christian. *Memoirs of Affairs of State.* London: H. Woodfall Publishers, 1733.

Cole, Susan, Guettel. 'The Uses of Water in Greek Sanctuaries,' *Early Greek Cult Practice,* ed. R. Hagg, *Acta Instituti Atheniensis Regni,* Ser. 4, 38 (1988), 161–5.

Collection Deloynes, 'Collections des pieces sur les beaux-arts imprimées et manuscrites recueillies par P.-J. Mariette, C.-N. Cochin et M. Deloynes,' Paris, Bibliothèque Nationale, Cabinet des Estampes, 1745–1881.

Conisbee, Philip. *Painting in Eighteenth-Century France.* Oxford: Phaidon Press, 1981.

Coquery, Emmanuel. *Visages du Grand Siècle. Le portrait français sous le règne de Louis XIV 1660–1715.* Paris, Somogy, Nantes: Musée des beaux-arts, 1997.

Correspondence complète de Mme duchesse d'Orléans, ed. M. G. Brunet. 2 vols. Paris, 1904.

Correspondance littéraire, philosophique et critique par Grimm, Diderot, Raynal, Meister, etc, ed. Maurice Tourneux. 16 vols. Paris: Garnier Frères, 1877–82.

Crow, Thomas. *Emulation: Making Artists for Revolutionary France*. New Haven and London: Yale University Press, 1995.

————. *Painters and Public Life in Eighteenth-Century Paris*. New Haven: Yale University Press, 1985.

Darrow, Margaret. 'French Noblewomen and the New Domesticity 1750–1850.' *Feminist Studies* 5 (Spring 1979), 41–65.

David, J. L. Jules. *Le Peintre Louis David, 1748–1825: Souvenirs et documents inédits*. Paris: V. Harvard, 1880.

Davis, Whitney. 'Winckelmann Divided: Mourning the Death of Art History.' In *The Art of Art History: A Critical Anthology*, ed. Donald Preziosi. Oxford and New York: Oxford University Press, 1998.

Dayan, Joan. *Haiti, History and the Gods*. Berkeley: University of California Press, 1995.

DeJean, Joan. *Ancients Against Moderns: Culture Wars and the Making of a Fin de Siècle*. Chicago and London: University of Chicago Press, 1997.

Delécluze, Etienne-Jean. *Louis David, son école et son temps, souvenirs*. Paris, 1855; reprinted Paris: Didier, 1983.

Deleuze, Gilles. *Difference and Repetition*. London: The Athlone Press, 1994.

Delon, Michel. *L'Invention du boudoir*. Cadeilhan: Zulma, 1999.

Demoustier, M. *Le Bouquet du Sallon*. Paris: 1787 Collection Delaynes, vol. 15, no. 388.

Denton, Margaret Fields. 'A Woman's Place: The Gendering of Genres in Post-Revolutionary French Painting.' *Art History* 21 (June 1998), 219–46.

Diderot, Denis. 'L'influence du luxe sur les beaux-arts (Salon de 1767).' In *Diderot: Salons*, eds Jean Seznec and Jean Adhemar. Oxford: Clarendon Press, 1957–67.

———— and D'Alembert, eds. *Encyclopédie, ou Dictionnaire raisonné des sciences, des arts et des métiers, par une société de gens de lettres. Mis en ordre & publié par M. Diderot ... & quant à la partie mathématique, par M. d'Alembert*, 17 vols. Paris, 1751–65.

Dorment, Richard. *British Painting in the Philadelphia Museum of Art. From the Seventeenth through the Nineteenth Century*. Philadelphia: Philadelphia Museum of Art, 1986.

Doy, Gen. 'Hidden from Histories: Women History Painters in Early Nineteenth Century France.' In *Art and the Academy in the Nineteenth Century*, New Brunswick, NJ, 2000, 71–5.

Duchemin, Marcel. *Chateaubriand: Essais de critique et d'histoire littéraire*. Paris: J. Vrin, 1938.

Duncan, Carol. 'Happy Mothers and Other New Ideas.' In *Feminism and Art History: Questioning the Litany*, eds Norma Broude and Mary Garrard. New York: Harper & Row, 1982.

Engerand, Fernand. *Inventaire des tableaux commandé et achétee par la Direction Générale des Bâtiments des Roi (1709–92)*. Paris, 1900.

Explications des Peintures, Sculptures, & d'autres Ouvrages de Messieurs de l'Académie Royale. Paris, 1737.

Faldi, Italo. 'Dipinti di figura dal Rinasciamento al neoclassicismo,' in *L'Accademia Nazionale di San Luca*. Rome, 1974.

Feliú, Carmen Añón. *'El Capricho' de la Alameda de Osuna*. Madrid: Fundación Caja de Madrid, 1994.

Felson-Rubin, Nancy. *Regarding Penelope: From Character to Poetics*. Princeton, NJ: Princeton University Press, 1994.

Fernández-Quintanilla, Paloma. *La mujer ilustrada en la España del siglo XVIII*. Madrid: Ministerio de la Cultura, 1981.

Foley, Helene P. 'Penelope as Moral Agent.' In *The Distaff Side: Representing the Female in Homer's* Odyssey, ed. Beth Cohen. New York: Oxford University Press, 1995.

Fortunati, Vera, ed. *Lavinia Fontana of Bologna, 1552–1614*, exh. cat. Washington, DC, National Museum of Women in the Arts. Milan: Electa, 1998.

Fourcaud, Louis de. *François Rude, sculpteur, ses oeuvres et son temps*. Paris: Libraire de l'art ancien and moderne, 1904.

Frederick of Prussia, *The Refutation of Machiavelli's Prince or Anti-Machiavel*. trans. Paul Sonnino. Athens: Ohio University Press, 1981.

Fréron, Elie Catherine. *L'Année littéraire*. 16 vols. Paris: Chez Mérigot, 1751–89.

Friedman, Susan. *Penelope's Web: Gender, Modernity, H.D.'s Fiction*. Cambridge: Cambridge University Press, 1990.

Gaehtgens, Thomas W. and Jacques Lugand. *Joseph-Marie Vien, Peintre du Roi (1716–1809)*. Paris: Arthena, 1988.

Gaite, Carmen Martín. *Love Customs in Eighteenth-Century Spain*. Berkeley: University of California Press, 1991.

Garnier-Pelle, Nicole. *Chantilly, Musée Condé, Peintures du XVIIIe siècle*. Paris: Editions de la Réunion des musées nationaux, 1995.

Gassier, Pierre and Juliet Wilson. *The Life and Complete Work of Goya*. New York: Morrow, 1971.

Gatto, Gabriella. 'Carriera, Rosalba.' In *Dizionario biografico degli Italiani*. Rome, 1977.

Gillespie, Charles. *Science and Polity in France at the End of the Old Regime*. Princeton: Princeton University Press, 1980.

Girod de L'Ain, Gabriel. *Joseph Bonaparte; le roi malgré lui*. Paris: Perrin, 1970.

Glendinning, Nigel. 'Goya's Patrons.' *Apollo* CXIV (October 1981), 236–47.

Godeau, Abigail Solomon. *Male Trouble: A Crisis in Representation*. London: Thames & Hudson, 1997.

Goncourt, Edmond and Jules de. *La Femme au XVIIIe siècle*. Paris: Firmin Didot, 1862.

————. *La Revolution dans les moeurs: La Famille, la monde, la vielle femme, les jeunes gens, le mariage, les demoiselles à marier, les gens riches, les lettres et les arts, la pudeur sociale, le catholicisme*. Paris, 1854.

Goodman, Dena. *The Republic of Letters: A Cultural History of the French Enlightenment*. Ithaca: Cornell University Press, 1994.

————. 'Women and the Enlightenment.' In *Becoming Visible: Women in European History*, eds R. Bridenthal, S. Mosher Stuard and M. Wiesner. Boston: Houghton Mifflin Company, 1998/3rd edn, 233–62.

Goodman, Elise. *The Portraits of Madame de Pompadour. Celebrating the Femme Savant*. Berkeley, Los Angeles and London: University of California Press, 2000.

Gordon, Alden Rand and Teri Hensick. 'The Picture within the picture: Boucher's 1750 Portrait of Pompadour identified.' *Apollo* CLV:2 (February 2002), 21–31.

Gordon, Katherine K. 'Madame de Pomadour, Pigalle, and the Iconography of Friendship.' *Art Bulletin* 50 (1968), 249–62.

Goulemot, Jean Marie. *Ces Livres qu'on ne lit que d'une main: lecture et lecteurs de livres pornographiques au XVIIIe siècle*. Aix-en-Provence: Alinéa, 1991.

Gouma-Peterson, Thalia and Patricia Mathews. 'The Feminist Critique of Art History.' *Art Bulletin* 69:3 (September 1987), 326–57.

Grandière, Marcel. *L'Idéal pédagogique en France au dix-huitième siècle*. Oxford: Voltaire Foundation, 1998.

Greer, Germaine. *The Obstacle Race: The Fortunes of Women Painters and their Work*. New York: Farrar, Strauss, Giroux, 1979.

Grosz, Elizabeth. 'Bodies–Cities.' In *Space, Time, and Perversion*. New York: Routledge, 1995.

Guiffrey, J. J. 'Ecoles de Demoiselles dans les ateliers de David et de Suvée au Louvre.' *Nouvelles Archives de l'art française*. Paris, 1874–75. Reprinted Paris: Société de l'histoire de l'art français, 1973.

Guigard, Joannis. *Nouvel Armorial du Bibliophile*. 2 vols. Paris: Emile Rondeau, 1890.

Gutwirth, Madelyn. *The Twilight of the Goddesses: Women and Representation in the French Revolutionary Era*. New Brunswick, NJ: Rutgers University Press, 1992.

Habermas, Jürgen. *The Structural Transformation of the Public Sphere: An Inquiry into a Category of Bourgeois Society*. Cambridge, MA: Cambridge University Press, 1989.

Harris, Enriqueta. *Goya*. London: Phaidon, 1969.

Haskell, Francis. *Patrons and Painters: A Study in the Relations between*

Italian Art and Society in the Age of the Baroque. New York: Harper & Row, 1971.

———— and Nicholas Penny. *Taste and the Antique*. New Haven and London: Yale University Press, 1981.

Hatzfield, Adolphe and Arsène Darmsteter, *Dictionnaire général de la langue française*. Paris: 1924.

Heidenstam, Oscar Gustaf von. *Une Soeur du Grand Frédéric, Louise-Ulrique, Reine de Suède*. Paris: Plon, 1897.

Herr, Richard. *The Eighteenth Century Revolution in Spain*. Princeton: Princeton University Press, 1958.

Hesse, Carla. *The* Other *Enlightenment. How French Women Became Modern*. Princeton: Princeton University Press, 2001.

Hoerschelmann, Emilie von. *Rosalba Carriera: Die Meisterin der Pastellmalerei*. Leipzig: Klinkhardt and Biermann, 1908.

Holland, Lady Elizabeth. *The Spanish Journal of Lady Elizabeth Holland*, ed. The Earl of Ilchester. London: Longmans, Green and Co., 1910.

Homer, *Odyssey*, trans. Robert Fagles. New York: Viking, 1996,

————. *Odyssey*, trans. Alexander Pope. 2 vols. Georgetown: Richards and Mallory; Philadelphia: P. H. Nicklin, 1814.

Hull, Isabel V. *Sexuality, State, and Civil Society in Germany, 1700–1815*. Ithaca and London: Cornell University Press, 1996.

Hunt, Lynn, ed. *Eroticism and the Body Politic*. Baltimore: Johns Hopkins University Press, 1991.

————. *The Family Romance of the French Revolution*. Berkeley: University of California Press, 1992.

Hutchison, Sydney. *The History of the Royal Academy, 1768–1986*. London: Robery Royce Ltd, 1986.

Hyde, Melissa. 'The 'Makeup' of the Marquise: Boucher's Portrait of Pompadour at Her Toilette,' *The Art Bulletin* 82:3 (Sept. 2000), 453–75.

————. 'Women and the Visual Arts in the Age of Marie-Antoinette.' In *Anne Vallayer-Coster: Painter to the Court of Marie-Antoinette*, ed. Eik Kahng et al. New Haven: Yale University Press, 2002.

Jacobs, Fredrika. *Defining the Renaissance Virtuosa: Women Artists and the Language of Art History and Criticism*. Cambridge: Cambridge University Press, 1997.

Jallut, Marguerite. 'Marie Leczinska et la peinture', *Gazette des Beaux-Arts* 73 (May–June 1969), 305–22.

Jean-Marc Nattier 1685–1766, exh. cat. Musée national des châteaux de Versailles et de Trianon 26 Oct. 1999–30 Jan. 2000. Paris: Réunion des Musées Nationaux, 1999.

Jeannerat, Carlo. 'Le origini del ritratto a miniatura su avorio.' *Dedalo* 11 (1931), 768–70.

Johns, Christopher. 'Venetian Eighteenth-Century Art and the Status Quo.' *Eighteenth-Century Studies* 28 (1995), 427–8.

————. *Papal Art and Cultural Politics: Rome in the Age of Clement XI.* Cambridge and New York: University of Cambridge Press, 1993.

Joullain fils ainé, C. F. *Réflexions sur la peinture et la gravure.* Paris, 1786.

Kamuf, Peggy. 'Penelope at Work: Interruptions in *A Room of One's Own.*' *Novel* 16 (Fall 1982), 5–18.

Kasl, Ronda and Suzanne L. Stratton. *Painting in Spain in the Age of Enlightenment: Goya and His Contemporaries*, exh. cat., New York: Indianapolis Museum of Art and Spanish Institute, 1997.

Katz, Marylin A. *Penelope's Renown: Meaning and Indeterminacy in 'The Odyssey.'* Princeton: Princeton University Press, 1991.

Kelly, Mary. 'On Sexual Politics and Art.' In *Framing Feminism: Art and the Women's Movement 1970–85,* eds Roszika Parker and Griselda Pollock. London: Pandora Books, 1987.

Kitts, Sally-Ann. *The Debate on the Nature, Role and Influence of Women in Eighteenth-Century Spain.* Lewiston, NY: E. Mellen Press, 1995.

Knight, Carlo. *La 'Memoria delle piture' di Angelica Kauffman.* Rome: Edizioni De Luca, 1998.

Kristeva, Julia. 'Women's Time.' In *The Kristeva Reader*, ed. Toril Moi. Oxford: Basil Blackwell, 1986.

La Font de Saint Yenne, *Reflexions sur quelque causes de l'état present de la peinture en France*, 1747. Collection Deloynes, vol. 2, no. 21.

Laine, Merit. 'An Eighteenth-Century Minerva: Lovisa Ulrika and her Collections at Drottningholm Palace 1744–1777,' *Eighteenth-Century Studies* 31:4 (Summer 1998), 493–503.

Landes, Joan B. *Women and the Public Sphere in the Age of the French Revolution.* Ithaca and London: Cornell University Press, 1988.

Laugier, Marc Antoine. *Manière de bien juger des ouvrages de peinture par feu M. l'Abbé Laugier, mise au jour et augmentée de plusieurs notes intéressantes par M**** (Charles-Nicolas Cochin). Paris: Claude-Antoine Jombert, 1771.

Lawrence, Cynthia, ed. *Women and Art in Early Modern Europe.* University Park, PA: Pennsylvania State University Press, 1997.

Lawrence, Karen R. *Penelope Voyages: Women and Travel in the British Literary Tradition.* Ithaca and London: Cornell University Press, 1994.

LeBruyn, C. *A Voyage to the Levant.* London, 1702.

Lefrançois, Thierry. *Charles Coypel: Peintre du roi (1694–1752).* Paris: Arthena, 1994.

Le Gendre, Gilbert Charles, marquis de Saint-Aubin-sur-Loire. *Traité de l'opinion, ou, Mémoires pour servir à l'histoire de l'esprit humain.* 6 vols. Paris: Chez Briasson, 1733.

Lémontey, P.-E. *Histoire de la Régence et de la Minorité de Louis XV jusqu'au ministère de Cardinal Fleury*. 2 vols. Paris: Paulin Librairie, 1827.

Lenoir, Alexandre. 'Mémoires. David. Souvenirs historiques', *Journal de l'Institut Historique* 3. Paris: Baudouin, 1835.

Lexicon Iconographicum Mythologiae Classicae (LIMC), 16 vols. Zurich and Munich: Artemis Verlag, 1994.

Lilley, Ed. 'The Name of the Boudoir.' *Journal of the Society of Architectural Historians* 53 (June 1994), 193–8.

Luise Ulrike, die schwedische Schwester Friedrichs des Grosen: Ungedruckte Briefe an Mitglieder des preussichen Königshauses, ed. Fritz Arnheim. Gotha: Friedrich Andreas Perthes, 1909.

Lundberg, W. 'Quelques portraits de Marie-Anne de Bourbon-Condé.' *Revue de l'art ancien and moderne* LXVIII (1930), 143–7.

Luynes, Charles Philippe d'Albert, duc de. *Mémoires du Duc de Luynes, sur la cour de Louis XV (1735–1758)*. 17 vols. Paris: Firmin Didot, 1861.

Maierhofer, Waltraud, ed. *Angelica Kauffmann: Gesammelte Briefe in den Originalsprachen*. Lengwil am Bodensee: Libelle Verlag, 2001.

Malamani, Vittorio. *Rosalba Carriera*. Bergamo: Istituto Italiano d'Arti Grafiche, 1910.

Malvasia, Carlo Cesare. *Felsina pittrice, vita de pittori bolognese*. Bologna, 1678.

Manners, Victoria and G. C. Williamson, eds. *Angelica Kauffmann, R.A. Her Life and Her Works*. London: John Lane, 1924.

Marín, José Luis Morales y. *Pintura en España, 1750–1808*. Madrid: Cátedra, 1994.

Marqués Mena, Manuela B. et al. *Goya and 18th-Century Spanish Painting*. Madrid: Museo del Prado, 2000.

Martin, Georges. *Histoire et généologie de la maison de Noailles*, n.p., n.d. Printed by Mathias La Ricamarie, 1993.

Martineau, Jane and Andrew Robison, eds. *The Glory of Venice: Art in the Eighteenth Century*, exh. cat. New Haven and London, 1995.

Maximus, Valerius. *Memorable Doings and Sayings (Facta et Dicta Memorabilia)*, trans. D. R. Shackleton Bailey. Cambridge, MA: Harvard University Press, 2001.

McClellan, Andrew. *Inventing the Louvre: Art, Politics, and the Origins of the Modern Museum in Eighteenth-Century Paris*. Cambridge: Cambridge University Press, 1994.

Mémoires secrets pour servir à l'histoire de la république des lettres en France. 36 vols. London: Chez John Adamson, 1780–89.

Memoirs of the comtesse de Boigne 1781–1814, ed. Charles Nicoulaud. New York: Scribner's Sons, 1907.

Menéndez, Juan F. Remón. 'The Alameda of the Duchess of Osuna: a garden of ideas.' *Journal of Garden History* 13 (Winter 1993), 224–40.

Mérard de St Just. *Lettre d'Artiomphile à Madame Mérard de St. Just sur l'exposition au Louvre en 1781, des tableaux, sculptures, gravures, et dessins des artistes de l'Académie royale*. Paris: 1782. Collection Deloynes, vol. 12, n. 277.

Mercure de France, January 1731, 40.

Mercure de France, May 1731, 1022.

Mercure de France, April 1732, 731.

Mercure de France, June 1732, 1302.

Mercure de France, January 1738

Mercure de France, November 1738, 2399.

Mercure de France, March 1740, 469.

Mercure de France, October 1741, 2167.

Mézières, Nicolas le Camus de. *Le Génie de l'architecture*. Paris: B. Morin, 1780.

Michel, Régis, ed. *David contre David*. Paris, 1993.

Mildenberger, Hermann. 'Cornelia und Julia als Vorbilder: Zur ikonographischen Deutung des Pendants von Angelika Kauffmann,' in *Angelika Kauffmann*. Patrimonia 90. Weimar: Kulturstiftung, 1996.

Mirimonde, A. P. de. *L'Iconographie musicale sous les rois bourbons. La musique dans les arts plastiques* (XVIIe–XVIIIe siècles). Paris: Picard, 1977.

Mitchell, Jerrine E. 'Picturing Sisters: 1790 Portraits by J.-L. David.' *Eighteenth-Century Studies* 31 (1997–98), 175–97.

Momus au Sallon, Comédie-critique en vers et en vaudevilles suivie de notes critiques, 1783, Collection Deloynes, vol. 13, n. 292.

Montaigne, Michel de. *The Complete Essays of Montaigne*, trans. Donald M. Frame. Stanford, California: Stanford University Press, 1958.

Montesquieu, Charles de Secondat, Baron de. *Lettres Persanes*. Paris: Baudel, 1964.

Mulvey, Laura. 'Pandora: Topographies of the Mask and Curiosity.' In *Sexuality & Space*, ed. Beatriz Colomina. New York: Princeton Architectural Press, 1988.

Munhall, Edgar. *Greuze the Draftsman*. London: Merrell Publishers Ltd, 2002.

Murnaghan, Sheila. *Disguise and Recognition in the Odyssey*. Princeton: Princeton University Press, 1987.

Muthman, Ruth Maria. *Angelika Kauffmann und ihre Zeit: Graphik und Zeichnungen von 1760–1810*. Düsseldorf: G. C. Boerner, 1979.

Nicholson, Kathleen. 'Ideology of feminine "virtue": the vestal virgin in French eighteenth-century portraiture,' in *Portraiture: Facing the subject*,

ed. Joanna Woodall. Manchester and New York: Manchester University Press, 1997.

Niclausse, Juliette. 'The Jewel-Cabinet of the Dauphine Marie-Antoinette.' *The Journal of the Walters Art Gallery* 18 (1955), 69–77.

Nikolenko, Lada. *Pierre Mignard. The Portrait Painter of the Grand Siècle*. Munich: Nitz Verlag, 1983.

Noailles, Marquis de. *Le Comte Molé, 1781–1855, sa vie, ses mémoires*. 3 vols. Paris, 1923.

Nochlin, Linda. 'Why Have There Been No Great Women Artists?' In *Art and Sexual Politics. Women's Liberation, Women Artists, and Art History*, eds Thomas B. Hess and Elizabeth C. Baker. New York and London: Macmillan, 1973.

Nolhac, Pierre de. *Louis XV et Madame de Pompadour*. Paris: Calmann-Lévy, 1903.

————. *J.-M. Nattier: Peintre de la cour de Louis XV*. Paris: Librairie Fleury, 1925.

Offen, Karen. *European Feminisms 1700–1950: A Political History*. Palo Alto: Stanford University Press, 2000.

Oppenheimer, Margaret A. 'Women Artists in Paris, 1791–1814'. Ph.D. Dissertation. New York University, Institute of Fine Arts, 1996.

Orlando, Pietro. *Abecedario pittorico, contenente le notizie de' professori di pittura, scoltura, ed architettura*. Venice, 1753.

Ortner, Sherry. 'Is Female to Male as Nature is to Culture?' in *Women, Culture and Society*, eds Michelle Zimbalist Rosaldo and Louise Lamphere. Stanford: Stanford University Press, 1974.

Oulmont, Charles. *J.-E. Heinsius (1740–1812). Peintre de Mesdames de France* in *Oeuvres complètes de Charles Oulmont*, vol. 19. Strasbourg and Paris: Istra, 1970.

Outram, Dorinda. *The Body and the French Revolution: Sex, Class and Political Culture*. New Haven: Yale University Press, 1989.

Pape, Maria Elisabeth. 'Turquerie im 18. Jahrhundert und der 'Recueil Ferriol'.' In *Europa und der Orient 800–1900*, exh. cat., Berlin: Martin-Gropius-Bau, 28 May–27 August 1989.

Painters by Painters, Exhibition catalogue. Wisbech: Cambridgeshire: Balding and Mansell International Ltd, 1988.

Parker, James. 'French Eighteenth-Century Furniture Depicted on Canvas,' *The Metropolitan Museum of Art* 24:5 (January 1966), 177–92.

Passez, Anne-Marie. *Adélaïde Labille-Guiard 1749–1803. Biographie et catalogue raisonnée de son œuvre*. Paris: Arts et Métiers Graphiques, 1973.

————. *Antoine Vestier: 1740–1824*. Paris: Fondation Wildenstein: Bibliothèque des Arts, 1989.

Pérouse de Montclos, Jean-Marie. *Vaux-le-Vicomte*. Paris: Éditions Scala, 1997.

Perry, Gill, ed. *Academics, museums and canons of art*. New Haven and London: Yale University Press, 1999.

————, ed. *Gender and Art*. New Haven and London: Yale University Press, 1999.

Peyre, R. 'Quelques lettres inédites de Louis David et de Madame David.' *La Chronique des Arts et de la Curiosité* 11–12 (1900), 97–8; 109–11.

Poignant, Simone. *Les filles de Louis XV. L'Aile des Princes*. Paris: Arthaud, 1970.

Pointon, Marcia R. *Hanging the Head: Portraiture and Social Formation in Eighteenth-Century Britain*. New Haven: Yale University Press, 1993.

————. 'Kahnweiler's Picasso: Picasso's Kahnweiler,' in *Portaiture: Facing the Subject*, ed. J. Woodall, Manchester and New York: Manchester University Press, 1997.

Pöllnitz, Karl Ludwig von. *Lettres et Memoires du Baron de Pöllnitz*. 5th edn. 3 vols. Frankfurt: 1738.

Pollock, Griselda. *Differencing the Cannon. Feminist Desire and the Writing of Art's History of Art's Histories*. London and New York: Routledge, 1999.

————. 'Feminist Interventions in Art's Histories.' *Kritische Berichte* 1 (1988).

Posner, Donald. *Annibale Carracci*. New York: Phaidon, 1971.

————. 'Madame. de Pompadour as a Patron of the Visual Arts.' *Art Bulletin* 72 (1990), 75–108.

Potts, Alex. *Flesh and the Ideal: Winckelmann and the Origins of Art History*. New Haven: Yale University Press, 1994.

Prinz, Wolfgang. *Die Sammlung der Selbstbildnisse in den Uffizien*. Berlin: Mann, 1971.

Proschwitz, Gunnar von. 'Lettres inédites de madame Du Deffand, du président Hénault, et du comte de Bulkeley au baron Carl Fredrik Scheffer, 1751–56', *Studies on Voltaire and the Eighteenth Century* 10 (1959).

Pucci, Susanne. 'The Discrete Charms of the Exotic: fictions of the harem in eighteenth-century France.' In *Exoticism and the Enlightenment*, eds G. S. Rousseau and Roy Porter. Manchester and New York: Manchester University Press, 1990, 145–74.

Rabb,Theodore K. 'Politics and the Arts in the Age of Christina.' In *Politics and Culture in the Age of Christina*, ed. Marie-Louise Rodén. Stockholm: Svenska instituteti Rom, 1997.

Radisich, Paula. *Hubert Robert: Painted Spaces of the Enlightenment*. Cambridge: Cambridge University Press, 1998.

————. 'Que peut définir les femmes?' *Eighteenth-Century Studies* 25 (1992), 441–68.

Rawagnau, Girolamo. 'Carriera, Rosalba', in *Biografia degli Italiani illustre nelle scienze, lettere, ed arti del secolo XVIII e de contemporanei compilata da letterati Italiani di ogni provincia e pubblicata a cura del professor Emilio d Tipaldo*. Vienna, 1836.

Reinhardt, Udo, 'Angelika Kauffmann und Homer,' *Jahrbuch Vorarlberger Landesmuseumsverein, Freunde der Landeskunde*. Bregenz: J. N. Teutsch, 2000.

Renard, Philippe. *Jean-Marc Nattier (1685–1766). Un artiste parisien à la cour de Louis XV*. Château de Saint-Rémy-en-L'Eau: Éditions Monelle Hayot, 1999.

Rétif de la Bretonne, Nicolas-Edme. 'Fausse immoralité de la liberté de la presse.' In *Monsieur Nicolas*, ed. Pierre Testud (1797); Paris: Éditions Gallimard, 1989.

Ribiero, Aileen. 'Fashioning the Feminine: Dress in Goya's Portraits of Women.' In *Goya: Images of Women*, exh. cat., ed. Janis A. Tomlinson. Washington, DC: National Gallery of Art, 2002.

Rice, Louise and Ruth Eisenberg. 'Angelica Kauffman's Uffizi Self-Portrait.' *Gazette des Beaux-Arts* Series 6:117 (1991), 123–6.

Rishel, Joseph J. and Edgar Peters Bowron. *Art in Rome in the Eighteenth Century*, exh. cat., London: Merrell; Philadephia: In association with Philadelphia Museum of Art, 2000.

Robert, Louise. *Les Crimes des reines de France depuis le commencement de la monarchie jusqu'à Marie-Antoinette*. Paris: Au bureau des Révolutions de Paris, 1791.

Roberts, Michael *The Age of Liberty, Sweden 1719–1772*. Cambridge, London, New York, New Rochelle, Melbourne, Sydney: Cambridge University Press, 1986.

Rollin, Charles. *Opuscules de feu M. Rollin*, 16 vols. Paris: Frères Estienne, 1771.

Rosaldo, Renato. 'Imperialist Nostalgia.' *Representations* 26 (Spring 1989), 108–9.

Rosenberg, Pierre. *Chardin (1699–1779)*, exh. cat., 1979. Cleveland: The Cleveland Museum of Art in cooperation with Indiana University Press, 1979.

Rosenthal, Angela. *Angelika Kauffmann: Bildnismalerei im 18. Jahrhundert.* Berlin: Reimer, 1996.

———. 'Angelica Kauffman ma(s)king claims.' *Art History* 15:1 (March 1992), 38–59.

———. 'She's got the look! Eighteenth-century female portrait painters and the psychology of a potentially "dangerous employment."' In *Portraiture: Facing the Subject*, ed. J. Woodall. Manchester and New York: Manchester University Press, 1997.

Ross, Michael. *The Reluctant King: Joseph Bonaparte King of the Two Sicilies and Spain.* London: Sidgwick & Jackson, 1976.

Rossi, G. G. de. *Vita di Angelica Kauffman, pittrice.* Florence, 1810; Pisa, 1811.

Rousseau, Jean-Jacques. *Émile, or On Education*, trans. Allan Bloom. New York: Basic Books, 1979.

————. *Politics and the Arts: Letter to M. d'Alembert on the Theater*, trans. Allan Bloom. Ithaca: Cornell University Press, 1989.

Roworth, Wendy Wassyng. 'Anatomy is Destiny: Regarding the Body in the Art of Angelika Kauffman.' In *Feminity and Masculinity in Eighteenth-Century Art and Culture*, eds Gill Perry and Michael Rossington. Manchester: Manchester University Press, 1994.

————, ed. *Angelica Kauffman: A Continental Artist in Georgian England.* London: Reaktion Books and Brighton Art Gallery and Museum, 1992.

————. 'Angelica Kauffman's *Memorandum of Paintings.*' *Burlington Magazine* 126 (October 1984), 629–30.

————. 'Biography, Criticism, Art History: Angelica Kauffman in Context.' In *Eighteenth-Century Women in the Arts*, eds F. M. Keener and S. Lorsch. New York: Greenwood Press 1988.

Sade, Comte Donatien-Alphonse-François de. *La Philosophie dans le boudoir.* In *Oeuvres* (1795), eds Michel Delon and Jean Deprun. Paris: Éditions Gallimard, 1998.

Saint-Méry, Médéric Louis Elie Moreau de, *Description topographique, physique, civile, politique et historique de la partie française de l'isle Saint-Domingue*, eds Blanche Maurel and Étienne Taillemite (1797). Paris: Société de l'histoire des colonies françaises, 1958.

Salmon, Xavier. 'The Drawings of Jean-Marc Nattier, Identifying the Master's Hand.' *Apollo* 429 (November 1997), 3–11.

————. *Jean-Marc Nattier 1685–1766.* Paris: Réunion des musées nationaux, 1999.

————. 'Jean-Marc Nattier à Chantilly.' *Le Musée Condé* 56 (October 1999), 31.

———— et al. *Madame de Pompadour et les arts*, exh. cat., Paris: Réunion des musées nationaux, 2002.

Les Salons *des 'Mémoires secrets' 1767–1787*, ed. Bernadette Fort. Paris: Ecole national supérieure de Beaux-arts, 1999.

San Juan, Rose Marie. 'The Queen's Body and its Slipping Mask: contesting Portraits of Queen Christina of Sweden.' In *ReImagining Women: Representations of Women in Culture*, eds Shirley Neuman and Glennis Stephenson. Toronto, Buffalo, London: University of Toronto Press, 1993, 19–44.

Sandner, Oscar, ed. *Angelika Kauffman e Roma*, exh. cat., Rome: De Luca, 1998.

―――――. *Angelika Kauffmann und ihre Zeitgenossen*, exh. cat., Bregenz: Vorarlberger landesmuseum, Vienna: Österreichisches Museum für Angewandte Kunst, 1968.

―――――. *Hommage an Angelika Kauffmann*, exh. cat., Vaduz, Lichtensteinische Staatliche Kunstsammlung and Milan, Palazzo della Permanente. Milan: Nuova Mazzotta, 1992.

Sandoz, Marc. *Les Lagrenée: I. Louis-Jean-Francois Lagrenée, 1725–1805*. Paris, 1983.

Sani, Bernardina. *Rosalba Carriera*. Turin: U. Allemandi, 1988.

―――――. *Rosalba Carriera: Lettere, diari, frammenti*. 2 vols. Florence: Leo S. Olschki, 1985.

―――――. 'La "furia francese" de Rosalba Carriera: Ses rapports avec Watteau et les artistes français.' In *Antoine Watteau (1689–1721), le peintre, son temps et sa légende*, exh. cat., eds François Moreau and Margaret Morgan Grasselli. Paris: Champion-Slatkine; Geneva: Editions Clairefontaine, 1987.

―――――. 'Lo studio del Correggio in alcuni pastelli di Rosalba Carriera.' *Annali della Scuola Normale di Pisa* 8 (1978), 203–12.

―――――. 'La terminologia della pittura a pastello e in miniatura nel carteggio di Rosalba Carriera.' *Convegno nazionale sui lessici technici del Sei- e Settecento*. Pisa, 1980.

―――――. 'Rosalba Carriera's "Young Lady with a Parrot".' *Museum Studies: The Art Institute of Chicago* 17 (1991), 74–87 and 95.

Sarrailh, Jean. *L'Espagne eclairée de la seconde moitié du XVIIIe siècle*. Paris: Librairie C. Klincksieck, 1964.

―――――. 'Diego Clemencin.' *Bulletin Hispanique* 24 (April–June 1922), 9.

Sartorio, Aristide. *Galleria di S. Luca*, vol. 9–10, *Musei e Gallerie d'Italià*. Rome, 1910.

Schama, Simon. 'The Domestication of Majesty.' *Journal of Interdisciplinary History* 17 (1986), 155–84.

Scheffer, Carl Fredrik. *Lettres particulières à Carl Gustaf Tessin, 1744–1752*, ed. Jan Heidner. Stockholm: Kungl. Samfundet för utgivande av handskrifter rörande Skandinaviens historia, 1982.

Schein, Seth L. 'Female Representations and Interpreting The Odyssey.' In *The Distaff Side: Representing the Female in Homer's Odyssey*, ed. Beth Cohen. New York: Oxford University Press, 1995, 17–28.

Schieder, Theodor. *Frederick the Great*, ed. and trans. Sabina Berkeley and H. M. Scott. London and New York: Longman, 2000.

Schulze, Sabine, ed. *Goethe und die Kunst*, exh. cat. Frankfurt: Schirn Kunsthalle, 1994.

Scott H. M., ed. *Enlightened Absolutism: Reform and Reformers in Later*

Eighteenth-Century Europe. Ann Arbor: University of Michigan Press, 1990.

Sensier, Alfred. *Journal de Rosalba Carriera pendant son séjour à Paris en 1720 et 1721.* Paris: J. Techener, 1865.

Shackelford, George T. M. and Mary Tavener Holmes. *A Magic Mirror: The Portrait in France, 1700–1900,* exh. cat., Houston: The Museum of Fine Arts, 1986.

Sheriff, Mary D. *The Exceptional Woman: Elisabeth Vigée-Lebrun and the Cultural Politics of Art.* Chicago and London: University of Chicago Press, 1996.

—————. 'A Rebours: Le problème de l'histoire dans l'interprétation féministe.' In *Où en est l'interprétation de l'oeuvre d'art,* ed. Régis Michel. Paris: Ecole nationale supérieur des beaux-arts: 2000.

—————. 'Reading Jupiter Otherwise: Or Ovid's Women in Eighteenth-Century Art.' In *Myth, Sexuality and Power: Images of Jupiter in Western Art,* ed. Frances Van Keuren. Special issue of *Archaeologia Transatlantica* 16 (1998), 79–93.

Skuncke, Marie-Christine, *Gustaf III, det offentliga barnet: en prins retoriska och politiska fostran.* Stockholm: Atlantis, *c.* 1993.

Snoep-Reitsma, Ella, 'Chardin and the Bourgeois Ideals of his Time', *Nederlands Kunsthistorish Jaarboek,* XXIV (1973), 185.

Le Soleil et l'Étoile du Nord; La France et la Suède au XVIIIe siècle, exh. cat., Galeries Nationales du Grand Palais, 15 mars–13 juin 1994. Paris: Réunion des Musées Nationaux, 1994.

Soria, Martín S. *Agustín Esteve y Goya.* Valencia: Institución Alfonso el Magnanimo, 1957.

Soulavie, abbé. *Réflexions impartiales sur les progrès de l'art en France.* 1785 Collection Deloynes, vol. 14 no. 331.

Soulavie, Jean-Louis. *Mémoires historiques et anecdotes, pendant la faveur de la Marquise de Pompadour.* Paris: A. Bertrand, 1802.

Sourches, marquis de. *Mémoires du Marquis de Sourches, sur le Règne de Louis XIV,* eds Gabriel-Jules le Comte de Cosnac and Edouard Pontal. 13 vols. Paris: Hachette, 1893.

Spell, Jefferson Rea. *Rousseau in the Spanish World Before 1833: A Study in Franco-Spanish Literary Relations.* New York: Gordian Press, 1969.

Staal-Delauney, Marguerite Jeanne Cordier, Madame de. *Mémoires de Madame de Staal-Delauney sur la sociéte française au temps de la Régence,* ed. Marguerite Jeanne Cordier. Paris: Mercure de France, 1970.

Starobinski, Jean. *L'Invention de la liberté 1700–1789.* Geneva: Skira, 1987.

Stein, Perrin. 'Amédée Vanloo's Costume Turc: The French Sultana.' *Art Bulletin* 78 (September 1996), 417–38.

————. 'Madame de Pompadour and the Harem Imagery at Bellevue.' *Gazette des Beaux-Arts* 123: 1500 (1994), 29–44.

Sterling, Charles, et al. *The Robert Lehman Collection, II, Fifteenth- to Eighteenth-Century European Paintings.* Princeton: Princeton University Press, *c.* 1987.

Stoichita, Victor Ieronim. *A Short History of the Shadow,* trans. Anne-Marie Glasheen. London: Reaktion Books, 1997.

Stryienski, Casimir. *Mesdames de France. Filles de Louis XV.* Paris: Émile-Paul, 1911.

Swozilek, Helmut, ed. and trans. *Memoria istoriche di Maria Angelica Kauffmann Zucchi riguardenti l'arte della pittura da lei professata scritte da G.C.Z. (Guiseppe Carlo Zucchi).* In *Venezia MDCCLXXXVII, Schriften des Vorarlberger Landesmuseums* Series B, 2 (1999).

Tcherny, Nadia. 'Domenico Corvi's Allegory of Painting: an Image of Love.' *Marsyas* XIX (1977–78), 23–7.

Théré, Christine. 'Economic Publishing and Authors, 1566–1789,' in *Studies in the History of French Political Economy: From Boden to Walrus,* ed. G. Faccarelle. London: Routledge, 1998, 1–56.

————. 'Women and Birth Control in Eighteenth-Century France', *Eighteenth-Century Studies* 32:4 (Summer 1999).

Thomas, Chantal. *La reine scélérante: Marie-Antoinette dans les pamphlets.* Paris: Seuil, 1989.

Tomlinson, Janis A. *Francisco Goya. The Tapestry Cartoons and the Early Career at the Court of Madrid.* Cambridge: Cambridge University Press, 1989.

————. *Francisco Goya y Lucientes 1746–1828.* New York: Phaidon, 1994.

Townsend, Joseph. *A Journey through Spain in the Years 1786 and 1787.* London: C. Dully, 1792.

Trapier, Elizabeth du Gué. *Goya and His Sitters: A Study of his Style as a Portraitist.* New York: Hispanic Society of America, 1964.

Trouille, Mary Seidman. *Sexual Politics in the Enlightenment. Women Writers Read Rousseau.* Albany, NY: SUNY Press, 1997.

Vici, Andrea Busiri. *I Pontiatowski e Roma.* Florence: Editrice Edam, 1971.

Vidal, Mary. 'David Among the Moderns: Art, Science, and the Lavoisiers.' *Journal of the History of Ideas* 56 (1995), 613.

Vigée-Lebrun, Élisabeth Louise. *Souvenirs.* (Paris: Charpentier, 1869), ed. Claudine Hermann. Paris: Editions des Femmes, 1984.

Vogelsang, Bernd. '"Bilder-Szenen" Kontexte der Weimarer "Historienbilder" Angelika Kauffmanns.' In *Angelika Kauffmann.* Patrimonia 90. Weimar: Kulturstiftung, 1996.

Vogtherr, Christoph Martin. 'Absent Love in Pleasure Houses. Frederick II of Prussia as art collector and patron,' *Art History* (2001), 231–46.

Walch, Peter. 'Angelica Kauffman.' Ph.D. dissertation. Princeton University, 1968.

Warnke, Martin. *The Court Artist: On the Ancestry of the Modern Artist*, trans. David McLintock. Cambridge:Cambridge University Press, 1993.

West, Shearer. 'Gender and Internationalism: The Case of Rosalba Carriera,' in *Italian Culture in Northern Europe in the Eighteenth Century*, ed. Shearer West. Cambridge: Cambridge University Press, 1999.

Wiebenson, Dora. 'Subjects from Homer's Iliad in Neoclassical Art.' *Art Bulletin* 46 (1964), 23–37.

Winckelmann, Johann Joachim. *The History of Ancient Art*, trans. G. Henry Lodge. 4 vols. Boston: James R. Osgood, 1873.

Wrigley, Richard. *The Origins of French Art Criticism From the Ancien Régime to the Restoration*. Oxford: Clarendon Press, 1993.

Yebes, Condesa de. *La Condesa-Duqesa de Benavente. Una vida en unas cartas*. Madrid: Espasa-Calpe, 1955.

Zucchi, Antonio. *Memoria delle pitture fatte d'Angelica Kauffmann – dopo suo ritorno d'Inghilterra che fu nel mese d'ottobre 1781 che vi trovo a Venezia*, MS, Royal Academy Library, London.

Zucchi, Giuseppe Carlo. *Memoria istoriche di Maria Angelica Kauffmann Zucchi riguardanti l'arte della pittura da lei professata scritte da G.C.Z. (Giuseppe Carlo Zucchi)*, ed. and trans., Helmut Swozilek. Venezia MDCCLXXXVII, *Schriften des Vorarlberger Landesmuseums*, Series B, 2 (1999).

Index

Picture references have been set in bold type.